Pastiche

Richard Dyer's *Pastiche* is a study of the poetics and politics of this widely used, seldom examined term.

Writing with his customary wit and style, Dyer argues that while pastiche can be used to describe works which contain montage or collage, it can also be used to describe works which are knowing imitations of previous works. Considering first of all the many things the term is used to refer to, the book then focuses on pastiche as a term to describe imitations that are meant to be understood and appreciated as imitations. This is traced in classic literary pastiche (notably Proust) and texts within texts (the play within the play in *Hamlet*, the shows within the show *Follies*), before widening out into a consideration of the relation of pastiche to genre, history, criticism and emotion. There is detailed consideration of a wide range of examples including *Madame Bovary*, *The Nutcracker*, the *Afro-American Symphony*, spaghetti Westerns such as *Once Upon a Time in the West*, neo-noir and *Far From Heaven*.

Dyer argues for the value of pastiche as a practice that cuts through some of the commonplaces of critical discussion, showing that a work can be critical of something without having to be parodically distant from it, able to acknowledge the history of its own emotional effects without in the process ceasing to be moving.

Pastiche is a key concept within film and cultural studies, and Dyer's text is the first full study of the term and its usage.

Richard Dyer is Professor of Film Studies at King's College, London. His previous publications include, amongst many, *Now You See It* (second edition 2003), *Only Entertainment* (second edition 2002), *The Matter of Images* (second edition 2002), *The Culture of Queers* (2002), *Seven* (1999), *White* (1997), *Brief Encounter* (1993), *Stars* (1979) and *Gays and Film* (1977).

Pastiche

Richard Dyer

Routledge
Taylor & Francis Group

LONDON AND NEW YORK

First published 2007
by Routledge
2 Park Square, Milton Park, Abingdon, Oxon OX14 4RN

Simultaneously published in the USA and Canada
by Routledge
270 Madison Ave, New York, NY 10016

Routledge is an imprint of the Taylor & Francis Group, an informa
business

© 2007 Richard Dyer

Typeset in Garamond by
Keyword Group Ltd
Printed and bound in Great Britain by
The Cromwell Press, Trowbridge, Wiltshire

British Library Cataloguing in Publication Data
A catalogue record for this book is available from the British Library

Library of Congress Cataloging in Publication Data
Pastiche/Richard Dyer
p. cm.
Includes bibliographical references and index.
ISBN 0-415-34009-8 (hardback: alk. paper)
ISBN 0-415-34010-1 (pbk.: alk. paper)
1. Pasticcio in art. 2. Arts, Modern. I. Title.
NX650.P377D94 2006-06-20 709.04–dc22
2006006443

ISBN 10: 0-415-34009-8 (hbk)
ISBN 10: 0-415-34010-1 (pbk)
ISBN 13: 978-0-415-34009-0 (hbk)
ISBN 13: 978-0-415-34010-6 (pbk)

For my class of 03 –
Cecilia, David, José, Karen, Kate, Lucas, Melinda,
Rahul, Rebecca, Shi-yan, Steven, Ventura and Vicente.

Contents

Figures

Introduction

Pastiche is a widely used but little examined term. It has two primary senses, referring to a combination of aesthetic elements or to a kind of aesthetic imitation. The second is the focus of this book.

A preliminary definition of the sense of pastiche pursued here might be: pastiche is a kind of imitation that you are meant to know is an imitation. Such an endearingly plain definition inevitably requires glossing, in almost every particular.

Imitation

First, pastiche is concerned with imitation in art. Imitation in the widest sense is the foundation of all learning, which is to say of behaviour, communication and knowledge. The nature and extent of this cannot be our concern here, though it is worth registering that pastiche is connected so evidently with such a fundamental aspect of human existence.

Second, when I say 'art', I do not mean this to carry any evaluative weight. I wish there was another word, for it seems impossible to cleanse 'art' of meaning 'good' or 'approved' or 'high status' art, but 'cultural production' is too broad and 'text' too literary.* The term 'a work' will sometimes do if the context does not make it ambiguous, and reminds us that art is something made and of stuff, and that it does something, that it works as meaning and affect. In what follows I use both it, 'art', and also 'aesthetic' indiscriminately as to value, to refer equally to popular, mass, middle and high brow. For what it's worth, I do not thereby imply that all works are equally valuable; but nor do I assume that a work produced at any particular cultural level is a priori better or worse than those at other levels. It's all art, it all follows, bends and breaks specific aesthetic rules and principles; some of it is dreadful, some wonderful, most of it neither.

Third, an entire work may be a pastiche (and there is even a recognised literary genre of pastiche, discussed in chapter 2). However, just as commonly

* Though the origin of the term 'text' is in weaving (cf. 'textile').

(perhaps more so), pastiche is an aspect of a work, something contained inside a wider work that is not itself pastiche (the plays-within-plays and so on of chapter 3) or a formal operation used within a work (such as Flaubert's use of Romantic pastiche in *Madame Bovary*, discussed in chapter 5).

Fourth, pastiche may imitate a specific work or else a kind of work (authorial, generic, period).

Fifth, the artistic imitation involved in pastiche is of other art, not of life or reality itself. The notion that art in some sense or other imitates life is a cornerstone of Western aesthetics but is not the kind of imitation addressed here. Pastiche is always an imitation of an imitation; it may be that there is an infinite regress in such thoughts, that one never arrives at the point where an imitation is an imitation of life but is always ineluctably an imitation of art. This rather giddying perspective may be tempered by a formulation that takes as given that there is indeed such a thing as reality, something beyond imitation, but which recognises that it is never expressed, and perhaps hardly grasped, unmediatedly, but only through using the forms of imitation at one's disposal to apprehend it. Such considerations are strictly speaking outside of the concerns bracketed by this study and the term pastiche itself, but I touch on them here as a trailer for an argument developed throughout the book, namely that pastiche is not something superficial, disconnected from the real and, especially, from feeling. It is rather a knowing form of the practice of imitation, which itself always both holds us inexorably within cultural perception of the real and also, and thereby, enables us to make a sense of the real.

Meant to

Dictionary definitions tend not to use more words than they need to, yet in one form or another a notion of 'meaning to' seems necessary to most such definitions of pastiche: 'usu. deliberately imitates' (Webster 1961), 'in professed imitation' (OED 1989), 'by one artist in the style of another, acknowledged as such' (Martin 1986), 'selfconsciously borrows' (Turner 1996), 'deliberately composed' (Jacobs 1958). This implies intention and intention is a notion that has made cultural theorists twitchy for at least a century. Intention acquired a bad name because it was often used in a strong sense, to refer to the biography or inner life of the artist, in ways that both are hard to prove and privilege such intention over what the art seems manifestly to be. However, we do not need to throw out all notions of intention just because of such problems. It is really not extravagantly speculative to say that a work is meant to be funny or sad, in this or that genre, is or is not pastiche.

In one usage, pastiche may be considered unintentional. This is when such and such a work is deemed to have failed to be what it set out to be and wound up 'merely a pastiche'.[1] In particular, a work may have aimed to be original but merely fallen into being like something else, and a second-rate version at that. The notion is often well conveyed by the qualifier 'poor man's'.

Thus in the opinion of some Brahms is just pastiche Beethoven, the British *Confessions* films are a poor man's *Carry On* films. Equally, it is possible to attend to a work in such a way that you only see that it is imitating, so that you yourself in effect pastiche the work; camp is probably now the most familiar form of this.

You

Pastiche intends that it is understood as pastiche by those who read, see or hear it. For it to work, it needs to be 'got' as a pastiche. In this sense, it is an aspect of irony (Hutcheon 1994: 89ff.). This implies particular competencies on the part of audiences and, to this extent, pastiche may be seen as élitist, including those who get it, excluding those who don't. Pastiche no doubt does often incite snobbery ("don't you get it?!"), but this does not necessarily overlap with élites as normally socially defined. Pastiche is used and recognised just as much in popular and mass culture as in middle and high brow. Considered purely as an understanding among producers and consumers, every pastiche has its particular group that gets it. However, pastiche may also be used by groups not defined as pastiche users in this narrower producer–consumer sense but in relation to other social divisions. Even at this level, pastiche is not the preserve of the powerful or of accredited arbiters of sophistication any more than of the marginalised or oppressed; it is found at all brows, in all social groupings. 'You' need to get it, but at the most abstract level, the concept of pastiche does not make a priori assumptions about who 'you' is.

Know

Most (probably to all intents and purposes all) people know that a given work is like others that preceded it and, even while transforming those, is also imitating them. However, most of the time we do not think about this and indeed it is a common experience that to think about it is to have one's interest and attention spoilt. Just as becoming aware of the rules of grammar or the actual sound of a word tends to make it harder to speak, so too our readiness and desire to lose ourselves in a work is hampered by being too conscious of the examples it is at once following and bending. In pastiche, however, the fact that such imitation is going on is a defining part of how the work works, of its meaning and affect.

Yet, except when something is actually labelled pastiche, as in the work discussed in chapter 2, it is not always easy to demonstrate that pastiche is going on, to be sure that one knows. Chapter 1 ends by suggesting that the case for any given work being considered pastiche has to be made through a combination of contextual and paratextual indications, textual markers and aesthetic judgement; chapter 2 explores, through the case of pastiches that are explicitly named as such by their makers, the textual markers of considerable

likeness combined with not too exaggerated elements of deformation and discrepancy. Chapters 3 and 4 address further the problem of recognition from two different directions. Chapter 3 looks at cases where it is likely that there is pastiche, where one work (a play, a painting, a film) frames another within it, the latter thus tending (but only tending) to keep the fact of imitation constantly to the fore and thus to be pastiche. The advantage of considering such instances is that both the context (the frame) and the inner work itself (by virtue of stylistic difference) provide further indications about the assumptions and formal operations of pastiche. Chapter 4, in contrast, looks at a case where it is most difficult to distinguish pastiche from non-pastiche: genre. To be aware of a work as being of a particular genre is perforce to be aware of it as an imitation of an imitation – yet there is, in principle, a difference between just an instance of the genre and a pastiche of it. Chapter 4 tries to get at what that difference is.

Kind

In many ways I have begun to specify what kind of imitation pastiche is – it imitates other art in such a way as to make consciousness of this fact central to its meaning and affect. The rest of this book seeks both to explore and to bring into focus what is involved and implied in this. I begin by situating the term pastiche in relation to other terms for practices of imitation: copy, plagiarism, parody and so on. Then follow the chapters on the specific, mainly literary mode of pastiche, on pastiche within a work not itself pastiche and on genre. The last chapter considers some of the aesthetic, expressive and political uses of pastiche. Two arguments are advanced there. First, while I hope throughout the book to show that pastiche is worth taking seriously, I am far from arguing that it is inevitably, say, clever or progressive – but it can be. Second, I especially want to argue against the notion that pastiche is incompatible with affect; indeed, the reason for being interested in it is that it demonstrates that self-consciousness and emotional expression can co-exist, healing one of the great rifts in Western aesthetics and allowing us to contemplate the possibility of feeling historically.

• • •

A note on notes and examples

Notes

I use numbered endnotes in the standard fashion to provide scholarly back-up and elaboration of points in the text. I also use two kinds of footnote.

First, asterisks. I have been struck by how often the terms explored in this book are of domestic, above all culinary, derivation, including pastiche itself. It has been common in the last century to take sexuality as the explanatory analogy par excellence for cultural and aesthetic forms, but perhaps we should

explore domestic arts and crafts too. Sex is driven, impulsive, climactic and it is possible for individuals to exist without it. In contrast, food and clothing are everyday and necessary. Elaborated, they involve skill and labour, savouring and satiation. If we take these as a primal source and model of art, they suggest a much more inclusive aesthetics, one apparently apparent to those who first started using domestic terms in aesthetic discourse. It is also suggestive that, given pastiche's low cultural status, it belongs with terms from the predominantly feminine arena of domestic practice rather than the rather more masculine one of sexual prowess. So I note with an asterisk the many connections between aesthetic and domestic terms, as a way of re-opening this perception of art after the sexuality years.

Second, daggers. Very often tracing a pastiche back to that which it pastiches opens up a trail of connections that take one far from the argument at hand. It seems a shame to let these go, for they indicate the pervasiveness of the practices of the imitative and alluding practices of which pastiche is a special case. I have used what typographers call a dagger (†) to indicate these, but one might think of this symbol as more like a needle and these footnotes as following the threads that link works together.

Examples

In a study as deliberately wide-ranging in terms of media and periods, but also as short, as this, the examples cannot pretend to be exhaustive. At the same time, since the value of a generalisation can only be judged by its ability to survive the qualification and even mauling that the detail and particularity of any example must entail, it is important to discuss examples reasonably thoroughly, rather than provide an extensive scattering of more briefly examined cases. The examples pursued here are those that came to mind and that I felt able or inclined to pursue. The fact that more are twentieth century than earlier, the vast majority are Western and more are film than other media, is not intended to make a case that somehow, over the last hundred years, the West and the medium of film have been more inclined towards pastiche than other centuries or media. Indeed, on the whole, albeit in ignorance, I doubt it.

• • •

I should like to thank Thomas Elsaesser, Alessandra Marzoli and Mario Corona, Jostein Gripsrud and Georgina Born, for providing me with the occasion to try out some of the ideas at the Universities of, respectively, Amsterdam, Bergamo, Bergen and Cambridge; Catherine Constable and Susan Speidel for inviting me to speak at Sheffield Showroom and Ann Kaplan likewise at SCMS London. I am especially indebted to Jostein for his question on the use of the word pastiche. Ruggero Eugeni and Luisella Farinotti prompted my thoughts on genre by inviting me to contribute to a special issue of *Communicazione sociale*; the Taylorian library in Oxford were especially obliging with the volumes by Delepierre and Karrer, and Richard Perkins at the University of

Warwick library was as ever unfailingly helpful in the pursuit of references. I'd like to give special thanks to Rebecca Barden, not only for commissioning this work but for all her support and encouragement while she was at Routledge, and also to thank Natalie Foster and Aileen Irwin in seeing this book so well through its last stages. I should also like to thank José Arroyo, Daniela Berghahn, Charlotte Brunsdon, Erica Carter, Malcolm Gibb, Todd Haynes, Roger Hilyer, Giorgio Marini, Georgina Paul, Martin Pumphrey, Ginette Vincendeau, Tom Waugh and James Zborowski for conversation, suggestions and various kinds of help (the last also for the index).

I decided to write this book after teaching a course on the topic at New York University. I want to thank Chris Straayer, not only for making this possible but also for responding so positively to my proposal of pastiche as a topic, and especially to thank those who took the class. I am conscious of specific debts, examples drawn to my attention, clarifying formulations and helpful, at times forensic questions, but above all for the enormous stimulation, inspiration and support I received from everyone in the class.

Notes

1 Margaret Rose refers to Hans Kuhn's discussion of the Swedish word 'pekoral' to designate 'an unintentionally comic or stylistically incompetent piece of writing by a "would-be" poet or writer' (Kuhn 1974: 604; quoted in Rose 1993: 68). Although here allied specifically to parody, pekoral seems near to indistinguishable from the use of pastiche to mean failed imitation. Note also the brief observation on *Shane* as pastiche in this sense in chapter 4, and the related designation by Susan Sontag of camp as 'failed seriousness' (1967: 287). On camp more generally, see Cleto (1999).

1　Pastiche and company

Pastiche is a widely used critical term: it is used a lot and loosely.
Among other things it is used to mean:[1]

an insulting depiction (in C. S. Lewis's Narnia books 'it is true that the fairly
evil empire of Calormen is pastiche Arab or Chinese' (Stephen L. R. Clark,
Times Literary Supplement letters, 9.05.03: 17));

empty harking back to obsolete models (Italian Fascist sculpture 'celebrating
the Ethiopian victory was more likely to pastiche, in a desolate way,
the art of ancient Rome' than adopt futurist models (Jonathan Jones,
The Guardian Saturday Review, 12.07.03: 19));

an inferior version (Dürer's painting 'The Virgin in the Garden' was in the
1950s 'relegated to the status of a later copy or pastiche' (Paul Hills,
Times Literary Supplement, 14.05.04: 20));

second-rate imitation ('acres of the score [of the musical *The Water Babies*]
strike the ear as being sub-Sondheim pastiche' (Paul Taylor, *The Independent*
Review, 23.07.03: 17));

empty historical recreation (Sofia Coppola's *Marie Antoinette* 'sidesteps mere
historical pastiche to get inside Marie Antoinette's head' (Sandra Ballentine,
The Guardian Review, 1.07.05: 15));

parody (ubiquitous);

next to camp ('k. d. lang's butch-pastiche of male country and western
singers' (Cindy Patton, Introduction to new edition of *Lavender Culture*
(Jay and Young 1994: xxv)), '*Far from Heaven* is much more than camp
or pastiche', Peter Bradshaw, *The Guardian* Review, 7.03.03: 12);

idealisation of a style (an article entitled 'A passion for pastiche', about the
revaluation of the houses of British 1920s developer Reginald Fairfax
Wells, speaks of 'his idealised notions of the English landscape, his pastiche
cottages' (Fred Redwood, *The Sunday Telegraph* Review, 21.04.02: 19));

something that is like something else without being a direct imitation of it
(the film *The Car Keys* is a 'postmodern Pirandello pastiche' (Mark
Kermode, *The Observer* Review, 10.07.05: 7));

a form of influence (Prince 'has become the single most pervasive influence
on contemporary cutting-edge black music. A generation ... have either

name-checked his songs, sampled his music and lyrics, or pastiched his slick, funky Eighties sound' (Sean O'Hagan, *The Observer* Review 04.04.04: 5));

a way of learning one's art ('At the age of eighteen, [Barraqué] was writing pastiche compositions in the styles of Schubert and Schumann' (David Schiff, *Times Literary Supplement*, 12.11.04: 11));

a useful rhetorical craft (Roman declamation, as an 'exercise that combined role-play, analysis, memorization and pastiche sounds ... educationally enlightened' (Emily Gowers, *Times Literary Supplement*, 5.12.03: 27));

effective historical recreation (Michael Faber's 'sprawling pastiche', The Crimson Petal and the White, set in 1870s London, 'reaches the places Dickens couldn't touch' (Emma Hagestadt, *The Independent* Review, 10.10.03: 31)).

And this does not include any of the various usages of pastiche to mean art combining different elements.

All of these usages are proper. One sees what they all mean, even though they do not all mean the same thing. I shall be quarrelling with the assumption in the majority of usages that pastiche is intrinsically trivial or worse, but there are no grounds for saying that the term cannot be used in any of the above ways. What I want to do in this chapter, however, is consider the many terms available for combination and imitation in the arts, as a means of distinguishing one particular practice among them, for which there is no other term but pastiche.

The word itself comes from Italian 'pasticcio',* which, in its earliest recorded use, meant a pie ('vivanda ricoperta di pasta e cotta al forno' ('food covered with pastry and cooked in the oven') 1535[2]). The idea of a mixed dish – meat and/or vegetables plus pastry – was then applied to art. In this usage, pasticcio referred to paintings produced by one painter using the motifs of another and presented as the latter's work. One of the earliest known such uses occurred in 1619 when a Roman Cardinal discovered that the painting sold to him by Terence of Urbino as a Madonna by Raphael turned out to be by Terence himself. The Cardinal summoned the painter and told him that when he wanted a pie (a pasticcio) he ordered one from his cook, Maestro Giovanni, who made such exquisite ones (Hempel 1965: 165–166[3]). This brings together three aspects of what have been the subsequent fortunes of the term pastiche.

First, a pasticcio work is based on putting together elements taken from elsewhere, and it is this combinatory principle that is discussed first below. Second, this involves the quotation/imitation of prior works, which leads to the notion of pastiche as a kind of imitation, the subject of not only the second part of this chapter but the rest of the book. Third, pasticcio painting

* Derived from pasta, meaning, in the first place, paste, thence pastry and pasta (as we now use it in English for spaghetti, lasagne, etc.).

involved the unacknowledged and deceitful use of combination and imitation, and this negative association has also clung to pastiche. Wido Hempel speculates that this too comes from the term's culinary origins: with a pie you can never be quite sure what ingredients you are getting (ibid.: 165). In any case, even before its use in an aesthetic sense, the word pasticcio had come to be used in Italian – and still is – to mean a deceit or a muddle.* Pastiche can now just mean, and I wish it did just mean, evident combination and imitation of prior works, but the negative associations persist, mainly now in terms of triviality or pointlessness. Part of the overall purpose of this book is to argue that these associations are not intrinsic to it.

In both its shifting history and current multiplicitous use, the word pastiche is in practice extremely elastic. This can be frustrating. In discussions during the preparation of this book, I've often found myself drawn into generally fruitless discussion about whether such and such really is pastiche. Very often, it probably is – it all depends on what you mean by pastiche. What concerns me is what we are trying to get at when we use the word and its cognates, rather than with revealing or legislating on what these do or should really mean. The distinctions that follow, between one practice and another, stand or fall by their logical validity and usefulness; what I cannot say is which of them is properly called pastiche, leave alone enforce my preferred use of the term. I am, however, moving towards a definition (already trailed in the introduction) of the way I want to use the term in the rest of the book.

PASTICCIO: PASTICHE AS COMBINATION

At a certain level of abstraction one could say that virtually all art involves combination. This may mean combination of means: of musical instruments, of lines, acting, costumes and sets, and so on. It may also mean the combination of elements taken from previous works, what now tends to be referred to as intertextuality.[4] However, combination pastiche is a particular principle of combination. A number of other words are or have been used in roughly the same way: amalgam, bricolage, collation, Creole, eclecticism, hybridity, motley, syncretism. Some others have primary, mainly culinary meanings – cocktail, farrago,** hotchpotch, mélange, mishmash, potpourri – linking them to some of the more historically specific forms sketched below: zarzuela[5] and masala (cookery), cento and patchwork (needlework), to say nothing of Brazilian cannibal art. From now on I am going to use the word 'pasticcio' (rather than pastiche) to refer to this whole field.

The particular principle of combination implied by pasticcio is suggested by its culinary source. A pie mixes things together such that the identities

* Cf. the nearest English culinarily based equivalent, the antiquated 'to get into a pickle'.
** From Latin for cattle feed.

of the different ingredients remain largely intact, albeit modified by their interaction and by being eaten all together. So too artistic pasticcio. The central notion is that the elements that make up a pasticcio are held to be different, by virtue of genre, authorship, period, mode or whatever and that they do not normally or perhaps even readily go together. Moreover, pasticci are mixtures that preserve the separate flavour of each element, not melting ingredients together indissolubly, nor taking bits so small that any other identity is lost (as in mosaic).

Pasticcio, even in so broad a definition, can in principle be distinguished from other kinds of combination.

For instance, the modernist modes of assemblage and collage, discussed below, are anticipated by work stretching back probably to before recorded time. Clear precedents include twelfth century Japanese tone poems made of paper, thread and paint, Native American masks using 'fibers, corn husks, teeth, fur, and other objects' and Western folk art (notably Valentine cards) (Meilach and Hoor 1973: 5–10). However, the materials are usually essentially a means to achieve a unified narrative and/or pictorial effect, without the memory of autonomy characteristic of the materials in pasticcio.

Another example: there are numerous varieties of theatrical performance that involve some combination of speech with music, song, dance and comedy: *commedia dell'arte*, the Elizabethan Court Masque, the Spanish *zarzuela*,[6] the German *Singspiel*,[7] the American musical. Typically, however, these are, to a greater or lesser extent, produced as a unified whole from the outset. There are instances where pre-existing elements were taken over: the ballad opera (of which *The Beggar's Opera* 1728 is the most familiar example) consisted of popular tunes of the day given new words and incorporated into a spoken drama; perhaps the first American musical, *The Black Crook* 1866, is widely thought to be the product of the double-booking of a melodrama and a ballet troupe, jammed opportunistically together and running for 40 years. However, though these are the shows commonly taken as founding the tradition of musical theatre, they are in fact untypical. The history of most musical theatre has been towards what is usually referred to as the integrated show (Engel 1967: 38), that is, with as much narrative and tonal blending of the elements as possible and no pasticcio-like desire to preserve the sense of setting side by side supposedly disparate performance traditions (speech, music, dance, spectacle).

Popular Hindi cinema also combines narrative with musical numbers, comic turns, fights, chases, melodramatic climaxes and spectacular set pieces. Although somewhat problematically embraced in recent years as camp and kitsch, Hindi cinema has more usually been disdained in the West for its promiscuous mixing of elements. Within Indian aesthetics, however, it may be understood as a kind of masala (cf. Thomas 1985). This is indeed the same word as used to refer to the blending of spices in Indian cookery, but whereas the Western culinary term pasticcio carries a sense of something particular, masala is seen as a fundamental principle of art and cuisine. It is based on

elaborate but tight groupings of emotional registers, organised under nine different basic categories (rasas); in classical Indian aesthetics, there are even rules for the production of the masala, recipes for the combination of rasas. Of course, film-makers in Bombay do not sit with manuals of masala aesthetics by their side, and in the context of Hindi cinema masala may simply mean providing as full a range of emotions as satisfyingly as possible. None the less, its opportunism in cramming in feelings is still subject to rough notions of not having too much of any one thing or not putting all the searing or all the hilarious bits together, and with no sense that it is inappropriate to combine so many different things. In other words, masala is not pasticcio.

Pasticcio's combination of elements held to be disparate seems at first glance to bring it close to another combinatory principle, montage. This is most commonly used in connection with film and photography (though it has come to be used analogously in relation to other arts (cf. Hoesterey 2001: 12–13)). In French it simply means mounting, hence editing, a film. All film is based on this, on sticking together shots, but usually these are shot in order to be combined, and in practice combined according to conventions that conceal spatial and temporal dislocation and play down graphic contrast. Film editing, par excellence an art of combination, is thus not typically pasticcio. This is even true of most examples of what in English usage is referred to as montage editing, the style of dialectical editing associated with the Soviet avant-garde of the 1920s and early 1930s, Eisenstein, Kuleshov, Vertov. Here, although the reigning principle of the editing is the meaningful and affective contrast between shots rather than the production of spatio-temporal narrative continuity, still the shots have been taken with the former in mind and, in principle at any rate, a quite precise meaning is supposed to be constructed from the contrast of shots. The early Soviet period does also contain perhaps the first instances of putting a film together out of distinct, and previously autonomous, material, the pre-existing archival material used by Esfir Shub for *The Fall of the Romanov Dynasty* (1927) (Petric 1984); but in this case, great care is taken to make the transitions between footage as smooth as possible, to promote the greatest narrative continuity. Thus neither dialectical montage, though it emphasises contrast between shots, nor Shubian, though it uses pre-existing materials, is pasticcio-like. (The term montage is, however, in practice used in a pasticcio sense in two of the forms discussed below, the collage film and photomontage.)

All the above combinatory forms provide limit cases for pasticcio. They are near to it, but only under certain circumstances can they be brought into the orbit of works that paste together different and evidently separable elements. This still leaves a number of forms that might merit being deemed pasticcio, including:

ASSEMBLAGE AND COLLAGE: visual works made up of disparate materials. Assemblage is usually reserved for three-dimensional works, collage

(from the French 'coller' (to stick together)) for two-dimensional ones. Any materials might be used. One of the most eclectic collagists, Kurt Schwitters, used almost anything that came to hand: wallpaper, wires, wire netting, wood, wool, wrappers, bits of objects, different kinds of paper, photographs, paint, etc. (Seitz 1961: 50, Wescher 1968: 154). As discussed above, assemblage and collage refer to basic techniques of aesthetic production, but have also been seen as distinctive products of both modernist (Seitz 1961) and postmodern (Hoesterey 2001) art. They are also features of much work produced outside the institutions of art. Southern African–American practices of yard decoration, grave dressing, altar pieces and sculptures, for instance, are assembled from a huge range of found materials, often with syncretic cosmological meanings, as in the Reverend George Kornegay's huge yard show in the 1980s in Selma, Alabama (McWillie 1996: 199):

> A wheel on a post ... becomes both an evocation of the Kongo cosmogram and 'Ezekiel's Wheel'; a stack of old television sets painted silver with bottles on top becomes both a 'TV motel' and an all-seeing eye enlivened with the protective flash of the spirit; a pile of whitewashed stones refers not only to ancestral legacies but to the scriptural exhortation, 'on this rock I will build my church'; an indecipherable script beside a telephone receiver electrifies 'the word of God'; a tepee (Kornegay is part-Indian) becomes a locus of empathy for all who have been culturally displaced.

Collage has also been used to describe films that cut together found footage (Curtis 1971: 143–146), going against both the standard and 'montage' practices of editing. *La verifica incerta* (The Uncertain Verification, Italy 1965 Gianfranco Barucello and Alberto Griffi), uses clips from a number of Cinemascope movies, shown still squeezed; *Meeting of Two Queens* (Spain 1991 Cecilia Barraga) puts together shots of Greta Garbo in *Queen Christina* 1933 with Marlene Dietrich in *The Scarlet Empress* 1934 so that they appear to meet within the same film.

CAPRICCIO (LITERALLY, A CAPRICE): a genre of painting, in which geographically distant features are shown occupying the same space. Thus in William Marlow's 1797 painting (figure 1.1), St. Paul's Cathedral in London appears to give on to the Grand Canal in Venice. There are precedents (e.g. wall paintings in Pompeii) and successors (e.g. Rex Whistler's mid-twentieth century murals) within Western tradition (Wilton-Ely 1996), but it was at its most popular in the eighteenth century. The term has some currency in music, usually to indicate a work without a prescribed structure or whimsical in tone; occasionally it may come close to pasticcio, as in Tchaikovsky's *Capriccio italien* 1880, a medley (see below) of popular Italian tunes.

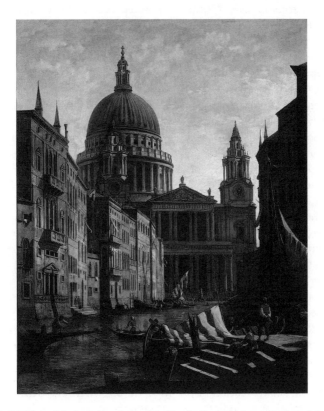

Figure 1.1 William Marlow *Capriccio of St Paul's Cathedral on the Grand Canal* 1797
(©Tate Gallery, London, 2005).

CENTO: a piece of writing constructed from quotations from other writings.*
A cento might seek to ride on the cultural prestige of its source texts or
to undermine it. The *Homerocentones Eudociae* (Homeric Cento of the
Empress Eudocia), for instance, written some time after AD 443, stitches
together lines from Homer to retell the story of Christ (cf. Usher 1998).
Other examples, on the other hand, may be satirical, ridiculous or lewd:
an epigram by Leo the Philosopher (C5 AD) recombines lines from
Homer to make it look like noble lamentations that merely lead up to
farting. Centos date back to Greek and Latin antiquity, but the practice

* The term derives from the Greek for needle, leading to the idea of stitching writings together.

can be traced throughout Western literature (Verweyen and Witting 1991); Serge Lacasse (2000: 53) notes the 1993 album *Plexure* by John Oswald, which merges 'very short samples from about 5000 recordings of popular songs',[8] while for Ingeborg Hoesterey the structure of the cento 'provides the most important prototype for the patchwork pastiche, the type most commonly found in aesthetic postmodernism' (2001: 11).

CONTRAFACTUM: in medieval and Renaissance music, the practice of putting different words to an existing melody, often to substitute a sacred for a secular text or, impudently, vice versa. A modern version is the game 'One Song to the Tune of Another' in the BBC radio programme *I'm Sorry I Haven't a Clue*, where for instance in a recent edition contestants were required to sing the words of 'Mack the Knife' to the melody of 'Land of Hope and Glory', 'The Red Flag' to 'Bring Me Sunshine' and 'How Much Is that Doggy in the Window?' to 'Blowin' in the Wind'.

HIP HOP: though coming out of African- and Latino-American urban youth culture, hip hop is no longer confined to this demographic, and is manifest across practices, especially dance, fashion, graffiti, music, poetry and video. In DJ-ing and tape/record production, it combines break beats (taking riffs or phrases from 'everything from dance-hall to country to rock'[9] and extending, repeating and layering them), scratching (playing the needle back and forth in the groove by hand), backspinning (spinning the record backwards as it plays), more extensive sampling (phrases and sections from records used for colour and melody as well as rhythm) and, now the most familiar feature, rapping (Rose 1994: 53–54). While hip hop has been related to postmodern aesthetics (Potter 1995), it can also be seen as a continuation of pre-modern oral traditions (Rose 1994: 21).

MEDLEY: a number of melodies strung together.

PHOTOMONTAGE: piecing together (usually sections of) photographs to make a new one (Ades 1976). Early examples were generally forms of *trompe-l'oeil*, either constructing a realistic scene or else something very close in spirit to the capriccio: Piccadilly circus in London as a meeting point of canals, with Venetian gondolas and bridges; a horse drawn cart with giant roosters on it.[10] However, the term is now primarily associated with the Berlin Dadaists (John Heartfield, Hannah Höch (figure 1.2)) and those seen as their inheritors, who paste together images without regard to creating an illusory picture of the world.

PASTICCIO: while this term covers the general principle of combination, it does also refer to a specific mode in music, bringing together elements from different sources (by different composers, in different styles) to create a new musical work. It is especially used of eighteenth century opera, notably the practice of putting together a score from available arias, according to proven popularity or the needs of particular singers, or of employing a number of composers for different sections (cf. Mackay 1994, Stern 1994).

Figure 1.2 Hannah Höch *Dada Ernst*, 1920–21. The Israel Museum, Jerusalem, Israel/Vera & Arturo Schwarz Collection of Dada and Surrealist Art/The Bridgeman Art Library © DACS 2006.

PATCHWORK: stitching together pieces of cloth to form a garment or item of furnishing (cover, bedspread, table cloth and so on) (Holstein 1973).

TROPICALISM: practices in twentieth century Brazilian culture that draw upon a vast range of indigenous and foreign sources.

> As expressed in music, theatre and film, Tropicalism provocatively mingled the folkloric and the industrial, the native and the foreign; its favoured technique was the collage of disparate discourses, the result of a 'cannibalistic' ingestion of the most heterogeneous cultural stimuli. (Stam et al. 1995: 404)

While often referring to a specific period (the late 1960s and early 1970s), it relates to a recurrent practice that has also been termed 'Cannibalism' and the 'aesthetics of garbage'. The former refers to modernist literature of the 1920s, especially as articulated in the *Revista de Antropogia* (Anthropophagic Review 1929), the most celebrated instance of which is *Macunaíma* (Marío de Andrade 1926/7), a 'rhapsody' combining 'popular expressions, proverbs, elements of popular literature and folklore with indigenous legends collected by [a] German ethnologist' (Johnson 1995: 179). The 'aesthetics of garbage' is a late 1960s practice, 'appropriate to a Third World country picking through the [cultural] detritus of an international system dominated by First World monopoly capitalism' (Stam et al. 1995: 394).

Such modes as circus, vaudeville, revue and early cinema programmes could also be considered, taken as wholes, combination shows. We may even identify the principle of pasticcio beyond this, to the interruptions of gags, songs, fights and recitations in the unfolding dramas of Shakespeare's plays, say, or the way the story interrupts gags, songs, skits and chases in the films of the Marx Brothers.[11]

Pasticcio pastiche is also widely identified as a characteristic feature of postmodern architecture (Jencks 1984), and Ingeborg Hoesterey's book *Pastiche: Cultural Memory in Art, Film, Literature* argues for it as a defining principle of postmodern art in general. She traces 'pastiche structuration' in architecture, collage and assemblages, films (e.g. *Blade Runner*, *Caravaggio*), writing (e.g. *Possession*, *The Name of the Rose*) and performance pieces (Laurie Anderson, Robert Wilson), as well as in advertising, pop music and videos, and design. Her analysis of *The Cook, the Thief, His Wife and Her Lover* (GB 1989 Peter Greenaway) takes the title as emblematic of pasticcio pastiche: the 'Cook stirs everything together' while 'thief is another name for the pasticher' (2001: 70).

Pasticcio mixes ingredients together, but not any old how, even if it may sometimes (deliberately) look like that. The difference between the elements assembled may be heightened or diminished and there may be a more or less strong sense of overall design. I discuss next both these dimensions in turn, before looking, at the end of this section, at some of the arguments around the value of pasticcio.

The sense of the distinctiveness of the different elements in pasticcio pastiche may be more or less pronounced. At one end of a spectrum we may place works that play down the contrast between the elements to the point where they are hard to discern. The operatic pasticcio inevitably occasioned shifts or leaps in musical texture, but these probably did not bother anyone and in any case were not the aesthetic aim. The capriciousness of the capriccio resides in the fact that it disguises the fact that it is making impossible juxtapositions. In Marlow's capriccio of St. Paul's in Venice, the wider Venetian and London townscapes are fully implied, yet the geographical and stylistic impropriety of their combination is disguised by their being painted in the same style, with consistency in the representation of light and careful adherence to the rules of perspective. Similarly, *Meeting of Two Queens* matches its two films as precisely as possible in terms of continuity of graphic qualities (tone, exposure, lighting) and standard spatio-temporal logic, so as to produce a thrilling journey of the two Queens towards each other followed by sequences of looks and gestures that create an erotic charge between these two favourite lesbian icons (Pidduck 2003: 265).

The operatic pasticcio, the capriccio and a collage film like *Meeting of Two Queens* constitute limit cases of the principle of pasticcio that overlap with some of those discussed above (music theatre, masala, montage film). They differ from these in being made up of elements from different sources (respectively, different authorial oeuvres, iconographic traditions, specific films), thus involving the pasting together of in some sense pre-existing elements. However, they do not seek to exploit differences between elements: the mismatch of sources in opera pasticcio either did not matter or was only evident to the most discerning ear; it is only knowledge of actual urban geography that makes it impossible to accept that St Paul's Cathedral could not be in Venice; we have to know that Garbo and Dietrich never made a film together to know that *Meeting of Two Queens* isn't an extract from it.

At the other end of the spectrum from these come works that strongly emphasise the different traditions and provenance of elements (and are probably what we are most likely nowadays to deem pasticcio). Leo the Philosopher's lewd cento, the many media used by Kurt Schwitters, the different patterns of the pieces used in patchworks, the interrupted formats of Shakespeare and the Marx Brothers; all these imply each element's existence beyond its place in the pasticcio, in, respectively, the poets' work, the habitual place of the different materials, the cloths from which the pieces are taken, and the longer text or film. This is variously achieved by strong textural contrasts, shifts in affective register, the sense of interruption and so on. In the case of Höch's *Dada-Ernst*, contrast between the montaged elements is emphasised by the fact that Höch did not re-photograph the assembled pieces, so that the edges of the cuts are visible, reminders that each item has been forcibly removed from another setting (Lavin 1993: 6). Hip hop and Tropicalist music, on the other hand, retain a sense of the difference of the elements but as layered and simultaneous rather than jaggedly contrasting, suggesting a closeness to the aesthetic

of 'the rhythm of the segments' that Zora Neale Hurston identified in black cultural traditions (1970: 26).

In between work that is technically but almost imperceptibly combination and that which exploits differences between elements, we may place *Homerocentones Eudociae* and a collage film like *La verifica incerta*. In both of these, in different ways, there is a play with difference and similarity between elements.

Eudacia took single lines from the *Iliad* and *Odyssey* of Homer and stitched them together to tell the story of Christ. She did make slight syntactical and even sometimes semantic alterations in the lines to make the whole flow consistently, but the point was to preserve Homer even while pressing him into Christian service. Herbert Hunger suggests that work like hers sprang from the authors'

> desire as good and active Christians, absolutely convinced of the superiority of the Homeric epic over all other Greek poetry, to present the Holy Story in the richest frame possible.[12]

As M. D. Usher points out, Eudacia's Homeric Centos are 'a perfect instance of intertextuality: the condition or quality of being poised between texts' (1998: 86).

La verifica incerta is in one way close to the capriccio: you know that each shot has a different source and that there is no logical connection, but the rules of mainstream film editing are strictly adhered to, producing an illusion of an impossible spatio-temporal continuity. A character looks at something off-screen and there is a cut to someone responding to being looked at, creating a sense that two people are looking at each other; but the startling changes in background, costume, colour, lighting and stock between the two shots also emphasise that they are taken from radically different sources. By using other devices, an effect of radical confusion is induced:

> The hero changes person mid-shot; camera movement reverses halfway through an action; the lighting jumps from phoney blue-filter darkness to over-exposed multi-shadowed 'daylight'; and the colour range ... cuts from all-over brown to washed-out blue-green. (Curtis 1971: 145.)

Whether or not, as I have been discussing, the differences between the elements in a pasticcio work are emphasised at the points where they are juxtaposed, there is also usually a principle of organisation in the work as a whole. Shifts, contrasts and interruptions may be the order of the day, but there is generally an overriding tone or underlying structure that makes some sense of it all.

This may be achieved by formal means. As already noted, the capriccio and opera pasticcio typically achieved stylistic consistency, while *Meeting of Two*

Queens develops a very clear narrative. In practice, medleys draw on one musical source (a composer, show, genre or period). The most prized patchworks arrange their disparate materials into very clear overall patterns. In such examples the structuring principle cannot be lost from sight. In other cases, equivalent formal elements are less dominating but still in effect hold things together. As Herta Wescher observes (1968: 154), 'however absurd the materials he utilised, Schwitters always integrated them into well-balanced compositions, in which straight lines and rectangles and circles make up firm scaffoldings'. The welter of events and imagery in *Macunaíma* can none the less be followed because the basic organisation is a picaresque journey narrative. The concept of interruption, as in Shakespeare and the Marx Brothers, implies a central element that is being interrupted.

Hip hop entails a rather different organising principle. In later and crossover take-ups of the music, the rap may provide the dominating thread that anchors the other elements. This though is a simplification of an aesthetic characterised by Rose as one of 'flow, layering, and rupture' (1994: 22). In the music, the intricate layering of breaks, scratching, backspinning, sampling and rapping produce a sense of flow, heightened by elements of pause, delay, disruption; similar devices characterise hip hop graffiti and break dancing. Thus a general overall feeling is achieved: forward propulsion immersed in complexity.

Coherence in pasticcio may also be achieved by an underlying principle of meaning which makes sense of the multiplicitous elements. Tropicalist traditions make sense as a way of negotiating Brazil's historical cultural situation, caught between indigenous traditions, post European conquest and present US hegemony. In music, for instance, figures like Caetano Veloso or Gilberto Gil combine jazz, calypso, soul, reggae, rock, European pop and much else to produce sounds that are none the less distinctly Brazilian (Stam et al. 1995: 465). Reverend Kornegay's yard is a product of a syncretic cosmology, linking perceptions and beliefs from different religious traditions to create an overarching belief system. Hannah Höch's *Dada-Ernst* may be seen as a study of the situation of women in modernity, with elements both celebratory (a female gymnast, a woman blowing a trumpet, another in a ball gown, a bobbed hair New Woman) and threatening (fragmented female bodies, boxers, coins at the crotch, a saw-like instrument as well as 'the disorienting variety in perspective, the disjunctive variations in scale, the interruptions of contours, and the visibility of seams') (Lavin 1993: 6–9).

However much a pasticcio may have a dominant or underpinning formal tone or structure, or may make sense by virtue of implicit meaning, still much of the flavour resides in the sense of profusion. Pasticcio often aims to look random, to create the feeling of abandonment to diversity, astonishment, surprise, tumult and chaos. Hip hop, Schwitters, *Macunaíma*, *La verifica incerta*, the Marx Brothers, all combine more diverse signals than you can take in at one go, which may be underpinned but cannot be contained by elements

of rhythm, narrative or design. There is often a sense of spilling over the edges of pattern, of breaking free from the control of narrative, of refusing the boundaries of media and genre. Even in the most controlled examples, where there is a dominant or very evident central thread, the latter may serve to highlight the feeling of exuberance or pleasing pandemonium set against it – the simple pattern against the busy fabric pieces in many patchworks, the story against the mayhem of the Marxes.

Pasticcio is then a compilation of disparate elements, though they may be more and less disparate, and the work overall may foreground or play down the disparities, make more or less apparent its organising principle. The Italian vernacular usage of pasticcio, to mean a muddle or jumble, has also informed a common critical view of artistic pasticcio. It can be seen as derivative, craftless, undisciplined, confusing, indigestible, too much, things thrown together anyhow, in short, a mess. This evaluative perception is hardly surprising in the emergence of the term in the critical context of classicism, which puts a premium on unity, simplicity and consistency, of harmony and decorum (of what properly goes with what), and its persistence in the age of romanticism and the supreme valuation of originality and the vivid individual vision (that is, one that has not been pasted together from other people's work).

However, pasticcio also has its critical champions. Robert Venturi, in his book *Contradiction and Complexity in Architecture*, an early (1966) and influential text in the development of postmodern architecture, declares:

> I am for messy vitality over obvious unity ... richness of meaning rather than clarity of meaning. (1977: 16)

These are two major aesthetic possibilities of pasticcio: vitality and richness. The contrasts and clashes of style, the pushing at and beyond the boundaries of balance and structure, the sense of surprise, shock, chance and disorientation, propulsive flow heightened by rupture, all these can feel energetic, exuberant, tonic. Equally the quantity of connotations, associations and echoes available in pasticcio's semiotic mix allows for stimulating intellectual and affective play between the elements. Even instances as staid as *Homerocentones Eudociae* or 'One Song to the Tune of Another' involve a rich interplay of the two elements brought into devotional or comic relation. (Still one should caution: mess is not necessarily energetic, lots of meaning does not necessarily constitute playful riches.)

All of this has been given a political gloss in recent discussion. Ingeborg Hoesterey argues that postmodern pasticcio works have 'emancipatory potential' (2001: 29), for their 'dialectical stance toward history' (25), the way they may stage 'a battlefield of cultural myths' (21) or draw attention to and rework 'cultural codifications that for centuries marginalized unconventional identities' (29). Pasticcio forms – notably hip hop and Tropicalism – can also be seen as both a product and an expression of the new, hybrid

identities forged in an era of multiple migrations and interacting hetero-geneous populations (Mercer 1994); indeed, pasticcio practices are even perhaps the only appropriate vehicle for the actual forging of those identities. They may also in the process constitute a cultural resistance to, even a subver-sion of, the homogenising thrust of dominant white cultures, locally and globally.

Beyond the specificities of postmodern debate and postcolonial identities, pasticcio is sometimes seen as intrinsically politically progressive. The very fact that it breaks the boundaries of medium and genre, and refuses decorum and harmony, implies that it challenges received wisdom about what is proper, about the way things are supposed to be done, about what goes with what. At least since romanticism, the very fact of challenging established understanding has often been seen as liberating, revolutionary, a good in itself. Moreover, pasticcio is par excellence – or apparently, or sometimes – encompassing, heterogeneous, multivocal. In contrast, the singular, homoge-nous and univocal character of other forms of art can be seen as the voice of authority that seeks to make all conform to its will or programme. In this perspective, pasticcio is the objective corollary in art of carnival – inclusive, often unruly, distrusted by authority – with all its exuberant promise, and also all the drawbacks of short-term, safety-valve expressivity and of politics without goals or strategy (cf. Pearce 1994, Stallybrass and White 1986, Stam 1989).

In sum, pasticcio combines things that are typically held apart in such a way as to retain their identities. It may emphasise or play down the differences between its sources, organise them more or less evidently and emphatically. It may be a wearying confusion or a stimulating array, a mess or a carnival.

PASTICHE: PASTICHE AS IMITATION

The earliest use of the word pasticcio in reference to art already contains the idea of imitation as well as combination. The Madonna that Terence of Urbino tried to palm off as a Raphael necessarily involved him in copying, as well as combining, motifs from Raphael to produce the new work. Pasticcio pastiche still involves imitation in one sense or another: quoting, referencing, reproducing, copying. Indeed it must logically be so, since it is only by virtue of each element being like (or actually being taken from) something else that a pasticcio can evidently be a combination of other things. However, pastiche is now also used to refer to a kind of imitation, whether or not in a context of marked combination. Webster's primary definition, for instance, is 'a literary, artistic, or musical work that closely and usu. deliberately imitates the style of previous work' (1961: 1652), and specialist art and music dictionaries[13] now tend to give something like this as the basic current meaning:

'Image that self-consciously borrows its style, technique or motifs from other works of art yet is not a direct copy', *The Dictionary of Art* (Turner 1996: 248);

> 'a piece composed deliberately in the style of another composer', *A New Dictionary of Music* (Jacobs 1958: 276);

> 'A work written partly in the style of another period', *The New Oxford Companion to Music* (Arnold 1983: 1398).

This meaning developed with the adoption of the term in France, modified from pasticcio to pastiche.* The earliest known example seems to come from a 1677 treatise[14] on art by Roger de Piles, in which he defines pastiches as 'Tableaux, qui ne sont ni des Originaux, ni des Copies' ('Paintings that are neither Originals nor Copies'). Gradually the term was used beyond painting, notably in relation to literature (Hempel 1965: 167–168). From this stems pastiche as a distinct and recognised literary practice, discussed in the next chapter.

De Piles' formulation – neither original nor copy – suggests a middle ground, something that may not be an entirely new work but also which cannot be understood as simply a reproduction or uninflected imitation of an existing work. It is this field of possibilities that I explore here.

In the previous section, I looked at a whole range of practices that could be yoked together, perhaps rather pasticcio fashion, under the heading of combination pastiche. Here I want to present pastiche among all the other terms that I can think of that have to do with art that imitates art, organised according to their relation to some key principles.[15] The first of these is that imitation is a particular kind of reference to other works. Second, imitation is not the same as reproduction. Third, different kinds of imitation may or may not wish to be known as imitation, and, fourth, those that do wish to be so known may or may not also signal the fact in the work itself. Finally, among those that do signal the fact, some may also imply an evaluative attitude towards their object of reference (e.g. parody, homage), others may but need not (and it is here that I wish to place the sense of pastiche that concerns the rest of this book).

First, to imitate something is perforce to refer to it. In this sense pastiche is part of the study of reference, allusion[16] and intertextuality,[17] of palimpsests[18] and doubly voiced discourses[19] and of repetition[20] and influence.[21] However, it is possible to refer to something without using imitation, at any rate in language. One can refer verbally to Odysseus or Emma Bovary, Hildegard of Bingen or Chinua Achebe, Toshiro Mifune or Diana Ross, without imitating them in any way. However, while words can be incorporated into paintings and photographs, and music can have lyrics, it is hard to reference through images or music themselves without actually being involved in imitation, even if only momentarily. Thus Brahms' First Symphony alludes to Beethoven's Ninth, but perforce does so by imitating it, using in the last movement a

* Perhaps under the influence of old Provençal and medieval Latin terms for pâté.

melody that is like that in the final movement of the Beethoven. Similarly, Todd Haynes' *Far From Heaven* references Douglas Sirk's *All that Heaven Allows* by looking like it.

Also, imitation may not in any strong sense involve reference. Some of the point of Brahms' imitation of Beethoven, or Haynes' of Sirk, is lost if one doesn't get each as a reference, but the resemblance of most genre films to those made before them in the genre usually merely enables them tell a particular kind of story in a particular kind of world rather than making a point about the fact that they are doing so. The fact that one work is like another does not mean that, in any interesting way, it is referring to it.

Second, imitation is not the same as unmediated reproduction. When for 'Millennium' 1998 Robbie Williams used the repeated lush string cadence of the James Bond theme 'You Only Live Once', he was not trying to be like it but was reproducing it (and, in this context, it makes no difference whether this was done by means of an orchestra playing that score or of actually sampling the soundtrack). When he brought out an album of songs associated, mostly, with Frank Sinatra in the kind of arrangements used by Sinatra (*Swing When You're Winning* 2001), he was imitating (and, perhaps, pastiching and/or rendering homage).[22]

An imitated work is like or similar to another, but does not replicate it; reproduction, on the other hand, actually or as far as possible, does. Pure plagiarism lifts a work, entire or in part, and offers it as newly minted; quotation, citation and sampling (all terms would cover the 'Millennium' example)[23] do the same with a section or snatch of a work, but acknowledge it, often carefully putting quote marks around it, a frame, inverted commas, a wider, overarching structure,[24] media of mechanical reproduction (prints, photographs, films, records, digital media) can reproduce a work ad infinitum. None of this is the same as imitating.

Third, within the category of imitation we can distinguish between works in which the fact of imitation is concealed at the point of being made available and those where it is not. Plagiarism, fake and forgery only work on their own terms if the audience does not recognise that imitation is going on, whereas other forms by definition acknowledge the element of imitation involved and often (copy, rewriting, pastiche, homage, parody) work best if the fact that they are imitating is taken into account.

Fourth, works which do not conceal the fact of imitation all the same may or may not signal the fact textually (by such markers as exaggeration, distortion, discrepancy and inappropriateness as well as framing indications, titles and so on).

Fifth and finally, with reference only to textually signalled imitation, some modes of signalling may ineluctably imply an evaluation of what is being imitated while others are more open. Homage and parody always imply, respectively, a positive or negative evaluation of their referent, whereas pastiche does not do so necessarily, that is, by definition and a priori.

The grid below is based on the last three distinctions discussed above.

CONCEALED		UNCONCEALED	
NOT TEXTUALLY SIGNALLED		TEXTUALLY SIGNALLED	
EVALUATIVELY OPEN			EVALUATIVELY PREDETERMINED
plagiarism	copies	pastiche	emulation homage
fake forgery hoax	versions		travesty burlesque mock epic
	genre		parody

My over-riding aim in laying out these many terms is to place and distinguish pastiche among them. In practice, that place and distinction are not particularly secure. The term pastiche is sometimes used interchangeably with others (copy and parody seem especially vulnerable to this[25]); sometimes pastiche is insistently distinguished from another term, precisely because, it is stated or implied, the two are liable to be confounded ('Mr Burne-Jones is not accused ... of plagiarism, but of *pastiche*, which is a very different thing'[26]); sometimes it appears in a list of practices where the precise sense in which it is being used is not clear (as in exuberant accounts of postmodern culture being characterised by some mix of allegory, camp, irony, parody, pastiche, play, simulation and so on); on occasion, it is assimilated to another term.[27]

Pastiche often seems to be a default term. In a discussion of *Lady and Gentleman at the Spinet*, a fake Vermeer by Han van Meegeren (see below), Hope Werness notes that an early commentator, taking it for a genuine Vermeer, 'mentions the obvious comparisons with other Vermeers'; then Werness comments in parenthesis, 'so many correspondences would seem to be a dead giveaway of the pastiche!' (1983: 20.) Later, noting the skill of van Meegeren's most successful fake Vermeer, *The Supper at Emmaus*,

she observes that unlike 'van Meegeren's earlier, pastiche-type forgeries, this painting has a more original character' (32). Something similar happens with Aleksander Kudelin's discussion of medieval Middle Eastern poetry (1997; discussed further below). He notes a number of distinct traditions that can be translated as the reply, the likeness, the solemn greeting, the imitation and so on, all based upon close imitation of classic poetry, but uses 'pastiche' as an umbrella term. He always puts it in inverted commas and refers to the view of E. Bertels that it is wrong to term these forms 'pastiches', since this constitutes 'an ahistorical approach and failure to comprehend the very specificity of literature in feudal society' (62). Yet he still hangs on to the word, albeit in scare quotes, because it points to a very basic practice of knowing imitation that has something in common with practices in Western tradition.

The promiscuity of pastiche's interrelations with other contiguous terms has to do not only with its own looseness of definition but that of so many of the others. Most have similar histories of complex, shifting, even contradictory meanings leaving uneven traces in current usage.[28] This is a common tale of the vagaries of language, but it also arises because these terms do have much in common. They are concerned with the same basic skill of imitation and they designate forms that have some degree of awareness of imitation built into them (even if that be the need to conceal the fact).[29] This is why they can be confused with one another, why one may be rescued from opprobrium or else condemned by being held to be another, why one often involves another, why they do form a company of terms.

Concealed imitation

Plagiarism

To plagiarise is to appropriate ideas, motifs, passages or procedures from other works or artists,[30] without permission or acknowledgment, in the context of knowing that one or other of the latter should be obtained. (This definition is itself an elaboration from that given in *Collins English Dictionary* (third edition, 1991), a plagiarism that I have by means of this bracket transformed into an acknowledgement.[31†]) Pure plagiarism involves direct but unacknowledged reproduction, but plagiarism is also often identified in imitation and moreover it is common for pastiche to be considered a form of plagiarism, hence my inclusion of the latter here.

The accusation of plagiarism (and it is always an accusation) has the force of theft and deceit behind it, but if one moves beyond motives, it can also be seen as a matter of labelling or degree.

† In the late nineteenth century, Anatole France wrote an 'Apology for Plagiarism', which he acknowledged he had himself taken from a tract by Jacobus Thomasius, *De plagio litterario*, published in Leipzig in 1686 (Bouillaguet 1996a: 3–4).

Labelling. In 1884 the novelist and playwright Charles Reade published in the American magazine *Harper's* a two-part story entitled 'The Picture'.[32] This was based on a novel, *Mlle. de Malepeire* 1854 by Mme Charles Reybaud, that had had considerable success in France in the period.[†] Reade was a champion of international authorial copyright, having written a major work on the topic, *The Eighth Commandment*, in 1860. Copyright is the legal form of concern with plagiarism and there is thus piquancy in Reade banging on about international plagiarism and then committing it. It seems that he had originally intended to publish 'The Picture' in a series to be called *Reade's Abridgements*, but then decided against. He had spoken out against the 'abridgement swindle' in *The Eighth Commandment*, presumably because it was a way round acknowledging and paying authors, the very thing that he too was not doing with 'The Picture'. Had he labelled 'The Picture' what it, also, was – an adaptation, translation or abridgement – along with acknowledging of what it was any of these things (and paying for it), he would not have been committing plagiarism.

Degree. All art involves learning from others, taking, adapting, borrowing, imitating, and since this is standard practice, there is not necessarily any felt need constantly to acknowledge it. The issue often is what and how much the artist has done with their borrowing, whether they have so transformed the element(s) appropriated as to produce a new work. In 1637 there was the first performance of a play that has since become a centrepiece of classical French theatre, Pierre Corneille's *Le Cid*; it was at once accused of being plagiarised from the 1618 Spanish play *Las Mocedades del Cid* ('The Youth of the Cid') by Guilhem de Castro.[††] Corneille acknowledged this source in a foreword to the first publication of the play in 1638, adding that he had also drawn on many other Spanish sources. However, Corneille's *Cid* is at once very close in narrative structure to de Castro's *Mocedades*, while quite far from it in terms of theatrical

† Reade's 'The Picture' was not the first English language version of *Mlle. de Malepeire*. Another had been published, as 'What the Papers Revealed', in the *St. James's Magazine* in 1867, shortened and transposed to Wales, but in most significant details clearly taken from Mme Reybaud. It was also published, as a translation, as *Where Shall He Find Her?* in 1867 and as 'The Portrait in My Uncle's Dining-Room' in the *Month* in July 1869, itself reprinted (but without acknowledgement as such) in *Littell's Living Age* in November of the same year and then again by the same publishers in book form in 1870. However, none of these translations credited the French author (or, come to that, the translator), perhaps to avoid paying the very rights that Reade campaigned for.

†† This was itself based on works dating back to at least the twelfth century that themselves continued an oral tradition of court recitations based on the life of Ruy Diaz de Bivar (1030–1099) (Corneille 1963: 23).

organisation and characterisation, notably in the way that it concentrates the three years of the Spanish version into 24 hours, drops many incidents to produce a greater purity of narrative line, tones down the violence and eliminates moments of comedy, such that 'the Spanish romantic epic drama has become a French classic tragedy' (Segall 1966: 93). The alteration and transformation are widely held to be enough to rescue Corneille from the accusation of slavish and only belatedly acknowledged imitation, or plagiarism.

It seems there has always been plagiarism. In one of the fables of Aesop (?620–564BC), a crow tries to pass itself off as a peacock by donning plumage he has stolen from the latter, giving us a common expression for plagiarism, 'to dress in borrowed feathers'; Aristophanes jokes about plagiarism in *The Frogs* (405BC). There does, however, seem to be a significant change in attitudes towards it from, say, the seventeenth century on. When, in classical, medieval and Renaissance times, emulation and the good copy were valued, plagiarism, so very close to them, did not seem like such a crime. Where there was disapproval, it derived partly from the sense of plagiarism exploiting the labour of others and partly from the view that resorting to plagiarism probably indicated that the artist was not really competent, leave alone capable of producing excellence. What alters this – and seems to make it matter more – is the interest in works as expressions of the artist, as things that are unique to him or her, bear their signature, express their artistic and/or actual personality, and for which they take responsibility (Randall 2001: 58). Works are no longer thought so important for whether they are well done or not, but for whether they authentically express the artist. The plagiarist can never do the latter, can never authentically express the borrowed author, since they can never have the authority of being them; they are using borrowed plumage, and only one's own, it is commonly assumed, can express one's self.

One might have thought such concerns would fade with post-modernity, but they have, it seems, been transformed into the question of ownership, shored up by the lucrative legalisation of the copyright. Conceptual art is in practice especially caught up in such issues. Since anyone could make the artworks involved, it comes to matter supremely who has made them. Joseph Beuys (1921–1986) arranged bits of wood and metal and other objects in an art space, which only become interesting when you know how they relate to Beuys' ideas. More recently this has become an aspect of celebrity culture. In 1999 Tracey Emin put her unmade bed, with all the detritus in and around it at home, into a gallery. Hostile commentators quipped that they too could have put their bed and mess into the Tate Gallery and called it art, but this is to miss the point, well understood by the patron of much contemporary conceptual art, the advertising magnate Charles Saatchi: Tracey Emin's bed is only interesting because it is her bed. One cannot plagiarise an Emin because one cannot be her; on the other hand, to anticipate the next section, one could fake an Emin, by labelling one's own object as being hers (though, given her celebrity, it's doubtful you'd get away with it).[33]

Fake, forgery, hoax

Fake, forgery and hoax[34] are the opposite of plagiarism. In the latter someone passes off the work of another as their own, whereas with the former you pass off your own work as someone else's.

Though the words fake and forgery can in practice be used interchangeably, there is a quite useful current distinction made between them. Both are works purporting to be produced by someone other than the person who actually produced them, but whereas a fake claims to be by a known, usually celebrated person, a forgery offers itself as a work by someone previously unknown:[35] thus the fake imitates a well-known artist, whereas the forgery invents an artist.

A fake may be a copy of a well-known work which claims itself as the original, but more commonly it is a work claiming to be a hitherto unknown work by a noted artist. In 1932 Han van Meegeren began putting on the market recently found paintings by Vermeer (painted by himself). His greatest success was *The Supper at Emmaus* 1937, which was only determined to be a fake (along with his many other Vermeers) at a trial in Amsterdam in 1947. The success of *The Supper at Emmaus* had partly to do with van Meegeren painting in the style of Vermeer's early years – not the Vermeer of meticulously rendered, glowingly coloured, ambiguous scenes of bourgeois life, but a religious subject, close to only one or two other, much less well-known Vermeers and showing, as did Vermeer, the influence of Caravaggio. It fitted with a growing interest (and value) in Vermeer and filled in one of the gaps in knowledge of the painter's output. Now, put next to an actual early Vermeer, it may seem obvious to us that the van Meegeren is a fake – but perhaps that is because we know it is. Its similarity to the art of its own time, including the rather old-fashioned Symbolist works that van Meegeren offered under his own name, may be what strike art historians now (Werness 1983). But can we be sure that in 1937 we would have known better than leading authorities of the time? Successful faking depends not only on the considerable skill of the faker, but also upon the way in which we perceive the faked object. The history of fakes is a history of changing perceptions of the artists in question and how those perceptions are themselves framed by contemporaneous tastes in art.

The Supper at Emmaus is a fake, whereas the work of Ossian is a forgery, since Ossian himself is more or less an invention. His work was presented by James Macpherson to the public in various forms and editions between 1760 and 1807 (Gaskill 1991: 2). The work purported to be translations 'from the Galic or Erse language' of a third/fourth century Scottish bard, Ossian. Within a few years, the authenticity of the works was being called into question, largely because there seemed to be no texts from which the translation had been made, and by 1805 it was widely accepted that Ossian was not a translation from the Gaelic (Stafford 1991: 49). Yet the exact nature of what Macpherson thought he was doing is not straightforward. He did not claim

to be working from original manuscripts, and indeed would have been mad to, given that 'Ossian' produced his work at a time when Gaelic was not yet a written language. Rather, he was working partly from fragments of later manuscripts, partly from oral tradition, partly from a conviction of what an ancient Scottish bard's work would be like (Böker 1991: 74). According to one view, Macpherson was either deliberately deceiving the public in claiming that these works of Ossian were straight translations from a named ancient poet or in fact understanding translation as something more like 're-creation', comparable to the work of archaeologists using similarly sparse materials and not far out of line with recent views of translation. It illustrates well the ambiguity of the very word 'forgery', explored in Groom (2002) and Ryan and Thomas (2003): as the latter put it, forgery means both 'to create or form, on the one hand, and to make falsely, on the other' (ibid.: x).

In 1769 Thomas Chatterton, who was to create a similar sensation to Macpherson with his forgeries of the work of a fifteenth century monk, Thomas Rowley,[36] published in the journal *Town and Country* six poems that are now referred to as his Ossianics. They were poems à la Ossian and thus might belong to the practice of explicit pastiche, often evoked by that expression (see chapter 3). Haywood (1986: 148) refers to one of them, 'The Hirlas', as 'a **pastiche** of the first poem in Evan Evans' *Some Specimens of the Poetry of the Antient Welsh Bards* (1764)' (an anthology based on fourteenth century manuscripts) and another, 'Ethelgar', as 'almost like a **parody** of Macpherson'. Chatterton offered them, as had Macpherson with Gaelic, as **translations** from ancient Saxon, Manx and Welsh sources, thus in effect producing **fakes** of **forgeries**.

Fakes and forgeries are not necessarily hoaxes, and yet hoaxing does involve exactly the same procedure: as exact and convincing an imitation as possible that you don't let on it is an imitation. However, a hoax only really comes to fruition when it is exposed as such, often by the hoaxer him or herself, for the point of the hoax is to see whether you can pull it off and/or to demonstrate that people are easily fooled.

In 1944 the Melbourne-based literary journal, *Angry Penguins*, published *The Darkening Ecliptic*, a collection of poems by Ern Malley, found by his sister Ethel after his death. Neither Ethel nor Ern existed; the poems were by James McAuley and Harold Stewart (Heyward 1993). They were put together from made-up lines (some from their own poems, even sometimes self-parody), adaptations from mainly modernist poetry (including 'a pastiche of Mallarmé' (ibid.: 95)), phrases from a report on mosquito control and random rhymes suggested by a rhyming dictionary. The result was gobbledygook that could be read as brilliantly allusive or surreal. There was something at stake in this, beyond the prank. McAuley and Stewart were aiming at modernist poetry, taken by its enthusiasts to be the cutting edge in literature. Some of the impact of *The Darkening Ecliptic* lay in its apparent authentication of this: Ern Malley, as a proletarian Melburnian, both provided Australian modernism with an authentic Australian voice and dissociated it from the taint of elitism.

After their hoax was revealed, McAuley and Stewart preferred to speak of it as 'a serious literary experiment' which 'proved that literary fashion can become so hypnotically powerful that it can suspend the operation of critical intelligence in quite a large number of people' (quoted in Heyward 1993: 137, 139). There was an edge to their choice of the word 'experiment' to describe what they were doing, since a key word for describing modernist work was itself 'experimental' (ibid.: 143). In fact, the random method they employed – another kind of pasticcio – did have something in common with developments in twentieth century modernism, where chance juxtaposition and free association are in principle valued. Read like this, despite the mischievous intent, Ern Malley might turn out to be actually a valid piece of high modernism.[37] McAuley and Stewart also put in jokes or nudges that should have alerted readers as to the nature of what they were up to. Such testing and joking are common to hoaxes, part of their generally being on a knife edge between deception and declaration. They both want to dupe but also, then, to display the fact that they have done so. They are drawn towards seeing how far they can push the exaggeration and distortion – the further they can go and still get away with it, the more they demonstrate the receiver's gullibility and their own prowess, while also providing themselves with a get-out: "But see how obvious we were being, how many clues we gave you!".

Concealed imitation always raises moral issues. Plagiarism and faking involve theft, taking from the labour of another, without permission or acknowledgement, for one's own prestige or profit; plagiarism, fakes, forgery and hoaxing all involve deception of the audience – you are not getting exactly what you think you are.

This should not have to matter. If the work is beautiful or funny or exciting or whatever, what is it to you who really produced it or why? However, in practice it does tend to matter. In part, this is because it is seldom agreeable to realise one has been deceived, and this is intensified if you have a strong investment in the fineness of your aesthetic response: to think that you appreciate Mozart and then not to be able to tell it from Salieri may be bad for your aesthetic *amour propre*. Secondly, correct attribution has come to affect the monetary value of a work. This in turn derives from the most decisive element affecting the reason why intention in practice matters, namely the centrality of authorship to the now most widespread understanding of art, the sense of worth residing in a significant, expressive relationship between a work and its creator.

Concealed imitation thus raises even as it defies and disturbs the criteria of originality, sincerity and authenticity. Plagiarism, fakes, forgery and hoaxes have always existed, but seem both to be less clear-cut categories and to have mattered less when copying was a norm and originality of no great importance. Concealed imitations come to be scandalous especially if they throw into crisis issues of origin of wider importance than mere individual authorship. Ossian's success had to do with the search for an ancient tradition of noble

Scottish culture,[38] Ern Malley's with the desire to rescue Australian modernism from the taint of cultural cringe and elitism.

Alex Haley's book *Roots* was published in 1976 and turned into a television mini-series in 1977, both with phenomenal success.[39] It tells the story of the author's ancestors, from capture in Africa in 1750 through slavery and emancipation in the American South to the professional careers of Haley himself and his siblings, including Haley's visit to Africa to trace these roots. It has, however, been accused of historical inaccuracy, multiple plagiarism (of both novels and memoirs), fabrication of sources and also gullibility (believing tales habitually spun for tourists); in 1993 one investigation concluded that *Roots* was 'an elegant and complex make-it-up-as-you-go-along scam' (Philip Nobile, quoted in Taylor 2001: 76), while David Harvey speaks more generally of the way in which under postmodernism 'the search for roots ends up ... as a simulacrum or pastiche' (Harvey 1989: 303[40]). Yet despite these largely upheld accusations and general critical neglect, *Roots* continues to be a key reference point in African-American culture. It mattered, and still does, because it provides an account of origins that counter such classic statements of white American origins as *The Birth of a Nation* (1915) and *Gone with the Wind* (novel 1936, film 1939), counters them in part by adapting some of their formal procedures, all the more powerfully for appearing (fortuitously, as it happens (ibid.: 82)) amidst the celebrations of the bicentenary of the American Declaration of Independence, the founding of the – white – United States.

Like Ossian, *Roots* was a forgery that claimed to be about origins and spoke to a desire for stories of origins. It compounded the felony by appearing to claim to be rooted in the autobiography and ancestry of the writer himself and not just in some ancient writers he claimed to have discovered. Yet, like Ossian, *Roots* also unsettles the easy deployment of notions of forgery. In terms of production, Haley paid tribute to the tradition of the African *griot*, the teller of ancestral tales who is a vehicle for the passing on of history and myth rather than simply their inventor; he was himself in turn referred to as 'the griot from Tennessee' and can be situated within a tradition of black writing as a shared cultural enterprise (Gates 1992). His practice can be traced much further afield. Derek Pearsall discusses such works as Geoffrey of Monmouth's *Historia regum Britanniae* (1135), the first account of King Arthur, works which are based on the known facts but also 'supply the gaps in the historical record and, in the absence of information, provide it' (2003: 10). Where there is no hard record, oral tradition and an empathetic imagination have to do the best they can. Haley's greatest misfortune was perhaps that, rather than acknowledging or perhaps even recognising what he was doing as something between archaeology and imagination, he deployed contemporary and Western discourses of autobiographical and empirical origins for his affirmation of a people's origins.

Macpherson, Chatterton, Geoffrey of Monmouth, just as much as Corneille, Reade, van Meegeren, McAuley and Stewart and Alex Haley, all knew the

difference between their work and someone – or no-one – else's. The differences between them are, first, how common, accepted and widespread copying and repeating is in a given culture. Even van Meegeren can be compared to the practice of rivalry or measuring oneself against the greats of the past that Aleksander Kudelin (1997) describes in medieval Middle Eastern poetry (see below) and, as we have seen, Macpherson, Geoffrey, McAuley and Stewart and Haley can all be related to contemporaneous practices that valued imitation. However, most of the examples I have looked at appeared when the notion of the copy was devalued with the ascent of the notions of originality and authoriality. The real difference between them and the other practices they can be related to resides in labelling. This is not a superficial difference. What you take something to be affects how you respond to and understand it, how you 'get it'. This is emphatically not to dismiss theft, deceit and mischief as moral categories, but rather to indicate that they also have aesthetic consequences in how we apprehend concealed imitations.

Unconcealed, unsignalled, neutral imitation

Copies and versions

Copies and versions all imitate a particular prior work (rather than a body, period or kind of work). Copies, however, aspire to be indistinguishable from that which they copy, whereas versions are always at some degree of evident variance from it.

Copies

A copy is a work that seeks to reproduce another work in the same medium as itself as precisely and accurately as possible.[41] (I am not including here two other perfectly proper uses of the word, namely, the facsimile by other means (e.g. a photographic copy of a painting) and the 'single specimen of something that occurs in a multiple edition' (Collins 1992: 354) (e.g. the copy you are reading of this book.)

In the visual arts, the copy was, before mechanical reproduction, the only way that a work could be seen beyond its unique location. In this context, a copy was greatly to be valued and notions of better and worse ones perfectly legitimate. Most that we know of the sculptor generally considered to be the greatest of ancient Greece, Praxiteles, we know from copies. Painters often themselves produced, oversaw or authorised copies of their own works.

The only difference between a copy and a fake of a particular painting is the label. Both try to reproduce the painting so accurately that you can't tell the difference just by looking. The copy tells you that that is what it has done and you admire it to the degree that it has succeeded. The fake not only does not tell you but even tries to pass itself off as the copied painting itself. Once exposed, one may still admire the skill but it is generally held to detract from its aesthetic value. (For discussion of why this should be so, see Dutton 1983.)

Closely related to the copy is the replica. This can just be a synonym for it, often used for three-dimensional visual forms. However, it also commonly refers to works where the prior work is lost or destroyed. A copy of a painting is most commonly produced by the copyist having the painting before them, but a replica has often to rely on visual and written sources other than the prior work itself. The Globe Theatre now standing by the Thames in London could not be based on actually going and looking at its original, which burnt down in 1613. In some traditions, a replica, produced because the original has worn out, is valued as the original. Objects of veneration in Japanese tradition and Russian icons, for instance, are renewed and used with no sense of the later version being spiritually of any less value (Jones 1990: 35, 41); in the middle ages, freshly produced legal charters, granting particular monastic rights, were 'sometimes no more than a repetition, from memory or tradition, of a genuine document lost or destroyed' and none the less valid for that (Pearsall 2003: 5–8).

Impersonation (when not caricature), look-alikes, cover versions (in the original sense of an exact but cheaper version of a current hit)[42] and tribute acts (reproducing the performance of a particular pop act, often one no longer performing live, or even actually dead) are all also forms of copy. Here, though, people performing exactly like other people is often felt as a more fundamental difference than copying in paint, creating a sense of the uncanny and bringing the copy more evidently into the orbit of the version.

Versions

A version presupposes some specific work of which it is a version. Versions also constitute a fundamental principle of a great deal of cultural production. All performances are inescapably versions of the work they perform as are all kinds of theatrical production; even an audio-visual record of a performance or production is itself a version of these, inflected by technological choices of level, angle, balance and so on. Even more fixed media often involve notions of version: definitive texts of literary works are often highly disputed (Shakespeare is a notorious case in point), films exist in censored, restored, director's cut and other versions. Moreover, any copy cannot be absolutely the same as the original and is therefore in some sense a version of it.

Versions can be considered in relation to two axes: degree of closeness to the imitated work and how much awareness of what is being imitated matters.

Versions may be more or less close to the template of the imitated work. In music, a transposition of key hardly alters the template at all, while a transcription for other instruments mainly simply makes the same music available in a different form. Orchestration, musical arrangements and remixes are closer to translation from one language to another, where the notion of faithfulness to the template remains but the differences between the musical forces or languages themselves are such that substantial changes in meaning and tone are almost inescapable. Abridgement, paraphrasing,

updating, change of setting, children's versions and bowdlerisations depart more purposefully from the template, although generally within a commitment to retaining the basic structure and flavour of the source. Adaptation (from one medium to another) allows more latitude, as do remakes (one film of another), though the reception of both is still haunted by the question of faithfulness.[43] Sequels, prequels and overlaps[44] take the source as a point of departure (and even here there may be a concern to be true to the characterisation, spirit and 'narrative thrust' of the primary work (Taylor 2001: 33)). Improvisation in music (ragas, cadenzas, jazz) and literary rewritings by definition depart more radically from their starting points.

Translation encapsulates the interest and difficulty of notions of closeness to template. Everyone knows that a translation can never be exactly like the source work, that is, that it can never actually be it; yet we do also mostly assume a translation should get us as close as possible to the original. Recent translation theory elaborates the many difficulties that stand in the way of this ideal, and also opens up the possibility of seeing translation as something creative. As Susan Bassnett puts it (2002: 81), all acts of reading are acts of interpretation and a translator is perforce first of all a reader; all translation thus involves interpretation. This has usually been considered the regrettable if inevitable intervention of human frailty and subjectivity, but it can also be seen as liberating.

Much depends on who is translating what for whom. Bassnett (ibid.: 13) contrasts the attitude of Dante Gabriel Rossetti translating Italian, for whom the source author 'acts as a feudal overlord exacting fealty from the translator', and Edward Fitzgerald, translating Persian, who sees himself as 'absolved from all responsibility to the inferior culture' of the source. The principle of modest and respectful closeness to the original (Rossetti) is also a form of subservience to it, and this takes on a particular salience in, for instance, postcolonial situations. Here freer translation may be a site of liberation from awed submission to the authority of the original, colonial source. Yet in other circumstances casualness about closeness (Fitzgerald) is *force majeure*: a contemporary translation into English of a text in an African language which happily takes liberties with its source is, for all its free spiritedness, liable to be racist. Such questions of power have been foregrounded by translation studies,[45] but in fact inform all questions of relation between imitation and imitated.[46]

Versions also differ in the degree to which a sense of the imitated work is important to understanding them. The transcription is the perfect palimpsest, in the original implication of the term: it obliterates from perception the work it is based on; improvisation, sequels and rewritings are strong versions of how we have come to value the palimpsest, one work showing through the other, the newer work only really working when taken in tandem with the older. It is this that may also recommend the latter to resistant cultures. Jazz improvisation on white songs may be seen as a form of ironic Signifying on them (Floyd 1995: 7–8, 141).[47] Rewritings in the twentieth century of a canonical text like *The Tempest* from African, African-American, Australian, Canadian, Caribbean, Indian-Canadian and Québécois perspectives,

many of them by women, bring out and provide a series of reflections on the colonialist and patriarchal imaginings of the play (D'Haen 1997, Zarbus 2002).

With adaptations and remakes it may or may not matter that that's what they are. Most of Shakespeare is adaptation and this may have been valued by his first audiences (in terms of the admired practice of 'turning' and 'embellishment' (Bate 1997: 10–13)), but it is not how his works are valued now. Most films are based on novels or stories that very few of the audience will know of, let alone have read (although some, especially of classics and best-sellers, do capitalise on it in their marketing). The term 'remake' implies knowledge of the fact of the previous film, and hence the potential for heightened intertextual awareness, yet in practice such knowledge may be more or less present. The more it is present, of course, the more pressing and/or creative becomes the issue of closeness to the original.

Genre

Genres are groupings of works recognised as being alike.[48] A symphony or sonnet or Western is like other symphonies, sonnets or Westerns, and so genre production is a species of evident imitation, of making and receiving something like something else because it is like something else. However, a straight genre work is not purposefully signalling the fact of imitation. One symphony, sonnet or Western may be like another symphony, sonnet or Western, but it is not necessarily, significantly or usually about that likeness. Thus straight genre works are like pastiche in that they imitate other works and you know they do, but unlike it in that this is not the point of them. Because of the extreme closeness between straight and pastiche genre works, often to the point where it is hard to tell them apart, I look at the relation between them in chapter 4.

Unconcealed, signalled, evaluative imitation

All imitation must imply an evaluative attitude: the very act of imitating implies at the least that the thing imitated matters enough to warrant imitating. Also, the forms of imitation considered so far in this chapter may be used to express a valuation towards what they imitate: the hoaxes and rewritings considered above, for instance, clearly have a critical attitude to what they imitate. However, none are by definition evaluative; it is only with homage, parody and their cognates that valuation is built inescapably into the very form itself.

Emulation and homage

Emulation and homage both express an attitude of admiration towards what they imitate. They come out of different sets of cultural assumptions: emulation models itself on predecessors as a matter of course, whereas homage is a conscious act of acknowledgement in a culture where this is not the norm.

Emulation

Emulation was a foundational aesthetic practice in the Western classical tradition. Longinus (?C1 AD), [49] taking his cue, he says, from Plato, commends 'the imitation of and emulation of the great historians and poets of the past', for

> certain emanations are conveyed from the genius of the men of old into the souls of those who emulate them, and, breathing in these influences, even those who show few signs of inspiration derive some degree of divine enthusiasm from the grandeur of their predecessors (1965: 119).

Horace too, a century before, urged apprentice poets, 'you must give your days and nights to the study of Greek models' (Horace 1965: 88), while Quintilian, more or less contemporary with Longinus, lists the authors that budding orators should read.

A work's connection to its predecessors was evident in emulation, but this was not the point of it. Rather, you imitated your predecessors in order to try to achieve what they had achieved. Horace followed Aristotle in taking mimesis (truth to nature) as the goal of art, but you learnt best how to do that by following those who had done it best before you. Longinus makes the same argument for the attainment of hypsos (sublimity).[50]

The dynamic is at work in medieval Middle Eastern poetry, as discussed by Aleksander Kudelin, but explicated by him more in terms of rivalry and competition. Here the poet 'is not a simple imitator, a follower, but a rival of their predecessor' (1997: 59). (One might detect something similar in Longinus' observation that Plato would not have written so well 'had he not been striving heart and soul with Homer for first place' (op. cit.: 120).) The notion of aesthetic competition was central to the system of such medieval literature and rooted in a sense of the timelessness of artistic consciousness: what was good and beautiful in the past would be good and beautiful now. Poets sought to outdo their predecessors in the production of verses modelled on them, but this should not be understood as the Œdipal conflict between artistic generations discerned by Freudian interpreters of Western culture (notably Bloom 1973). First, there was no desire to put aesthetic adversaries to flight, but rather '"peaceful co-existence" between the author-predecessor and the author-successors, their rivals' (Kudelin 1997: 61). Second, it was always understood that one could never actually surpass one's predecessors, because, just like them, one was working towards a transcendent, absolute goal that could never be attained.

Homage

Emulation is a taken for granted practice of cultural production, one with limited purchase in an age of originality and copyright. Homage, on the

other hand, is the deliberate recognition and appreciation of a specific pred-
ecessor, where such practice is no longer the cultural norm.

Homage may be used in any of the arts, but it is especially and explicitly
used in relation to music. There may be polemical intent: post- and anti-
Romantic composers wanted to reconnect with classical and baroque
composers and thus produced works like *Hommage à Rameau* (Debussy 1905),
Le Tombeau de Couperin (Ravel 1919) and *Scarlettiana* (Casella 1926); a white
singer, Rosemary Clooney, situates herself as heir to a black jazz great with
the 1992 album *Tribute to Billie* (Holiday); a pop megastar, Robbie Williams,
reclaims Frank Sinatra for the post-rock generations with *Swing When You're
Winning* 2001.

Musical homage may involve composing or performing like the person to
whom homage is being paid, but it need not involve imitation in this direct
sense. Debussy's *Hommage à Haydn* 1909 doesn't sound at all like Haydn, but
is a waltz using the three letters in the latter's name which have equivalents
in musical notation (H [= B natural], A, D). His *Hommage à Rameau*, on the
other hand, is 'a tribute, not, as one might be led to expect, in the form of a
pastiche, but of a majestic sarabande of classical proportions and develop-
ments' (Lockspeiser 1980: 150). The sarabande itself is a classic dance form
for which Rameau had an affinity; Debussy develops it with an harmonic
freedom that 'the harmonic-conscious Rameau would have been delighted' to
use had he lived a century later (Schmitz 1950: 105).[†]

Homage is implicit in a great deal of the other forms discussed here and not
least pastiche. Ingeborg Hoesterey considers it to be defining of the literary genre
of pastiche (see chapter 2) and that postmodern pastiche variously combines
'quasi-homage and parodic modes' (2001: 83). Homage is a dimension of much
of the material discussed subsequently in this book: 'The Murder of Gonzago'
(*Hamlet*), *Follies* or *Far From Heaven*. However, it is not the main point of them.

Travesty, mock epic, burlesque

Travesty and mock epic are now most widely understood as opposites: trav-
esty is high subject matter dealt with in a low manner, mock epic is a low
subject in a high manner.

[†] Debussy himself has in turn had many homages paid to him, which did take the form of imitation/
pastiche: two years after his death, the December 1920 edition of *La Revue musicale* published a set of
specially commissioned homages under the heading *Le Tombeau de Claude Debussy*, with pieces (two
called 'Hommage à Debussy', two 'à la mémoire de Debussy') by Francesco Malipiero, Béla Bartók,
Florent Schmitt, Igor Stravinsky, Manuel de Falla, Erik Satie and Maurice Ravel; Thomas Manshardt
performed what is now referred to as his *Hommage à Debussy* as if it were a piece by Debussy himself and
entitled 'Les saules au bord de l'étang' ('Willows by a Pond'), a title typical of Debussy's piano minia-
tures; in 2003, the Spanish jazz pianist Horacio Icasto released an album called *Debussiana*, improvisa-
tions on Debussy's 'Jardins sous la pluie' ('Gardens under the rain' from *Estampes* 1903) and also on
composers that have an affinity with him (or that Icasto plays as if they have), Ravel, Prokofiev,
Gershwin and Piazzola, ending with Icasto's own 'Debussiana'.

The term burlesque is much more promiscuous (cf. Rose 1993: 54ff); it can mean travesty, even mock epic, but is also used for parody or mockery, for a specific tradition of knockabout, parodic theatre (Dentith 2000: 134–153) and for striptease. The latter has to do with burlesque comic sketches coming to share the bill with strippers in American vaudeville, but one might also note that striptease numbers did also often involve a kind of travesty guying of higher things: strippers doing ballet, heroic theatre, military spectacles and so on. I do not specifically discuss or use 'burlesque' further here.

Travesty

The term travesty comes from the Italian travestire, to dress or disguise, and suggests the idea of one mode being dressed in the guise of another. In practice this meant a serious mode dressed as frivolous. It became a current usage in the seventeenth century, notably with the publication of Giovanbattista Lalli's *Eneide travestita* 1634 (Hempel 158ff), which took the classical epic most admired at the time, the *Aeneid*, and retold it in a light, comic manner. Lalli saw his version as a work of entertainment, something to be appreciated 'in the hours of respite from serious occupations' (quoted in ibid.: 159). Travesty need not imply more than this; the humour arises from the simple mismatching of two incongruent elements. However, travesty has also been understood in terms of lowering, either in the sense of bringing something down to a more familiar level or of debasing it.

Classic travesty like Lalli's made its epic points of reference feel more familiar by, for instance, the use of short (readily grasped, umpty-tumpty) poetic lines rather than long (nobler, expansive) ones, vernacular language, and familiar, and hence often anachronistic, references (Genette 1982: 67). The effect is liable to be comic, but is also a way of allowing contemporary readers to feel at home with the remote qualities (in time and rank) of the classical tradition. This may though also have the effect of debasing the noble tone and pretensions of the original. Richmond Bond, in a study of eighteenth century English 'burlesque poetry', suggests that travesty 'lowers ... by applying a jocular, familiar, undignified treatment' (1932: 4, quoted in Rose 1993: 56), often by including elements of deflating common sense and lewdness.

Travesty, principally poetic in the seventeenth century, became dramatic in the eighteenth century and also operatic (Offenbach, Gilbert and Sullivan)[51] in the nineteenth. Theatrical travesty may have been prefigured by the satyr plays in ancient Greek theatre, which came after and deflated performances of the tragedies and typically presented 'a famous mythological character in a grotesque situation rich in comic possibilities' (Sutton 1980: 13; quoted in Dentith 2000: 42). One of its modern forms is the British *Carry On* film series, in which a stock company of performers are put in a variety of generic settings: *Carry On Cowboy* (Westerns), *Cleo* (epics), *Emmanuelle* (soft porn), *Henry* and *Don't Lose Your Head* (costume drama), *Screaming* (horror),

Spying (James Bond), *Up the Jungle* (Tarzan), *Up the Khyber* (imperialist adventure) and so on (Medhurst 1992).[52] The point is that Charles Hawtrey, Hattie Jacques, Sid James, Kenneth Williams, Barbara Windsor and the other *Carry On* regulars perform in each film as if there had been no change of time, setting or genre. Sometimes there is parody of the genre in question, but most of the time the performers' stock characters and the string of verbal and visual (and usually dirty) puns carry on regardless. The effect of the comic disparity between characters and gags and the relatively serious subject matter is deflationary, bringing the latter down to the stereotypical and lavatorial level of the former.

Mock heroic

The treatment of a low subject in a high style: the style of one of the forms associated with high seriousness and unquestionable aesthetic achievement (e.g. epic or tragedy) is used to deal with subject matter deemed worthless or trivial. It is both mock (not true epic or tragedy because not about what is taken to be intrinsically grand subject matter) and mockery (making fun of the subject or the style or both).

The founding example is generally said to be the *Battle of the Frogs and Mice* (circa 4BC), in which a clash between said creatures is treated as if it were between the most almighty and heroic figures of epic. One of its masterpieces is generally agreed to be Alexander Pope's *The Rape of the Lock* 1714. The language of the latter draws on both generic epic conventions and reference to specific works (from Homer to Pope's contemporaries (including their translations of the Greek and Roman canon)), and it uses all this to recount an incident when an admirer, 'the Baron', snips a lock of hair from a young lady, Belinda, without asking her and to much subsequent ado.

The moment of the cutting of the lock illustrates the mock heroic method. The Baron has long 'admir'd' Belinda's two curling locks of hair at her neck and at last, on a visit, over coffee, his opportunity arises (III: 125–134):

> But when to Mischief Mortals bend their Will,
> How soon they find fit Instruments of Ill!
> Just then, *Clarissa* drew with tempting Grace
> A two-edg'd Weapon from her shining Case;
> So Ladies in Romance assist their Knight,
> Present the Spear, and arm him for the Fight.
> He takes the Gift with rev'rence, and extends
> The little Engine on his Finger's Ends,
> This just behind *Belinda's* neck he spread,
> As o'er the fragrant Steams she bends her Head …

The Baron does not just take out a pair of scissors. Rather, an unearthly being, a nymph (Clarissa), who is compared to a Knight's Lady in medieval

Romance, produces an instrument of war (a weapon, a spear, an engine). Even Belinda going to take a sip of coffee is transmuted in to the high-flown vocabulary of bending over 'fragrant Steams'.

The comedy derives from the discrepancy between style and subject. In part the poem pokes fun at the inflated high seriousness of epic. If taking out a pair of scissors is, conforming to epic style, a nymph furnishing a resplendent weapon of war, then the style itself may be seen as highfalutin and over-elaborate to the point of ridiculousness. But this cuts both ways, to style and subject, and the effect depends on finding the latter essentially trivial. This may pose problems with *The Rape of the Lock*, perhaps especially today, when the sense that snipping off a curl is trivial, a bit of harmless naughtiness, may be harder to accept; it may on the contrary be understood as indeed a form of rape, a male violation of female space and will, which makes it harder to see the mockery of epic style for the mockery of womanhood. In this perspective, *The Rape of the Lock* may seem merely to confirm that high flown language is appropriate to the doings of Gods and Heroes, but not for the footling concerns of women.

Parody

Parody, from the ancient Greek παρωδια (*parodia*), is the oldest term discussed here, at least two thousand years older than pastiche (Hempel 1965: 151). It applied first to singers imitating other singers and then to imitative verse and prose (Rose 1993: 7–8[53]); in this usage, it did not carry the connotations of humour, criticism or ridicule that it developed later.

Because of this and because it literally means song (*ōidē*) alongside (*para*), many recent theorists have wanted it to be used to embrace a wide range of imitative practices. At times it becomes virtually interchangeable with intertextuality; Guido Almansi and Guido Fink in their 1976 study-cum-collection of parodies, *Quasi come* (*Almost Like*), though covering much of the gamut of the second half of this chapter, open with an even more extreme stretch for the word, declaring theirs to be 'a book about parody, that is, a book about writing' (since in some sense or other all writing is 'false') (1991: v–vi). Such usages of parody tend especially to squeeze out pastiche as a distinguishable concept (cf. Kiremidjian 1969–70, Hutcheon 1989, Billi 1993, Brand 1998).

Yet, quite apart from the fact that it is difficult deliberately to change the common associations of a word, and problematic to argue from what a word has meant to what it should mean now, it also seems useful to make a distinction between works that imitate to make fun, mock, ridicule or satirise (parody) and those that do not (pastiche).[54] I propose that we retain the sense of the term parody offered by Simon Dentith (2000: 9): 'any cultural practice which provides a relatively polemical allusive imitation of another cultural production or practice'. Similarly Margaret Rose stresses that pastiche differs from parody in being 'neither necessarily critical of its sources, nor necessarily comic' (1993: 72), Gérard Genette categorises pastiche as 'imitation without

satire' (1982: 34–35) and Fredric Jameson speaks of 'blank parody', 'mimicry without parody's ulterior motive, without the satirical impulse, without laughter' (1983: 114).[55]

In this perspective, other terms are more clearly related to parody, mainly indicating differences of tone. Satire and caricature seem the most explicitly informed by social or political criticism and are often used to refer to works that mock attitudes and behaviours as much as or rather than aesthetic forms. Spoof, skit, take-off, lampoon and send-up are more light-hearted and inescapably comic, the first three more genial, hardly critical at all, the last two crueller, more undermining. I do not consider these further here.

I want to illustrate parody here in a particularly strong instance, the imitation news programmes of Chris Morris, and to compare them with three other imitation news presentations that are however not parodic. All in their way were infamous. The comparison will, I hope, confirm the usefulness of hanging on to a notion of parody as a mode distinct from pastiche and also refine the notion of pastiche itself.

On the Hour (BBC radio 1991–1992), *The Day Today* (BBC television 1994) and *Brass Eye* (Channel 4 1997) were three series parodying the increasingly dominant format of news broadcasting: a string of short items, some in the studio, some pre-filmed inserts, some live outside broadcasts, all linked by an anchorman (played by Chris Morris, the series' devisor and co-writer (with Armando Iannucci)), punctuated by logos and graphics and underscored by music. All deployed both exaggeration and inappropriateness.

The series were mercilessly precise in their mimicry of fast news style, yet always tweaking every detail up a notch or more, including the shiny, department store sets, the anchorman's energetic, sometimes shouted, sometimes heavily deliberated delivery, and the busy music, with its underlying pulse and periodic fanfares and drum rolls. The opening credit for *The Day Today* (on the first episode of which I shall concentrate (tx 19.01.94)) encapsulates the method: an intergalactic explosion becomes a series of differently coloured globes become a satellite becomes an orb becomes a football (with the countries of the globe on it) becomes a sphere with faces on it, which is then finally split apart and recombined into the logo for the programme. With hectic, clashing music, this is entirely accurate in reproducing the brash, high-speed, explosive style of contemporaneous news programme credits, but in the exaggeration also highlighting their willed excitement, false connections between elements and self-importance. The whole pace and tone of the credit and the series as a whole seem to embody one of the earliest critiques of the mode, made by Stuart Hall in 1970, its 'heady, breathless immediacy', its production of 'actuality without context', its sense of 'a meaningless explosion of meaningless and violent acts – 'out there' somewhere, in an unintelligible world ...'.[56]

It is, however, in its use of inappropriateness that the Chris Morris news parodies are most audacious. At times this takes the form of reporting straight-facedly utterly mad items of news. The opening headline items of

the first episode of *The Day Today* consist of the Conservative MP Virginia Bottomley shown 'refreshed after three days on cross', the entrepreneur and hot air balloon flyer Richard Branson seen emerging from a dinghy after his 'clockwork dog crosses Atlantic floor', and someone covered in a cloth and escorted by police, with the explanatory commentary 'sacked chimney sweep pumps boss full of mayonnaise'.

Elsewhere, however, the discrepancy relates to the handling of (almost) plausible news items. One (headline: 'Stylish Death') concerns the execution of US serial killer and Elvis Presley fan Chapman Baxter, who, dressed in Presley's Las Vegas style and after gorging huge quantities of cheeseburgers and drugs, is executed on an electric chair in the form of a toilet as a black serviceman sings 'Are You Lonesome Tonight?'.[†] The grossness of the elements reaches its peak as we hear Baxter's final screams just off-screen, while the reporter perkily addresses the camera: "So as Baxter turns as blue as his suede shoes, this is very definitely one Burger King with extra fries to go. Barbara Wintergreen, CBN news, at the Elvecution Tennessee State Penitentiary". The parody thus skewers both the conscienceless media circus surrounding executions and the way killers may themselves buy into notions of celebrity, their own and their models.[57]

'Stylish Death' exaggerates an inappropriateness that is in fact to be found in the media coverage of executions. This move, whereby inappropriateness turns out to be merely an exaggeration of what is being targeted, was taken still further in the most notorious of Morris' programmes, the *Brass Eye* special on paedophilia (tx 05.07.01). Here things are pushed to a point of lunacy. The title for the episode is 'Paedogeddon'. The first images are of street signs for Fancia Drive and Youngbottom Ride and of a man with 'paedo' written on his forehead clutching two children to him and laughing hysterically. The presenter (Morris) says that "people like this are everywhere", which is "why my own children are here with me", at which point he shuts filing cabinet drawers with a child in each, saying "Goodnight children". There is a trailer for a programme called 'Paedophile Island': '100 kids and an ex-offender on an island full of cameras – what is going to happen?'. Barmy facts are presented by celebrities as if they are truths: the comedian Richard Blackwood holding a computer keyboard tells us that "online paedophiles can actually make your keyboard release toxic vapours that make you suggestible", the singer Phil Collins, wearing a baseball cap and T-shirt with the word 'Nonce Sense' on them calls on us to have 'Nonce-sense',[58] while the DJ Dr Fox tells us that

> Genetically, paedophiles have more in common with crabs than they do with you or me. Now this is scientific fact. There's no real evidence for it but it is scientific fact.

[†] Almost a grace note this, a kind of negative of the white Presley's covering of black music.

The programme was widely condemned for making fun out of a subject, paedophilia, that was beyond the pale of what could be a fit subject for humour. Yet what the risible tabloid-style punning terms, the sadistic and prurient imagery, the incitement-to-violence formats taken from reality television, the readiness of celebrities to get in on the moral game, the atmosphere of frenzy tipping over into the surreal (children in filing cabinets), what all point to is the contemporaneous media hysteria surrounding paedophilia. Given the actual incidence and location of child abuse, to say nothing of both the neglect and media sexualisation of children, one might say that the *Brass Eye* paedophilia special had got all too literally close to home.

Chris Morris' parody newscasts may be contrasted with three non-parodic examples of imitation news: *The War of the Worlds*, *Culloden* and 'News on the March' from *Citizen Kane*.

The War of the Worlds was Orson Welles' radio adaptation of H. G. Wells' 1898 novel, transposed to and transmitted on 30th October 1938 (Halloween). It takes the form of an evening's broadcasting broken into and finally overtaken by news of a Martian invasion of Earth (specifically of Grover's Mills, New Jersey). A live dance band transmission is interrupted by a bulletin of strange sightings in the sky, then interviews with scientists and senior politicians, updates, on the spot broadcasts from where the Martians have landed and so on; at first there is a return to the dance band and then anodyne filler classical music, but this eventually falls away until the whole broadcast is handed over to the New Jersey State Militia as the Martian invasion takes its grip. *Culloden* (tx 15.12.1964) is Peter Watkins' television version of John Prebble's 1961 study of the 1746 battle of the Highland Scots against the English and the Lowland Scots, ending in the massacre of the former. It is presented as an outside broadcast from the site of the battle, with long-distance panning shots and closer hand-held shots, interviews with or straight-to-camera addresses from participants, commentary from on-the-spot observers and a voice-over narrator both linking the elements and providing factual information. The style, according to Watkins, was to have a 'bumpy, journalistic grain and realism, exactly as though it is happening there and then and being recorded by a sort of *World in Action* team'.[59]

The subject of Chris Morris' parodies is the way contemporary broadcasting constructs the news, not just as a mode of presentation but as a shaping of the perception and understanding of events in the world. *The War of the Worlds* and *Culloden*, on the other hand, use the style of news broadcasting to lend immediacy, urgency and gravitas to the events portrayed. Neither in any way questions the modes of news casting themselves. The only reasons we know they are imitation newscasts are paratextual (scheduling, introductory announcements)[60] and because both deal with events that, respectively, have never happened or happened when there was no television to record it. In fact, there were those who did believe that the fictional events in *The War of the Worlds* were taking place (cf. Cantril 1940),[61] whereas no-one presumably believed they were actually seeing the none the less historically real events of

the battle of Culloden.[62] It is hard to know what to call both programme's deployment of news form. There is no suspicion of parody; like pastiche, they are close to what they imitate and yet clearly not it, but unlike pastiche, they do not bring out the role of form and convention in the mediation of subject matter. Indeed, both seek to harness the energy and truth claims of news casting to make their accounts vivid and believable and thus in effect affirm the values and practices of news presentation.

The newsreel 'News on the March' from *Citizen Kane* (USA 1941 Orson Welles) is different again. This is a compilation of old news and documentary footage held together by a dominating voice-over, which unfolds the life of the late newspaper magnate Charles Foster Kane who is to be the subject of the rest of the film. The reference point is *The March of Time* series (1935–1951), which were not newsreels but featurettes dealing usually with a single item in the news, such as the death of an important national figure.[†] 'News on the March' is sometimes referred to as parodic (e.g. Bordwell 1976: 276, Naremore 1996: 274, Plantinga 1997: 103, Garis 2004: 42), but this seems a later perception.[63] The first reviewers seem to have taken it as an imitation at once straight and signalled, in short, as pastiche:[64]

> 'a staccato March-of-Time-like news feature' (Bosley Crowther, *New York Times* 2.5.41);
> 'a brilliantly handled March of Time sequence' (Joy Davidman, *The New Masses* 3.5.41);
> 'The effect of the "real thing" [in the 'News on the March' sequence) is quite startling' (Cedric Belfrage, *The Clipper* May 1941);
> 'The life of Kane told as *March of Time* would tell it' (*Horizon* 4, November 1941).

In many respects, 'News on the March' seems almost philological in its recreation of the style and approach of *The March of Time*. Welles had worked on the latter in radio and film and adapted its techniques in making *The War of the Worlds*. The shooting script speaks of combining 'the more obvious characteristics of the 'March of Time' ... to give an authentic impression of this now familiar type of short subject' (Mankiewicz and Welles 1990: 11). It runs nine minutes, much longer than newsreel items but the kind of length of those in *The March of Time*. It combines, like them, existing stock and newsreel footage with graphics and recreated scenes. The latter were common

[†] A 1936 radio edition of *The March of Time* featured an obituary of the arms tycoon, Sir Basil Zaharoff, of which *Citizen Kane* has several echoes (scenes of papers being burnt, witnesses testifying to Zaharoff's ruthlessness, his lonely life in a gigantic palace). At one point, Zaharoff, played by Welles, expresses his dying wish to be wheeled out "in the sun by that rosebush", suggesting not only the 'rosebud' of *Kane*, but also the shots in 'News on the March' of Welles as the ageing Kane being pushed round a sunny garden in his wheelchair (Carringer 1985: 18).

practice in *The March of Time* (Fielding 1972: 148–152) and evident in 'News on the March' not only because about a fictional character (albeit one presumed to be based on William Randolph Hearst), with shots of Welles as Kane standing impossibly in Downing Street with Chamberlain or sharing a balcony with Hitler, but also in shots such as that of a socialist agitator in Union Square, taken in classic propaganda fashion from below against a sky beside loudspeakers, a shot too clean, firm and set-up to be taken as raw newsreel footage. The visual quality of the latter is very variable (as in any actual compilation it is), overall grainy ('Toland's imitation of newsreel stock is always perfect' (Naremore 1996: 274)) but manifesting different degrees of distress. Cedric Belfrage, in his contemporary review, felt that 'a camera of early days [had] presumably been used' to give the particular rhythm of older film (1996: 45–46) and Ken Barnes speaks of the recreation of hand-cranked camera techniques.[65] The editing was not by *Kane*'s editor, Robert Wise, but by the RKO newsreel department, 'because Welles felt they could best capture the spirit of the original [i.e. *The March of Time*]' (Carringer 1985: 110); they also edited the music, a pasticcio of elements taken from previous RKO films together with popular classics 'as they were scored for those films' (ibid.: 148–149; cf. Smith 1991: 79). The music, like the guiding 'Voice of God' narration,[66] gives that sense of a structure that is always starting off on a new tack. The actual voice mimics the distinctive voice and delivery of *The March of Time*'s narrator, Westbrook Van Voorhis:[67] vigorous, stentorian, 'omnipotent and impassioned' (Plantinga 1997: 160). In every detail, 'News on the March' is as like *The March of Time* as can be, while clearly not being it.

'News on the March', while unequivocally evoking a recognised form of news presentation, is neither, à la Chris Morris, mocking it, nor, like *The War of the Worlds* and *Culloden*, using it for its association with immediacy and fact. Rather it forms part of *Citizen Kane*'s wider play with the possibilities of truth and knowledge.

It is a pastiche, the second in the film. Before it there is a sequence of Gothic mysteriousness, in which a series of dissolves lead us through a sequence of chiaroscuro and sometimes skewed shots, from outside Kane's cavernous castle of Xanadu to his death bed and back again, all accompanied by brooding and sinister, minor and chromatic, horror film music.[†] 'News on the March' follows immediately, and only after it does the narrative film proper begin, with the reaction of the newsmen to the screening of 'News on the March' that they have just been watching. They feel that it hasn't really

[†] The theme is 'a sort of variant of the ancient hymn, *Dies Irae* [Day of Wrath]' (Bernard Herrmann, the composer of *Citizen Kane*, quoted in Rosar 2001: 107), which William Rosar (2001) notes is also used by Rachmaninov for his tone poem *The Isle of the Dead* 1909, inspired by the painting of the same name by Arnold Böcklin, which is stylistically related to Kane's Xanadu palace as shown in the opening sequence of the film and which was used as the inspiration (and title) for a later RKO/Val Lewton horror film in 1945, with music sounding more like Herrmann than Rachmaninov. The latter also incorporates the *Dies Irae* into his *Rhapsody on a Theme of Paganini* 1934.

told them anything new or revelatory about Kane, and this sets in motion the investigation of the narrative. It might seem that the rest of the film is an attempt to find the truth behind the distortion and rhetoric of 'News on the March'. Yet the newsmen themselves seem merely to feel the latter is inadequate, not stupid or contemptible, not untruthful. Moreover, the more they interview people who knew Kane, the less they seem to grasp him. And if, unlike the newsmen, we at any rate find out what Kane's dying word 'Rosebud' refers to,[68] it is a revelation that says everything and nothing, a simplistic psychological key to what we have seen to be a complex and elusive personality.

In this perspective, 'News on the March' is no less, but no more, limited as a source of knowledge than the memories of Kane's associates, which are self-interested, often bitter, quite likely faulty, addled by drink and/or age. The Gothic sequence and the news featurette are polar opposites: a Gothic, expressionist projection of inner states of loneliness, anguish and death and the public face of a powerful public man. Yet both are an aspect of the truth and use particular means to convey it. The film deploys pastiche to make evident the particularity of the means but not to discount the truth – partial and limited, like all knowledge, but not not knowledge. It sets a tone of flexibility towards the truth, of scepticism but not nihilism, which continues in the use of memory and in the less-than-total revelation of the burning sled.

'News on the March' anticipates the rest of *Citizen Kane* formally as well. Just as the featurette shuffles the life of Kane rather than simply unfolding it chronologically, so does the film as a whole; and just as 'News on the March' seems to keep starting up again, so does *Kane* (cf. Mulvey 1992: 39–40). In 1949, Parker Tyler argued that *Kane* is not only about a journalist but that it adopts 'a pervasive attitude of journalism toward [its] story', pointing to the role of the reporter, the film's news-like assemblage of bits and pieces, its occasional photographic 'emulation of newsreel cameramen "on the sneak"' (Tyler 1971: 260). *The March of Time* itself (and American newsreels generally) 'took its structure, its style, its personnel, and many of its news-gathering techniques from the older newsprint media' (Fielding 1972: 136). There is a continuity of awareness across the whole film of the modes, ambitions and achievements of news as an enterprise, regardless of medium, including rather than over against 'News on the March'.

To treat 'News on the March' as parody diminishes *Kane*'s attitude towards knowledge. Parody implies a sure position outside of that to which it refers, one of secure judgement and knowledge. *Kane* is more inside the problem of judgement and knowledge, more ready to acknowledge that it doesn't have all the answers, doesn't know exactly what to think. In one way 'News on the March' is indeed much nearer to parody than *War of the Worlds* or *Culloden*. They use evident imitation as a technique but to foreground subject matter not to draw attention to the mediation of it. But in turn *War of the Worlds* and, especially, *Culloden* are more like parody because they operate from a clear position of knowledge. 'News on the March' is typical of pastiche,

in occupying a middle ground and, as a consequence, of not even being unmistakably, unarguably pastiche.

Pastiche and parody are distinguished by attitude, but also by the nature of their relation to that which they imitate. Mirella Billi suggests that, while both signal the fact of imitation,

> parody may be distinguished from pastiche chiefly because it brings out the difference between the two texts ... rather than the similarity. [...] Whereas parody is transformative, pastiche is imitative. (1993: 36[68])

One might say that, while it always possible to misread both pastiche and parody as straight imitation, it is much easier to do so with pastiche because it remains formally closer to that which it imitates. Yet, as F.J. Lelièvre points out, the ambiguity of the prefix 'para' in parody indicates both nearness and opposition (Rose 1993: 8[69]); the very fact that parody involves 'the inclusion within its own structure of the work it parodies' (Rose 1993: 51) gives the former a dependence on the latter, the parody on the parodied, brings it back closer, courts complicity. Perhaps parody is theoretically distinct from pastiche chiefly because it minds being inexorably implicated in that from which it seeks to distance itself and that is why it is so hysterical – so angry, so mocking, so unkind – about it.

Many of the examples discussed in this chapter turn on the question of labelling. This has to do both with the difference that concealment makes and also how we understand and respond to the implicit expressive intention of the work. Charles Reade's 'The Picture' could have been treated as an adaptation, abridgement or translation had he acknowledged (and paid for) its source in *Mlle de Malepeire*; McPherson could have offered Ossian as an imaginative recreation of an authentic but unrecorded tradition; Chatterton's Ossianics could be considered emulative pastiches if they were not offered as translations or did not lapse into parody at points; *The Darkening Ecliptic* could have been a parody, or perhaps a critical pastiche, had it not been presented as *bona fide* experimental poetry. Equally, the uncertainty over whether 'News on the March' is best understood as parody or pastiche depends upon how it is labelled, albeit unconsciously.

Judging which label is most appropriate – and especially, for the purposes of this book, deciding when labelling something a pastiche is justified – involves considering a combination of paratextual, contextual and textual evidence. Paratextual evidence has already been discussed above in relation to *The War of the Worlds* and *Culloden*; its most obvious form is when a work is actually called a pastiche, and this is the subject of the next chapter. Contextual evidence involves what one can glean about the decisions that went into the making of the work; where, as is common, the pastiche is found within a wider, non-pastiche work, that work may be especially important in understanding the pastiche as a pastiche. I have deployed both kinds of contextual

evidence in my discussion of 'News on the March' and *Citizen Kane* above, and the role of a wider work as context for a pastiche is the subject of chapter 3. Textual evidence, the markers of pasticheness in the pastiche itself, is the trickiest form of evidence. In the next chapter I look at the three formal elements of pastiche as found in French literary pastiche: likeness, deformation and discrepancy. However, these are also the techniques of parody (as evinced in my discussion of *Brass Eye* above). The difference may often and demonstrably be one of degree (pastiche is more like its referent, less exaggerated, less discrepant), but sometimes it comes down to the way the same techniques work if taken (from para- and contextual evidence) as parody or pastiche.

Both textual evidence and immediate contextual evidence (i.e. the evidence of the framing text) also involve an aesthetic judgement. My argument about 'News on the March' is partly that one understands both it and *Citizen Kane* better if one treats it as a pastiche rather than a parody, because this fits better with *Kane*'s overall concern with knowledge. This itself assumes that *Kane* is a unified text; in more pasticcio-like texts, this would be a more problematic assumption. Many of the examples that follow may appear mildly dubious, as if I am being merely wilful in calling 'The Murder of Gonzago', *Once Upon a Time in the West*, the national dances in *The Nutcracker* or the Blues and Spiritual themes of *The Afro-American Symphony* pastiche. My discussion of them as pastiche stands or falls by the validity of my deployment of the evidence for them being pastiche, but also by the degree to which treating them as pastiche illuminates them, how much intellectual and affective sense it makes of them.

Notes

1 See also the accounts of academic usages of pastiche in Karrer (1977: *passim*), Genette (1982: 105ff), Rose (1993: 72–77) and Borello (1996: 94–100).

2 Manlio Cortelezzano and Paolo Zolli: *Dizionario etimologico della lingua italiana* volume 4, Bologna: Zanichelli (1985: 890). Carlo Battisti and Giovanni Alession (*Dizionario etimologico italiano*, Florence: G. Barbera, 1954: 2797) give the same starting point.

3 The anecdote comes originally from Giovanni Baglione's 1642 *Lives of the Painters*.

4 Intertextuality is a much used and contested term. Here I take it to indicate that all texts are ineluctably caught up in the languages and conventions they inhabit, beyond specific and/or explicit reference to other texts, beyond authorial intention, and certainly beyond the narrow confines of great or progressive literature, all of which are, however, positions to be found within intertextual studies. (Cf. Plett 1991, Allen 2000.)

5 Although it seems that this is one case where the culinary meaning – a kind of fish stew – is based on the artistic term, itself derived from the Zarzuela palace where such shows were given.

6 A form of popular theatre combining dialogue, songs, choruses and dances, dating back to the early seventeenth century and especially popular during the nineteenth.

7 Stage form with dialogue and interpolated songs, both in the vernacular rather than the elevated language of Grand Opera, emerging in Germany in the eighteenth century. Canonical works of German opera, such as Mozart's *The Abduction from the Seraglio* 1782, Beethoven's *Fidelio* 1805 and Weber's *Die Freischütz* 1821 are all Singspiele.

8 Lacasse (2000: 51–53) relates this to Oswald's earlier 'plunderphonics', in which he took recorded music by, for instance, The Beatles, Dolly Parton, Public Enemy and Michael Jackson, and radically remixed it to produce 'an entirely new sonic configuration'.

9 Prince Be Softly of P.M. Dawn, an early (1980s) hip hop DJ, quoted in Rose (1994: 52): 'I can take a Led Zeppelin drum loop, put a Lou Donaldson horn on it, add a Joni Mitchell guitar, then get a Crosby Stills and Nash vocal riff'.

10 The former a c.1905 postcard (Ades 1976: 19), the latter featured in *L'Illustration Européene* (Brussels 2 April 1911) (Scharf 1974).

11 Cf. also, for instance, Samuel Beckett's widespread grafting of others' work into his own, perhaps as a means to shed individuality of style (Gontarski 2002).

12 Hunger, Herbert *Die hochsprachliche profane Literatur der Byzantiner* II, Munich: C.H. Beck (1978: 100); quoted in Verweyen and Witting (1991: 171); my translation.

13 Dictionaries of literary terms still privilege the combinatory meaning (e.g. Fowler (1973: 138–139), Baldick (1990: 162)). On the other hand, it seems not to figure as a term at all in dance and ballet dictionaries.

14 Hoesterey (2001: 4–5) discusses the problems of sourcing this use.

15 I am thus covering much of the field designated by Gérard Genette in *Palimpsestes* (1982) as that of hypertextuality, works defined by their relation to other works. I make the notion of imitation more central to the distinctions I make and do not focus on literature.

16 On allusion, see for instance Perri (1978) and Hebel (1991).

17 Cf. note 4 above.

18 A palimpsest is a manuscript in which one text has been written over another (or even several in succession); with age, the earlier texts may show through the attempts to erase or write over them, and it is this sense of one text showing through another that Genette has taken as a metaphor for the many forms of intertextuality discussed in *Palimpsestes*.

19 Bakhtin's term (1984: 199); cf. Pearce (1994: 51).

20 Cf. Billi (1993: 36), Kawin (1972).

21 Influence differs conceptually from these other terms in that it refers to a demonstrable process rather than just semiotic similarities or connections between works of which the parties involved may or may not have been conscious. See Hermerén (1975). The neurotic dynamics of influence in the age of originality are the basis of Bloom (1973); see also the deployment of the term ventriloquism in Connor (2000).

22 I am grateful to James Zborowski for lending me these examples and discussing them with me.

23 Another term, 'appropriation', is also used, but in practice may mean either or both plagiarism and quotation/sampling.

24 In so far as quotation, citation and sampling both deform the selected element (by taking it out of its context, deracinating it) and transform it (putting it into a new context, rooting it in new connections), they do some of the things that imitation and, a fortiori, signalled, evaluative imitation, including pastiche, do (cf. Still and Worton (1990: 10–12)).

25 The *Dictionnaire encyclopédique Quillet* simply stated 'Pastiche: see Parody' (noted by Mortier (1971: 203)).

26 *The Nation* 24.11.1892 (emphasis in original); this is the *OED*'s second example of the use of the word in English (1989: 321).

27 Karrer begins his 1977 study *Parodie, Travestie, Pastiche* by distinguishing pastiche from the other two terms, but as the book progresses, the space allotted it gradually diminishes and by the end it is referenced merely as a practically indistinguishable variant of the other two.

28 Etymological accounts of this field may be found in, among others, Hempel (1965), Genette (1982), Borello (1996), Hoesterey (2001) and Groom (2002).

29 Karrer discusses the technique of pastiche as a means to achieve such deceptions as plagiarism and hoax (1977: 48–49).

30 A sub-category of plagiarism is auto-plagiarism, where the artist reuses their own previous work. According to view, this is reprehensible laziness, uninteresting repetitiveness, creative economy, development and variation on a theme, or playful repetition, self-reflexivity and irony.

31 See also Mallon (2001) and Randall (2001).

32 This paragraph and the footnote in this paragraph are taken/paraphrased/plagiarised from Mallon (2001: 41–88).

33 On Emin, see Merck and Townsend (2002).

34 On these categories, see, in addition to works referenced in the text, Jones (1990), Eco (1994).

35 Both fakes and forgeries can also claim to be produced by anonymous artists; here a fake would be within a celebrated tradition (e.g. Benin wooden statuary, Amish quilts), whereas a forgery would have to invent such a tradition (e.g. the Scottish kilt and clan differentiated tartans, whose origins are supposedly lost in the mists of time but which were probably invented quite some time after the Union with England of 1707 (Trevor-Roper 1983)).

36 Published posthumously 1771.

37 Heyward (1993: 152–153, 231–238) discusses such positive evaluations of Malley, although himself argues that McAuley and Stewart are too conscious in their deployment of surrealist tropes to be properly understood as producing poetry from the unconscious (ibid.: 236).

38 Cf. Trevor-Roper (1983: 16–18).

39 The account of the fortunes of *Roots* here is based on Taylor (2001: 63–90).

40 Harvey specifically references *Roots* earlier in his study (87); Taylor (2001: 87) alerted me to Harvey in this context.

41 The notions of the ersatz and faux are close to the copy, in that they are works (as well as materials and design products) that try to be indistinguishable from something else (ersatz wood looks and feels like wood, a faux medieval romance is as like an actual one as possible) in a context where none the less they are known not be that something else. Both perhaps are having their cake and eating it, in the sense that they might well like to get away with being taken for the thing they imitate but at the same time are discreetly presented as not being so. Faux (from French 'false') probably carries more overtone of deceit than does ersatz (from German 'substitute').

42 Cf. Lacasse (2000: 46–47), Pollard (2004).

43 On adaptation and fidelity, see McFarlane (2000), Naremore (2000b) and Stam (2000).

44 For example, *Wide Sargasso Sea* (Jean Rhys 1966), *Rosencrantz and Guildenstern Are Dead* (Tom Stoppard 1967), *Heathcliff* (Jeffrey Caine 1977).

45 For further discussions, see Lefevere (1992), Bassnett and Trivedi (1999) and *Anglistica* 5: 1–2 (2001).

46 Most evident below in chapter 3 (the relation of 'The Murder of Gonzago' to earlier drama, *Man of Marble* to communist culture and *Watermelon Woman* to African-American filmic representation, all examples of a struggle for control over the style and representation involved) and the first part of chapter 5 (the national dances in *The Nutcracker*, Jewish 'black' music, Still's *African-American Symphony*). Elsewhere, there is less power differential and less at stake, though the issue of who is in charge of the form remains.

47 On Signifying, see chapter 3, p. 79.

48 Other terms for groupings include cycle (a much more restricted clustering, for instance a number of consecutively composed works by the same artist or a brief period of film production, such as the peplum and Western in Italian cinema) and formula (often used to disparage unimaginative or inflexible genre production, notably in relation to pop music).

49 There is dispute as to the author of 'On the Sublime', but he (presumably) is usually referred to as Longinus. (See Dorsch 1965: 24.)

50 That is, 'excellence of expression' that will 'transport ... with wonder' (Longinus 1965: 100).

51 The term operetta was first used for such burlesque opera, but then acquired its own light, comic and sentimental connotations.

52 Not all *Carry Ons* have a generic context. There are not dissimilar series in other countries: the Marx Brothers (USA), Totò (Italy), Uuno (Finland) and so on.

53 Rose's main reference point (in common with, for example, Hempel (1965: 151–152) and Dentith (2000: 10)) is Householder (1944).

54 Taking her cue from eighteenth century usages of the word parody, Linda Hutcheon 1989 analyses of a number of instances of postmodern parody that fit the conceptualisation of pastiche that I am canvassing in here.

55 See also Jameson 1984, 1991.

56 Hall (1970: 1058); Hall's specific reference point is the Radio 4 lunchtime news-magazine programme *The World at One*.

57 The treatment is thus at once satirical and parodic; Ziva Ben-Porat (1979) makes the same observation of *Mad* magazine's satire-parodies of TV series.

58 Nonce is prison slang for child molester.

59 Quoted by John Cook in BFI Video Catalogue. *World in Action* (Granada television 1963–) was widely regarded as the cutting edge in radical television documentary of the period.

60 The term 'paratextual' comes from Genette's 1997 study of the many different apparatuses that frame and filter a text.

61 Jeffrey Sconce (2000: 110–118) casts doubt on the scale of this belief and the supposed subsequent panic. I am grateful to Charlotte Brunsdon for drawing this discussion to my attention.

62 The gap between twentieth century means and eighteenth century subject matter, as well as aspects of the editing style and the period in which it was made, lead Colin McArthur (1980: 47–49) and Terry Lajtha (1981) to suggest that *Culloden's* project is a Brechtian one of distancing the viewer from the events the better to understand their significance, though both consider it not entirely successful in realising this.

63 Welles himself in 1982 seems also to accept Peter Bogdanovich's reference to it as parody and says that Henry Luce, the proprietor of *The March of Time*, also saw it as one at the time, although only after his wife made him see it 'as a joke' (Bogdanovich and Welles 1996: 551). Although one should hardly discount Welles' words lightly, this is a retrospective account, made at a time when the news reel style of the 1940s and 1950s was universally perceived as obviously meriting amused condescension, and it is not surprising to learn that a sophisticate like Clare Booth Luce, the author of *The Women*, would have seen it so at the time. Among more recent commentators, Ken Barnes on the 2003 Universal DVD audio commentary refers to 'News on the March' as 'cunningly accurate', while Simon Callow calls it a pastiche (though seeing the script itself as 'wickedly parodistic') (1995: 523–524).

64 Quotations taken from reprints of reviews in Gottesman (1996: 33–53).

65 Audio commentary, Universal DVD 2003.

66 The term is Bill Nichols' in his discussion of modes of address in documentary film (1981: 183); Plantinga considers *The March of Time* 'the best example of "Voice-of-God" commentary' (1997: 103).

67 This is sometimes said to have been voiced by Welles himself, although in his interview with Bogdanovich (1996: 551) he says it was done by the actor William Alland. Welles also says that he would like to have got Van Voorhis himself, further suggesting the aspiration to precise imitation.

68 The name of the sled that Kane is playing with as a boy before his mother has him packed off East for education and advancement, a sled we see being thrown into a fire in the closing shots of the film.

69 The transformation (parody): imitation (pastiche) distinction is also made by Gérard Genette (1982: 36) and Bilous (1983).

70 Rose's summary of Lelièvre (1954: 66).

2 Pastiche called pastiche

Pastiche is a term used loosely and widely. Given its common negative connotations, few set out to produce it, and yet there is a tradition of writing that actually calls itself pastiche. Although narrower in conception than the range of works proposed by this book, it is a good place to start examining that range: at least here we don't have to wonder whether it is legitimate to consider such and such pastiche, since that is what it calls itself.

Pastiche became considered and named as a practice of writing in France in the nineteenth century, although it may be said to have existed before and elsewhere.[1] Both Octave Delepierre in 1872 and Léon Deffoux in 1932 suggested a fitful lineage back to ancient times,[2] with, for example, Aristophanes pastiching Euripides (Deffoux 1932: 11) and early Christians adapting Pindar and Virgil (Delepierre 1872: 23ff.); Gérard Genette (1982: 106) nominates Plato as the first extant instance of pastiche, in the way the various speakers in *The Symposium* speak in the style of well-known philosophers;[3] all trace the practice through the Renaissance and after. Roland Mortier identifies the first 'true' pastiche in the work of La Bruyère in the late seventeenth century (1971: 204), but the word itself was not used in a literary sense until a century later, under the influence first of a passing reference in Diderot's *Salon* of 1767 and then in Marmontel's article on pastiche in his 1787 *Éléments de littérature* (Hempel 1965: 168–169). A quite recent anthology (Caradec 1971) goes back as far as François Villon (1431–?) and up to the present, and pastiche goes on being produced.[4] It is not uniquely French and a small body of examples could be supplied from most Western languages, but it is really only in French literature that it constitutes a recognised and respected practice.

Its *annus mirabilis* was perhaps 1908, which saw the first publication of pastiches by Marcel Proust in *Le Figaro* (subsequently collected in 1919 as part of *Pastiches et mélanges* (Proust 2002)[5]) and the pastiches of Paul Reboux and Charles Muller in the review *Les Lettres*, eventually collected and published in 1931 as *À la manière de ...* *. Proust's pastiches all dealt with the scandal of a

* This title draws on the culinary term, *à la manière de*, usually shortened, and used in English too, as *à la*, as for instance, œufs à la russe (eggs Russian-style, i.e. with mayonnaise and cooked vegetables) and the shaming pommes de terres à l'anglaise (potatoes English-style, i.e. plain boiled).

man named Lemoine, who had persuaded a large number of people to invest in a system for making diamonds out of coal and in 1908 was condemned to six years' imprisonment for extracting money under false pretences. The choice of subject is suggestive: Lemoine had no such system, but the claim was just about plausible,[6] and Lemoine claimed to be making real diamonds by an artificial process, not producing convincing fake ones. The case plays on that borderline of false but plausible that is also the province of pastiche.

Some have speculated about why pastiche should be a French speciality. The word of course is French,[7] and words facilitate and normalise the adoption of a practice. Perhaps consciousness of the rules of grammar, vocabulary and style is more fully articulated in France than in most countries, above all through the prestige of the Académie Française, founded in 1635, which pronounces and is heeded on such rules, and through the establishment of national uniformity in school teaching under Napoleon.[8] Hempel (1965: 171–172) suggests that it is the strong and officially sanctioned awareness of a literary tradition in France, and the concentration of literary life in Paris, that makes writing works that foreground aspects of that tradition come naturally; Albertsen (1971: 3–4), drawing on the Académie Française's 1835 definition of pastiche as a work 'in which one imitates the ideas and style of some famous writer', argues that classic French literature does not make a sharp distinction between 're-using a broken tradition (pastiche) and furthering a living one (imitation)', and thus does not treat pastiche as an odd or disreputable practice.

In addition to its geographic and medium specificity, French literary pastiche is narrower than pastiche as discussed in this book in two other ways. As the 1835 Académie Française definition, and the practice of Proust, Reboux and Muller, make clear, this kind of pastiche pastiches other writers, not, for instance, genres or periods, and its purpose is light, generally comic. Léon Deffoux, writing when pastiche was especially in vogue, speaks of the various tones of pastiche as 'pungency, irony and playfulness' (âpreté, ironie, enjouement) (1932: 7), Jean Milly, introducing a scholarly edition of Proust's pastiches, speaks of pastiche's aim of 'making the reader laugh or smile' (1970: 25), while Annick Bouillaguet suggests pastiche 'most often aims at a comic effect' (1996a: 22). I shall argue in the rest of this book that it can do more than this.

Yet pastiche à la Proust or Reboux and Muller does encapsulate many of the implications of pastiche more generally. Attempts to define it seem always to locate it between other, more definite practices. Pierre Laurette (1983: 115) speaks of the 'uncertain place of pastiche', referring back to De Piles' 1677 definition of pastiches as 'neither originals, nor copies':[9] they are not the thing which they imitate and nor are they trying to pass themselves off as that, but they are enough like it to raise the question of what they are, if they are not just copies. Deffoux (1932: 6), considering a number of French dictionary definitions, situates pastiche between straightforward imitation and parody: 'pastiche seems more nuanced than parody and more pointed than imitation'

('le pastiche apparaît plus nuancé que la parodie et plus aigu que l'imitation'). Thus pastiche does something beyond replication, but not taken to the point that it becomes parody, ridicule or burlesque. This uncertain, but suggestive and productive, place is the subject of this book.

• • •

Studies of literary pastiche suggest formal procedures that (as noted at the end of the previous chapter) are also basically those of all pastiche (and all signalled imitation) more generally: likeness, deformation and discrepancy. In pastiche, the latter two distort the sense of likeness much less than in, say, parody, travesty or even often homage. In what follows, I describe these formal procedures briefly, referring especially to Proust's pastiche of Flaubert on the Lemoine affair (see appendix 1), not least because I discuss *Madame Bovary* and *Flaubert's Parrot* in chapter 5.

Likeness

A pastiche is very like that which it pastiches. In some cases, it may be all but indistinguishable from it, in others more obviously different, but it must always seem pretty close.

Proust's version of how Flaubert might have approached the Lemoine affair, for instance, draws on many of the standard perceptions of Flaubert's procedures.[10] It deals only with a brief period in Lemoine's trial, a few hours beginning with a pause in proceedings followed by the opening statements of prosecution and defence. Moreover, it does not give us those statements themselves, nor even their content, but a sense of their character and, more, their impact on the audience. The latter are in fact the principal subject matter, described at length and including in the last paragraphs their inner thoughts about what they would have done with the money Lemoine could have made.[11] It is in these last paragraphs that 'Flaubert' uses the 'free indirect style' that has become one of the most noted aspects of his writing (and is discussed further in chapter 5). This is all characteristic of Flaubert: the privileging of description over narrative, the seeking out of the set piece that will bring various elements tellingly together (cf. in *Madame Bovary*, the ball at the château Vaubyessard, the agricultural show) and approaching it from an oblique angle (here, the audience taking centre stage over Lemoine, prosecution and defence). The latter is part of what Proust himself identified as especially characteristic of Flaubert, putting all elements of reality on an equal footing, flattening out difference.[12] So not only are the key figures in the trial and the audience treated with the same attention, but the physical details of the scene and the inner daydreams of the audience are also given equal weight. All is approached through the accumulation of detail associated with naturalism and shot through with an attitude of contempt for all concerned. The latter is a commonplace focus of Flaubert criticism: Julian Barnes's narrator in *Flaubert's Parrot* puts it as argument number one in 'The Case Against'

Flaubert ('That he hated humanity') (1985: 149–150) and it is also a view that Proust gives to Sainte-Beuve in his pastiche of the latter, which takes the form of Sainte-Beuve critiquing 'Flaubert's' 'Lemoine Affair' ('The author is of a school which never sees anything noble or admirable in humanity' (2002: 29)). In the Flaubert pastiche, everyone appears ridiculous, sometimes repulsive, always self-serving and/or self-deluding. At one point, in the heat of the courtroom, a woman takes off her hat, which has a parrot on it; at once young people start making smart remarks at its and her expense and women stuff handkerchiefs in their mouths to muffle their laughter. The hat with the parrot on it is ridiculous[†] but, for 'Flaubert', the scoffers and gigglers are no less reprehensible: no-one gets away.

The form of a pastiche's likeness is subject to perception. A pastiche imitates its idea of that which it imitates (its idea being anything from an individual memory through a group's shared and constructed remembering to a perception current at a given cultural–historical moment). The pastiched text does not itself change: leaving aside the vagaries of manuscripts and editions, the words are what they are, but the perception of their significance and affect changes. Different periods and cultures see and hear different things in texts and this must be registered in any imitation, and therefore pastiche, of them.

One can overplay such observations: an eighteenth century pastiche of Shakespeare would almost certainly be recognisably Shakespearean, but it would also be recognisably eighteenth century, differing in emphasis and tone from a twenty-first century pastiche. Changes in the perception of given texts also vary considerably in degree and frequency. In some cases, a perception may remain quite constant: I suspect that a pastiche of Flaubert written today would not come up with anything markedly different from Proust's. On the other hand, in chapter 4 I discuss the example of neo-noir cinema, where within a few years of the petering out of noir production in the 1950s, quite different constructions of noirness were being produced, based on differing perceptions of their antecedents.

A pastiche is formally close to (its perception of) what it pastiches but not identical to it; very like, but not indistinguishable from. There is then the question of how it is distinguishable.

Literary pastiche commonly signals itself as such. The word, or the phrase 'à la manière de', may be used in the title. Even where this is not so, contextual elements may make the pastiching evident. The first four of Proust's treatments of the Lemoine affair appeared in *Le Figaro* of the 22nd February 1908; they were evidently pastiches by virtue of their appearing in the literary supplement (not the main news section), being all about the same subject and, above all, supposedly by authors, most of whom were dead before the Lemoine affair occurred,[13] while one of the living, the drama critic Émile Faguet,

† An echo of the ambiguously scorned parrot in Flaubert's 'Un Cœur simple' 1877.

is here shown writing a review of a non-existent new play on the affair (by a real playwright, Henry Bernstein) that most readers would probably know had not just opened in Paris. To take a later example of paratextual signalling: Patrick Rambaud's 1988 pastiche of Marguerite Duras, *Virginie Q*, was published under the name of Marguerite Duraille although 'présenté par' Rambaud. The pseudonym and the pastiched author's name, Duraille and Duras, are like enough to alert the reader, who can then note the similarity of the book's title to Duras' handling of names (*The Ravishing of Lol V Stein* 1964, Hélène L in *The Lover* 1984, *Emily L* 1987)† and the virtual facsimile in the cover of this book published by Balland of the style of Duras' books published by Éditions de Minuit (Bouillaguet 1996a: 23–24).

A rather more subtle – and missable, even disputable – form of signalling may take the form of self-reflexive details in the text. In the Flaubert pastiche, the writer at one point comments, of the prosecution's interminable, depressive and obsequious opening statement, that, while terrible for Lemoine, 'the elegance of the formulations made up for the grimness of the indictment' (Proust 2002: 23). Such a view is also what has often been said in Flaubert's defence, that however sordid the scene or full of contempt the attitude, every page is exquisitely written. I consider similar nods to the reader in, for instance, my discussion of *Body Heat* below (chapter 4: 120–122).

Where such extra- or intra- signalling is not present, the text itself, while being enough like that which it pastiches to be recognisable as such, must also be enough unlike it to be recognisable as pastiche. It departs from strict and complete adherence to the formal qualities of the pastiched work(s). In practice, even if you did not know that the relevant dates made it impossible, you would be unlikely to mistake 'Flaubert's' 'L'affaire Lemoine' for something actually written by Gustave Flaubert, because, albeit with exceptional subtlety, Proust does also deploy the other markers of pastiche: deformation and discrepancy. These markers are a matter of degree – too much exaggeration, say, or discrepancy between form and subject matter, and the work tips over into parody or burlesque; too little and it becomes, if not a fake, then an open copy or a genre piece. It is to the two forms of this departure from indistinguishability as they appear in pastiche, deformation and discrepancy that I now turn.

Deformation

Pastiche deforms the style of its referent: it selects, accentuates, exaggerates, concentrates.

It **selects**. It does not reproduce every detail of the referent, but selects a number of traits and makes them the basis of the pastiche. These traits may

† Duras also sometimes referred to her lover, Yann Andréa, as 'Y.A.', and his 1983 memoir of her is entitled *M.D.* (Paris: Éditions de Minuit).

be taken to be the 'essential' ones (Albertsen 1971: 3) or the characteristic ones (and will relate to the historical and cultural perception of the pastiched work discussed above). The very act of selection deforms the original, makes the trait appear more present and insistent than it was in the original. In Milly's account, traits thus become revealed as (or reduced to) authorial tics and subtler tendencies are turned by the pasticheur into tics (1970: 30); Karrer (1977: 118, 189–191), drawing on Deffoux and Hempel, terms this a process of mechanisation of an authorial style. Pastiche may thus be seen as a kind of synecdoche, whereby the parts (the traits) are taken for the whole (the totality of the original œuvre) (Milly 1970: 33). Paratextually the Marguerite Duraille *Virginie Q* appears to be a pastiche of all Duras, but really only relates to two novels in a much bigger oeuvre[†] (Bouillaguet 1996a: 26).

Deformation may also involve working on the traits themselves, **accentuating** and **exaggerating** them, and repeating them more frequently than in the original. Flaubert's realism, for instance, is noted for the very precise, lengthy and detailed account of a scene that does not flinch from trivial or sordid details. However, in Proust's pastiche of how Flaubert would retail the Lemoine affair, this becomes, suggests Milly, an 'abuse of realism', so that in the description of the trial room nothing at all is left to the imagination: 'not dust, nor the spots of mould on the official portraits, not a cobweb, not a rat, no bad smell' (1970: 28). It is not enough that the president of the court is old, clown-like and plump, he has to have sideboards and they have to be mucky with flecks of tobacco. It goes just that one step beyond even Flaubert's taste for the trivially sordid.

Flaubert's love of accumulating detail can also be pushed to the point of comic bathos. Thus:

> Eventually the judge made a sign, a murmur rose, two umbrellas fell over. (Proust 2002: 24)

The drama of the judge's intervention as well as his dignity and authority are mischievously undercut by those trivially falling umbrellas.

Pastiche also usually **concentrates**. It is rare for a pastiche to be as long as that which it pastiches. In her discussion of *Virginie Q*, Annick Bouillaguet notes the way that a pastiche 'reduces a hypotext of several hundred pages to a mere few dozen' (1996a: 27),[14] with a resultant concentration, such that, for instance, the many closed spaces of Duras' oeuvre become one enclosed space in *Virginie Q*: the pastiche condenses a general movement in Marguerite Duras' work, whereby open spaces are gradually abandoned and even enclosed spaces become narrower and more contained, and this is taken to its logical conclusion in *Virginie Q*, where all that is left is the centre of the room.

† Namely, *L'Amant* 1984 and *Les Yeux bleus cheveux noirs* 1986, which are, however, themselves rewritings of Duras' *Un Barrage contre le pacifique* 1950 and *La Maladie de la mort* 1983.

Proust's 'Flaubert's Lemoine pastiche effects a triple concentration. It is characteristic of Flaubert, as has already been noted, to find the telling set-piece through which to focus – concentrate – the narrative; choosing a moment in the trial is doing what Flaubert might have done, but here it not only concentrates the whole of the affair but at the same time also distils the whole of Flaubertian style into a few pages.

Discrepancy

Pastiche may also be achieved by discrepancy, by something inconsistent or inappropriate in an aspect of the writing that makes one see more clearly the style of the rest of the writing, which is to say, the style that is being pastiched.

One procedure of discrepancy has to do with having the writer write about something he or she could or would not have written about; the style stands out qua style because it no longer belongs naturally, effortlessly, of course-ly, to the subject matter. The Saint-Simon (1760–1825), Chateaubriand (1768–1848) and Balzac (1799–1850) pastiches of the Lemoine affair (1908) are especially striking in this regard, but it is also true of the Flaubert (1821–1880). Not only had he been dead nearly 30 years before the affair, but he did not write newspaper accounts of real events, and if he had, this 'Affaire Lemoine' would have been markedly inadequate since it neither explains anything about the affair nor offers commentary on it.

Most of Proust's Lemoine pastiches are anachronistic in this general sense (those authors could not have written about this), but also sometimes go further, more fully underscoring the pasticheness. One way is to have authors refer to Proust himself, often disparagingly, sometimes obliquely (as when, in the Flaubert Lemoine pastiche, someone day-dreams of a cork-lined room, something much prized by Proust himself). This in-joking reaches a peak in the Saint-Simon pastiche, where this eighteenth century chronicler of court life includes references to Proust's twentieth century circle in his account of the affair (Milly 1970: 28). In the case of the Ruskin pastiche,[15] which claims to be a translation, anachronistic discrepancy is exaggerated to a point of delirium: it begins with Ruskin describing Paris seen from the air (Ruskin died in 1900, the first flight was in 1903, the first cross-Channel in 1909), moves on to his viewing the frescoes of the Lemoine affair by Giotto (1267?–1337), this massive anachronism then almost defied by having Ruskin start off his account of the frescoes with the reader's supposed question, 'Whatever put it into Giotto's head to paint the Lemoine affair?'[16]

Discrepancy may also be achieved by interruptions of extraneous elements, most often jokes or witticisms, that both remind the reader that the text is not be taken straight-facedly and reinforce the sense of the stylistic flow of the text by the very departure from it. This can be a use of stylistic anachronism (and its geographical equivalent), the pastiched author using a term that was not available to them in their time, place or cultural milieu. It may

be an actual gag. I have not discerned instances of these in the Proust pastiches (unless indeed you count the umbrellas in the Flaubert pastiche or Ruskin's mad question about Giotto), but compare the discussion in the next chapter of the documentary material in *Man of Marble*, where a verbal description flatly contradicts a visual image and where at one point the character (or, perhaps, the actor) seems virtually to wink at us as he poses for an absurdly monumentalist statue of himself.

• • •

For all the acceptance of literary pastiche as a valid and valued practice, it is still seen as minor, secondary. It is a bit of affectionate fun, though it may have its uses. Nicolas Chatelain, author of a 1855 collection of *Pastiches, ou imitations libres de style de quelques écrivains des 17ᵐᵉ et 18ᵐᵉ siècle* (*Pastiches, or Free Imitations of the Style of Some Seventeenth and Eighteenth Century Writers*), says that his purpose springs out of the pleasure one gets from reading different authors and the conviction that 'one cannot fail to perfect one's own style by imitating the most beautiful models'.[17] Antoine Albalat's 1934 book *La Formation du Style par l'Assimilation des Auteurs* (*Forming a Style by Assimilating Authors*) has a chapter on pastiche (57–66) (cf. Karrer 1977: 241). Pernette Imbert in *Enrichir son style par les pastiches* (*Enrich Your Style through Pastiches*) (1991) describes her use of pastiche in teaching French language and literature: by getting students to write a passage *à la manière de*, say, Balzac or Duras, she impels them to become as inward as possible with the style of Balzac or Duras and in the process to strengthen at a very sophisticated level their knowledge of how the language works and how to use it. Proust, on the other hand, recommends pastiche as a way of getting one's forbears out of one's system: 'I cannot recommend enough to writers the purgative, exorcising value of pastiche'.[18] Milly notes the idea that pastiche is a kind of literary criticism, but observes that it is different from analytic criticism precisely because it does not keep its distance and gives way to the style of the work it is criticising. All these functions of pastiche make it cherishable, intelligent, instructive, but they also restrict its reach. The purpose of this book is to explore what else pastiche can achieve, and with this in mind, I end this chapter with a consideration of another Proust pastiche which demonstrates what else pastiche can do beyond charm.

Near the beginning of *Le Temps retrouvé* (*Time Regained*), the final volume of *A la recherche du temps perdu*,[19] the narrator–protagonist Marcel borrows an as yet unpublished volume of the journal of the Goncourt brothers from a woman he is staying with; he starts to read and what he reads he tells us he is now transcribing for us (1989: 287). What follows is a pastiche of the Goncourts, describing a visit to the salon of M. and Mme. Verdurin in the period when Marcel himself was an habitué of their highbrow gatherings (as he has previously described). The passage encapsulates much of the way pastiche works.

It is formally very close to what it imitates, yet it is clearly not it. Did we not know the Verdurins were fictional characters, we might well assume

this really was a passage from the Goncourt journal. One would have to be very conversant indeed with the latter to appreciate both how very precise it is (Bouillaguet 1996b: 51–94, Sayce 1973: 103–109) and to note the rare points at which, deliberately or otherwise, it does not read quite right (Bouillaguet 1996b: 95–96). Yet, close as it is formally to the Goncourt brothers, we do also know that the Verdurins are fictional characters already presented to us in the novel and thus that the text can only be an imitation, that is, a pastiche.

It works as pastiche if you know what it is imitating. That is, you have, minimally, to know that the Goncourt brothers and their journal existed and, preferably, to have some familiarity (directly or by hearsay) with what their writing is like, to realise that the pastiche is of something real and recognisable. Proust could assume that this would be so of his first readers.[20]

It facilitates an experience of the imitated work. Proust could have had Marcel tell us what the diary entry says without actually giving us the passage itself, but by doing so, we have an almost direct experience of it. Almost direct, because it is framed by what Marcel says briefly about it beforehand and also because it is a pastiche and thus must always remind us of being at one remove from what is being imitated. Yet these elements are minimised: this pastiche is very accurate indeed in its imitation, and Marcel's longer reflections on the passage come after it,[21] thus allowing us an encounter with it not too much directed by his attitude. Reading the passage confirms in Marcel his growing sense that he does not have the aptitude for literature that he thought he had; he knows he cannot do what the Goncourts do so consummately. Yet it also makes him feel that in any case literature 'doesn't reveal profound truths', which in turn makes him sad, for it means that 'literature was not what I had thought it was' (Proust 1989: 287). Only after he has put the passage aside does it also make him start to reflect on what literature could and should be, less concerned with accurate surface description à la Goncourt and more with the inner life in relation to the external world. This of course is one way of describing *A la recherche du temps perdu*, the book that Marcel himself is narrating. The point could have been made by referring to the Goncourts, without recourse to pastiche. Using pastiche gives it weight and allows the reader to experience this kind of writing in the context of Marcel's/Proust's attitude towards it.

To fulfil some of its functions in the novel, the section of the Goncourt journal has to be a pastiche for purely technical reasons. It describes a visit to the Verdurin salon that Marcel has also made and subsequently described (and which, in principle, we will have already read); one of the things that strikes him about the Goncourts' account is the discrepancy between how they record it and how he has. Since the Verdurins are fictional characters, Proust cannot use an actual extract from the Journals, for neither the Verdurins nor Marcel figure in them. Equally, he cannot have Marcel observe and write about a real scene that the Goncourts did write about and then print the section where they do so at this point in the novel, because this would work against the way

characterisation works in the latter. Characters that run across the whole novel sequence are central to the construction of *A la recherche du temps perdu* because much of it is concerned with the mutability of characters and of Marcel's perception of them: Proust could not have done this with real people and it would have interrupted the design to plop in one scene involving real people just in order to then be able to quote the actual Journal.

For these reasons, the extract from the Goncourt journal has to be a pastiche. But why does it have to be from a journal supposedly written by real writers at all, rather than a pastiche (or even uninflected insertion) of a journal by invented ones – like the Goncourts perhaps (because it is important that Marcel reflect on his writing in relation to a naturalistic text), even evidently referencing them, but still not openly pretending to be them? In part, by making it a pastiche of a real work, Proust stays within the tradition of pastiche discussed in this chapter – the 1835 Académie Française definition of pastiche as the imitation of 'the ideas and style of some famous writer'. But it also relates to the wider novel's concern with the relation of writing to reality.

Among its meditations on this relation, *A la recherche du temps perdu* considers the idea of the perception of external reality as neither a direct apprehension of it nor a wholly subjective projection, but rather a subjectively mediated observation of a reality that is both separate from the observer and has an effect on him or her; moreover, it also recognises that writing is in any case never actually either the real or consciousness themselves. In other words, writing, like all art, has in its relation to external reality and consciousness the same inescapable dynamic of mediation as they have in relation to each other.

This is illustrated by Marcel's reflections on the difference he perceives between the Goncourts' account of the Verdurin salon and his own memory of it (which is to say the account of it given earlier in the *A la recherche du temps perdu*). He is not led either to dismiss the Goncourts' account as wrong because it does not tally with his, nor to dismiss his own as based on mere and inevitably faulty memory. Rather, he comes to contemplate the notion of a reality beyond the impressions and reactions that give rise to both the Goncourts' and his own version of things, a reality as much (but not more) within the writer as within the things. This sense of a reality that goes beyond any particular account of it gains more credibility by the novel allowing the space for a different particular account than the one that Marcel has himself provided.

I suggested a couple of paragraphs back that Proust could not have done what he does with characters if they were also real people, if he were constrained by both facts and propriety in relation to them. Yet Proust's characters are, often fairly obviously, based on real people. Similarly, Marcel, the narrator of *A la recherche du temps perdu*, is in all sorts of particulars not Marcel Proust, its actual author – yet the fact that they share a first name and that both write the book we are reading, also prevents one making a neat separation.

Just as Proust's characters are a mediation of the people he knew, so Marcel mediates Proust. With the Goncourt journal Marcel/Proust indicates who – but more especially what (the written work) – he is mediating; but because it is a pastiche, he also indicates *that* he is mediating. He could not do that so pointedly if he were merely making up writers who preceded him.

The Goncourt pastiche also illustrates a more general point about the relation of a pastiche to what it pastiches. On the one hand, it demonstrates that Proust could write like the Goncourts if he wanted (even if Marcel, he himself says, could not) (Bouillaguet 1996b: 10).[22] At the same time, Proust's evident, easy, unmocking ability to reproduce the form and style suggests that, even though Proust and Marcel do not (want to) write like this, they are not setting it up as something to be knocked down or reacted against. There is no dreary male Œdipal anxiety of influence (to use Bloom's formulation (1973)), no fear of being penetrated by previous texts (to use Still and Worton's (1990: 31)). Proust is willing to inhabit another style, even while not identifying himself with it. This is what pastiche typically does.

The Goncourt pastiche in *A la recherche du temps perdu* suggests some of the things that pastiche can do beyond amuse. It is also a text within the text. These are often pastiches and are the subject of the next chapter.

Notes

1 It is not uniquely literary. In particular, musical pastiche, mainly French, from the late nineteenth century onwards, has been produced and named as such, but it is most often understood as homage and I discuss it briefly under that heading in the previous chapter.

2 Some of their earlier examples may also be understood as travesty, parody, hoax or plagiarism.

3 More precisely, either characters speak in an identifiable style (e.g. Phaedrus speaks like the orator Lysias) or they are named people whose style Plato imitates (e.g. Aristophanes, Alcibiades). In Plato's *Phaedo*, there is a speech by Lysias, which 'no-one after twenty-four centuries has been able to [determine] is a counterfeit or a (long) quotation' (Genette 1982: 106).

4 Genette (1982: 102) reckons one collection every four or five years and gives some examples from the 1940s to the 1970s.

5 The title brings together the two senses of pastiche discussed in chapter 1: pastiche as a kind of imitation and pasticcio pastiche, a kind of mélange, that is, mixture. For further discussion of Proust's pastiches, in addition to subsequent references, see Genette (1982: 108–131).

6 Diamonds are a form of carbon and in 1892 the eminent French chemist Henri Moissan had succeeded in producing minute diamonds from it.

7 See previous chapter (p. 22).

8 Pastiche is – or was - even a recognised form of exercise in French schools (Mouniama 1983: 28).

9 See previous chapter (p. 22).

10 Milly (1970: 85, 104–105) points out the use of specific images from Flaubert's work in the pastiche as well as many of his grammatical habits.

11 Almansi and Fink (1991: 133) see these dreams of 'luxury and evasion' as characteristic of Flaubert's 'little Bovary-like anti-heroes'.

12 See *Contre Sainte-Beuve* (Proust 1954: 204), quoted in Milly (1970: 86).

13 This is true of the subsequent Lemoine pastiches. The exceptions, apart from Faguet, were the poet Henri de Régnier (who read the one of him and, according to a friend of Proust's, 'did not seem discontented and said he could recognise himself in it' (quoted in Milly 1970: 140)) and Maurice Maeterlinck, who was born before but died after Proust and the pastiche of whose version of the Lemoine affair was not published until Milly (1970).

14 The term hypotext is taken from Genette (1982), a coinage to cover any kind of text to which a given subsequent text is in a relation of allusion, imitation or reference.

15 Published posthumously in 1953 and reprinted in Milly (1970: 326–331).

16 "Mais quelle idée Giotto a-t-il eue de représenter l'Affaire Lemoine?" (ibid.: 329).

17 Quoted in Delepierre (1872: 191–192).

18 Marcel Proust: *Chroniques* (Paris: Gallimard, 1927, 204), quoted in Laurette (1983: 121).

19 The perhaps more familiar, if less literal, title of the first English translation is *Remembrance of Things Past*, but the most recent translation has the more strictly accurate *In Search of Lost Time*. *A la recherche du temps perdu* was published between 1913 and 1927; the Goncourt pastiche is on pages 287–295 of volume IV of the Pléiade edition (Proust 1989) and 23–32 of the most recent English translation (Proust 1996). In addition to references in the text, the Goncourt pastiche is also discussed in Milly (1970: 43–45).

20 Goncourt is still a well-known literary name in France, but perhaps more because of the prestigious annual literary prize inaugurated by the brothers than because they are still much read. Proust himself won the prize in 1919 for the second volume of *A la recherche du temps perdu*, *A l'ombre des jeunes filles en fleurs*.

21 Although this was not Proust's original intention, where Marcel's musings preceded the passage and thus encouraged us to read it more insistently through his eyes (Bouillaguet 1996b: 8–9).

22 Proust had of course already demonstrated this with his rather more teasing pastiche of the Goncourts writing about the Lemoine affair.

3 The pastiche within

In *Hamlet* 1600,[1] Hamlet has a group of strolling players put on a play called 'The Murder of Gonzago'. He and the court watch it and we watch both it and them watching it. 'The Murder of Gonzago' is a pastiche.

Any play-within-a-play (or poem-within-a-poem, film-within-a-film and so on) is liable to be a pastiche. The very act of framing one work within another in the same medium or mode[2] tends to bring out the sense that the medium or mode of the framed work is being used differently to its use in the framing work. It is akin to the common practice of putting inverted commas, or 'scare quotes', around terms in much contemporary discourse. As in my example ('scare quotes'), such framing of an element of a sentence at once signals the speaker's awareness of the particularity of the element, generally indicates a distance he or she wishes to take from it and yet allows the flavour of it to colour the sentence. In the example of 'scare quotes', I was both signalling that I know the term is less formal, more 'slangy' than 'inverted commas', and taking some distance from it, partly from an uneasiness with the readiness of intellectuals to distance themselves from the language they use, partly, less defensibly, from irritation with the styles and habits of a certain neck of the academic woods, but all the time wanting to keep the flavour in, even allowing it to contaminate the style elsewhere ('slangy'), partly because I know sometimes you can't do without it and partly because, in its simultaneous position of being within and without that which it indicates, 'scare quotes' has much affinity with pastiche.

A work-within-a-work does not have to be pastiche, and next I shall look briefly at a couple of instances where it is not. Yet often to mark difference between the work within and the frame work there is recourse to pastiche and the rest of the chapter looks at this, turning first back to *Hamlet*, which raises many of the issues of the marking and function of pastiche, before turning to look at the critical use of pastiche within in the films *Man of Marble* and *Watermelon Woman* and its exuberant possibilities in the stage musical *Follies*.

A work-within-a-work does not have to be pastiche, as illustrated by two seventeenth century theatre works: *The Roman Actor* 1626[3] by Philip Massinger and *L'Illusion comique* 1636[4] by Pierre Corneille. Both play on the idea of not being able to distinguish between theatre and life, and hence for

some of the time between the frame play and the play within, but they do so to different ends.[5]

There are three very short plays within the play *The Roman Actor*. Stylistically, there is no difference between them and the frame play. Each is performed by the eponymous actor, Paris, and his troupe before the tyrant Domitianus Caesar and members of his court. The first is a morality, 'The Curse of Avarice', intended to convince the avaricious father of one of the courtiers of the evils of avarice; it fails so to convince him and Caesar has him executed. Here no-one confuses theatre and life, but Caesar has the hapless father put to death for not drawing the correct lesson about life from the show. The preparation of the second playlet, 'Iphis and Anaxarete',[6] a tragic romance, has been overseen by Caesar's new wife, Domitia; during the performance of it, she is so transported that she cries out in horror when Paris as Iphis is about to hang himself when his love is scorned. Domitia has been rehearsing the play, she must know it is only a play, and yet, she says, 'what I saw presented carried me beyond myself' (Massinger 2002: 48). It transpires that Domitia has taken a fancy to Paris, not so much confusing theatre and reality as responding to the glamour of the actor as tragic lover: her response may either be an unguarded expression of such lust or a calculated cover for it (pretending that she is treating the events as real). By the time of the third playlet, 'The False Servant', Paris has given in to Domitia's advances and Caesar has found out; he himself takes the role of the lord who discovers his wife in the arms of his servant and kills him; Paris plays the servant and Caesar actually kills him. Caesar knows full well it's only a play, but he chooses to treat it as if it's reality, in part because (like 'The Murder of Gonzago') it mirrors a real situation. All three playlets play as if there is no discernible difference between theatre and reality, as if you can confound them, in a context where, none the less, all the characters do know the difference.

The 2002 production by Gregory Doran at Stratford-on-Avon opened with a fight between two gladiators, ending with the death of one of them. But they turn out to be Paris and his fellow actor Latinus rehearsing. This provided a telling keynote to the play. Although it is called *The Roman Actor*, it is an unfamiliar work and we had no reason to suppose we were not seeing gladiators and a play opening with a violent death. We did not know they were actors – except of course that that is precisely what we did know, since we surely did not imagine someone was actually being slaughtered for our amusement. The trick allowed us from the start to be conscious of the way that, like Domitia and Caesar, we both do and do not know it's all only theatre.

In *The Roman Actor* we and the characters know when we are watching a play. In *L'Illusion comique*, however, we, like a key central character, are deceived. The play concerns a father, Pridamant, who banishes his son Clindor and then some years later regrets it and turns to a magician, Alcandre, to see if he can tell him what has become of Clindor. Alcandre tells him by conjuring up visions of moments from Clindor's life since his banishment, visions that Pridamant and we watch. After various escapades, Clindor

is seen killed by the husband of a woman he is having an affair with. Pridamant is horrified, but then Alcandre shows him the final vision: Clindor and the other people in the visions being paid as actors. The death of Clindor was part of a tragedy with which, now an actor, he is having great success in Paris.

There are in any performance of *L'Illusion comique* four ontological levels, one within another. There is first whatever company is actually putting it on. Then there is Pridamant in Alcandre's magic grotto, and thirdly the visions of Clindor's life that Alcandre conjures there. Finally there is the playlet that culminates in Clindor's death, which is only revealed to be such, to us and Pridamant, after it is over. But are all the visions (including that of the actors being paid) themselves plays? This is unclear. When Alcandre conjures up the first, he knocks three times with a stick on the floor, the standard form for signalling the start of a play in French theatre, and he (and the stage directions) (134–136[7]) make a great play on the finery with which Pridamant can see Clindor garbed, finery that he invokes again at the end (1638) in the context of Clindor the actor; the final scene, of the actors being paid, is revealed by a curtain being raised, a theatrical gesture to reveal what is behind the theatre. All this could suggest that everything that Alcandre shows Pridamant, and not just the playlet, is theatre. Yet this is not certain: Pridamant and Alcandre do not join the actors at the end; the latter remain out of reach (and, apparently, earshot), as in a vision; Clindor, it seems, is never actually, literally, present before his father. Robert Nelson, in his classic study *The Play within a Play* (1958), argues that *L'Illusion comique* demonstrates the magic of theatre: Alcandre is the showman, able openly yet mysteriously to conjure an illusion of the real before our very eyes, one that, equally mysteriously, we are willing to go along with.

Both *The Roman Actor* and *L'Illusion comique* play upon the possibility that we can behave as if we cannot tell theatre from reality (and, for the sake of enjoying the play, usually need to), and to do this they do not point up stylistically the difference between the play within and the frame. The lines for the characters in the plays within are not written to be spoken differently from those for the characters in the frame play. This is not so with 'The Murder of Gonzago'.[8] Here (3.2: 139–244[9]), the writing of the play within is distinctly different from the frame. The latter is written in a combination of blank verse and prose, both often broken up with short phrases and exclamations. 'The Murder of Gonzago', in contrast, is 'fustian ... [characterised by] drumming couplets, mostly self-contained, long-drawn-out sententious commonplaces, repetition of ideas, laboured periphrases, references to classical mythology, and ... numerous inversions of normal sentence structure' (Hibbard 1987: 257). Before this, there has been a dumb show, acting out the central event of the play (Gonzago's murder) in mime, a practice that had become old-fashioned by the time *Hamlet* was written (ibid.). Earlier still, in the scene where Hamlet greets the arriving players (2.2), there is a long speech, taken from a play, in which Aeneas tells Dido of the slaughter of Priam, spoken here

first by Hamlet himself and then taken up by the First Player. This too is in a markedly different style from the frame *Hamlet*, full of epic rotundity and elaborate similes, and often presumed to be a pastiche of Marlowe's *Dido, Queen of Carthage* 1594.

Productions can choose to emphasise the difference between 'The Murder of Gonzago' and *Hamlet*.[10] Sometimes there has been a raised stage, curtain, even proscenium; less often the clothes of the players have been markedly different from those of the court; the performances can be hammed up; sometimes the women are played by boys. However, the last is a mistaken gesture towards historical accuracy: though in the first productions Ophelia, Gertrude and the women of the court would also have been played by boys, there is no call for such differentiation. Like proscenia and hamming, it emphasises difference, whereas other approaches have played it down: always a separate space for the performance, but sometimes just slightly raised (on a flight of steps for instance), sometimes not even this spatially marked; no difference between the stage and court costume; straight performance (along the lines Hamlet counsels (see below)); women playing women. These seem to me to catch better the careful placing – and pastiche writing – of the play within elements: distinct but not set apart, not risible or disconnected from the affective life of Hamlet and the court.[11]

Characters within plays do not think of themselves as watching a play within a play (Nelson 1958: 7); only for us are plays-within-plays plays-within-plays. For Hamlet, Claudius and the rest, 'The Murder of Gonzago' is neither a play-within-a-play nor a pastiche. Some of them do see it as old-fashioned. In at least one production,[12] the courtiers tittered at the 'quaint and amusing' dumb show (Hapgood 1999: 192) and Hamlet's mother Gertrude finds that the Queen's protestations of undying love for the King in the play are over the top ('The lady protests too much, methinks' (3.2: 216)). Hamlet himself has some consciousness of the play's dated style. It is he who asks the players to do this particular play, but he also gives them advice on how to play it: 'trippingly on the tongue', 'not saw[ing] the air too much with your hand', in short, realistically, 'to hold, as 'twere, the mirror up to nature' (3.2: 2–20).

It is to be a test of Claudius' guilt. Hamlet is not entirely sure that the Ghost is to be believed (in the sense of really being that of his father) (2.2: 587–592). When he says, 'The play's the thing/Wherein I'll catch the conscience of the king' (593–594), he surely means as much that he is testing whether Claudius is guilty as demonstrating him to be so (even if that is what he is inclined to believe). Yet he chooses to test him with a quaint dumb show and a fustian play.

Hamlet's critique of old fashioned acting and writing takes place in the context of both an enthusiasm for these players (they are 'those you were wont to take delight in – the tragedians of the city', says Rosencrantz to him (2.2: 324–325)) and a sideswipe at the new fashion for all-boy companies ('an aerie of children, little eyases' Rosencrantz (355)[13]). Just because the

former are not the latest thing, it does not follow that they are worthless. They are besides the occasion of one of Shakespeare's most fascinating statements on the weird power of theatre. When Hamlet recalls and recites part of Aeneas' speech, one full of epic peroration and thus so unlike the frame *Hamlet*, he does so in the context of praising the play from which it comes ('an excellent play, well digested in the scenes, set down with as much modesty as cunning'), with the speech the one he 'chiefly loved' (2.2: 430–437). After the First Player has taken over the recitation and then everyone has left, Hamlet reflects (539–548) on the extraordinariness of acting, its ability to feign emotions that have nothing to do with the player and yet which can move both him or her and the audience:

> Is it not monstrous that this player here,
> But in a fiction, in a dream of passion,
> Could force his soul so to his whole conceit
> That from her working all his visage wanned,
> Tears in his eyes, distraction in's aspect,
> A broken voice, and his whole function suiting
> With forms to his conceit? And all for nothing.
> For Hecuba!
> What's Hecuba to him, or he to Hecuba,
> That he should weep for her?

In short, if for Hamlet 'The Murder of Gonzago' and Aeneas' speech are old fashioned and for us pastiche, they are none the less truthful and moving for it. The death of Priam and the distress of his wife Hecuba do move the Prince (and, done well, us) and 'Gonzago' does after all 'catch the conscience of the king'.

They also place the frame of the play itself. *Hamlet* is, among other things, a play about modernity. Although Hamlet is even sceptical about the philosophical scepticism he has studied as a student at Wittenberg ('There are more things in heaven and earth, Horatio, than are dreamt of in our philosophy' (1.5: 174–175)), he is none the less a product of it, wary of taking the Ghost at face value, especially when it urges him to kill, and, what's more, to kill his mother's husband and, what's even more, the King. Though Hamlet is not so modern – or, given the realities of power, so foolish – as to think Claudius should be tried by due process of law, he is modern enough to want proof that satisfies him (provided by the use of a performance, 'The Murder of Gonzago').

Similarly, *Hamlet* is a play modern in style, unlike 'The Murder of Gonzago' and Aeneas' speech. Hamlet praises them but yet wants them to be performed differently, more naturally, something indeed like *Hamlet*. Just as Hamlet is modernising but not yet modern, able to believe in ghosts and in the principle of revenge yet sceptical and needing proof, so *Hamlet* recognises the merits, even perhaps regrets the passing, of the kind of play it supersedes, yet in the very process of showing that also demonstrates that it, *Hamlet*,

is indeed superseding it. Hamlet – and, surely, *Hamlet* – counsels some kind of realism as the ideal of theatre (the mirror to nature). The play-within-the-play format reinforces this – by showing what is not realistic, 'Gonzago' and 'Aeneas' allow *Hamlet* to assume the position of the unmarked, transparent, indeed natural and real thing that Hamlet says a play should be: the play within allows *Hamlet* to affirm itself as a mirror to life, the very model of modernity. The old fashionedness of 'Gonzago' and 'Aeneas' has the effect of confirming the new fashionedness of Hamlet, *Hamlet* and Shakespeare.

• • •

Though they are only plays, and though they are pastiches, Aeneas' speech and 'The Murder of Gonzago' are concerned with truth. Not only is the reaction to 'Gonzago' taken as evidence of the truth of what the apparition of Hamlet's father has vouchsafed, but more generally, *Hamlet* affirms the sense of an emotional truth within the evident artifice of theatre. The difficulty for productions of *Hamlet* since the period in which it was written is to render the affective power of 'Aeneas' and 'Gonzago', even while signalling them as pastiche. Yet without that emotional truth, the point of these pastiches within is lost. This concern with truth – with what truth, and what kind of truth, a work can and cannot deliver – is also central to the films *Man of Marble* and *The Watermelon Woman*.

The eponymous Man of Marble (in *Człowiek z marmuru* Poland 1977) is Mateusz Birkut, a phenomenally productive bricklayer in Poland in the 1950s, who becomes a star worker of the socialist state, only to be disillusioned, discredited and finally forgotten. His fame rests on his development of a particular method of bricklaying, displays of which are filmed and used to promote him as a hero of socialist labour. In one display, a burning hot brick is passed to him, damaging his hands so badly that he can no longer work; suspicion falls on his best friend and co-worker, Wincenty Witek, and a show trial is arranged of the latter and three other men 'united by one aim, to destroy our country's development'; though clearly innocent, Wincenty is found guilty and imprisoned. This forms part of Mateusz's disillusion with all that he has been involved in; he turns to drink and throws a brick at a police station to have himself arrested and imprisoned; the brick is the one he had saved with such faith from the first bricklaying display. Ideologically rehabilitated and released from prison, Mateusz finds his common-law wife Hanka has left him and finally disappears from public view. Such is Mateusz Birkut's story. However, the film *Man of Marble* is organised around the attempt by a film student, Agnieszka, to find out about this legendary yet now shadowy figure, and to make her diploma film about him. To do so, in addition to interviewing those who knew him, she views films from the period. These constitute the main films within the film and are of two kinds: raw footage and documentaries (including newsreels). In other words, there is footage shot to be used in documentaries, but discarded for one reason or another, and documentaries themselves edited up from other footage.

There are also a number of isolated shots, where we see someone filming and then see what they are seeing through the camera, shots that I shall call camera-point-of-view shots and return to later.

The differences between the films within and the frame film are clear: the former are being watched within the latter, and they are black and white and documentary as opposed to colour and narrative fiction. Yet great pains are taken to get the formal qualities of the films within right. Much of the material is distressed, so that it looks like it has been left lying around (the raw footage) or worn out from projection (the documentaries). The editor who shows Agnieszka the raw footage says it was never used 'for technical reasons of course', the film implying that the real reasons were ideological; yet this footage does include (that is, *Man of Marble* carefully constructs) what would surely be regarded in most conventional filmmaking as technical faults, such as overexposure in an interview with Mateusz before he became famous, a hand-held camera dropping awkwardly towards the ground in a scene of him leading his fellow villagers to vote (in an election he regards as 'a farce') and, twice, a hand coming up in front of the camera to prevent further filming. It also often has that slightly baffling quality of material that has not been edited into sense, where it is hard quite to work out what is going on. The documentaries are similarly precise in their formal imitation. The lettering for the credits, the delivery of the voice-over and the use of stock appropriate music could all be taken from documentaries of the period. At points, actual footage from the period is edited in: public appearances by Bolesław Bierut,[14] banners of him and Stalin, mass displays, crowds storming a giant statue. These function to shore up the credibility of the documentaries as documentaries. Even in a sequence where President Bierut is seen talking with Hanka, Mateusz's future wife and a champion gymnast, a sequence one knows must be faked, since Hanka is a fictional character, still the film *Man of Marble* works on the assumption that we will (for the sake of the film) take the meeting of Hanka and Bierut as Agnieszka takes it, as something that actually happened.

In all these ways the films within *Man of Marble* are as accurate as possible in their imitation of this footage. However, the very juxtaposition of material, especially of out-takes and fragments with a finished documentary, suggests the constructedness of at least the latter (cf. Turim 2003: 97). Moreover, from time to time there are touches in the films within that slightly disrupt the material and thus signal imitation. These work differently in the documentaries as opposed to the raw footage.

The documentaries are pastiches, although of an extremely understated kind. It is important for the structure of the film that this is so. The investigative structure, Agnieszka's quest to find out about Mateusz Birkut, requires that the material she looks at merits interrogation not just amused dismissal (and there are no such reaction shots to the material), while the historical/political point of *Man of Marble* would be undermined if the propaganda material it is opposing is obviously just nonsense. None the less,

throughout the two documentaries that Agnieszka and we watch, details nudge us towards perceiving the manufacture of the images.

There is the in-joke of the director of *Man of Marble*, Andrzej Wajda, listing himself as assistant director in the credits to the main documentary Agnieszka looks at, 'They Are Building Our Happiness', about the construction of the city of Nowa Huta. The title credit of this reads 'ONI budują NASZE szczęście', that is, *they* are building *our* happiness, emphasising them and us rather than building and happiness and thereby exposing the rhetoric of totalitarianism. Sometimes, there is play with the relation of voice-over to image. At the start of 'They Are Building Our Happiness', the camera pans down a drab hall decorated only with a vast banner with '1950' written on it in plain lettering, while the narrator says, "In the gaily decorated hall of Warsaw Polytechnic". Neither image nor voice on their own are inflected any way other than straight, but the contrast between the claims of the narration and the image itself bespeaks the attempt to manipulate the image to say something more than it does. In the newsreel of the show trial ('Polish Film Chronicle no. 28 1952: "Traitors in the Dock"'), the voice-over refers to this 'significant lesson for all of us in Poland', and each defendant is shown nodding, as if, impossibly, they have heard and are agreeing with what the voice-over has just said. Elsewhere, light is used manipulatively. In 'They Are Building Our Happiness', Mateusz and Hanka move towards the opaque window of the workers' flat they have just acquired; light shines beatifically through it and Mateusz flings it open, to reveal immediately before them the light-excluding wall of an identical block of flats. In 'Traitors in the Dock', there is evident difference in lighting between the prosecutor, a model of performed reasonableness who 'exposes the lies of and evasions' of the defendants, with soft light coming down from his right, making his hair and temples glow, and the defendants, with harsher, frontal light exposing them to scrutiny. There are also other editing gags. Exemplary worker Mateusz in 'They Are Building Our Happiness' looks up from his night school studies at a mathematics blackboard, and there is a cut to what, according to classic film grammar, he sees, but which in this case is Hanka in a leotard in the gym, suggesting Mateusz's mind was really on something else. A little later there is a shot of him stripped to the waist; his pupils look down to his right, in what might suggest uncertainty, embarrassment or also amused disdain. Cut to the heroic socialist realist statue for which he is evidently posing; perhaps his eye movement undercuts the solemnity of the business of propagandistic statuary, perhaps here Mateusz 'almost winks at the spectator' (Falkowska 1996: 145).

These moments function as faults in the careful imitation of the formal fabric of the documentaries, allowing their overall project of manipulation to be evident. They reveal the gap between the claim being made and what the images show, reveal it inadvertently, presumably, as far as the makers of the documentaries are concerned, and deliberately on the part of Wajda and *Man of Marble*. Perhaps some of these moments are on the edge of parody: it is not

clear to me whether they merely reproduce something of the crassness of Polish propaganda of the 1950s or actually highlight it.[15] Either way, the documentaries themselves do not become parodies; rather the discrepant moments keep reminding us of the fact of imitation, that is, they produce pastiche.

The raw material is by and large straighter. *Man of Marble* is mainly making a point with this footage about the reasons it was suppressed. Sometimes this is very clear: Mateusz and Wincenty as young workers in an altercation with a local official over food rations, dangling a gudgeon[16] angrily in his face; Mateusz at the show trial, making to take his shirt off to show the judge the scars that indicate that his earlier statement was made under duress. At other points the footage gives something away as it were inadvertently: a tractor ploughs up and sweeps away cherry trees in blossom, clearing the way for the soullessness of Nowa Huta; at the trial, Mateusz tells the judge mockingly that he is a known dangerous subversive, having "already made one attack on the authorities with a gudgeon".

There are, however, two moments in the raw footage which are less easy to take straight (that is, as accurate recreation of footage that gives access unproblematically to the ways the things it shows actually were). These both occur in what we are told are out-takes from a film we never see called 'The Start of a City'. There is first an interview with Mateusz before he became a bricklayer, where Jerzy Radziwilowicz's performance seems perhaps a little too determinedly wide eyed, innocent and sheepish. This could be a miscalculation in the performance: Radziwilowicz does this routine elsewhere in the film, outside of the films within; his performance becomes much more compelling, it seems to me, in Mateusz's later phases of disillusion and anger. Second, at the end of the out-takes there is cross-cutting, after the gudgeon incident, between Mateusz and Wincenty laughing and the local official scurrying away; each cut back to the latter has him considerably farther away, underlining the comic effect of him scampering off faster than his legs can carry him. This has all the hallmarks of subsequent editing for comic effect. Perhaps Wajda and his editors[17] just couldn't resist the fun of manipulating the material here beyond the reproduction of the look of unmanipulated material.

These moments might seem to undermine the function of the raw footage for *Man of Marble* by highlighting the fact that it too has been constructed for the film. There is, however, another explanation. We are told that 'The Start of a City' was made by Jerzy Burski, a now eminent director whom Agnieszka subsequently interviews. In this interview he explains how he discovered and invented Mateusz Birkut. The flashback illustrating his words clearly shows how he manipulated the events of the bricklaying display to make the men appear in a certain way. He has them shaved, gets them to walk properly 'like workers' from their huts in the morning onto the building site, reprimands Mateusz for making the sign of the cross before starting work and so on. Even the idea of the bricklaying contest itself is his. In other words,

Burski shows that what was filmed was already constructed and managed, even before the manipulations of camera position, editing and dubbing. This may then explain the discrepancies in the out-takes. In the interview, Mateusz seems unconvincingly a simple peasant lad; but when do we suppose this was shot? Most likely after he became famous. This means that he is here acting himself, or rather the image of himself that we learn the propaganda machine wanted him to have, but as he is not an actor, he can't really do himself very well. As for the editing of Mateusz, Wincenty and the runaway official, this we may put down to Burski having perhaps started to play about with the material, giving rise to the exchange between Agnieszka and the editor after they have watched it:

"I didn't know Burski filmed such things"
"He doesn't anymore, unfortunately".

Burski's interview with Agnieszka acknowledges that he was involved in fakery, and the raw footage perhaps carries traces of this. Yet the difference between it and the documentaries remains central to the film and its concern with truth. The raw footage may be limited by its opaque, fragmentary quality, requiring Agnieszka to make sense of it, but the documentaries are deliberate falsifications, which Agnieszka has to see through.

Man of Marble is committed to the notion of truth. There is urgency both in Krystyna Janda's intense and nervy performance as Agnieszka and in the momentum of the film's investigative structure, both in turn related to the period in which the film was made, the rise of Solidarity and the beginnings of the break-up of Communist hegemony in Poland. The film ends with Agnieszka's discovery of Mateusz's son Maciej at the Lenin Shipyard in Gdansk, already becoming the site of strong working-class resistance to the regime; the sequel film, *Man of Iron* (*Człowiek z żelaza* 1981), pursues the story in direct relation to the development of Solidarity, including footage of its leader Lech Walensa alongside Agnieszka and Maciej, specifically allying the project of *Man of Marble* with that of Solidarity. Part of the political urgency of the film as of the movement is speaking the truth against the lies of the regime.

In this context, the raw footage is important in providing Agnieszka with pointers to the truth, suggesting the role that film can have in the pursuit of truth. Yet, as we have seen, it is inadequate both because it cannot of itself fully articulate how things really are and because it at times betrays the fact that what is filmed may itself have been arranged to be filmed. The sense of the limitations of film is also suggested in the occasional camera point of view shots mentioned above, where we see someone filming with their eye to the camera lens and then see what they are seeing through it.

These include Agnieszka near the start of the film astride the statue of Mateusz, now lying discarded on its side in a museum store, Burski filming Mateusz laying bricks, Agnieszka's crew filming her interviewing Wincenty and later filming Hanka coming to greet them. These have much the same

quality as the raw footage (which in a sense is what they are): they are evidence but require interpretation. The significance of the statue of the film or its reason for being in store are not yet clear so early in the film, Wincenty is evasive in interview, Hanka imagines the crew are coming to see her for her minor fame as a gymnast. One camera point of view shot during the brick-laying display and seen within Burksi's flashback shows Mateusz straightening up for a stretch from his labours; the shot before shows pain and exhaustion in his face, but the point of view shot silhouettes him against a gathering sunset, the sun flaring slightly into the lens on the contours of his shoulders. The point of view shot makes him look heroic, classic masculine and worker hero imagery, suggesting the gap between how things are and how they can look through the camera.

Neither the raw footage nor the camera point of view shots (leave alone the documentaries) demonstrate unproblematically film's ability to tell the truth. Yet *Man of Marble* remains committed to this, affirming it partly in Agnieszka's film but principally in itself. Agnieszka is going to tell the truth, not only about the manufacture of Mateusz as hero but also about what happened to him subsequently, notably by her determinedly tracking down both Hanka and then their son Maciej. The interviews with these two will not only reveal the truth, but also privilege a particular kind of truth: the personal and intimate, a truth implicitly presented as superior to any kind of public, political truth. Hanka gives her interview in darkness, Agnieszka emphasising that this is woman to woman, guaranteeing authenticity; Maciej, at first reluctant, finally relents, perhaps, it is hinted, after beginning a relationship with Agnieszka (a hint confirmed in *Man of Iron*), another locus of truth telling in a certain kind of romantic rhetoric.

Yet the film explicitly shows Agnieszka eschewing film in these two encounters. She takes Hanka into the privacy of the latter's bedroom and deliberately closes the window on the sound recordist crouching outside it with a microphone, so that Hanka's narrative cannot even make it to sound-track. She waits for Maciej outside the shipyard and first sees him through her camera, but then lowers it and goes to meet him face to face, in effect discarding the use of the camera for this encounter. The film ends with the pair of them walking down the corridor of the studio, presumably to film his interview, but we never see it. What we see then with Hanka and Maciej is Agnieszka abandoning filming to get the truth, while the truth of her own final film is postponed until after *Man of Marble* is over.

There is only one kind of film left to tell the truth, which is *Man of Marble* itself. Mateusz's story is for the most part told through flashbacks, that is, enactments of the events that Agnieszka's interviewees unfold to her. There is no sense in these that the flashbacks need to be handled with care as sources of truth. Although there are celebrated examples to the contrary, where flashbacks are variously unreliable (*Stage Fright*, *Rashomon*, *8½*, *The Usual Suspects*), the dominant convention has been that what you see in a flashback is what happened: the fact that it is being remembered or told

within the framing narrative does not need to be taken, in this convention, as colouring or distorting the truth of what is being shown. *Man of Marble* works entirely within this convention, even though the characters telling the flashbacks are either inclined to be self-serving or else, in the case of Hanka, in a highly emotional state. What you get in *Man of Marble*'s flashbacks is what really happened to Mateusz.

It is against this telling of Mateusz's story that the pastiche of the footage within *Man of Marble* needs to be set. The documentary claim on truth is revealed as either deceitful (e.g. the editing of the newsreels, the setting up of the bricklaying contest) or at best limited (the opacity of the raw footage and camera point of view shots), and showing this by means of pastiche conveys the flavour of the material, even its power, while also building in the sense of doubt about its truthfulness that spurs Agnieszka on. Not unlike *Hamlet*, pastiche in *Man of Marble* serves to affirm the truth and, in context, modernity of the frame film itself. However, in *Hamlet*, the pastiche itself also expresses a truth, literal and emotional, whereas in *Man of Marble* it is a vehicle for indicating deception and inadequacy, also both literal and emotional.

• • •

The title *The Watermelon Woman* (USA 1996) refers, like *Man of Marble*, to a cultural type that the film investigates through an individual who embod- ied it.[†] In this case it is a black actress from the 1930s, Fae Richards, who played secondary roles in Hollywood and later starred in independent black cast films; in the former, however, she was known only as the Watermelon Woman, aligning her with the stereotype of the happy-go-lucky, child-like, lazybones Negro. Like Mateusz Birkut, Fae Richards is a fiction representing a real historical phenomenon, here too investigated on screen by a young debutante film-maker, Cheryl (played by the film's own director, Cheryl Dunye). Just as Agnieszka's investigation is fuelled by a political concern with socialist imagery, so Cheryl too has an agenda, namely, the absence of films about black women's history. She also responds personally to Fae, despite the marginality of the latter's roles ('something in the way she looks and moves is serious, is interesting'), and she finds her attractive ('the most beautiful black mammy').[18]

Watermelon Woman includes straightforwardly filmed narrative material (Cheryl working in a video store, hanging out with best friend Tamara, having an affair with a white woman, Diane, going shooting alone), but these are subordinate to the various elements that make up Cheryl's investigation.

[†] It also echoes the title of one of the first black directed Hollywood films, *Watermelon Man* (Melvin Van Peebles 1970), which, through the narrative device of a white man who wakes up to find himself black, makes fun of racial imagery. Dunye follows Van Peebles both in referencing a classic stereotype of African-Americans and in subjecting it to cinematic play.

The latter include the archival material of Fae Richards (fiction films, newsreels, home movies), footage shot in the preparation of Cheryl's film though not actually included in it (formal and vox pop interviews, Cheryl's direct address to camera, shots of sites associated with Fae and of visits to archives), material shot as part of Cheryl and Tamara's video business (a wedding, a poetry and percussion performance by Sistah Sound at a Women's Community Centre) and the final documentary about Fae, consisting of the archival material, Cheryl's voice-over and a breezy jazz score.

Of these within elements, the preparation footage seems the furthest from pastiche. The performances here, even in the complex cases (see below) of Cheryl Dunye herself as Cheryl and Irene Dunye as her mother, as well as of black memorabilia collector Lee Edwards (Brian Freeman, maybe slightly camping it up), stone butch lesbian and Fae Richards fan Shirley Hamilton (Ira Jeffries), Fae's lover's sister, Mrs Page-Fletcher (Patricia Ellis), all seem to me wholly convincing, and there is nothing distorted or discrepant about the filming style. In so far as they draw on conventions from documentary in a context where we know it is not a documentary, these elements are technically mock-documentary,[19] but they do nothing to draw attention to this, and are thus barely in this sense pastiche.

The interview material is in an obvious sense (she's not in it) further removed from Fae herself than the actual archival footage of her. On the other hand, this has its own distance: it is old and in black and white, more removed stylistically from the rest of the film and from contemporary (i.e. 1990s) film and video norms. It is also fragmentary: a few shots from a couple of fiction films, some bits of home movie footage, photographs and, the one complete film item, a newsreel. This serves the film's purpose well, reproducing the sense of black women glimpsed in the margins of films and largely occluded by history.

This archival material is of three kinds. First, and most clearly pastiched, is the newsreel, produced by the all-black Liberty Studios and recording the visit of Fae to her home town of Philadelphia, attending a benefit for the National Association for the Advancement of Colored People and discussing making a gangster film at Liberty Studios. The voice-over is cheery, just managing in words and delivery to fall short of parody: 'Well, look who it is folks, Hollywood's popular Fae "the Watermelon Woman" Richards', 'Get this, folks, while in the city Miss Richards spoke with Jay Liberty Wells'. The image is distressed from age and the sound is tinny. Some of the camerawork is hand-held, unlikely in even a low budget newsreel of the period, and it ends with an anachronistic zoom back from Fae and Jay in conversation[20] and an unanachronistic fade to black. In other words, there are elements of slight exaggeration and minor inaccuracy that, as in pastiche, together point up the fact of imitation. The home movie material, on the other hand, though we know it is not genuine archival footage, does nothing to remind us of the fact. Here, the use of a hand-held camera, though for the 1940s material still probably strictly speaking anachronistic, conforms to the norm for home movies,

as does the interplay of the subjects with the camera, either apparently unaware because turned away from it (Fae and her lover Martha at a lesbian party) or shooing it away embarrassedly (as June Walker, Fae's last lover, does when the camera hovers over her at a card game). This footage functions to show us fleetingly the private Fae – lesbian, away from the limelight.

The feature film footage occupies a space between the newsreel, not far off worthless in terms of what it tells us of Fae, and the home movies, with their tantalising glimpses of the real Fae. Both the newsreel and the home movies are moreover presented directly to us, different from the narrative and Cheryl's footage only by virtue of picture quality (distressed monochrome) and period markers of dress and setting. The feature films, on the other hand, are seen on the monitors on which Cheryl herself watches them, with consequently inferior sound and picture quality. They are thus insistently framed, the object of the film's interrogation.

There are two features, supplemented by photographs and film titles. The first, *Plantation Memories*, shows Fae as Elsie, a black servant complete with bandana, running up to a white woman, Missy Parker, seated in the crook of a large old tree, wearing a huge skirted white Southern belle dress; Elsie comforts Missy Parker, assuring her that Masser Charles will come back: "I know he will, I pray to God all night long – this morning this little angel told me he's coming back, back to you". This is accompanied by a very syrupy arrangement of the archetypal white Southern melody, 'My Old Kentucky Home'. (The final documentary on Fae also refers to another plantation movie in which she appeared, *Louisiana Lady*.) None of this is over the top; in particular, Fae's performance (that is, that of Lisa Marie Bronson, the actress who plays her) is much less eye-rolling and hand-wringing than Cheryl's mimicry of it later in the film. Rather, though the clichés of dress, script and music are lightly pointed, something else comes through, in Fae's/Bronson's performance, highlighted by the use of close-ups of her and also of shots over Miss Parker's shoulder that centre on Elsie rather than her mistress. This sense of something else is important to Cheryl's project; it is both what inspires her, this 'something in the way she looks and moves [that] is serious, is interesting' and also validates the historical endeavour, of seeing past white constructions to the reality of black women.

The other feature film is *Souls of Deceit*. The title recalls such 'all-black productions' as *Body and Soul* (Oscar Micheaux 1924), *Scar of Shame* (Colored Players 1926), *The Burden of Race* (Reol Studio 1921) and *Deceit* (Micheaux 1921); as Cheryl remarks, it is "one of the few race films she ever starred in", and it is clearly a passing-for-white drama, a recurrent narrative in the 1920s and 30s in both Hollywood cinema and black literature and, as here, independent black film. The scene we see is between Fae, whose character's name we do not get to know, and a woman called Irene. Fae upbraids Irene with powdering her face white, and when Irene says why should she not "be happy fitting into their [the white] world" and that "God made me this colour and he did it for a reason", Fae slaps her face. The image has the bare sets and

harsh lighting characteristic of much black independent production of the period. Irene's face is more brilliantly white, different from but evocative of the livid white complexions of the 'high coloured' women in these films; its very extreme brightness also plays on the ambiguity of the role, the idea of being born 'this colour' yet having in fact to enhance it to the point of excess, another of *The Watermelon Woman*'s proliferation of motifs of performance, pastiche and imitation (and not forgetting the title of the most famous of (white produced) passing books and movies, *Imitation of Life* novel 1933, films 1934 and 1959). As with *Plantation Memories*, we see more of Fae in *Souls of Deceit* than the other woman, suggesting again the something 'serious and interesting' that comes through against the poverty and creakiness of the vehicle.

Cheryl watches *Souls of Deceit* with Diane, her white girlfriend, and the film toys with the possibility of analogy between passing for white and going with white. At one point we cut away from the film back to Cheryl and Diane and the latter's seduction of Cheryl; the film's soundtrack becomes indecipherable, but when they start to kiss, it is becomes audible again and we hear Fae's voice as in commentary to Cheryl: "You're a no-good lying tramp, that's what you are. Committing a sin that will surely send you to hell".

In addition to the variously marked pastiche dimension of the films within, there are other pastiche or quasi-pastiche elements in *The Watermelon Woman*. There is a karaoke night at a lesbian club, with first a white woman (the unforgettably decent V. S. Brodie from *Go Fish* 1994) singing with determined funk the 1978 disco hit, 'Boogie Oogie Oogie', and then Yvette, a black woman brought along to meet Cheryl, doing an excruciating cover of the vocally taxing 'Loving You', a 1975 hit record for Minnie Riperton. The karaoke principle of vocal substitution is then reproduced in a sequence of Cheryl speaking Elsie/Fae's words from *Plantation Memories*, sitting beside it playing on a monitor, exaggerating the vocal delivery and adding histrionic gestures. This contrasts with the Sistah Sound performance, at the other extreme from karaoke, insistently rooted in markers of authenticity: poetry as statement, African instruments (bongos and cowbell). The flat vocal delivery of the rap, with its refrain 'For I am Black Woman/Black Woman I am', suggests parody, and the performance is in any case undermined by Cheryl's video crew, intent on filming the 'cute' women in the audience rather than the higher minded performance poetry.

There are in-jokes too. Diane is played by Guinevere Turner, co-writer, co-producer and co-star of *Go Fish*, the queer lesbian independent film crossover hit. Cheryl holds up the cover of a book called *Hollywood Lesbians*, probably Boze Hadleigh's 1994 book but credited here to Doug McGowden ("I wonder if he's a lesbian?"), a name very close to Doug McKeown, who co-wrote and directed the fiction films within *The Watermelon Woman*. Behind Cheryl and friends at dinner, there is a poster for *The Attendant* 1992, with the director Isaac Julien's name very clear in shot; Julien is the doyen of the kind of black filmmaking to which *The Watermelon Woman* too belongs: anti-essentialist, gay, politically ardent without being easily correct.

There are also a number of levels of performance that go beyond straight playing of a character. There is parody in the performance by Sarah Schulman, a well-known lesbian writer and activist,[21] as the white archivist of CLIT (Center for Lesbian Information and Technology), at once naively enthusiastic and solemnly collectivist. Three other women play themselves. One is Irene Dunye, Cheryl Dunye's mother playing Cheryl's mother, who seems to play it entirely straight, unawed by her clever, sassy daughter, reminiscing about going to actual black entertainment venues in her youth, never having heard of the Watermelon Woman (as after all Irene Dunye could not have) and yet recognising a photo of Fae (we are told) as a woman who used to sing in the clubs she went to, clubs that were also full of weird folks of the kind Cheryl would like. Irene Dunye's segue into the fiction of recognising someone who never existed is so convincing that one wonders if the photo (which we never get to see) was really one of Fae or an actual singer from the period. Secondly, Camille Paglia, in characteristic motormouth delivery, scatters ideas at once interestingly provocative (such as that one might consider the mammy figure an image of joy and fruitfulness) and slightly barmy (that men cutting up and handing out watermelon slices is like Holy Communion). Is she just like this anyway or is she aware that she is and sending herself up a little? At the end of the sequence, where she has had to play along with the fiction of Fae Richards and Martha Page, she seems almost unable to suppress a smile, as if about to give away that she is in on the game and a good sport to boot.

Then there is Cheryl (Dunye). Cheryl, the character, played by Cheryl Dunye, the director of *The Watermelon Woman*, is, like Cheryl Dunye, a young debutante filmmaker, making a film about the Watermelon Woman. However, unlike Cheryl Dunye, Cheryl does not know that the Watermelon Woman/Fae Richards is Cheryl Dunye's invention, and the film about the Watermelon Woman that Cheryl makes and shows us at the end is in but is not itself the film *The Watermelon Woman*, that Cheryl Dunye has made.

The Watermelon Woman, and especially the conundrums set in motion by Cheryl Dunye as Cheryl, may be said to Signify. This term has been developed in African-American criticism to describe a distinctly African-American mode of indirect expression, including the use of improvisation, metaphor, performance, repetition and syncretism, embodied in specific cultural forms and practices (Gates 1984, Floyd 1995, Yearwood 2000). Importantly, Signifying, though not realist in form, is rooted in the real, in African-American history and experience. Signifying is playful but urgent, its strategies of indirection those of survival, of being able to talk about the forbidden subject of one's own conditions of existence; its tropes carry with them the memory of the realities of African experience in America. Likewise *The Watermelon Woman*. It has the quick brilliance of Signification, the sense of displaced, teasing meanings, but also the feeling of connection to the real.

The latter is rooted in two elements, though neither is transparently realist. One is the singer Toshi Reagon, briefly encountered by Cheryl singing in the

street, her song continuing over Cheryl walking along intercut with home movie footage of Fae and June and with June's words on the soundtrack ("Please Cheryl, make our history before we are all dead and gone"). Reagon's music combines a range of styles, folk and rock as well as gospel and blues; she combines many signs of authenticity: a street singer, dressed in denim against a graffiti covered wall, accompanying herself on acoustic guitar. The song is called 'Fascination', the thing that has motivated Cheryl all along.

The momentum of the sequence leads to Cheryl's last straight to camera section, introducing the bio-doc of Fae. Like the other preparation footage discussed above, this is technically mock-documentary. Yet, as I have already suggested, nothing in the filming of these sequences signals the fact of being mock (that is, they are not significantly pastiche) and this is because they most directly express the point of truth in *The Watermelon Woman*, namely, Cheryl's desire for there to have been a beautiful black lesbian presence in film. It is these documentary sequences that give force (if, for you, they do) to the final mini bio-doc of Fae. They anchor the myriad levels of pastiche, in-joke and Signification in the fierceness of desire, fuelled by sexual desire but even more a desire for a positive presence in history.

The film ends with a title admitting that the film is an invention but that 'we must make our own history'. Andrea Stuart, in a coruscating review of the film, argued that 'this feels like a copout' (1997: 64) and certainly desperately wanting something to be so does not make it so. Yet there is no reason to suppose that there were not attractive black lesbian women working in Hollywood and race films in the 1930s, who retired when they saw the limitations of the former and when the latter ceased to be made. The new lesbian and gay histories of Hollywood (Madsen 1998, Mann 2002, McLellan 2000), of black and lesbian bohemia, to say nothing of the echo of the career of Lena Horne, all suggest that *The Watermelon Woman*'s history is not implausible. If there can be a Cheryl Dunye, why could there not have been a Fae Richards? *The Watermelon Woman* Signifies on the gap between empirical evidence and imaginative probability, a gap which is especially aptly explored by pastiche.

Man of Marble and *The Watermelon Woman* both use the pastiche within to interrogate the truth value of the medium they are working in. In both cases, and like *Hamlet*, the effect of the inner pastiche is to authenticate the outer frame. This is clearest in *Man of Marble*, where the possibility of truthful film-making lies only within the fiction film we are watching or, possibly, in the interview and finished film that happen only after this film is finished; all the film within the film is inadequate, because deceitful, opaque or fragmentary. *Hamlet* and *The Watermelon Woman*, on the other hand, retain a sense of the truthfulness of their works within even while marking their own distance from them. Hamlet recognises the emotional truth of the old-fashioned players' texts and performances, Cheryl glimpses the spark of seriousness and interest in even marginalised and stereotyped black performers like Fae. For the purposes of this study, however, the point is not so much these attitudes as the way that pastiche enables an expression of these attitudes

simultaneously with an experience of the works involved – or, rather, an experience of those works as they are felt through those attitudes.

• • •

Follies is a pastiche show so brilliant as to be breathtaking at times.[22]

The musical *Follies* also works with the double perspective of *Hamlet* and *The Watermelon Woman*: it recognises its own difference from past forms while acknowledging their emotional truth. At the same time, it situates itself within the relationship at the heart of pastiche, between an imitation and that which it imitates, rather than making the latter an object of scrutiny (as in both *Man of Marble* and *The Watermelon Woman*). From this perspective, it generates a set of variations on that relationship, from works clearly framed and maintained within to the within style bleeding into elements of the frame itself. Pastiche is revealed as extraordinarily flexible and productive, not just a way of expressing attitudes towards past works but also of using them.

Follies has a book by James Goldman, lyrics and music by Stephen Sondheim and orchestrations by Jonathan Tunick.[23] It had its first production in New York in 1971, and there have been several notable ones since, including New York 1985 (a celebrated concert performance at the Lincoln Center), London 1987, the Paper Mill Playhouse, Millburn, NJ, 1998 (which produced the only available complete recording of the score) and New York 2001.

Musicals have often featured shows within, but the latter have seldom themselves been musicals. *Kiss Me Kate* 1948[24] does feature excerpts from a musical version of *The Taming of the Shrew*, but usually the shows within are from other traditions of musical theatre: melodrama (*Show Boat* 1927), fashion shows (*Roberta* 1934), ballet (*On Your Toes* 1936), night clubs (*Pal Joey* 1940, *Guys and Dolls* 1950, *Flower Drum Song* 1958), modern dance (*The Pajama Game* 1954), burlesque (*Gypsy* 1959), revue (*Funny Girl* 1964), cabaret (*Cabaret* 1966), vaudeville (*George M!* 1968), drag shows (*La Cage aux Folles* 1983), even razzmatazz preaching (*Anything Goes* 1934 and *Sweet Charity* 1966), as well as the marines' show in *South Pacific* 1949, the Oriental(ist) dance drama in *The King and I* 1951 and the children's show in *The Sound of Music* 1959.[25] Most often shows within musicals tend towards parody,[26] with a marked difference in musical style between the within and the frame numbers. The effect, perhaps even the function, of this is to lend credibility to the, if you think about it, bizarre convention of characters bursting into song and dance in the middle of conversation, and also gravitas, something that even comedy musicals aspire to. The desire to establish musicals as American Musical Theater to some extent depended on acknowledging but also taking a distance on such non-narrative, sometimes morally questionable predecessors as burlesque, cabaret and vaudeville.

Like other musicals with shows within them, *Follies* is a musical featuring numbers from a non-narrative form (revue). However, the frame structure is greatly attenuated, merging the narrativity of the musical with the

non-narrativity of revue, and though the numbers within are musically different from those of the frame, they are not, mainly, parodic.

Follies is set in an old Broadway theatre, the Weismann, on the eve of its demolition. Its founder, Dimitri Weismann, is throwing a party for his ex-showgirls (and, where they have them, their menfolk). The frame is this reunion, encounters with old friends, reminiscences; in the course of the evening, two long but unhappily married couples, Sally and Buddy, Ben and Phyllis, seem to be about to split up, with old flames Sally and Ben going off together, but things at the end are much as they were at the beginning. These rather desultory narrative elements are accompanied by scenes with the younger selves of many of the characters; these are often simultaneous with or interjected into the party narrative, with a climax being reached as Sally, Buddy, Ben and Phyllis shout at their younger selves for the mistakes they made that ruined their lives. This is a breakdown of naturalism rather different from the one sanctioned by musicals (bursting into song), but it is already anticipated by having the stage criss-crossed from time to time by showgirls, ghosts or emblems the past.

All of the above is interspersed with musical numbers. Some arise, as in a conventional musical, from the narrative, from the characters' thoughts or interactions, but others are revue numbers, in several different forms. These are:

- old numbers done by the ex-showgirls at the party (thus still within the space and time of the frame):

 'Beautiful Girls', with all the old girls executing a Follies walk-down; 'Rain on the Roof', 'Ah Paris', 'Broadway Baby', in which party guests Emily and Theodore Whitman, Solange Lafitte and Hattie Walker, respectively, 'relive their old Follies solos' (Goldman and Sondheim 2001: 23);

- two numbers, each signalled as having been old Follies numbers, each started by ex-showgirls at the party who are then joined by their younger selves:

 'Who's That Woman?', led by Stella, joined by a chorus formed by the others at the party, then echoed by all their younger selves, tapping in unison, singing in counterpoint;
 'One More Kiss', begun as a solo by Heidi, then becoming a duet with her younger self, involving both counterpoint and harmony;

- a dance routine, 'Bolero d'amore', performed in precise echo of each other by the older and younger versions of professional couple dancers, Emily and Theodore, both pairs simply emerging from people dancing together at the party;

- an actual number from the past (that is, as if by, in filmic terms, a cut to the past):

 'Loveland', a lavish production number celebrating the bliss of love;

- a number following on immediately from this, sung and danced by the younger selves of, first, Ben and Phyllis and then, to different words, Sally and Buddy ('You're Gonna Love Tomorrow', 'Love Will See Us

Through'), an impossible number in that Ben and Buddy were never in show business, leave alone the Follies;

- a number for each of the members of the two main couples in their older incarnations, in a style from the age of the Follies but with words relevant to how they are now:

'The God-Why-Don't-You-Love-Me Blues' (Buddy),
'Losing My Mind' (Sally),
'Lucy and Jessie' (Phyllis),[27]
'Live, Laugh, Love' (Ben).[28]

As can be seen, the narrative and the revue elements bleed into one another: narrative reminiscences become revue numbers, revue numbers are used to express narrative concerns, the space–time of the party and of the revue merge. This is often reinforced by the specific, often ironic placing of the revue numbers within the narrative. 'Who's That Woman?', as sung in the Follies, is about a young socialite coming to see, in the mirror, the emptiness of her life, but it could seem to be about Stella and the others now; the unison tap routine between the older and younger showgirls is a triumph of pizzazz, but the number is placed immediately after an exchange scene between Sally and Phyllis (who join in), as they are beginning to acknowledge aloud the ravages of time. 'Loveland' and the intertwined numbers of Ben–Phyllis and Buddy–Sally that follow it occur after the revelations of the mistakes and betrayals in the past that culminated in Sally marrying the wrong man, with the older selves shouting angrily at the young ones before the stage gives way to the sugary optimism of 'Loveland', 'You're Gonna Love Tomorrow' and 'Love Will See Us Through'. These in turn are followed by the four numbers where the main characters use revue styles to express what they are now feeling: melancholy, frustration, cynicism, despair. The three bright, optimistic Follies numbers are, then, framed by anger and bitterness borne of what has come after.

In all these ways *Follies* merges the narrativity of the musical (including the use of numbers within this) and the non-narrativity of revue. Yet it maintains a stylistic distinction between the numbers in the former and those in the latter, between, as it were, *Follies* and the Follies. Some of the eight frame numbers are distinctly Sondheim, with spiky lines, jerky rhythms and hints of dissonance that sometimes give way to romantically falling cadences ('Don't Look at Me', 'The Road You Didn't Take') or sometimes don't ('The Right Girl', 'Could I Leave You?'); others, if not so unmistakably his are none the less recognisably in the Kern, Rodgers and Hammerstein, Bernstein lineage to which he belongs ('In Buddy's Eyes', 'I'm Still Here', 'Too Many Mornings'). The revue numbers, on the other hand, are all pastiche, musically, lyrically, as performed and, often, by whom:[29]

'Beautiful Girls' (the Ziegfeld Follies style, 'Glorifying the American Woman', with classically trained tenor and showgirl walk-down[30]);

'Rain on the Roof' (the professional couple number, expressing love with childish delight, dancing as they sing (one such couple were Marge and Gower Champion, the first of whom played the role in the New York 2001 revival; singing married couple, Pearl Carr and Teddy Johnson, played the parts in the 1987 London production));

'Ah, Paris!' (the naughty, oo-la-la 'French' number, sung by a character whose name, Solange Lafitte, might seem improbable had she not been played in the first production by Fifi D'Orsay, and in the Paper Mill Playhouse Production by Liliane Montevecchi, both veterans of exotic Europeanness);

'Broadway Baby' (the showgirl young hopeful, perhaps most familiar from the Warner Brothers film musicals of the 1930s (sung in the first production by Ethel Shutta, who had been in Follies-type shows in the 1920s[31]));

'Bolero d'amore' (Latin couple display dancing);

'One More Kiss' (Viennese style operetta love song, which Heidi says 'Franz Lehar wrote for me in Vienna' (ibid.: 14));

'Loveland' (the big production, major key romantic love number);[32]

'You're Gonna Love Tomorrow' and 'Love Will See Us Through' (similar in tone and style to 'Rain on the Roof');

'The God-Why-Don't-You-Love-Me Blues' (knockabout vaudeville number, with Buddy in 'plaid pants, garish jacket and shiny derby hat' (ibid.: 71));

'Losing My Mind' (torch song, Sally 'costumed in a clinging, beaded silver gown, as if she were a screen seductress from the 1930s' (ibid.: 77));

'Lucy and Jessie'[33] (jazzy, blaring narrative-based number, recalling 'The Saga of Jenny' from *Lady in the Dark*,[34] performed by Phyllis showing her legs and accompanied by chorus boys);

'Live, Laugh, Love' (nonchalant male solo, with Ben dressed and at one point dancing like Fred Astaire, surrounded by chorus girls).

The pasticheness of these numbers is achieved partly by their stylistic contrast with the rest of *Follies*, partly by the estrangement produced by having older women sing younger women's songs and/or actually singing with embodiments of their younger selves, partly by ironic placing (making it hard to take, especially, 'Loveland' and the following duets straight). It is also achieved by slight distortions in the actual writing and performance of the numbers. 'Rain on the Roof', for instance, not content with 'Pit-patty-pat' to celebrate the rain, throws in 'Plunk-planka-plink', more evocative of guitar playing, the effect then heightened by the ever so slightly disconcerting extra syllable of 'Plunk-planka-plink-planka'. Similarly, 'Lucy and Jessie' has the insistent rhymes of a nursery song at odds with the sophisticated wit of the words and, by the end, the unexpected rhythm:

Jessie is racy
But hard as a rock.

Lucy is lacy
But dull as a smock
Jessie wants to be lacy,
Lucy wants to be Jessie.
That's the sorrowful précis
It's very messy.

The orchestrations are similarly precise and restrained in their distortions: bright, twirling brass phrases over a boisterous beat for 'Ah Paris!', for instance, sugary vocal and string harmonies for 'Loveland' or, for the clownish 'The God-Why-Don't-You-Love-Me Blues', comic rude brass, twiddling violins, staccato woodwind, squeaky chorus girls and rattle. More broadly, Jonathan Tunick, the orchestrator, tried to catch the sound of the Broadway orchestra in the pit, but not what that 'actually sounded like, it's what you *thought* the pit band sounded like' (quoted in Zadan 1990: 155), a concise definition of pastiche's dynamics of imitation and remembrance.

Like *Hamlet* and *Watermelon Woman*, *Follies* recognises the possibilities for emotional truth within what it nonetheless pastiches. Some numbers acknowledge, relatively straightforwardly, the genuine touchingness ('One More Kiss') or real fun ('Rain on the Roof', 'Ah Paris!', 'Broadway Baby') of the forms they pastiche. 'Loveland', on the other hand, seems almost a reprehensible lie in both its sugariness and its placing against not just the loss of love between the couples but, as we see just before it, the deceits and mistakes on which their marriages were based in the first place. This bitter irony not only colours the blithe tone of the immediately following duets, 'You're Gonna Love Tomorrow' and 'Love Will See Us Through', with their bright musical arrangement and fresh, unforced vocal delivery, but also turns some of the lyrics sinister: 'Tomorrow's what you're gonna have a lifetime of/With me!', 'Love will see us through/Till something better comes along'. We know that tomorrow has been misery for Buddy and Sally, not least because it has gone on and on, and we know that love has not been enough to see Ben and Phyllis through, that better things have come along, and yet they are still stuck with each other. The effect is then ratcheted up in the last, simultaneously sung lines:

And if you love tomorrow, But the minute we embrace
Then think of how it's To love's old sweet song,
Gonna be.
Tomorrow's what you're Dear, that will see us through
Gonna have, Till something,
And Monday's what you're Love will help us hew
Gonna have, To something,
And love is what you're Love will have to do
Gonna have Till something
A lifetime of Better comes
With me! Along!

Bringing in the dreariness of Mondays, remorselessly repeating 'gonna', saying love will simply 'have to do' is a lowering emotional tone set against a musical brightness that begins to feel hysterical. Perhaps the longed-for forever of love songs is commonly tinged with dread at the thought.

It is this sense of realising something implicit but often unacknowl-edged in the pastiched form that forms the basis of the four final solos. 'Losing My Mind' is the most straightforward and the least pastiche – it could equally well appear in the frame and has been much recorded. Geoffrey Block suggests George and Ira Gershwin's 'The Man I Love' as 'a likely antecedent', notably in the way it follows the contours of the tune (1997: 281). Considering the lyrics, *mise-en-scène* and title of the show, another obvious reference is the torch song that featured in Follies style revues, one of the most familiar of which now is 'My Man', sung by Fanny Brice in the 1921 *Ziegfeld Follies* and by Barbra Streisand as Brice at the end of the film version of *Funny Girl* 1968. In the latter, though an onstage number, it expressed the real feelings of Brice deserted by her husband, an effect intensified by the extreme simplicity of the staging, Brice/Streisand in a plain V-neck black dress against a black curtain. 'Losing My Mind' works very similarly. Sally has told her husband Buddy that she is leaving him for Ben, the man she has always loved, but now, as the number starts, she knows that Ben is not willing to leave his wife and that, for him, 'it was finished years ago'. She wears an elegant gown ('clinging, beaded silver') standing with curtains parted 'just enough to form a graceful frame' (Goldman and Sondheim 2001: 77). Like 'My Man', 'Losing My Mind' carries the burden of its relation to the narrative all the more strongly for being stripped of distracting *mise-en-scène*. It not only acknowledges the expressive intensity of the material it pastiches, it also retains it, even in the act of pastiching.

The three versions of Phyllis's number all play on the idea of a split person-ality: poor girl Harriet who becomes rich ('Uptown/Downtown'); pure, young Lucy who wants to be like mature, sexy Jessie, and vice versa ('Lucy and Jessie'); and an unnamed lady who 'was smart, tart,/Dry as a martini' but 'underneath ... all heart' ('Ah, but Underneath'). The number, though lighter and more paradoxical than Phyllis in the frame, none the less is consonant with her characterisation there. The wit of the words is very close to that in her challenging song to Ben, 'Could I Leave You?', albeit less bitter. The routine with the chorus boys (simulated striptease in 'Ah, but Underneath') catches the sassiness we have already seen (flirting with a waiter) and heard (in her reminiscences about an affair, in her singing to Ben of the pleasure she'd take 'With a boy half your age/in the grass') in the frame. The number though also allows Phyllis to appear a more complex, divided character, not just the familiar wise-cracking dame embittered by life. In the 'Lucy and Jessie' variant, she implies that along with love and romance she also quite wanted the conventionality of her marriage. The 'Ah, but Underneath' variant is less sanguine: not only does the lady die, but the words, playing on

the striptease motif also furnished in the bump and grind melody and orchestration, suggest a bleak self-perception:

> No one ever glimpsed her potential
> But when stripped down to the essential –
> Mind you, this is confidential –
> Way down underneath ...
> Sometimes when the wrappings fall,
> There's nothing underneath at all.

Both 'Losing My Mind' and the different versions of Phyllis's song indicate the potential of the Follies number to express feelings and character – that they expressed them then and still can. The numbers for Buddy and Ben, on the other hand, work by undermining the pastiched style. Buddy's 'The God-Why-Don't-You-Love-Me Blues' does so by drawing out the morbid, hysterical edge already present in this kind of routine. In the central section, Buddy dances with two girls, one 'a caricature of his beloved Margie [his mistress]' (ibid.: 71), the other 'a cartoon of Sally [his wife]' (ibid.: 73); in squeaky voices, they echo his lines, as chorus girls do, but in such a way as to render them at first just comic, then unpleasant:

With 'Margie':	
She says she really loves me.	I love you.
She says she really cares.	I care. I care.
I'm perfect, she swears.	You're perfect, goddammit.
She says that if we parted	
She says that she'd be sick.	Bleah (vomiting sound).
With 'Sally':	
She says she loves another.	Another.
A fella she prefers.	Furs. Furs.
She says that he's her idol.	Idolidolidolidol –
Ideal, she avers.	You deal ... 'avers'?
She says that anybody	Buddy – Bleah!
Would suit her more than I	Aye, aye, aye.

Buddy's performance is frantic, with him chasing 'Sally' round the stage and the pair of them colliding with 'Margie' before all three sing the final chorus together, the two women interjecting shrill distorting echoes: 'Bla-bla-blues!', 'Woo!', 'Oh!'. The whole thing comes together in a furiously fast, long-drawn out phrase from Buddy counterpointed at the end by choppy phrases from the women and dissonant high notes from all three on the last word:

Buddy:	'Margie' and 'Sally':
Those	
'If-you-will-then-I-can't,	
If-you-don't-then-I-gotta,	

Give-it-to-me-I-don't-want-it,
If-you-won't-I-gotta-have-it,
High-low-wrong-right-
Yes-no-black-white,
God-why-don't-you-love-me-oh- 'Fast-slow-kiss-fight-
you-do-I'll-see-you-later' Stay-go-up-tight'
Blues! Blues!

Buddy's Follies number still uses its vaudeville clown style to convey his feelings, his inability to love anyone who loves him, but pushing it towards all out hysteria. Ben's number, 'Live, Laugh, Love', on the other hand, ends up unable to express what he feels. The song is blithe, nonchalant, the singer preferring life, laughter and love over ambition and intellectual pursuits; at points he 'dances nimbly and does some fancy work with a hat and cane, à la Fred Astaire' (ibid.: 84). Yet increasingly he is unable to continue with the routine. He needs prompting, then he dries completely; he tries to speak his feelings of self-hate, first against the chorus cheerfully reprising his song, then against all the Follies numbers that come in gradually, first (Buddy's 'Blues') as counterpoint, then as mounting cacophony, until he cries out 'Phyllis!' Unlike Sally and Phyllis and even to a considerable extent Buddy, Ben cannot fully inhabit his number; it can only be turned to emotionally expressive use at the point where he breaks down, where he refuses its carefree optimism.

The pastiche of the numbers for the women recognises that they are drawing on a specific and no longer wholly current musical tradition, but this in no way diminishes the emotional force. With the men, such emotion can only be produced by pushing the pastiche towards the grotesque or collapse. One could explain this in terms of Buddy and Ben never having been in show business. Yet this is a musical, everyone sings in musicals, including Buddy and Ben in the frame; moreover, men did sing in the Follies, including in the two modes allotted Buddy and Ben, vaudeville clown and sophisticated song and dance man. Another explanation is possible. Women were the *raison d'être* of Follies shows, and although this was primarily as projections of male fantasy, it did also allow a space for expression through performance. The show business tradition has also perhaps continued to make more space for passion, sentiment, wit and glamour than the rock culture that displaced it, modes that have long been congenial to women.

Beyond this, it may also be telling that the women can make their numbers work for them better than can the men, and not just because the referent is show biz but also because the numbers are pastiche. Pastiche, or at any rate this use of pastiche, requires an acceptance that one is not at the centre of discourse, that one is not the only begetter of the forms one uses, that language speaks us more than we speak it, that we are at least as much penetrated by culture as producing of it. The illusion of being at the centre of discourse is easier to sustain if you are also at the privileged point of society

or have something invested in, or see the possibility of, occupying it. Many men are excluded from this, even white, rich, middle-class men; perhaps at some profound level all people are, we never fully inhabit or experience ourselves as wholly producing discourse. But the illusion remains powerful especially to the (relatively, potentially) powerful. It is easier to accept cultural forms that fully acknowledge where they come from, their derivativeness, if you have no fear of being penetrated by culture. While probably almost no-one ever experienced utterance as emanating wholly from the imperatives of the self, still attaining this is an illusion more readily entertained by those supposedly at the centre of society: men, heterosexuals, whites. Pastiche can only work for you as emotional truth if you surrender something of yourself to the sweep of discourse and perhaps it's easier to do this if you have never had illusions otherwise.

• • •

Pastiches within give with one hand and take with the other. They say, this is what this sort of thing is like; and they get close enough to convey, or remind us of, the flavour of it. Yet they also say: this work is not this sort of thing. The frame indicates the difference and may suggest an attitude towards the work within, but so does the inflection – the pastiching – of the work within itself. The works considered here have different attitudes towards this sense of a work within so near and yet so far. For *Man of Marble*, there is a feeling of relief, even liberation, the film as it were sloughing off the modes that film was being required to inhabit. There is more admiration in *Hamlet* and *The Watermelon Woman*, a sense that while these things are passing (*Hamlet*) or past (*The Watermelon Woman*), still there was much in them, and both seek for and affirm a connection with what they pastiche. *Follies* too recognises that these are past forms, yet also suggests that, even in the very act of pastiching, they are recoverable and serviceable. All seem to say: they don't make them like this any more. It is their responses to this that differ:

> Thank God! (*Man of Marble*)
> Pity, but we have to move on. (*Hamlet*)
> Yes, but there's still something 'serious and interesting' there. (*The Watermelon Woman*)
> There's life in the old form yet. (*Follies*)

Pastiche, because it is not insistently distant, because it is not a priori critical, can suggest all these things and more. And – weeping for Hecuba, 'the most beautiful black mammy', 'Losing My Mind' - it can also move us.

Notes

1 On the dating of *Hamlet*, see Hibbard (1987: 3–5).
2 For the purposes of this discussion, to avoid extra complication, I exclude works in one medium or mode contained within a work in another, different one. Thus I do not consider

here, for instance, the poems within the prose narrative of *Possession* (A. S. Byatt 1990), which are undoubtedly pastiche (cf. Neubauer 1997), nor the numerous stage numbers in putting-on-a-show film musicals.

3 First published 1629.

4 The text used here is from 1692 (see Corneille 1937: 6).

5 A play within a play may be an aspect of 'metatheatre' (Abel 1963), that is, theatre that includes an internal commentary on itself. However, on the one hand, metatheatre may also be achieved by dialogue, asides, addresses to the audience or even the production itself seen as a commentary on the text (Puppa 1997: 427) and, on the other hand, a play within a play need not be primarily concerned with metatheatrical commentary – it is not in *The Roman Actor* and *Hamlet*, for instance.

6 Not actually so named by the text.

7 References refer to lines as in Corneille 1937.

8 In much discussion the play within the play in *Hamlet* is referred to as 'The Mousetrap', but this is only the name Hamlet gives it in one of his many jokey remarks during the performance.

9 All quotations taken from the Oxford edition (Hibbard 1987).

10 This account is based primarily on the production images (drawings, paintings, photographs) assembled in Mander and Mitchenson (1955: 66–87), ranging from a 1730 engraving to the 1948 Stratford production, and on Rosenberg (1992: 550–601) (see especially his discussion of performance style 580–581) and Hapgood (1999). I have also looked at film, television and recent stage productions.

11 Carol Replogle shows in some detail the continuity of the 'ornate texture and archaic flavour' of the language in 'The Murder of Gonzago' with both contemporaneous writing and Shakespeare's own usages for 'well-born characters' (1969–70: 158).

12 New York 1964, directed by John Gielgud.

13 'Aerie': nests of birds of prey; 'eyases': young hawks (Hibbard 1987: 220). In the company referenced here, the Children of the Chapel, boys played all roles, not just the female ones.

14 President of Poland 1946–1956.

15 Janina Falkowska (1996: 154) observes that 'They Are Building Our Happiness' 'would be a parody if it were not such a precise re-creation of the era's socialist newsreel propaganda'. Much depends on both familiarity with the material and the investment one may have in being distanced from and perhaps superior to it. This is suggested Bjørn Sørenssen's account of the differences in reactions among a contemporary audience in Nowa Huta itself (2003: 104):

> The older part of the audience acknowledged their past with nods of recognition, while the younger generation reacted with derisive and sometimes incredulous laughter accompanied by irritated hushing from the elders.

16 A kind of small freshwater fish.

17 Maria Kalinciska and Halina Prugar-Ketling.

18 There is also an eroticism in Agnieszka's interest in Mateusz, suggested in the sequence where she straddles the bare torsoed statue of him and in her eventual probable relationship with Maciej (played by the same actor as Mateusz); however, this is only hinted at by the film, whereas it is a central concern of *The Watermelon Woman*.

19 Dunye had already played with mock documentary in *She Don't Fade* 1991 and *The Potluck and the Passion* 1993 (see Smith 1998: 104–110). On mock-documentary in general, see Roscoe and Hight (2001).

20 While some versions of zoom lens were available from the late 1920s, their use was highly marginal, and common use of the zoom only really became possible from the late 1940s (Salt 1983: 293).

21 Schulman's own work, like *The Watermelon Woman*, manages to be at once aware of the social construction of identities, not least through cultural production, and yet still able to take identities seriously as a basis for political activism (cf. Munt 1992). Also, one of her novels, *People in Trouble* 1987, about the impact of AIDS, provided, unacknowledged,

much of the plot for the musical *Rent* (book and lyrics by Jonathan Larson 1996), which, however, also privileged a heterosexual romance taken from *La Bohème*, a case of plagiarism and adaptation discussed in Schulman (1998), returning us once again to two of pastiche's close cognates.

22 Douglas Watt in the *Daily News* on the first New York production (quoted in Secrest 1998: 216).

23 In the jargon of American musical theatre, the 'book' refers to the spoken and acted part of the show. The orchestrations in *Follies* are especially important to the pastiching, as have been of course the different set and costume designers for the various productions.

24 Dates refer to first productions.

25 Film musicals within film musicals are rarer, although do include *Singin' in the Rain* 1952 and *A Star Is Born* 1956, as well as numbers in some biopics: *The Jolson Story* 1946, *Till the Clouds Roll By* 1946, *Funny Lady* 1975.

26 *Kiss Me Kate, Roberta, On Your Toes, The Pajama Game, The King and I* and *The Sound of Music* are notable exceptions, imitating as they do modes that the implicit cultural hierarchies of Broadway are disinclined to make fun of: respectively, the musical itself, haute couture, ballet, modern dance, foreign and children's shows.

27 The first song written for Phyllis's number was 'Uptown/Downtown', which was replaced for the first New York opening by 'Lucy and Jessie'; this in turn was replaced for the first London production by yet another song 'Ah but Underneath', which was also used in the Paper Mill Playhouse revival.

28 Replaced in the 1987 London production by 'Make the Most of Your Music' (see Block 1997: 290).

29 According to Craig Zadan (1990: 147), 'Sondheim says he intended to imitate the styles of the great songwriters of the times, and affectionately comment on them as well', and Zadan gives the following connections: 'One More Kiss' (Friml and Romberg), 'Lucy and Jessie' (Porter), 'You're Gonna Love Tomorrow' and 'Love Will See Us Through' (Kern and Lane, with Ira Gershwin/E. Y. Harburg lyrics), 'Beautiful Girls' (Berlin), 'Broadway Baby' (DeSylva, Brown and Henderson), 'Loveland' (Kern), 'Losing My Mind' (George Gershwin with Fields lyrics). Banfield (2001: 198–200) proposes other possible reference points.

30 Its most obvious referent is 'A Pretty Girl Is Like a Melody' by Irving Berlin, written for the 1919 Ziegfeld Follies and used for the rest of the series and in the film *The Great Ziegfeld* 1936. The latter also featured 'You Never Looked So Beautiful', used again in *Ziegfeld Girl* 1941, while *Ziegfeld Follies* 1946 featured 'There's Beauty Everywhere' and 'Bring on the Beautiful Girls'. The self-consciousness of the latter was heightened by including a comic variant, 'Bring on the Wonderful Men'. On the 'Ziegfeld Walk', see Cohen-Stratyner (1984: 317–18).

31 Indeed had appeared in *The Passing Show of 1922* in the same theatre, the Winter Garden, that *Follies* opened in in New York (Secrest 1998: 212).

32 For a detailed account of this kind of number, and notably the 'Laceland' number from the 1922 *Ziegfeld Follies*, see Cohen-Stratyner 1984.

33 And 'Uptown/Downtown' and 'Ah But Underneath' (see note 27).

34 1941; Moss Hart (book), Kurt Weill (music), Ira Gershwin (lyrics).

4 Pastiche, genre, history

At a meeting of the Hollywood Directors' Guild in 1950, a speaker stood up and identified himself thus: 'My name's John Ford. I make Westerns'.[1] The anecdote is often told to illustrate Ford's modesty and straightforwardness, but here I want to explore two other implications. First, Ford knows what he is doing (making Westerns), and secondly what that is is clearly seen as unproblematic, a fixed reference point.

Ford knows that he is making Westerns, and in that sense he is self-conscious, but it would seem inappropriate to call most of his, or anyone else's, Westerns self-conscious: to know what you are doing does not necessarily mean that what you do is marked by foregrounded awareness of the fact. Moreover, Ford did in fact make some Westerns that are extremely self-aware meditations on the genre, but they do not use the particular form of self-awareness that concerns this book, pastiche. One of the concerns of what follows, then, is to explore the differences between knowing what you are doing (straightforward genre production), reflecting on this in a work and pastiche as a specific form of that reflexivity.

Ford also takes what a Western is as given. This is rather different from the makers of *The Great Train Robbery* 1903, who, despite its reputation as the first Western, probably did not know they were making a Western, and it is a fortiori different from John Huston or Otto Preminger, who, in directing, respectively, *The Maltese Falcon* 1941 and *Laura* 1944, certainly did not know they were making films noirs. Genres do not spring immediately into existence, they must be identified and promulgated as such, and pastiche plays its part in this. This historical process is the second underlying concern of this chapter, which opens out at the end to a wider consideration of pastiche and history.

My focus is deliberately restricted to narrowly definable genres and to film.

In so far as genre just means type or kind of work, it can designate very broad practices. Aristotle, usually taken to be the first (extant) namer of genres in Western tradition, speaks of such broad categories as epic, tragedy, comedy, dithyramb[2] and 'music composed for the flute and lyre' (1965: 31); some film genre theory argues that the main genres of cinema should really be considered to be the narrative feature, documentary and avant-garde film (Williams 1984).

There are also different ways of differentiating between generic categories, including the emotional affects offered and sought (e.g. melodrama, comedy, romance (cf. Thomas 2000)) and textual qualities of form or of subject matter (Dubrow 1982: 7).

Such broad approaches are not, however, relevant to a study of pastiche. This requires circumscribed, and therefore recognisable and isolatable, styles and concerns. Thus one cannot really pastiche, say, tragedy in general, although one can undoubtedly pastiche ancient Greek, Elizabethan or French classical tragedy, or, even more specifically, Euripidean, Shakespearean or Racinian tragedy. Similarly, the long tradition of the sonnet has been a source of reference and engagement for all who have taken it up (ibid.: 14–23), but pastiching within it none the less requires greater specificity – to write a sonnet now is merely to write within a given poetic structure; you would have to write one like Petrarch and the Petrarchans, the English Romantics or the French symbolists before it could be eligible to be considered an act of pastiche.

The genres I focus on are filmic. This is partly because of my relative familiarity with them (genre study entails considering a large number of works and I did not feel inclined to become competent in, say, the Petrarchan sonnet or gangsta rap) and partly because of the liveliness of recent writing in the field (e.g. Altman 1999, Gledhill 2000, Neale 2000, Thomas 2000). My focus is narrower still, considering just two genres, the Western and film noir (especially neo-noir). I look at these in relation to the two issues I derived from Ford's declaration: kinds of generic self-awareness (focusing especially on the Western) and the role of pastiche in defining genres (neo-noir). At the end, on the other hand, I consider pastiche in relation to history in the widest terms.

Generic self-awareness: the Western

The Western is instantly recognisable, in its look (cowboys and Indians, homesteaders, prairies and deserts, townships, ranches and saloons, sometimes wagon trains, sometimes cavalry, **Playbill** lettering,[3] certain stars[4]) and its sound (gunshots, horses' hooves, the clink of spurs, laconic male speech, distinctive musical scoring[5]). These are not only in the films but also in posters, trailers, records, reviews, websites and learned works. You won't get all of these in any one film but you will get enough to evoke a world and with that other expectations: narrative situations (e.g. chases, shoot-outs, bar-room brawls) and thematic structures (e.g. the confrontation of wilderness and civilisation). It is all this that also makes the Western amenable to self-awareness. Its very distinctiveness is liable to make people especially aware that they are making or choosing to go to see this kind of thing, and this in turn enables reflection upon so making and choosing, reflections that can be built into the films as self-awareness.

In this section, I begin by looking at kinds of self-awareness in the Western, of which pastiche is only one. I then look at pastiche in the Western in three

instances. First, films in which characters themselves are seen to pastiche Westernness and which usually in the process wind up becoming actual or pastiche Westerns. Then, two groups of films – spaghetti Westerns and Westerns centred on women – that, by virtue of, respectively, geographic distance and a major change in generic gender organisation, tend to be especially aware of the Western as a distinct choice with distinct expectations, an awareness liable to result in pastiche. Both these two groups raise the historical question of pastiche in relation to what it pastiches and I end this section with a preliminary discussion, through the instance of the Western, of pastiche and the historical processes of generic definition, a topic that is more centrally the focus of the subsequent section on neo-noir.

Self-awareness in Westerns takes many forms. There are travesty (the Marx Brothers' *Go West* 1940, *Cat Ballou* 1965, *Carry on Cowboy* 1965, *Shanghai Noon* 2000) and parody (*A Bear of a Story* 1916, *His Bitter Pill* 1916, *The Frozen North* 1922, Buster Keaton's *Go West* 1925, *Along Came Jones* 1945, *The Paleface* 1948, *Blazing Saddles* 1974, *Rustler's Rhapsody* 1985)[6] Westerns. There are remakes (several of *The Last of the Mohicans* 1911, 1920, 1932, 1936, 1992,[†] *Pale Rider* 1985 (re-make of *Shane* 1952)) and ripostes (*Rio Bravo* 1958 as a reaction to *High Noon* 1952[7]). There are Westerns that introduce new (or what are perceived as new) elements to the genre and may thus make the habits of the genre more evident: new angles on subject matter (Native Americans (*Broken Arrow* 1950, *Alien Thunder* 1973, *Dances with Wolves* 1990), women (*Johnny Guitar* 1954, *Heartland* 1979, *The Ballad of Little Joe* 1993)) or new stylistic elements (noir (*Pursued* 1947, *Ramrod* 1947), Gothic (*High Plains Drifter* 1972, *Comes a Horseman* 1978), naturalism (*Will Penny* 1967, *The Culpepper Cattle Company* 1972), 'acid'[8] (*The Shooting* 1967, *El topo* 1972, *Dead Man* 1996)). There are Westerns that in dealing with ageing cowboys seem to be writing valedictories for the genre, which means signalling awareness of it even while saying it is dying (*Ride the High Country* 1962,[9] *Monte Walsh* 1970, *Unforgiven* 1992). I shall not discuss all these here (though some may use or court pastiche). There are also both self-reflexive and self-conscious Westerns that are, none the less, not pastiche, which I shall discuss next. And then there is pastiche Western.

Westerns may have built into them a reflection on the significance of what they are doing. Among the most celebrated instances, John Ford's *Fort Apache* 1948 and *The Man Who Shot Liberty Valance* 1962 (Pye 1996) both use a double time frame, relating what happened in the past to the present, and end with a verbal reflection on what has been recounted. In *Fort Apache*, the commander of the eponymous fort, Colonel Thursday (Henry Fonda), leads the cavalry into a disastrous battle with the Apaches;[††] the film ends with a

† These are just the Hollywood versions; there are also German (1920, 1965) and Italian (1965) versions and television versions (1971, 1977).
†† An allusion to Custer's battle with Sioux and Cheyenne at Little Big Horn.

coda, in which Thursday's second-in-command, Captain, now Colonel, York (John Wayne), in conversation with a group of journalists, affirms the heroic image of Colonel Thursday with which they are familiar, over against the depiction of Thursday that we have just seen. In *The Man Who Shot Liberty Valance*, a senator and his wife, Ransom and Hallie Stoddard (James Stewart and Vera Miles) travel from Washington DC to the small Western town of Shinbone to pay their respects to an obscure, recently deceased cowboy, Tom Doniphon (John Wayne); Ransom is celebrated as the man who shot the notorious outlaw, Liberty Valance (Lee Marvin), an act that represents the establishment of law in the West; Ransom tells the local reporters what really happened, that is was Tom Doniphon who shot Liberty Valance.

Both films tell the truth about a legendary character: the dead Colonel Thursday (who foolhardily led his troops to their death but is celebrated for his courageous last stand) and the living Senator Stoddard (who did not shoot Liberty Valance, even though his celebrity rests on the widespread belief that he did). The use of flashbacks puts the events recounted, which form the bulk of each film, into a perspective. *Fort Apache*, whose coda takes place soon after the main story, stresses the continuity of values between the two time frames: the cavalry should continue to live by the values embodied by the image of Colonel Thursday. *The Man Who Shot Liberty Valance*, on the other hand, stresses the gap between the two frames, not only in the evident ageing of Ransom and Hallie but also in symbolic and stylistic particulars: the train journey, which takes the older Ransom and Hallie to Shinbone, contrasts with the stagecoach journey that opens the flashback; slow dissolves, into and out of the flashback and within it, suggest the fading slow sadness of memory (Leutrat 1995: 42–44, 75–76). Yet in neither film is there a stylistic difference between the frame and the main story. There is no pastiche, nothing that keeps to the fore the fact that the tale is being recounted and in Western film form. The reflexivity comes from the contrasts in time and mood, from the very fact that the story is being told and not simply unfolding before one (something one only knows in *Fort Apache* at the end), and above all from closing verbal observations.

In *Fort Apache*, York affirms the truth of an image the journalists have learnt from school books and paintings against the truth he, and now we, know: the books and paintings are, he avers, 'correct in every detail'. In *The Man Who Shot Liberty Valance*, the editor of the *Shinbone Star* tears up the notes that his junior reporter has taken from Ransom's story of what really happened and pronounces: "This is the West, sir. When the legend becomes fact, print the legend". In *Fort Apache* York conceals the truth, so that only we know the distortion involved in producing the myth of the West; in *Liberty Valance*, the representative of the media knowingly colludes in perpetuating a myth he now knows to be untrue, and makes it an article of faith that one should reproduce all such myths. Both films thus reflect upon the promulgation of images of the West, but without recourse to pastiche.

Such self-reflexive Westerns build into themselves elements that prompt reflection on what they are doing. Others, however, signal a consciousness of

themselves as Westerns that also indicates a wish to distinguish themselves from typical genre production. In 1955 André Bazin wrote of the kind of 'Western that would be ashamed just to be itself' (Bazin 1971: 149). He had specifically in mind post-war Westerns such as *Duel in the Sun* 1946, *High Noon* 1952 and *Shane* 1953, but the cultural status of the Western had long, perhaps always, been such that many films would not want to be 'just' a Western. One of the commonest forms of this is the development since the 1920s of the A-Western as American epic: *The Iron Horse* 1924, *The Big Country* 1958, *How the West Was Won* 1962, *Dances with Wolves* 1990. By using historical figures, incidents and motifs (the building of the railroad, the wagon train, the encounter of red and white peoples) and/or foregrounded moral dilemmas, significant locations, painterly composition of the landscape, sweeping orchestral music and high production values, A-Westerns declare themselves to be about history and myth, celebrations of the archetypes of the nation or of humanity itself. In this development there is a self-consciousness about the genre which often feels like a species of self-importance: 'Westerns are better when not so self-importantly self-conscious' (Pauline Kael on *Shane* (quoted in Countryman and von Heussen-Countryman 1999: 73)); 'The A-Western is conscious, pompously conscious, of its responsibility to represent America's essence' (Simmon 2003: 114).

Very often in the attendant preparation and publicity, and sometimes in the films themselves, there is a sense of such productions seeking to be a cut above the typical or B-Western. David Selznick, for instance, was resistant to making *Stagecoach* because he saw it as 'just another Western' (Buscombe 1992: 15).[†] It was by grafting 'the sturdy appeal of the traditional Western proper ... on to the classier pedigree of the Hollywood A-feature' (ibid.) that *Stagecoach* came to be both made and promoted. As Edward Buscombe shows, *Stagecoach* is in its deployment of generic tropes and its casting deeply rooted in the B-Western and such antecedents as the Wild West Show; yet it fashions its group of stagecoach travellers into significance as a cross-section of the society that conquered and settled the West, while the look of its photography and costumes also made it, in the *Hollywood Reporter*'s words, 'one swellegant Western that even the carriage trade will go for' (quoted in ibid.: 88).

Stagecoach melds B-Western attractions (John Wayne, Indian chases, cavalry to the rescue) with A-Western values (Claire Trevor, narrative significance, picturesque cinematography). *Shane* seems to want to purify the genre more fully, 'to freeze the Western myth once and for all' (Warshow 1971: 150),[10] dwelling on A values and insisting on the actual momentous significance of B attractions. Even more than *Stagecoach*, it was made and perceived to be

† *Stagecoach* may have been a version of Guy de Maupassant's short story 'Boule de suif'. (Buscombe suggests most critics are doubtful (1992: 35–36), although Joseph McBride upholds the view in his biography of Ford (2003: 278, 284).) When *Boule de suif* was filmed in France in 1945 André Bazin thought it seemed a good 'pastiche' of *Stagecoach* (unaware of the latter's putative relation to 'Boule de suif') (Bazin 1975: 146).

'above the run-of-the-mill horse opera' (*Daily News*, quoted in Countryman and von Heussen-Countryman 1999: 72) and notably what was perceived to be the Western's most degraded manifestation, 'singing cowboy glamour' (ibid.: 33). Its studio, Paramount, pushed it as Academy Award material (always a sign of a certain level of pretension), campaigned for the script to be awarded the Pulitzer prize and had the music turned into a Symphonic Suite, all bids for attaining the cultural status of literature and classical music. Edward Countryman and Evonne von Heussen-Countryman also emphasise the handling of the elements in the film itself. There was considerable attention paid to historical accuracy in dress and setting; composition draws on the conventions of nineteenth century landscape painting, while the music uses the orchestral palette of pastoralism and what Aaron Copland had forged into the symphonic Western sound (Brownrigg 2003: 65–66). Elements are also made to appear as if in archetypal simplicity. Much of the detail of the book is discarded. The long introduction of Shane (a series of shots that has him riding past the camera into the landscape, then picked out against it, gradually moving closer to the homestead that is the main location for the film) and his equally long departure (receding into the distance, disappearing over the horizon, with the boy's voice endlessly repeating his by now iconic name) take a relatively standard element of the Western, the lone cowboy who comes along, sorts things out and then moves on to fresh situations and adventures, and pushes the treatment towards the abstract and mythic. Likewise, the confrontation with the chief badman is pared down in the *mise-en-scène* to the moral and literal antinomy of light and dark. None of this makes *Shane* pastiche in the sense of signalled imitation: it does not deploy conventions to acknowledge their role in mediating the story and world view unfolded. Rather, it takes the conventions as something more than mediations, as tropes that can be revealed to contain an essential truth about America and eternal human verities of morality and character. It does this with such care and deliberation that the conventions stand out starkly – if you don't buy into them as authentic archetypes, they are liable to appear merely conventions, to be perhaps pastiche in the sense of failed achievement rather than deliberate choice.[11]

Neither self-reflexive nor self-conscious Westerns, as I have defined them, use pastiche. The latter operates in two ways in Westerns: within the world of the narrative and/or in the style of the film itself. In the first case, we see people adopting Western dress and behaviour; in the second, the construction of the film is signalled as itself adoption.

Characters in films may perform Westernness. We may not know that they are doing so at first. In *New Frontier* 1939, we see a cowboy (John Wayne) chased by Indians; when he makes it into a town, it is revealed that this was a show put on to celebrate the town's jubilee, with whites dressed as Indians (Simmon 2003: 101–102). In *Hearts of the West* 1975, set in the 1930s, the hero Lewis Tater (Jeff Bridges), stumbling in the desert on the run from thieves, suddenly finds himself surrounded by whooping and hollering cowboys, who,

it turns out, are on location for a film. In these cases, the West is put on as pageant and movie, respectively, but we do not know that what we see is a put-on until it's over, producing retrospective pastiche. In the case of *Hearts of the West* we may suspect that the whooping cowboys are pastiche from the filmic context: it opens with a spoof silent Western film-within-the-film, Lewis is established as a naïve writer enamoured of the legend of the West and the overall tone of the film is lightly comic; even so, the effect of the sequence resides in the possibility that these are real cowboys surrounding Lewis.

Wild and Wooly (1917 John Emerson) offers a more sustained presentation of pastiching at this level. In it Douglas Fairbanks plays Jeff Hillington, a rich young New Yorker obsessed with the West. The people of the Western town Bitter Creek hope to persuade Jeff's father, a railway magnate, to build a branch from the main railway line to a mining development out of town; he sends Jeff to investigate. Learning beforehand of Jeff's obsession with the West, the town decides to transform itself into the way it was in the 1880s, making over frontages and interiors. When Jeff arrives in town, he is delighted to find, apparently, the West just as he imagined it. When townsfolk pretending to be bad men molest the town beauty, Nell, or confront Jeff, he soon despatches them, and without harming them, since the townsfolk have put blanks in his gun. They even lay on a train hold-up and an Indian uprising. However, under the cover of this fakery, Steve, an Indian agent, and his Mexican side-kick Pedro, decide really to rob the train, using the uprising as a distraction, with Pedro abducting Nell while he's at it. When this happens and the Indian uprising gets out of hand, Jeff proves himself a true Western hero, recovering the loot from Steve, rescuing Nell first from Pedro and then from the Indians, and liberating the town from the Indians.

In *Wild and Wooly* the people of Bitter Creek put on a Westernness that they no longer practice – except that some of them really do still want to rob trains, make off with girls and cross over to Mexico, and the Indians can still be troublesome (especially when, as here, they discover the alcohol in the town saloon). The film moves from the most overt declaration that the West of the Western no longer exists to an affirmation that really it does. We see the modern small town being turned into a Western township (crudely painted signs replace modern ones, bear skins are hung in the hotel saloon, people change into cowboy and cowgirl clothes); characters wink at one another behind Jeff's back and we see them going into character as bad guys for his benefit; and there are elements of parody, notably in the intertitled dialogue (by Anita Loos): when Jeff, barely arrived, says he'll sort out the threat from Wild Bill Higby of Dirty Ditch (already a parodic, almost burlesque, set of names), one man says "Wish you'd come last Thursday, there wasn't a killin' all day long", as if everyone in the West just lives for killings; and when Jeff shows an interest in Nell, a local man says "Take keer of our Nell, pard, – she ain't had much book-larnin' and she's had to use alkali for face powder, but her heart's as big as all outdoors", lines combining mockery of Western pronunciation, sentimental clichés and a touch of the grotesque (alkali for

face powder). All of this keeps reminding us that the West we and Jeff see is
fake. Yet at the end of the film, the town remains as it has been made over,
classic Western adventures have been experienced for real and the townsfolk
on horseback wave their cowboy hats in farewell to Jeff. In other words, it
becomes a Western pretty much like any other. It even in one of its final
intertitles refers to itself generically. Jeff has gone back East by train, leaving
Nell behind. 'But wait a minute!', cries a title, 'this will never do! We can't
end a Western without a wedding.' Thus by the end *Wild and Wooly*, which
seemed to set itself up as a modern comedy, is referring to itself as a Western
and, in the process, spelling out one of the rules of the genre, that it should end
with the cowboy settling down.[12]

It is always clear in *Wild and Wooly* that the townsfolk are putting on the
West, even if Jeff is fooled by it. Yet it becomes the real thing. This is because
of course what the townsfolk are putting on is a Western, both in the sense
of the characters acting in line with broad cultural ideas of the West and also
the performers and filmmakers in fact using the *mise-en-scène*, performance
style and scenarios of the Western film.

Wild and Wooly makes clear the sources of Jeff's fascination with the West
in media images. He reads dime novels, has cowboy and Indian paintings on
his office walls and a statuette of a cowboy on a rearing horse on his desk.
Much of his imagination of the West is really of rodeos: when he gazes at a
painting on his bedroom wall, he takes up the pose of a man in it, and, by
means of a dissolve, the painting comes to life and the man mounts and rides
a bucking bronco, a standard rodeo turn; then Jeff practices circling a lasso,
twirling it round himself as in a Wild West Show.

Jeff also goes to see Westerns at the movies. Here the film performs a char-
acteristic trick. We have already been introduced to the character of Nell in
Bitter Creek and seen her go out riding. Jeff goes to see a movie, *The Round-
Up*, in New York. When he comes out he looks at one of posters for the film,
of a woman on horseback. Cut to Nell riding in the country, then back to Jeff
telling a bystander "That's the kind of mate I'm going to have!", then back
to a medium shot of Nell on horseback, turning and riding off down a trail.
The editing makes it seem that Jeff in his imagination sees the real Nell, and
thus the film itself confuses the West of Jeff's fantasy with the real West of
Bitter Creek; but then, of course, both Wests are really movie images.

This play on imagination, reality and film is established from the begin-
ning of *Wild and Wooly*. It opens with three pairs of shots, each contrasting
the Old West (wagon train, stagecoach, a posse riding into town) with today's
(locomotives, goods train, cars). This contrast seems to be repeated with the
introduction of Jeff's father. We see him in collar, tie and suit, at breakfast
reading a newspaper; the film then cuts to a young man wearing a scout hat,
sitting cross-legged on the ground eating off a tin plate, a cactus behind him
on one side, a wigwam and a cauldron on the other. Though in reverse order
from the three opening pairs, we seem here once again to have a contrast
between today (in the East) and the Old West. But then we see that the young

man is reading a Western story book and the camera tracks back to reveal that he, cactus, wigwam, cauldron and all, are actually indoors, in a rather spacious and well appointed room in a house. This is Jeff, who is playing at living as a Westerner, but the film uses both an editing pattern and a tight framing (that excludes any non-Western *mise-en-scène*) that makes the image seem momentarily to be from a Western.

Once the film has given us both this and the edit of Nell, really out West, and Jeff looking at a cowgirl on a movie poster, there is no problem in having the townsfolk's charade of Westernness segue into a Western film proper. After all, what are both characters and performers doing but acting as in a Western, the standard backlit sets and scrubland exteriors the very ones used for making straight Westerns? The paired opening shots might even already be indicating this to us: the shots of the West today are actuality material, but the shots of the Old West could only be recreations, and recreations for the movies at that.

If, in their different ways, Jeff and the townsfolk put on being and then become Westerners, the film itself also plays with being a Western and by the end becomes one. This is fun: as in all his films of the period, Fairbanks' performance conveys boyish amusement at doing all this, not least in the set pieces of his athletic display, always indicating that he, Fairbanks, is not fooled by either put-on or for-real Westernness (cf. Studlar 1998). However, if it is fun, it is also disquieting. In the move via pastiche to straight Western, Jeff's open-hearted, hybrid imagination of himself as a cowboy living like an Indian (his father calls him "that Comanche Indian")[13] and the film's recognition of the corrupt treatment of the Indians by Indian agents (in the character of Steve) give way to standard issue images of Indians as gullible and drunkards, while the sequence of Jeff riding to the rescue of Nell surrounded by Indians intent on abducting her for their Chief's delectation is straight out of *The Birth of a Nation* (a massive hit from just two years before). In the move from playing at Westernness to being a Western proper, *Wild and Wooly* seems to require shedding any sense of fellow feeling or political awareness vis-à-vis the Indians.

The move in *Wild and Wooly* from putting on the West to becoming a Western is also present in *Westworld* 1973. This imagines a future in which people visit fictional 'worlds' – ancient Roman, medieval, Western – perfectly simulated not only in setting but even down to the humanoids inhabiting them. We know from the start that 'Westworld' is a simulacrum and are reminded that it is so throughout the film by scenes in the control room, shots of the 'worlds' seen on CCTV and glances and verbal exchanges between the clients. Consequently, we know that when a client shoots someone, he's only shooting robots. Yet in two particulars this acting out of Westernness (by clients and robots alike) bleeds into real Westernness (that is, becomes like a Western film rather than a fictional world within a sci-fi movie). First, the sequences within 'Westworld' are for the most part shot like a Western. Confrontation scenes, for instance, use cutting between antagonists and

bystanders to build up tension and shot: reverse shot of shooter and shot-at. Western-style background music is used that, as in all movies, we have to assume the characters cannot hear, but which underlines events and creates general Western ambiance for our benefit. Thus, although we always know from context that it is simulacrum, many sequences taken on their own could be from a Western movie. Second, as the film develops, the machinery gets out of control and the robots start killing the clients for real, leading to a sequence of pursued and pursuer through a canyon, at which point the film has actually become a Western.

My Name Is Nobody (*Il mio nome è nessuno* 1973) crosses the idea of people performing Westernness, as in *Wild and Wooly* and *Westworld*, with the self-reflexiveness of *Liberty Valance* and in the process does not so much, like the former, become a Western, as become itself pastiche. In it, Henry Fonda plays Jack Beauregard, a legendary gunman shadowed throughout the film, much to his irritation, by the young gunman, Nobody (Terence Hill/Mario Girotti).[†] Beauregard is tired of being a legend and just wants to get away to Europe (he has a ticket booked on a boat from New Orleans), but Nobody does not want the myth of the West simply to peter out with the likes of Beauregard slinking quietly away. He therefore stages Beauregard's exit as a suitable finale. First he sets up a confrontation between him and a mass of charging cowboys, the Wild Bunch, saying:

> "Just think of it, 150 pure bred sons of bitches on horseback and you facing 'em alone. You'll be written up in all the history books."

As Beauregard proceeds to rout the Bunch, a series of cuts between him and pictures in history books illustrating the event, with Nobody's words "You'll end in history" in voice-over, recalls the equation between painting and event in *Fort Apache*. Except that here, in fact, the illustration accurately represents the event, which has, however, been rigged by Nobody, who has concealed dynamite in the Bunch's saddles, indicating to Beauregard to shoot at the latter not the men themselves, thus exploding them rather than gunning them down. So it's a magnificent last stand, accurately illustrated, yet based on a sly strategy. There is a further echo of *Fort Apache*. Beauregard does not know what Nobody has planned until the last minute, thus he does face up to the Bunch bearing down on him; like Captain Thursday (that is, also, Henry Fonda), his character is not in doubt, even if the grounds on which his ultimate fame rests are (in *Apache*, distorted subsequent representation; in *Nobody*, at-the-time trickery).

† The name Nobody is taken by the Native American character in *Dead Man* (specifically on this borrowing, see Rickman (1998: 395–396)). Jim Kitses (1998: 27) refers to *Dead Man* as 'a striking pastiche of *The Man Who Shot Liberty Valance*'. For further discussion of *Dead Man* and revisionism in the western, see Hall (2001) and Rickman (op. cit.).

The film does not end with this confrontation. Defeating the Wild Bunch consolidates Beauregard's legendary status rather than relieving him of it. The only way out is to die, suitably. Beauregard and Nobody face each other in a final shoot-out in the street, Nobody draws first and Beauregard falls. But this is in New Orleans, has been staged for a photographer and is faked: Beauregard is not really shot even though everyone thinks he is, leaving Nobody with the burden of being the Man Who Shot Jack Beauregard.

As with *Wild and Wooly* and *Westworld*, *My Name is Nobody* shows characters putting on the West, but more extensively than them it also itself pastiches the Western. For instance, every so often there is a long sequence of the Wild Bunch riding through the country. They are a huge number of men, much more than the eponymous Bunch of Sam Peckinpah's 1969 film,[14] and it is the riding through the country, rather than getting somewhere, that matters: the Bunch spread out across the (very) wide screen against impressive landscapes of boulder and desert; the great swirls of dust thrown up by the galloping; and devices which dwell on the loveliness and excitement of the movement and formation (including a spectacular crane shot, an extreme close-up of horses' legs in soft focus, slow motion, and a use of a telephoto lens so that, while the bunch are clearly moving towards the camera, they never seem to get any nearer). All this is to music (by Ennio Morricone) that combines confident whistling of a cheery, soaring theme, male choral grunts and tinny guitar riffs, in other words, worked-over Western music elements, heightened at points by a synthesised 'Ride of the Valkyries'. In short, these sequences are slight exaggerations of blockbuster Western elements, made all the more notable by their lack of any significant narrative function, so that they become displays of generic form qua form, that is, pastiche.

This handling of the Wild Bunch sequences is characteristic of Italian spaghetti Westerns,*[15] and it is to these that I now turn more fully. Pastiche is their ground both contextually and textually.

Spaghetti Westerns have long been referred to in passing as pastiche. Michael Parkinson and Clyde Jeavons (1972), for instance, call them, disparagingly, 'astonishingly popular and lucrative pastiches of the hallowed American Western',[16] and Edward Buscombe, favourably, 'highly self-conscious pastiche' (1992: 75). The very fact of a Western being made not in the American West or even North America, and at a time when Hollywood Western production was considerably diminished, may suggest that at the very least it is apt to be pastiche, to be not the real thing and evidently conscious of it.[17] Moreover, the cultural presence of the Western, the overdetermined sense of its Americanness in the context of the overwhelming global presence of American popular culture, means that its iconography and style is always

* Frayling (1981: xi) notes other culinary terms used to qualify non-American Westerns – Sauerkraut, Paella, Camembert, Chop Suey, Borsch and Curry Westerns – and also that another food term was once used for Hollywood Westerns: oaters.

redolent of American values. To do Americanness in an evidently Italian (or at any rate un-American) way is liable to feel like putting it on.

Liable but not inevitable. In a discussion of the German films based on the novels of Karl May, Tassilo Schneider (1998) argues that while these German Westerns do not (as some have averred) simply reproduce the Hollywood model, nor are they involved in pastiching it; rather they transform it into a utopian space of adventure, stripped of the historical/mythic connotations of American Western *mise-en-scène* and narrative structures. Schneider explicitly contrasts this with the spaghetti example.

The spaghetti, pastiche sense of Europeans doing Americanness without quite inhabiting it is carried in the names of both the heroes and the actors playing them as well as of other personnel. The heroes' names sometimes (Ringo[†]) have Hollywood Western connections; more (Biondo, Django,[††] Sabata, Sartana, Trinità) do not; and still others are a rejection of naming ('The Man with No Name' in Leone's *Dollars* trilogy, Nobody in *My Name is Nobody*). They are played sometimes by Italians who retain their (star) names (Franco Nero) or who sometimes do but at other times adopt punningly Hollywoodian names (Giuliano Gemma/Montgomery Wood) or hybrid Anglo and Latin ones (Gianni Garko/John Garko, Gian Maria Volonté/Carlo John Wells) or who became known principally by Anglo-Saxon names (Terence Hill (Mario Girotti), Bud Spencer (Carlo Pedersoli)), or else sometimes actually by Hollywood stars, bit players, newcomers and has-beens (William Berger, Clint Eastwood, Henry Fonda, Burt Reynolds, Lee Van Cleef); one of the most popular spaghetti stars, Tomas Milian, was Cuban; secondary roles often went to older Hollywood stars (Dan Duryea, Farley Granger, Jack Palance). Some directors, well known from other genres, went under their own names when making spaghettis (Damino Damiani, Carlo Lizzani), but others sometimes used their own names, sometimes Anglo-Saxon ones: Sergio Corbucci (aka Stanley Corbett and Gordon Wilson Jr), Sergio Leone (Bob Robertson), Sergio Sollima (Simon Sterling). No-one doubted for long that these were Italian films:[18] they were marketed as such, most of the other personnel have Italian names and many of the performers were familiar Italian faces; equally, anyone would know that the Western is a quintessentially American genre. The names play promiscuously with this sense of mixture, not simply and invariably substituting Anglo for Italian names, but more a teasing of the taken-for-grantedness of the underlying generic reference points, a teasing that contributes to the default pastiche tone of the films.

My Name is Nobody ratchets this up in its use of Henry Fonda and Terence Hill. Fonda embodies the classic Hollywood Western (at its most morally serious),

[†] Echoing the name of John Wayne's character in *Stagecoach* and of the reluctant legend Jimmy Ringo in *The Gunfighter* 1950.

[††] Named after Django Reinhardt (according to Hughes (2004: 59)), that is, a foremost European exponent of a quintessential American art form, jazz.

Hill the spaghetti (at its most slapstick, in especially the two Trinity films (see below)). The opening sequence stresses Fonda's pedigree by reworking the beloved barbershop sequence from *My Darling Clementine* 1946, down to his spraying himself with perfume after a shave (whereas in *Clementine* the barber sprays him, to his subsequent mild embarrassment); the confrontation with the Wild Bunch reruns, as noted above, Custer/Thursday/Fonda's last stand in *Fort Apache*. Beauregard's (Fonda's) desire just to get away to Europe gestures towards to spaghetti Westerns and their complex relation to the legends of West. Hill/Girotti/Nobody/Trinity, on the other hand, is given ample opportunity to display his impish taste for violent tricks and outwittings and his constant desire for beans and sleep.

But spaghettis do not need to be as self-consciously and specifically allusive as this. They mostly pastiche general tropes of the Western rather than specific films, such as the entry of the cowboy hero and the shoot-out.

Nearly all spaghetti Westerns open with a lone protagonist riding into the film's world, most commonly coming in to a landscape from a space behind the camera (as in such canonical Hollywood openings as *My Darling Clementine* and *Shane* (discussed above)), then, via a series of shots riding through country, arriving in a small town. Dimitris Eleftheriotis (2001: 115–122) shows how the opening of *Ringo and His Golden Pistol* (*Johnny Oro* 1966) pushes this towards a celebration of Ringo/Giuliano Gemma's 'physical presence, in his black clothes, golden pistol and his love for gold'. The opening of *They Call Me Trinity* (*Lo chiamavano Trinità* 1970) likewise emphasises Trinity's character: close-ups of a gun in a holster and boots with spurs being dragged over sand, then a track starting on Trinity/Hill/Girotti's face with stubbled chin and his hat over his eyes, yawning, and then the camera moving down his body, revealing that he is lying on a travois, showing his tattered granddad vest and very faded, dusty jeans and finishing on bare feet, an image of cool (and, as the English language title song has it, Trinity is 'always cool'), then finally a long shot, horse and travois coming in from behind the camera screen left, all to the accompaniment of a breezy tune whistled to acoustic guitar accompaniment. The opening anatomises the hero: his gun, his boots, his Western-attired body. The close-ups do not serve a narrative function, as they might further into a Hollywood Western, but rather display the adoption of Western elements. This is emphasised by the fact that nothing is doing what it is supposed to do narratively in a Western: the gun and boots are out of use, the travois is being used for lazy transport not carrying the sick, Trinity is not on the alert. Like the rest of this film and the sequel *Trinity Is Still My Name* (*Continuavano a chiamarlo Trinità* 1971), this sequence nudges towards comedy: the tone of the music is light-hearted and to begin with a hero being carried lazily along on a travois rather than riding into the scene is a gag. Yet this is not parodic nor, yet, travesty, but pastiche, the savouring of generic elements as generic elements.

The shoot-out is a set piece of the Western, early on in a film the moment at which the hero demonstrates his prowess, climactically the decisive

confrontation between him and the forces of disorder. Cowboys in Hollywood Westerns have preternatural abilities at being quick and unfailingly accurate on the draw. While dazzling and thus, we at some level probably know, a trick, the agreed fiction is that the skill resides in the man himself. The dazzle is pushed much further in spaghetti Westerns. Where in, say, *Dodge City* 1939, *My Darling Clementine* 1946, *Gunfight at the O.K. Corral* 1956, *Doc* 1971, *Tombstone* 1993 or any of the other films based on the O.K. Corral shoot-out (cf. Buscombe 1988: 115), everything is clear spatially (where people are in relation to each other and the setting) and temporally (the sound and sight of someone shooting cuts to someone falling back shot), in spaghetti Westerns, characteristically, extreme close-ups and extraordinarily rapid editing fragment space and time and make it impossible to work out how the hero manages to outshoot his opponents. Since the latter are often many against the hero on his own, the thrill is even more incredible. When in *My Name Is Nobody*, Beauregard/Fonda, inside a barber's shop, outshoots three men outside who draw on him simultaneously, the barber's son turns to his father and asks "How'd he do it, pa? I only heard one shot", and gets the reply, "It's a question of speed, son". Yes, indeed, but here, as throughout spaghettis, it's the speed of editing rather than of drawing and shooting.[19] Western heroes everywhere win shoot-outs thanks to editing, but in spaghetti Westerns the editing itself constitutes the excitement, a visceral explosion of near-subliminal cuts that stun the eye. Spaghetti Westerns thus, and characteristically, take a standard formal procedure of the Western and then exaggerate and intensify it, to the point that it is carrying most of the force rather than the action it is disclosing.

This procedure is typical of pastiche, although spaghetti Westerns are seldom, perhaps never, all pastiche. It is the default mode that then enables them to push things towards, for instance, light-hearted slapstick (Trinity), manic perversity and violence (Django), political comment (*A Bullet for the General* [*Quien sabe?*] 1966, *Duck You Sucker* [*Giù la testa* aka *A Fistful of Dynamite*] 1971, *Bad Man's River* [*E continuavono a fregarsi il milione di dollari*] 1971) and high seriousness (*Once Upon a Time in the West* [*C'era una volta il West*] 1968). There are, however, perhaps two major impulses, often combined: boys having fun and ironic self-reflection.

The boys-just-want-to-have-fun impulse is already evident in *The Life of an American Cowboy* (see below) and the Douglas Fairbanks' Westerns that made *Wild and Wooly* possible, and also in Tom Mix, Tim Holt, Gene Autry, Roy Rogers and, on television, *The Lone Ranger* and *Rawhide*.[†] Such figures, just like Billy the Kid or, come to that, Shane, are detached from the world of

† Which, running from 1959 to 1966, starred Clint Eastwood, who then, beginning with *A Fistful of Dollars* 1964, went on to be the most internationally famous star of spaghetti Westerns (even though he only made three).

homesteaders and townships, free to roam in search of adventures. This is even more strikingly so of spaghetti Westerns, where the hero is also detached from many of the meanings of the Hollywood Western, even from the meaning of the lone hero in the Western. As Eleftheriotis shows, Ringo, Django and the rest stand out against the *mise-en-scène* of the film, which in any case lacks detail, and thereby are doubly disconnected from the ideological freight this carries in the American Western. This is of a piece with the impossible death-by-editing shoot-outs and the frequent sequences of cheery, aimless riding about the countryside that fill spaghetti Westerns. As a result, instead of the hero representing the values of the cowboy and the West, he is valued for how he looks, how he rides, how he shoots – as Eleftheriotis puts it, in spaghettis 'to be pretty is to shoot well' (2001: 122). The fun then is not just the galloping about, the (often slapstick) rough and tumble of a brawl, nor alone the explicit and sometimes aestheticised portrayal of the entertaining nastiness of violence, but also male narcissism and sometimes homoeroticism in the presentation of the body. What is still at some level ideologically – mythically, historically – motivated in, even, Douglas Fairbanks or *The Lone Ranger*, is in spaghettis prized for the opportunity afforded for certain kinds of human (though, in the event, exclusively male) pleasures of voyeurism and display. The Western generic tropes remain important, for they provide certain notions of American freedom, opportunity, space and mobility favourable to the kind of fun spaghetti boys want to have; yet, precisely because there is a sense that it is only a bit of fun, all these notions are no longer quite meant, which is the sense in which the fun of the spaghetti Westerns is a kind of pastiche.

Spaghetti Westerns do also sometimes take themselves, the Western and its Americanness more seriously. I want to consider here one of the best known spaghetti Westerns, *Once Upon a Time in the West* (figures 4.1, 4.2, 4.3), and in particular one moment, the arrival of Jill (Claudia Cardinale) at Flagstaff, a moment in which one sees the process of pastiching at work.

Once Upon a Time in the West deals with a standard moment in the epic of the West: the coming of the railroad and the establishment of community (cf. *The Iron Horse* 1924, *Union Pacific* 1939, *Carson City* 1951, *How the West Was Won* 1962 (Buscombe 1988: 205–209)). It gives this a Marxist gloss: the railroad is both a technologically advanced and a commercially driven enterprise that is antithetical to the lawless, chivalrous, revenge-driven, in short, pre-capitalist mentality represented by gunfighters; the railroad entrepreneur is driven by greed, ready to do anything to achieve commercial dominance (including employing pre-capitalist gunfighters); but in the process he must produce a workforce, and at the end of the film it is they, united around the figure of the woman, who seem to be about to inherit the earth. As in classic Marxist models, capitalism sweeps away feudalism and brings the benefits of order and technology; it also produces, and exploits, a working class that is necessary to it and will eventually overthrow it and create a communitarian society. This intellectual schema co-exists with sequences of incredible

out-shootings, laconic humour and romantic lyricism, producing the film's particular 'once upon a time' flavour.†

The historical model and the lyricism are condensed in the coming of the railroad to the town of Flagstaff and in the scene of Jill's arrival there by train. She comes as bride to one of the settlers, McBain, but he is not at the station to meet her. She looks about her, then makes enquiries and has herself driven out to McBain's ranch, Sweetwater (where she discovers he has been killed). Three things indicate the work of pastiche: music, camera movement and Jill.

As Jill looks about her, there is a honky-tonk piano playing somewhere; we do not see where, but given its familiarity and the sound level mixed with ambient sound of voices, a light wind and the unloading of the train, it's reasonable to assume it's playing in some nearby bar room. Jill looks at her watch, then checks out the station clock; on a cut to a close-up of the latter, the honky-tonk piano and ambient sound fade away; on the cut back to Jill, we have the introduction of the musical phrase that introduces the title theme of the film. The sound level is now clearer and closer, with only ambient wind underlay; the uneven, almost hesitant phrase is played, over a deep sustained bass chord, by a harpsichord, 'pungently but also fragilely metallic' (Miceli 1994: 143). The tempo and instrumentation are distinctive for a Western, meditative and archaic, yet both the syncopation of the rhythm and the timbre of the instrument in fact carry over sound qualities from the honky-tonk piano. In part this is an effective way to bridge the shift from music within the world of the film to music without it (diegetic to non-diegetic), so that the latter seems to rise imperceptibly out of the former. It is, though, also a demonstration of the pastiche principles of distortion (slowing down the rhythm) and discrepancy (substituting harpsichord for honky-tonk piano), used here not just to maintain the sense of a film that is doing but not quite inhabiting its ur-genre (the Hollywood Western) but also to suggest perspectives of quiet reflection and archaism (that is, perhaps, Europeanness).

Jill stands and looks about some more as this phrase is repeated; then, with the camera cut back some distance from her, framing her just left of centre of the widescreen and with her facing the camera, she starts to walk directly towards it. At the moment she starts, the title theme comes in on the sound-track, a soaring melody sung wordlessly in an effortless, clear, high soprano (Edda Dell'Orso), with string orchestra accompaniment; as Jill goes to the station manager's office and thence out into the town, the melody completes and then, via a tremendous rising orchestral bridging crescendo, is taken up again on massed violins with accompanying wordless mixed voice choir and occasional harpsichord chords. Romantic music does occur in Westerns, though nearly always specifically tied to love scenes and usually pretty well indistinguishable from such scenes in other films (Brownrigg 2003: 242–244), and where such themes have been used as a basis for the score (most famously and influentially in *High Noon*) they have not usually been sung by women.

† Frayling (2005: 59–63) the many 'explicit citations' of classic Westerns in *Once Upon a Time in the West*.

The nearest anticipation of *Once Upon a Time in the West* in this respect is *Johnny Guitar*, itself an extremely unusual Western that more generally prefigures *Once Upon a Time* in its search for a new look and tone for the Western.[20] In *Johnny Guitar*, the melody, if not as long-lined and soaring as *Once Upon a Time*, is less regular and strophic than the *High Noon* and other such themes, and it is sung by a female voice (Peggy Lee). However, the latter is heard only over the final moments of the film and addresses a man (Johnny); elsewhere, the theme is used always to accompany the romantic/melodramatic scenes between ex- and renewing lovers Vienna (Joan Crawford) and Johnny (Sterling Hayden). Achingly yearning, it never attains the dreamy lyricism of the *Once Upon a Time* theme, which is moreover associated with a woman, but not within a love context, rather as a pioneer. The main theme is a transformation beyond pastiche, but it has been arrived at (and is usually introduced elsewhere in the film) via pastiche (the archaic, meditative phrases) and, as we shall see, contributes to the pastiche effect of the camera movement and the figure of Jill as well as more broadly to the 'Once Upon a Time' feel that casts the whole film into the ambit of pastiche.

When Jill advances towards the camera, it starts to move backwards away from her; it then tracks right with her movement into the station manager's office and then, in exact synchrony with the rising musical crescendo, it cranes up, past the office roof, to disclose a panorama of Flagstaff, with Jill, now bottom centre of the frame, walking into the town (and thus up the screen). Camera movement is common enough in Westerns, usually to follow the exciting actions of characters or sweep across landscape; here it begins by following a narratively interesting but not exciting character movement and then gives way to a spectacular crane shot of a townscape. Moreover, the town is in the process of being built and the central character is a woman. In other words, again a basic procedure of the Western is both exaggerated (the smoothness of the camera's movement, the precision of its interaction with the music and character movement, the technical prowess of the track giving way to the vertiginous crane) and discrepantly applied (to a town, one moreover in the making, and to a woman).

Both the voice (and, perhaps, lyricism) of the music and the camera's centring insist on Jill as the key to the image. Women in the Western have tended to play secondary roles (cf. Levitin 1982 and Cook 1988). They may be whores, necessary comfort and release for the lone cowboy, in which case they cannot usually become wives and mothers. The latter roles, often marginal in terms of action, are none the less symbolically essential, especially in the more historically minded Western, for they are the unspoken ultimate reason for the action, the settlement of the land by the reproduction of the white race. Jill draws on the same symbolism and she has nothing to do with the aberrant female cowboy discussed below. She does, however, amalgamate the whore and wife/mother image. She was a whore before coming West, arrives as a bride and turns out to be McBain's wife already and, therefore, his widow. At the end of the film, after some hesitation, she decides to settle, and, as one

Figure 4.1 Once Upon a Time in the West 1968 (Paramount/The Kobal Collection).

of the other characters (Cheyenne (Jason Robards Jr)) has suggested, takes out water for the railroad workers. This is an image of the nurturing woman, wife, helpmate, mother, but it is also a sexual image, for it signifies her acceptance of the main thrust of Cheyenne's advice:

> "[You] can't imagine ... how happy it makes a man to see a woman like you, just to look at her. And if one of them should pat your behind, just make believe it's nothing – they earned it".

This reconciliation of whore, wife and mother in the figure of Jill is achieved partly through foreignness. Jill comes from New Orleans, with its continental European, mixed race and sexually permissive connotations, rather than the morally pure, mono-racial and asexual New England backgrounds of many Western women, embodied supremely by Clementine (Cathy Downs) in *My Darling Clementine*. And Jill is played by a well-known Italian star.†

† Cardinale had already played in a Western, *The Professionals* 1966; there she was a railroad millionaire's wife kidnapped in Mexico who does not want to return to the West; as with Leone's use of Henry Fonda (classic good guy, one time Mr Lincoln) in *Once Upon a Time* as an unremittingly callous killer, Cardinale is cast exactly against her previous association with the West: she wants to be there, for the railroad.

Figure 4.2 Once Upon a Time in the West 1968 (Paramount/Rafran/The Kobal Collection).

Jill's/Cardinale's Europeanness (Italianness, spaghetti-ness) makes possible this reconciling twist on the usual roles of women in the Western, contributing to the film's sense of the desirability, otherness and impossibility of the West of the Western.

The final shot of the film is accompanied by the theme tune, which undergoes a variation taking it to even more lyrically soaring heights, Edda Dell'Orso now recorded with yet more echo, so that it sounds almost

Figure 4.3 Once Upon a Time in the West 1968 (Paramount/Rafran/The Kobal Collection).

Figure 4.4 The Quick and Dead 1995, Ellen's clothes (Tri Star/The Kobal Collection/ Close, Murray).

like a female chorus, the embodiment of the principle of womanhood. The shot is one long take, the camera first zooming in quite fast on Jill as she strides confidently towards the men carrying two pails of water, then pulling much more slowly back, as she chats to the men (notably one of the black workers, all part of the utopian vision of inclusion) and they gather around her, with the dust of their movement creating a haziness around them all.

As the camera cranes back higher, the film's title in Playbill lettering appears over the shot and recedes spiralling from the camera until it fades from sight, while the camera tracks now away from the group around Jill to the panorama of the working men and beyond that to the two main surviving male characters riding away. The towering music and camera movement, the hazy image and the spiralling title all evoke what has all along been implicit and what that title makes explicit, namely, that this is all fairy story, a long 'if only', a desire for there to have been a West like this along with an acknowledgement that there never was (and a Marxist critique of the historical West), a pastiche sublime.

Part of the pastiche quality of *Once Upon a Time in the West* is achieved, as already noted, through the impossible reconciliation of female gender roles in the figure of Jill/Claudia Cardinale. A genre so overdetermined in terms of gender as the Western is liable to be thrown out of gear when there are sex role changes: a change in gender role is a change in the generic conventions. However, the Jill/Cardinale reconciliation of roles does not challenge the options for women in the Western. Other films (*Annie Get Your Gun, Calamity Jane, Cat Ballou, Cattle Queen of Montana, Johnny Guitar*) have played with putting women in the male Western roles. Often this has meant pushing the genre flavour towards acceptable feminine spheres of melodrama and the musical, often getting a laugh out of the cowgirl protagonist and insisting on the need for her to learn femininity in order to get the thing she obviously most wants, a man. All of this reaffirms the Western's generic gender equations. However, two mid-90s films, *Bad Girls* 1994 and *The Quick and the Dead* 1995, both put women centrally into male roles in a way that risks highlighting those conventions as conventions, which could mean pastiche. This is what happens overwhelmingly in *The Quick and the Dead* but only occasionally in *Bad Girls*.[21]

The latter tells of a group of prostitutes who become outlaws after shooting a client molesting one of their number. In the process, they hook up with various men, one of whom is captured and has to be rescued by the women, in a sequence leading to a final shoot-out. *Bad Girls* works very much within the style of the Hollywood A-Western feature (albeit not a super-production) and for the most part finds plausible ways to reconcile the women with their masculine roles: the idea that whores were independent women who could look after themselves is in any case not far-fetched, and the film takes care to show that some of the characters have to learn to use a gun, while others are willing if need be to use their femininity to get what they want. *The Quick and the Dead* is based around a shooting contest, one of whose contestants, and the ultimate winner, is, unprecedentedly, a woman, Ellen (Sharon Stone). Its style is a hybrid of Western traditions (wholly integrated with one another, thus not pasticcio): part B-Western (boys – and a girl – just having fun in a pointless, sadistic contest), part A-Western (high production values, with Stone near the highest point in her career), part contemporary Hollywood art cinema (a dark cinematographic and musical palette reminiscent of *Seven* 1995),

part spaghetti (gunfights as moments of visceral explosive pleasure for the viewer as well as of cinematic sleight of hand, music based on Morricone (cf. Brownrigg 2003: 98) and a denouement that explicitly references *Once Upon a Time in the West*[22]).

An index of the films' tendency towards pastiche – and the difference between them – resides in costume.

For most of *Bad Girls*, the women wear women's clothes. This may provide a sense of cognitive dissonance, women in lacy bodices and voluminous skirts, with long flowing hair, riding fast astride horses to rescue one of their number from the gallows, chasing after a bolted horse and cart or riding off with the booty from a train hold-up. Yet everything about the film – how it is acted, shot, its music in the expansive tradition of *The Big Country* and *The Magnificent Seven* – tends towards encouraging us to adapt our ideas of Western action to accommodate it being performed by women who do not thereby have to be seen as masculine.

Only at the end of *Bad Girls* do the women dress in cowboy clothes: Stetson hats, patterned shirts, waistcoats, gun belts, black, brown or beige jeans and boots. In *The Quick and the Dead*, in contrast, Ellen wears male clothing virtually throughout: brimmed hat, duster overcoat, embossed leather jacket, broad gun belt, leather trousers with Mexican slit bottoms, boots with spurs (figure 4.4). In both cases, the sense of pastiche is nearer to the fore, partly because of the ambiguity of such clothes in relation to gender. By the 1990s they had long become accepted, indeed utterly normal items of female clothing,[23] and their suitability is if anything heightened in both films by the unmistakably female glamour of the stars who wear them. Yet historically such clothes are identified as male, something reinforced by the asymmetry in such gender divisions in the conventions of accoutrement.[24] Equally, these specifically Western items of clothing carry particular masculine Western values. Thus, while there is nothing outlandish anymore in seeing women dressed like this, it does still carry an echo of masculinity, of its historical gender and genre appropriateness, something further underlined by the poses of the women with guns at the ready and the narrative situations (a gang facing down another in order to rescue one of their number, a shooting contest), all traditionally male. Just because cowboy clothes are now near normalised as female clothing, but yet carry reminders that this was not always so and a fortiori in generic situations like this, they begin to render the image something like pastiche, something like performing or acting out the West.

This may be at work in the final sequence of *Bad Girls*, where, dressed as described, the girls ride in what one might call Bunch formation across the horizon and into the ranch of badman Kid Jarrett (James Russo), confront him and rout him and his men in a gun battle. Yet the sequence is not shot and played in a way that pushes it towards pastiche and it might be that to see it as pastiche is to see it as failing to pull off the scene as a straightforward generic confrontation between Western gangs (as if, in other words, the fact that one of the gangs is all female simply must make it feel played at). *The Quick*

and the Dead, on the other hand, is grounded in pastiche (not least in its amalgamation of Western modes, indicated above). Its central conceit – a contest in which the contestants shoot to kill one another – works up the boys-just-want-to-have-fun impulse into the deadly serious business of a lethal shoot-out. It also plays explicitly on the issue of clothing and gender. In the opening, pre-credits sequence, someone on horse back, in Stetson and duster overcoat, rides into the scene in classic fashion (*My Darling Clementine, Shane, A Fistful of Dollars, Ringo and His Golden Pistol*); a man burying gold sees the stranger and thinks they've come to steal from him; he shoots and the stranger falls; as he peers over the body, the stranger knocks him out with a kick; only when the stranger says "Arsehole" do we realise it's a woman. Throughout the film, much is made of the sound, with and without tracking close-ups, of boots with spurs on them. Sometimes they turn out to belong to one of the men, but sometimes Ellen. However, the camera has only to track up Sharon Stone's body, her legs and behind sheathed in leather, for not just her gender but the glamour of it to be evident. Sound and initial image retain the association of this clothing with Western masculinity; the track up the figure reminds us that, outside the Western, such a look is also feminine; but since after all this is a Western, the net result is to emphasise the person wearing these clothes as someone putting something – Westernness – on.

At one point in *The Quick and the Dead*, Ellen does wear women's clothes, when she is invited to dinner by Herod (Gene Hackman), the organiser of the shooting contest and the man she wishes to kill. We see her lay out satin lingerie, then see her walking across the street trailing a long, flouncy skirt behind her, with a flower-patterned shawl round her shoulders and hair piled high up on her head; later, at dinner, we see she is wearing a frilly off-the-shoulder dress, while shots from below the table enable us to see her garters and black lace stockings, as she releases a small gun from its holster. All of this is excessively feminine, offset by the confidence of her stride across the street and the gun concealed in amongst the lace; in other words, it suggests femininity as masquerade, something put on rather than innately possessed.

Masculinity can also be performed (though the perception of this is perhaps even more threatening than the masquerade of femininity, with masculinity, and especially Western masculinity, strongly invested in notions of naturalness and authenticity). A sense of this seems to be at work in *The Quick and the Dead*. The contestants act out pointed, only just exaggerated stereotypes of masculinity: Ace (Lance Henriksen), for instance, introduced by the sound of his clinking spurs, then a track along a long shadow and up its source, dressed in black leather embossed with spades,[25] with trimmed beard and moustache and flat black hat, standing holding the saloon doors open; Sergeant Clay Cantrell (Keith David), pausing laconically to light a long-stemmed pipe, when asked how to spell his name when names are being taken for the contest, and replying "Correctly", wearing a blue cavalry officer overcoat and presenting himself later as a "gentleman adventurer", deep voiced,

very conventionally handsome but, still surprising given the genre and the Southern indicators, African-American;[26] and Spotted Horse (Jonothon Gill), in black suit with long black hair and braid, and chunky Native American necklace, speaking in defiant but broken English ("Many white men leave this town in wooden box"). More developed is the Kid, played by Leonardo DiCaprio. He looks as pretty (clean, blonde, floppy hair, pink, smooth complexion, often smiling) as Sharon Stone (often dirty, always scowling), perhaps even more so; his youthful prettiness clothed in neat, clean masculine Western gear (tastefully blended browns, with, like Ellen, a large loose patterned scarf about his neck) seems far more a performance of masculinity than does hers. This is reinforced by the film's overt deployment of mythic overtones, of Œdipus, who is destined to kill his father in Greek myth (just as, according to Freudianism, all men must do symbolically if they are really to become men), and of King Herod, who has all newborn children slain on hearing of the birth of a potential rival, the Saviour, Jesus. Kid is one of the participants in the contest organised by Herod, who turns out to be his father; the time comes when they must face each other in the contest and, against Œdipal (but not Biblical) expectation, it is Herod who kills him and not vice versa. Kid is almost comic in his preening assumption of grown-up masculinity (and Ellen/Stone conveys as much when he first comes on to her and then when she beds him) and is unable to live up the Œdipal archetype. In contrast, Ellen, a woman, puts on masculinity and does deliver on its promise: she does kill the archetypal father (the organiser of the contest and also the killer of her father).

When, at the end *Bad Girls*, Cody (Madeleine Stowe) finally confronts Jarrett, he is out of bullets; she tosses him one, saying "Die like a man", that is, in a fair shoot-out. The irony of this being said by a woman may also lead to a reflection that what men have always done in Westerns is act 'like' men, that everything is a species of gender performance that only appears to come naturally to one sex rather than another. If Cody and the others may appear to be acting like men in the last part of the film, then her "Die like a man" may in turn suggest that so have the men been all along.

My use of the terms 'masquerade' and 'performance' above draw on now well established discourses within gender studies, stemming, respectively, from the work of Joan Rivière (1986 [1929])[27] and Judith Butler (1990, 1991). Their work argues that we should learn to see femininity (Rivière) and gender more generally (Butler) against the grain of what we take them to be, not as given and natural behaviours, but as enactments, based on endless reiteration and imitation. Pastiche may be one way in which works can show that this is so, since it is by definition the open presentation of imitation. However, as with all such aesthetic manoeuvres, it doesn't necessarily work like that. Both films do also slip into the default position of the naturalness of, especially, male masculinity. The contestants and the comparison of Ellen and the Kid in *The Quick and the Dead*, and Cody's line to Jarrett in *Bad Girls*, are striking and suggestive, reinforced in the former by the film's overall tone

of pastiche. However, both films also have male characters and performances that suggest the naturalness of their assumption of masculinity, the sense indeed that it is not assumed but the embodiment of how they are, that it is being not performance. They may be threateningly bad, but if so have mature authority (Herod/Gene Hackman) or a real sense of threat (Jarrett). The good men may be wounded or restrained (in *Bad Girls*, Josh (Dermot Mulroney) is captured and William (James LeGros) is wounded, unable to join the rescue party for Josh; in *The Quick and the Dead*, Cort (Russell Crowe) is a peerless gunfighter who has undergone a Christian conversion and refuses to fight); such maimed or held-in masculinity may serve to explain why the women have to behave as they do, against their upbringing and even natures (and if Cody does face down and kill Jarrett, she and the girls fail to rescue Josh, whom Jarrett kills in front of them). Moreover, while sidelined from the action, the masculine capability of Josh, William and Cort is always clearly established, and they never cease to be attractively virile. Mulroney, LeGros and Crowe all sport designer stubble; this is a major feat of grooming (and thus of putting on masculinity), requiring daily trimming, but it signifies natural growth and is a kind of attractiveness only available to men. In short, if aspects of both films deploy pastiche and thereby break open the masquerade and performance of gender by virtue of generic discrepancy, they also hang on to a sense that masculinity is none the less more appropriate to some people (that is, men) than to others.

Both spaghetti Westerns and those centring on women suggest some kind of distance – cultural, geographic, ideological, gendered – from the standard Western. I by no means wish to argue that such distancing is a *sine qua non* of pastiche production, but cultural shifts and dislocations are liable to make one aware of the particularity of a convention that one adopts, thus making the option of pastiche more readily apparent.

Spaghetti and woman-centred Westerns also affirm the sense, noted in the John Ford declaration with which I opened, that the Western is a known quantity that is there to be pastiched. Yet very often what is involved in pastiche, as well as other kinds of revisionist and self-aware Westerns, is the construction of an implicit model of the Western that turns out on inspection to be at the least questionable. *Once Upon a Time in the West* and *The Quick and the Dead*, for instance, appear innovative in their centring on women, yet the implicit perception, that women are marginal to the Western, may turn out to be, if one looks back across the genre, at the very least exaggerated (Lucas 1998). I retailed this perception above and the effect of both films depends on assuming this to be so, yet it may not be. Again, Sergio Leone's Westerns are often considered canonical to the Italian Western mode (indeed, for many, perhaps most, filmgoers they are virtually the only familiar instances of it), yet they are in many ways exceptional, both to spaghetti Westerns in general and in terms of the narrow band of canonical Hollywood Westerns they reference.

One can push these considerations back further. Edward Buscombe, for instance, comments of André Bazin's much-cited judgement on post-war superwesterns like *Shane* that he saw in such films 'something extra to the Western which was not there in its original state of innocence' (1992: 85), evoking a very common trope of genre criticism, the positing of an age of innocence when a given genre existed in a pure, uninflected form. Yet films that might be taken to exemplify this state of being appear less innocent when set in their historical context. *Stagecoach*, for instance, often considered the quintessential Western, was, as we have seen, made to be exceptional, not 'just another Western'.

It might even be reasonable to say that *Life of a Cowboy*[28] 1906 involves pastiche and perhaps contributed to the sense that there was something, the Western, to pastiche. Earlier films than this are still now commonly presumed to be the first Westerns, notably *The Great Train Robbery* 1903, but also *A Bluff from a Tenderfoot* 1899, *The Pioneers* 1903, *Kit Carson* 1903 and *Cowboy Justice* 1904; however, many researchers suggest that, if categorised at all at the time, these were most likely seen as belonging to, for instance, the railway travel, true crime or ethnography genres (cf. Altman 1999: 34-38, Musser 1990, Neale 1990: 52–56) and the word 'Western' was not used in this sense until around 1910.[29] Edwin S. Porter, who had made *The Great Train Robbery*, none the less regarded the later *Life of a Cowboy* as his first Western. In it, a cowboy performs various rope and horse rodeo tricks alongside what we would now regard as typical Western moments: thwarting a stagecoach robbery, beating up an Indian in a bar. The sense of a continuity between rodeo stunts and narrative adventures, all part of a 'life', perhaps suggests that they are all performances (as they were in rodeos[†] and Wild West Shows), not to be straightforwardly believed in, that is, not a million miles from pastiche. Although in line with the way films were made at the time, the apparent narrative incoherence of *Life of a Cowboy*, the sense of it as just a jumble of actions, perhaps also relates to what it is doing in relation to genre: it is referencing the tropes of a genre, the Western, that had barely been named or perhaps even perceived as such. It is a pastiche that contributes to bringing the genre more firmly into existence by indicating that it already exists.

All Westerns know they are Westerns, are in this sense self-aware; but most just get on with the job of being Westerns. A few make self-awareness part of their concerns, some by explicit reflection on the genre, some by tweaking the elements or introducing discrepant notes, that is, by pastiching. All such processes posit what the genre is and was like; they confirm, delineate and at times even bring the genre (back) into being; they are an integral and even sometimes originatory aspect of a genre's history.

† Rodeos were themselves show contests based on actual cowboy work; in effect, they pastiched the labour involved in controlling horses and cattle.

Generic definition: neo-noir

> *Neo-noir* is, quite simply, a contemporary rendering of the *film noir* sensibility. (Erickson 1996: 321)

Any work implicitly evokes and acknowledges prior models of cultural production, of which it is necessarily a perception and on which it is necessarily a variation. When this is more evident, we evoke notions of genre (of the work's likeness to a category). With pastiche (and other forms of self-awareness) the process becomes even more explicit, a positive affirmation of what a genre is like, even an intervention in defining it. This dynamic, touched on at the end of the last paragraph, I explore more fully here through the example of neo-noir.

This is a style in contemporary film, television, fashion and publicity[30] that reworks the visual style and/or mood of the film noir of the 1940s and 1950s; I shall refer to the latter as classic noir, a notion that neo-noir itself plays a part in producing. It has become a commonplace to consider neo-noir pastiche. In 1974 *The Listener* referred to 'genre pastiches like *Chinatown*', a connection then enshrined as one of the most recent usages of the word pastiche in the 1989 *Oxford English Dictionary*. Neo-noir is one of the pastiche forms that Fredric Jameson identifies influentially as symptomatic of postmodernism (1984: 67). Overviews tend to fall back on pastiche as a term to describe those instances of neo-noir they judge negatively: *The Hot Spot* 1990 'is little more than a superficial exercise in genre pastiche' (Grist 1992: 285), *Romeo Is Bleeding* 1993 'never rises above the level of a clever pastiche' (Naremore 1998: 266), *L.A. Confidential* 1997 'is pastiche, a résumé of familiar elements skilfully assembled to evoke a style from the past' (Hirsch 1999: 13).

The prefix 'neo' suggests the notion of a return to an earlier form that has been in abeyance, and at times it seems almost a synonym for pastiche. Eighteenth and nineteenth century neoclassicism in painting and sculpture looked back to ancient Greece and Rome and to the renewal of these models in the Renaissance, twentieth century neoclassicism in music harked back to the baroque, to music before romanticism. Both kept in play notions of the classic, and this perhaps always shadows neo production; and both, in their self-conscious adoption of a form against the current of contemporary practice, often come into the orbit of pastiche. Similarly, neo-noir indicates a re-adoption of a style that was perceived to have fallen into desuetude. Noir had begun to peter out as a regular product in the mid 1950s, and although there were notable instances thereafter (*Odds Against Tomorrow* 1960, *Underworld USA* 1961, *The Naked Kiss* 1964, *Harper* 1966, *Point Blank* 1967, *Taxi Driver* 1976), they were received as stragglers or isolated instances; it was only in the 1980s that noirs begin to be made in numbers of a critical mass that suggested a new phenomenon: neo-noir.[31]

What makes the case even more interesting is that the very term 'film noir' was unknown in a Hollywood context until the 1960s. This, and the fact that

neo-noir is so widely seen as pastiche, makes it an especially promising way into considering questions of pastiche and history, that is, for the moment, the role of pastiche in the development and perhaps even the recognition and invention of genres. The discussion that follows assumes that pastiche is indeed a meaningful designation of or within neo-noir. I begin by considering the way in which neo-noir is pastiche, before considering its relation to classic noir.

I want to focus the discussion of neo-noir's pasticheness through one film, *Body Heat* (1981 Lawrence Kasdan) (figures 4.5 and 4.6). This is often referred to as representative of the form, as occupying 'a seminal position' (Grist 1992: 272), as being 'paradigmatic' (Spicer 2002: 131) and 'symptomatic' (Hirsch 1999: 179), as well as being perhaps the occasion of the first recognition of neo-noir 'as a distinct formal category' (ibid.: 18). It is also named by Jameson in his critique of postmodern pastiche (1984: 67) and Grist concurs that, despite being 'entertaining [and] stylish', its 'superficiality underlines [its] status as a postmodern artefact [because] its generic reference is not parody ... but pastiche' (Grist 1992: 272–273).

In *Body Heat*, Ned Racine (William Hurt), a lawyer in the Florida town of Miranda Beach, has an intense affair with a married woman, Matty Walker (Kathleen Turner), which leads to them murdering her rich husband. However, Matty has manipulated the situation, such that at the end Ned is in prison for the murder while Matty, presumed dead, has escaped with her large inheritance to a tropical beach.

Body Heat has the following classic noir elements:[32] an aimless man attracted to a beautiful woman, an urban diner, Venetian blinds, neon lights, snap-brim hat, cigarettes, mournful jazz tunes, hard-boiled, sexually charged language, murder, chiaroscuro lighting, fog at night and black skies. It also explicitly echoes two classic noirs in plot and aspects of dialogue and *mise-en-scène*: *Double Indemnity* (1944 Billy Wilder) and *The Postman Always Rings Twice* (1946 Tay Garnett), the latter itself remade contemporaneously with *Body Heat*. Like Matty in *Body Heat*, Phyllis (Barbara Stanwyck) in *Double Indemnity* sexually manipulates a small-time professional (insurance agent Walter (Fred MacMurray)) to murder her considerably older husband and reap a rich reward; in both, the opening dialogue between the couple crackles with sexual innuendo; like Matty to Ned, Phyllis at the end declares she really loves Walter, a declaration that remains unproven in both cases; the only major difference is that Phyllis does not get away with the murder. In *Postman*, Cora (Lana Turner) persuades Frank (John Garfield) to murder her considerably older husband; like Lana Turner, Kathleen Turner is first seen dressed in brilliant and leg-revealing white; like *Postman*, *Body Heat* is suffused with an overwhelming sense of heat, conveyed in the title, dialogue and images of sweat on flesh and baths in ice, a heat at once oppressive but also expressive of uncontrollable sexuality.

Body Heat also includes a number of generic cues that nudge us towards seeing its imitativeness.

Figure 4.5 Body Heat 1981 (Ladd Company/Warner Bros/Kobal Collection).

Figure 4.6 Body Heat 1981 (Ladd Company/Warner Bros/Kobal Collection).

- Matty gives Ned a hat, a 1940s snap-brim hat in a period moreover, the 1980s, when men no longer wore hats, suggesting the way he is being set up as an old-style noir fall guy.
- There is a shot of a spider's web with a spider at its centre, inserted between the sequence of Ned setting up the murder and Matty lying awake in bed with her husband; the idea of woman as spider is common in writing on film noir,[33] as well as being a venerable tradition, and this shot underlines the sense of Ned's being drawn into the femme's fatal machinations.
- As Ned walks past the band on the boardwalk, before seeing Matty for the first time, it is playing 'That Old Feeling'; the presentation underlines the song's period, with shadows of the musicians thrown up on the cyclorama behind the band, especially when the trombonists and trumpeters stand for their solos, in the manner of presentations of big band jazz in the movies of the 1930s and 1940s; Ned may be having a feeling he's had before, and one as old as desire itself, but it is also specifically a feeling suggested by noir jazz.
- Everyone in *Body Heat* smokes, which must have struck audiences even in 1981 and much more so now; when everyone lights up at a tense moment in the meeting between Ned, Matty and the lawyers after Mattie's husband's death, one of the lawyers, Peter (Ted Danson), declines one offered him, saying "I don't need my own, I'll just breathe in the air"; later, on a pier, Ned, who's been jogging, offers Peter a cigarette, who takes it and then throws it away, while Ned starts coughing, which he also does later in the film; cigarettes are part of the glamour of film noir, but Peter (and Ned's cough) also articulates the contemporary consciousness of the price of smoking.
- At the start of the film, Ned watches from his bedroom window a fire ablaze; the woman he has just been in bed with asks what it is:
 "It's the Seawater Inn – my family used to take dinner there twenty-five years ago – now somebody's torched it to clear the lot."
 "That's a shame"
 "Probably one of my clients" (sniggers) [...] "My history is burning up out there".
 Twenty-five years ago takes us to 1946, with noir in full swing. Ned (whose surname is Racine, French for root) is aware of the significance of the past and able to mouth platitudes about it; but he is also cynical about the reason for the fire and sniggeringly dismissive of his implication in it (as a lawyer to tawdry clients). He thus encapsulates some of the attitudes that neo can have towards classic noir: historically conscious, cynically dismissive, smart-ass.

Most of these nudges are concealed within the dramatic construction of the film (although Stephen Schiff, in a contemporary review, says that it 'has been roundly pooh-poohed in some quarters for being such a calculatedly

noirish picture' (1994: 32–33). 'That Old Feeling' is played not sung, is just ambient and is plausible (seaside resorts often provide dated entertainment). Peter's rejection of smoking is part of his rather prissy characterisation. The fire gives Ned the idea for the murder (he buys an old property, dumps the body in it and sets fire to it) and is also how Matty in turn intends to kill him (by sending him to find something in her boathouse, whose door she has booby trapped to explode in flames). Unlike the explicit commentary in *Fort Apache, The Man Who Shot Liberty Valance* and *My Name is Nobody*, discussed above, *Body Heat*'s cues inflect the telling of the story, which is to say that they are part of the way it produces pastiche, indicating noirness as the story goes along. Even more important though is its style.

One would not mistake *Body Heat* for a 1940s/1950s noir. It does film noir but not quite like earlier film noir did it and it is especially this that makes it reasonable to describe *Body Heat* as pastiche. This is evident in at least three elements: colour, sexual explicitness and music.

Film noir is so associated, not least by its very name, with the use of black and white photography, that the idea of noir in colour seems a contradiction in terms. However, neo-noir may be said to achieve the quality of noir black-and-whiteness by other means.[34] Developments in technology in the 1980s made possible colour photography that could achieve the strong contrasts as well as the inky blacks of the cinematography of the 1940s and 1950s (Erickson 1996: 314–316), while a number of New York-based photographers found ways of lighting and developing colour stock to create a noir-like look; and a very controlled use of colour, especially coloured light, above all red, could create equivalents to the chiaroscuro of classic noir (Naremore 1998: 191–192). All of this is very clearly illustrated by *Body Heat* (cinematographer Richard H. Klein). When Ned and Matty first meet, on the boardwalk at Miranda Beach, the sky is pitch black and she stands out in the middle of the scope screen in a white dress, bright light rimming the shapely outline of her back, with a tinge of blue and red catching the grey sand and wooden railings. This sense of an over-ridingly black and white composition is even stronger in a later scene of the pair taking a bath together. Strong directional lighting makes their suntanned flesh at points literally white; in the establishing shot, apart from gold pipes, everything is black and white: black bath, black and white tiles, their flesh tones; then a cut to close-up has their flesh standing out against an utterly black background, relieved only by a black and grey striped tile and a splodge of grey-white light in the upper left hand corner of the screen. Elsewhere, such techniques are supplemented by red. When Ned meets her at her local bar, the Pinehaven Tavern, the predominant colours are darkness, (diegetic) neon red and white rimming light; in cross-cutting between them, she is shot against red, he against the dark, a variation on the standard romantic lighting set-up of male desire yearning towards the alluring woman. Even in less obviously noir set-ups, *Body Heat* is drawn towards a restricted palette relieved by red: as Ned goes about setting up the

crime, in the day time, wearing a white shirt and black tie, the colours are predominantly grey, cream, flesh and slate, plus a scattering of red objects: his car, a van that passes on the motorway, a valet in a red waistcoat, signs ('For Sale', 'Rent a Car'), the reflection of red stripes in the car rental window, a red car driven by a clown.

Occasionally this principle of composition is supplemented by a couple of others associated with 1940s/1950s noir. Fragmentation: when Ned returns to Matty's house after she has locked him out (making a show of not wanting to have sex with him), he sees her through the front door, her body broken up by its squares of glass. Skewed angles: when, once he has broken his way into the house, they start to embrace, there is a shot from below, a skewed angle that also includes a turning ceiling fan, the twist of the banisters and a blurry pool of bright light; the colours are white, grey, beige and flesh and her red skirt.

This last shot also illustrates the sexual explicitness of the film: we clearly see his hand between her thighs. That there was sexual lust and act between characters in 1940s/1950s film noir is of course indubitable, but its physical detail is not shown. In *Body Heat*, as in other neo-noirs, it is very clear who is doing what to whom (e.g. Matty fondles Ned's penis in his shorts, he takes her from behind, they discuss whose genitals are sorest). Neo-noir also spells out the perverse sexualities hinted at in earlier noir: a teenager cruises Ned in the toilet in *Body Heat*; a woman has a child by her own father in *Chinatown* 1974; a bull dyke brothel keeper touches up her girls in *Farewell My Lovely* 1976. All of this is in the noirs of the 1940s and 1950s, but showing it, stating it, in neo-noir marks the latter's distance from its referent, the same as but not the thing itself.

The score of *Body Heat* (composer: John Barry) is predominantly a languorous melody on tenor saxophone over strings (though the sax disappears in the central sequence of planning and executing the murder). This is par excellence the sound of noir – except that it isn't in fact the basis of the musical scores of 1940s/1950s noir (cf. Boujout 1984, Butler 2002[35]). Jazz does figure in the latter, but only when heard in night clubs (often played by whites) and is either piano or vocal ballad or else hot jazz. The jazz sound of neo-noir is doubly anachronistic, for not only does it not appear in the noirs of the earlier period but its kind of smooth, sinuous and sultry 'Midnight Jazz' is itself predominantly a product of the 1960s and later.

This last point should give us pause. It suggests that what neo-noir imitates is not straightforwardly noir but the memory of noir, a memory that may be inaccurate or selective. As noted before, pastiche imitates its idea of that which it imitates. This is suggested in the present context by considering another noir made after those of Hollywood in the 1940s and 1950s, one which has the added interest of having been described by its director, François Truffaut, as a pastiche, and yet which sounds and feels very different from the noirs discussed so far: *Tirez sur le pianiste* (*Shoot the Pianist*) France 1960.

This tells of a Parisian café pianist, Charlie (Charles Aznavour), who gets caught up in the conflict between his two older, criminal brothers, Richard and Chico, and two other hoodlums, Ernest and Momo. To escape the latter, the brothers hole up in their parents' house in the country. Ernest and Momo kidnap the brothers' other, much younger brother Fido (who lives with Charlie), to get him to take them to the brothers. Charlie's new girlfriend, Léna (Marie Dubois), drives Charlie to the brothers to warn them, but when Ernest and Momo turn up, she is shot dead in the crossfire.

Though there are evident differences from 1940s and 1950s Hollywood noir (there is no femme fatale, it is shot in widescreen), *Tirez sur le pianiste* is none the less recognisably noir in its story and its style.[36] The former (based on a novel, *Down There* 1956, by noir writer David Goodis[37]) produces a sense of bleakness, of hope doomed to be destroyed by events over which the protagonists have no control. This is especially emphasised by the use of a back story (presented as a flash-back): Charlie had been a rising concert pianist, until his wife, having told him that he got his first break when she slept with a leading concert promoter, killed herself. Now he is an anonymous café pianist, always playing the same tune, until Léna, who has found out about his celebrated past, persuades him to go back to his interrupted career; they go to the café for Charlie to hand in his notice; but the café owner, Plyne, jealous of Charlie's success with Léna, picks a fight with him, in the course of which Charlie kills him. The chance of a new life has been immediately snatched away from him. At the end of the film, Charlie is holed up with his criminal brothers awaiting the arrival of the latter's rivals; Léna comes to tell him that he has been cleared of the charge of murdering Plyne, that it was an accident, but this second chance at happiness is also snatched away as Léna is shot by one of the brothers' rivals and dies in Charlie's arms. At the end of the film he is back in the café, playing the same tune, staring expressionlessly ahead of himself.

As well as this fatalistic narrative, *Tirez sur le pianiste* is also noir in its style, notably of lighting and editing. The opening sequence, after the credits, has a man careering down a city street with wet pavements, apparently pursued by a car, whose headlights glare into the camera; the pace of the cutting is fast, so that the headlights together with the points of light that the man runs past and a moment when he enters the full light of a street lamp, all in a context of darkness and night, together create a chiaroscuro flicker quality; the noise of the car, the roar of the engine and squeal of tyres and breaks, reinforces the sense of both threat and confusion. Towards the end of the film, long sequences of driving at night – Ernest and Momo with the kidnapped Fido, Léna with Charlie – are lit (in a classic noir and wholly unrealistic style) as if from the dashboard, strong light picking them out in the darkness, with the low angle creating shadows in the chin and over the cheeks.

Much of the film is not lit like this, but with the even, bounced light that characterised French New Wave cinema. Yet every so often noir lighting intrudes. Quite near the beginning, Charlie and Léna are walking home together

down a well- and undramatically lit street, and she realises that they are being followed; she shows him this in her make-up mirror, which we see in close-up, and then drags him down a side alley, plunging them into chiaroscuro set-ups of striated light and then sharply delineated areas of light and dark. This sense of being dragged into the dangerous noir world increases towards the end of the film. The sense of the co-existence of two worlds, conveyed in the contrast of the well lit and the chiaroscuro, is itself characteristic of some Hollywood noirs, where the hero is seen in a domestic setting that he has to leave (often in order to protect it) (cf. *The Dark Corner* 1946, *Kiss of Death* 1947, *Act of Violence* 1949, *The Big Heat* 1953). At one point, *Tirez sur le pianiste* even seems to comment on this. Charlie returns home, moving about his flat in the dark, checking that his little brother is sleeping alright; like many characters in noirs, he seems to live in a flat behind a flashing neon sign, and as he moves about, the flat is repeatedly illuminated and then plunged into darkness; however, when he goes into his bedroom and puts on two small table lamps, their light cancels out this effect, safe domestic light cancelling threatening, exterior noir light.

Yet for all this noirness, *Tirez sur le pianiste* is markedly different from the neo-noir represented by *Body Heat*. This has to do, first, with the fact that it is a film of the French New Wave (whose interest in noir can be found also in, for instance, *A double tour* 1959, *A bout de souffle* (Breathless) 1960, *Le Doulos* 1963, *Alphaville* 1965 (Vincendeau 2006)). *Body Heat*, for all its self-awareness and transgressions (sexual explicitness, a femme fatale that gets away with it), is a classically constructed mainstream Hollywood genre movie. *Tirez sur le pianiste*, in contrast, is New Wave not only in such stylistic features as digressions, ellipses, gags, jump cuts, loose camerawork and even lighting but also in its relation to genre. If *Body Heat* produces a consistent, albeit neo, stylistic tone, *Tirez sur le pianiste* is constantly changing tone. As described above, the opening sequence of a man running frantically along a street immediately evokes anguish (noir); but then he runs into a lamppost (slapstick) and is helped to his feet by a man with whom he proceeds to have a very everyday chat about the vagaries of married life (social realism). This is the procedure throughout the film, which also moves into other generic modes, notably a (Western) shoot-out at the end of the film. Such shifts in tone and generic reference constitute a pasticcio of pastiches, with the interruptions bringing one up short against the fact of imitation and reference.

Such procedures are sometimes interpreted as anti-noir. Jean-Paul Török, writing in *Positif* in 1961, took the view that the genre of the thriller 'is quite dead' and in any case unusable in France, and thus argued that *Tirez sur le pianiste* is 'not a film noir'; rather, 'the rules and conventions of the genre are systematically destroyed ... from the inside' (1993: 229), and Truffaut too at that time spoke of it being 'the explosion of a genre (the detective film) by mixing genres' (1993: 135). Whereas *Body Heat* finds a new way of making a genre film, *Tirez sur le pianiste* disrupts the very notion of films made coherently within a given genre. This does not mean, however, an attack on noir as such

(or indeed any other specific genre). Indeed, Truffaut, in the same interview, refers to what he is doing in *Tirez sur le pianiste* as what 'I would call a *respectful pastiche* of the Hollywood B films from which I learned so much' (ibid., emphasis in original). Thus genres become repositories of situations, styles and iconographies that can be used and combined, to set one another off, to highlight, pastiche-fashion, what is characteristic, interesting or suggestive about them.

Tirez sur le pianiste differs from *Body Heat* not only because its comes out of a different aesthetic project but also because it operates with a different sense of what noir is. *Body Heat*'s referents are *Double Indemnity* and *The Postman Always Rings Twice*, big budget, major studio (Paramount and MGM) productions with top stars (Fred MacMurray and Barbara Stanwyck, John Garfield and Lana Turner); it has the production values and star power of other A noirs, such as *Laura* (C20 Fox 1944; Dana Andrews, Clifton Webb, Gene Tierney), *The Blue Dahlia* (Paramount 1945; Alan Ladd, Veronica Lake) and *Gilda* (Columbia 1946; Glenn Ford, Rita Hayworth). *Tirez sur le pianiste* draws on low budget films from minor studios and with stars most people never heard of: *Detour* (PR 1945; Tom Neal, Ann Savage), *They Live By Night* (RKO 1948; Cathy O'Donnell, Farley Granger), *Gun Crazy* (United Artists 1949; Peggy Cummins, John Dall), *The Hitch-hiker* (Filmmakers 1953; Edmond O'Brien, Frank Lovejoy), *Kiss Me Deadly* (Parklane 1955; Ralph Meeker). It is not just that these films have a grainier look, are often either simply dark or more starkly chiaroscuro, with run-down settings and cheap looking or dishevelled costumes; they also have an unhinged quality about them, of unpredictability, fatality and compelling implausibility. It is especially this last that recommended them to the New Wave directors, suggesting as it did a marvellous irrationality. This was a quality admired by the surrealists of the 1920s and 1930s, who celebrated B pictures for their lack of bourgeois realism and hide-bound good sense and who also considered that one of the best ways to appreciate movies was to go in and out of cinemas, not knowing what was showing, so that you freed the imagery of its narrative constraints and you mixed up generic tropes. *Tirez sur le pianiste* is not a surrealist film, yet it is informed by a sense of the fierce and strange allure of cheap imagery and the tonic effect of promiscuous genre pasticcio. Thus its film noir is not the film noir of neo-noir.[38]

Not the least surprising thing about this is the relation of *Tirez sur le pianiste* to the French tradition of film noir. The term 'film noir' was applied in France to Hollywood films in the immediate post-WWII years.[39] On the one hand, an analogy was being drawn between the Hollywood productions we now as a result call films noirs and a tradition of French films that had already started to be referred to as films noirs since the late 1930s (cf. O'Brien 1996); but, on the other hand, the Hollywood films were seen by these French critics as something quite different from (and better than) the French. Although later critics have explored the influence of 1930s French noir on the Hollywood variant (Durgnat 1970, Vincendeau 1992: 51, 2006), the early

French critics downplayed or denied it, partly out of that rejection of mainstream French cinema – the well-made, bourgeois, cinéma du papa – that would lead to the style of the New Wave. In this context, American cinema, especially the B movie, seemed more energetic, less hide-bound, with more sense of rebellion and madness. In fact, there is more of French film noir in *Tirez sur le pianiste* than is often acknowledged. If it consciously takes the doom from Goodis, it could also have found it in *Le Jour se lève* 1939, *Le Corbeau* 1943 or *Une si jolie petite plage* 1949, and the adoption of aspects of American clothing (the trench coats of Charlie and Léna) and weaponry (guns) is evident in many post-war French gangster movies;[40] there is, too, unlike the Hollywood model, an emphasis on everyday life and unmarried domesticity (cf. many Jean Gabin vehicles, and Charlie's tender concern for his young brother Fido echoes especially that of lonely Inspector Antoine for his young son in *Quai des Orfèvres* 1947), and Charlie's piano playing has little of jazz in it and everything of 'Milord', 'Boum!' and other classic French chansons. These elements, though, precisely because they are there as a matter of course, unaddressed despite the rejection of the cinéma du papa, are not pastiched and if anything serve to underscore the pastiche quality of the elements taken from American film noir.

Looking at *Tirez sur le pianiste* suggests then two characteristics of pastiche in relation to genre history:

- the form of a pastiche is in part governed by the modes other than pastiching within which it is also of necessity working (mainstream Hollywood as opposed to French New Wave, standard narrative cinema as opposed to modernist pasticcio);
- a pastiche imitates what it perceives to be characteristic of its referent, perceptions that are temporally and culturally specific.

I want to turn now to considering how pastiche also functions in genre history in the identification of genres and also in their renewal.

By 1906 Edwin S. Porter probably knew he was making a Western with *Life of a Cowboy* (even if he might not yet have used the word), as did John Ford throughout his career, but the makers of *Detour*, *Double Indemnity*, *Gun Crazy* and *The Postman Always Rings Twice* did not know that they were making films noirs. Neo-noir says that, all the same, they were. The French naming of them so and the take-up of this by Anglo-Saxon critics identified film noir as a generic term retrospectively, and this was reinforced when a sense of noir entered consciously – pastiche fashion – into actual film-making, first in the likes of *Tirez sur le pianiste* and then in those of *Chinatown* and *Body Heat*. Critics may designate a hitherto unsuspected category, but pastiche more powerfully demonstrates the category's existence by being able to imitate it so recognisably; if the category did not exist it could not be imitated.

Thus pastiche contributes not only to fixing the perception of the genre that it pastiches but to identifying its very existence. Moreover, in the case of

neo-noir, it contributes to making the case for something whose existence is in fact problematic. Noir is notoriously hard to pin down, so many supposed instances seeming not to fit: unquestioned noirs turn out to be lacking a feature you'd think indispensable (the landscapes of *The Postman Always Rings Twice* and *Detour* are more sun drenched than chiaroscuro, the eponymous Gilda and Laura are not in fact fatal, nor wishing to be), while most overviews contain titles of which I find myself saying "why've they included *that?*" Yet neo-noir assures us that there was such a thing as noir and that this is what it was like, in practice side-lining the kind of film referenced by *Tirez sur le pianiste* to fix moody chiaroscuro lighting, fatally glamorous women and midnight jazz scores as essential noir.

Neo-noir harks back to something much less clear-cut than the act of pastiching may make it appear, perhaps not quite something that never existed, but at any rate something more elusive and vague than posited by the neo of neo-noir. In the process, however, it also produces a wave of noir production, so that making things noir becomes simply a way of doing things, aware of where the style supposedly comes from but not especially nostalgic or ironic about the fact, not so much neo-noir as just noir now. Indeed there has emerged a common model of the history of noir (e.g. Grist 1992, Martin 1997, Spicer 2002) that places pastiche neo-noir as something coming between modernist or revisionist noirs in the 1960s and 1970s (*Harper, Point Blank, Klute* 1971, *Chinatown, Taxi Driver*) and noirs of the 1990s which either use the genre with a heightened sense of ironic inter-textuality, pastiche gone mad (*The Two Jakes* 1990, *Reservoir Dogs* 1992, *Romeo Is Bleeding* 1994), or else have simply got over noir's provenance and distinctiveness and got on with working with its tropes and styles (*Red Rock West* 1992, *The Last Seduction* 1994, *Someone to Watch Over Me* 1987, *Seven* 1995, *Bound* 1996).[41]

This has also made it possible to take noir in new directions, one of the most striking of which is a number of films that put back the black in noir: *A Rage in Harlem* 1991, *Deep Cover* 1992, *One False Move* 1992, *The Glass Shield* 1995, *Devil in a Blue Dress* 1995 (cf. Covey 2003, Diawara 1993, Naremore 1998: 246–253, Nieland 1999). Many have argued that the unspoken subject of classic film noir is African-Americans. Black people are only visible in the margins of 1940s and 1950s noir, coming a bit more centre stage with *Odds Against Tomorrow* 1959 (Harry Belafonte an equal member of a three-man bank heist gang) (Naremore 1998: 233–246). Yet it may also be that the emphasis in so much classic noir on the allure and dangers of the city – allure represented through nightclub jazz, dangers through darkness – speaks of a white perception that the city was increasingly becoming a black space threatening even to white men, leave alone women (Murphet 1998). African-American neo-noirs fill in that space, as if to say this is indeed a black space and this is what it's like. Yet these films are not characterised by pastiche. Even *Devil in a Blue Dress*, which is set in Los Angeles just after the Second World War, though it involves historical re-creation does not pastiche noir

style but uses and even in some respects refuses it. The Angst associations of
chiaroscuro are replaced with muted colour, and voice over and flashbacks are
used to create a stable position of knowledge from which the hero, Easy
Rawlins (Denzel Washington), recounts and understands the story (Oliver
and Trigo 2003: 168–172). The film is grounded in the African-American
culture of the period of its setting: its look from a painting behind the cred-
its, 'Bronzeville at Night' 1949 by Harlem Renaissance painter Archibald
Motley Jr, its images of black community life from *Shades of LA*, a photo-
graphic collection in the Los Angeles Public Library, and its sound rhythm
and blues of the period (not anachronistic Midnight Jazz). Black noirs now
fill in the blank produced by the erasure of African Americans from classic
noirs, a development made possible by neo-noir, the moment of pastiche,
even though black noirs are not themselves pastiche.

The neo-noir moment of pastiche made such things possible because most
were never empty exercises in style. Rather the style was used because it was
redolent of certain feelings and perceptions that still seemed relevant and
serviceable. In a contemporary review of *Body Heat*, bad object par excellence
of the critique of neo-noir, Stephen Schiff observed that '*Body Heat* isn't – and
can't be – a pure, contemporary film noir' because it is about the way that '*old*
films noirs ... [have] crept into our dreams until they're part of our uncon-
scious vocabulary' (1993: 33). Noir activated what was still a memory of a
way of doing things, a way still appealing and suggestive. Part of this had to
do with sexuality, the recovery of a language of glamour and allure in an age
where the availability, permissibility and ubiquitous imagery of sex risked
making it banal.[42] James Naremore suggests it also had to do with the need
to find a vocabulary to express an equivalent trauma to that of the 1940s,
namely Vietnam (1998: 34–37, 209), and perhaps it has continued to express
the continued anxieties of a fearful era, better perhaps than more realist
approaches.

Pastiche noir is able to recognise and mobilise the structure of feeling it
perceives to have been caught by classic noir. It does also seem to say: they
don't make them like this anymore. This may be a source of regret and nostal-
gia – if only we still did Angst and sexiness like this. It may be a source of
self-congratulation, a sense of the contemporary noir being an improvement
on its earlier incarnation: in colour, able to be sexually explicit, sophisticat-
edly unfazed by disillusion and so on (cf. Gallafent 1992). Yet in the very
moment of reflecting on such films not being made any more, neo-noir is
making them, and some of them work genuinely in terms of anguish, sexu-
ality and disillusion, enough to make noir become simply a viable style
among others.

There is also a further potential gain. Even noir now must trail a sense of
where the style came from, what it came out of, and thus allow the possibil-
ity of inhabiting its feelings with a simultaneous awareness of their historical
constructedness. But they are not the less feelings for that. Pastiche makes it
possible to feel the historicity of our feelings.

History

Generic pastiche is a special case of the way more generally pastiche's signalled imitation at once mobilises the qualities of and indicates a relationship with prior works (albeit sometimes immediately prior and even ongoing). In other words, pastiche is always and inescapably historical. I want in this final section to look a little more about what this implies, moving now away from the instance of genre.

First, to understand what any given pastiche is doing one has to return it to its historical context. This is a basic – and hardly controversial or unusual – principle informing all the analyses in this book.

Second, as suggested above following on from my discussion of *Tirez sur le pianiste*, the historicity of a pastiche involves both the historically specific aesthetic forms within which it works and the prevalent perception of what it is pastiching.

Third, there may be historical circumstances that favour the production of pastiche. Pastiche is to be found throughout the Western cultural tradition, high, middle and low (and I don't see a reason why it should not be found throughout all human cultural production), and in so far as this book is trying to rescue pastiche from postmodernism (as one colleague suggested to me with a twinkling eye), it is to argue that pastiche should not only be understood through the postmodern instance (cf. Wilson 1990). However, there may be more pastiche, or it may be more characteristic, in specific historical periods, which include those listed below. All have to do with the possibility of recognising the fact of form, with seeing that given ways of saying or making or performing things are not simply the inevitable human way those things are said, done and performed.

- Periods in which a multiplicity of traditions are brought together (under the pressure of geographical exploration, imperialism or migration) which enable the perception that particular forms are indeed particular. Thus societies like ancient Rome and Elizabethan England (both centres of imperialism, exploration and migration) and the contemporary globalising and diasporic world might account for the use of pastiche in, respectively, the *Satyricon* (Petronius C1 AD), Shakespeare and postmodernism.
- Periods in which new media suddenly make available a huge range of hitherto inaccessible works, such as the printing press (enabling the work of Cervantes and Rabelais) and audiovisual innovations since the nineteenth century (Jenny 1982: 35–38),[43] the suddenness and multiplicity heightening a sense of the variability of ways of doing things.
- Periods which feel themselves to be coming at the end of an era, such as early Modern Europe and the contemporary world.[44] The emergence of modern literary pastiche in the late seventeenth century, for instance, is concurrent with a feeling in the period of living at 'the end of a great

literary movement, in an epoch suffused with a feeling of unsurpassable perfection' (Mortier 1971: 204–205). Likewise, there is often in post-modernist theory a sense of a *'fin de millénaire*, when history appears to have reached its end and when all that seems to be possible is some post-historical afterpiece, some carnivalesque postlude', such that there is nothing left but 'a new Alexandrianism of quotation, parody and travesty [and, thus, pastiche] ... that plays its serene, intoxicated or despairing games with the left-overs of the cultural heritage and the garbage of the cultural industry' (Pfister 1991: 208).[45]

- Periods (such as Western modernity since the eighteenth century) in which imitation of other arts is not so universally recognised as the basis of cultural production as to make specific forms of it, such as pastiche, copies or even plagiarism, unremarkable. In other words, without the modern investment in originality, pastiche would probably not stand out as worthy of designation or disdain.

- Cultures in which there is a strong, enforced and thus foregrounded sense of proper form, such as France (cf. chapter 2 p. 53).

- The longevity of a form, such that it comes to feel tired or out of date. This is a common argument about the tendency towards various forms of self-awareness in genres and styles late in their development, something often seen as a form of decadence. Jenny (1982: 59–61), however, sees intertextuality (of which pastiche is a particular case) more positively, as a way of coping with the 'threat of stagnation' that comes from 'cultural persistence' and thus 'a fitting instrument of expression in times of cultural breakdown and renaissance'.

- The importance of repetition and recognisability in the economics of, specifically, mass and capitalist cultural production: mechanical repro-duction, multiple copies, series, serials, cover versions, remakes, genres, cycles, formulae, all of which insist on sameness and thus facilitate reflec-tion and play on sameness.[46]

- The perception by a social group that cultural forms do not speak for them. This might apply to any group (or even isolated individual), though there may be an especially strong case to be made for the affinity for pastiche of Jews and gays in the past two centuries, groups that are both placed outside of prevailing social norms and yet can pass within them and have been increasingly (though unevenly) socially accepted, such that their relationship to cultural norms is at once external (conscious of them qua norms) and internal (able and increasingly permitted to use them).

None of the above are necessary for the production of pastiche nor do they inevitably give rise to it, but they may make it more likely.

Fourth, pastiche has a role in cultural history. In my discussion of genre, I suggested that pastiche may have the effect of affirming the existence of a genre by the very fact of being able to imitate it (arguable of both the early period of the Western and of neo-noir) and also be a stage in generic renewal

(neo-noir being a step towards normalising contemporary noir production). It may also fix for a time the perception of a given form: Proust's Flaubert pastiche sees more of the proto-naturalist in the latter than we might now, *Body Heat* eclipsed the feeling for B-movie noir evident in *Tirez sur le pianiste*. Pastiche may also have a role in designating things as past, as I suggested about *Hamlet* and the kind of drama represented by 'The Murder of Gonzago'. In the next chapter I suggest that this is so also of *The Afro-American Symphony* and *Far From Heaven*, although the former also suggests the continuity of the past with the present. In some cases, pastiche evokes (or may be taken to evoke) a past or contemporaneous form or style as somehow more innocent and simple, less self-aware.[47] This seems to be especially true of the Western, each pastiche (*Wild and Wooly, My Name is Nobody, The Quick and the Dead*) somehow implying that what went before were Westerns unaware of themselves as constructions, but it is also implicit in the use of romanticism in *Madame Bovary* and can certainly be extrapolated from both *The Nutcracker* and *The Afro-American Symphony*, and some have thought it to be true of the implied attitude of *Far From Heaven* towards 1950s melodrama.

The mode of pastiche may thus be a product of historical circumstances and/or a factor in cultural development. Either way, it is always inescapably historical in two senses: it always references something before it and it always signals the fact (if it did not, it would not be pastiche). When – as with the Angst and sexiness of film noir, or, to anticipate, the pathos of *Far From Heaven* – it is also emotionally engaging, its inescapable historicity facilitates our feeling the sources of our feeling. T.S. Eliot (1920: 44), discussing awareness of earlier art, observed that 'the historical sense involves a perception, not only of the pastness of the past, but of its presence' and Charles Jencks uses the term 'the presence of the past' in relation to pastiche in his *What is Postmodernism?* (1986). What I am suggesting is that that sense of the presence of the past in pastiche is not just something cerebrally observed but felt. It is part of the knowledge we can have of our place in history. We make our own feelings but not in affective circumstances of our own choosing; pastiche can help us understand those circumstances through feeling them.

Notes

1 See Studlar and Bernstein (2001: 18) on the provenance and authenticity of this remark.
2 A kind of choral hymn in honour of Dionysius.
3 See Buscombe (1988: 202).
4 For example, Broncho Billy Anderson, William S. Hart, Tom Mix, Gene Autry, Roy Rogers, John Wayne, Clint Eastwood.
5 Brownrigg (2003: 63–111) notes inter alia the use of cowboy instruments (male voices, whistling, guitar, fiddle, Jew's harp, harmonica, accordion), honky-tonk piano, Native American and Mexican elements and the influence of Aaron Copland's harmonies, orchestral colours and rhythmic patterns.
6 Many of these are discussed in Harries (2000); the parodies often lapse into travesty (e.g. the farting sequence after a supper of baked beans in *Blazing Saddles*), while there is parody in the travesties.

7 See Wood (1968: 32–35).

8 '... revisionist Westerns in which American history is reinterpreted to make room for peyote visions and related hallucinogenic experiences' (Rosenbaum 2000: 47–62).

9 Released in Britain with the more valedictory title *Guns in the Afternoon*.

10 First published in 1954.

11 See Introduction, pp. 2–3.

12 A generic rule that was still in place in *Stagecoach* but is liable to surprise us now where the cowboy as 'inveterate loner' (Buscombe 1992: 76) has become a primary expectation.

13 The fact that he lives in a wigwam is in line with earlier Westerns in which the West was identified with the native peoples and white Americans were seen to find themselves in these aboriginal Americans (cf. Simmon 2003: 3–31). Baird (1998) traces this impulse in later films.

14 As if calling them the Wild Bunch were not enough, this allusion is reinforced by having a grave marked 'Sam Pekimpek' in a Native American cemetery visited by Beauregard and Nobody.

15 Frayling (1981) discusses the appropriateness of spaghetti as a metaphor for a product that is distinctively Italian but globally present, symbolising both sophistication and popular appeal. Eleftheriotis (2001: 92ff.) stresses the implication of hybridity in the term, spaghetti Westerns being quintessential Italianness plus quintessential Americanness.

16 Quoted in Frayling (1981: 124).

17 This is an aspect of what Frayling (1981: 121–137) calls the 'cultural roots' controversy in spaghetti Western criticism.

18 The first Italian Westerns had all-Italian casts and personnel, in fact and in name; when it seemed that this wave was running out of steam, producers did seem to think that some fake Anglo names might pass new Italian Westerns off as actually American. This seems to be initiated around the time of *A Fistful of Dollars* (*Per un pugno di dollari* 1964), whose phenomenal national and international success suggested however that what was still marketable was this distinct kind of Western, distinctive because of its spaghetti flavour.

19 If you pore over spaghetti Western shoot-outs on an editing table, video or DVD, you can see the sleights of hand involved (e.g. cutting from someone going for their holster to someone else having already drawn their gun; the chronology makes it seem that the latter has acted in response to the former, but the strictest logic says he must have acted before his opponent); of course, the point is the impact on the eye of the speed, not its chrono-logical accuracy. Incidentally, poring over the soundtrack of *My Name is Nobody* indicates that in fact there are three gunshots coming from Beauregard, though you can't see the action that produces them.

20 On *Johnny Guitar*, see, inter alia, Charney (1990), Perkins (1996), Robertson (1996), Peterson (1998).

21 I am grateful to Kate Bernstein for raising these issues and drawing *Bad Girls* to my attention.

22 In *Once Upon a Time in the West*, a flashback reveals that as a boy Harmonica was forced by Frank to kneel with his older brother, his neck in a noose, standing on his shoulders; when the brother finally kicks the boy away, he thereby hangs himself, as Frank calculates; this is why Harmonica has sought revenge on Frank throughout the film and finally kills him. In *The Quick and the Dead*, a flashback reveals that as a girl Ellen was forced by Herod to shoot at the rope from which her father is hanging, alive; she misfires and kills him, as Herod calculates; this is why Ellen has sought revenge on Herod throughout the film and finally kills him.

23 For *The Quick and the Dead*, Gaines and Herzog (1998) specifically reference the clothes style of J. Peterman.

24 That is, female clothing has not become accepted, leave alone utterly normal for men, with the result that, supposedly deviant or comic occasions apart, men are always everywhere seen in men's clothes, thus reaffirming the sense that these are ineluctably male clothes.

25 That is, as on playing cards.

26 Westerns have featured African-American cavalrymen, notably *Sergeant Rutledge* 1960 (whose eponymous hero was played by Woody Strode, to whose memory *The Quick and the Dead* is dedicated and who appears briefly, greeting Ellen on her ride into town) and *Glory* 1989, but not as Southern officers and gentlemen as well.

27 Cf. Doane (1982).

28 Known in Great Britain as *Life of an American Cowboy*. For a more detailed account of the film, see Musser (1991: 360–363).

29 Cf. Neale (2000: 43) (drawing on Leutrat 1985). Neale (43–47) discusses a range of factors that come together to produce the Western (in literature as well as film) in 1910 as a category and not just an adjective.

30 On the reach of noir beyond film, see Naremore (1998), especially pp. 254–277.

31 However, Grist argues that 'the most generally accepted starting point for modern *film noir* is *Harper*' (1992: 1966), while Spicer claims that the 'neo-noir revival began with *Point Blank*' (2002: 136); Naremore suggests that 'film noir did not become a true Hollywood genre until the Vietnam years, when productions such as *Taxi Driver* appeared with some regularity', because only then had the term gained sufficient currency to be recognised as such within Hollywood (1998: 37). Erickson (1996: 307) says that the first film actually to be advertised as noir was *The Hot Spot* 1990, which Stanfield (2002: 256) notes was marketed with the slogan 'Film Noir Like You've Never Seen Before'.

32 I take the first eight from Naremore (1998: 1).

33 Notably Place (1998: 53–60), an article first published in 1978 in Ann Kaplan's *Women in Film Noir*, both article and book quite possibly an influence on the development of 1980s noir.

34 See also Ginette Vincendeau's discussion of Jean-Pierre Melville's last three films, *Le Samouraï* 1967, *Le Cercle rouge* 1970 and *Un flic* 1972, as, in Melville's own words, 'black and white films in colour' (2003: 186, 210).

35 Butler discusses this point specifically in relation to *Body Heat* at 167–169.

36 On Truffaut and noir see Guérif (n.d.) and Fairlamb (1996). The latter also discusses the relation between *Tirez sur le pianiste* and the work of Nicholas Ray, mainly *Johnny Guitar* but also his noirs *In a Lonely Place* and *On Dangerous Ground*.

37 Goodis wrote novels turned into Hollywood noirs (*Dark Passage* novel 1946/film 1947; *Nightfall* 1947/1956) and himself worked on Hollywood noirs (*The Unfaithful* 1947, *The Burglar* 1956 (based on his 1953 novel)), but his reputation was much higher in France through the publication of his work in the paperback thriller series, the Série Noire (that gave its name by association to film noir), and many more of his novels have been filmed there (e.g. *The Moon in the Gutter* 1953 as *La Lune dans le caniveau* 1983, *The Wounded and the Slain* 1955 as *Descente aux enfers* 1986). On Goodis and film, see Wooton and Taylor (n.d.).

38 Alain Silver (1996) points out that there is also a strand of low budget American neo-noir much more within the tradition behind *Tirez sur le pianiste*, including films such as *Delusion* 1991, *Genuine Risk* 1990, *Guncrazy* 1992, *The Kill-off* 1990 and *Reservoir Dogs* 1992; this though is much less likely to be the kind of film evoked by the term neo-noir.

39 By Nino Frank in 'Un nouveau genre "policier": L'aventure criminelle' ('A New Crime Genre: The Criminal Adventure') in *L'Ecran français* 61 (1946, 14–16) and Jean-Pierre Chartier in 'Les Américains aussi font des films "noirs"' ('Americans also make "black" films') in *La Revue du cinéma* 2 (November 1946, 67–70) (both translated in Silver and Ursini 1999, 12–20, 21–24), and then most influentially by Raymond Borde and Étienne Chaumeton in *Panorama du film noir américain, 1941–1953*, Paris: Éditions de Minuit, 1955. For further discussion see Naremore (1998: 11–27, Vincendeau 2006).

40 Michel Marie (2003: 45) specifically notes for instance 'the strong influence of the American [noir] model' in costume and lighting in *Bob le flambeur* 1955; see also Vincendeau (2006).

41 We do not have to consider this process only as one phase succeeding another. Neo-noir persists alongside noir now: *Miller's Crossing* 1990, *Mortal Thoughts* 1991, *The Man Who Wasn't There* 2002, to say nothing of European adoptions of the mode (e.g. the British *The Near Room* 1995, *Shallow Grave* 1995 and *Croupier* 1999), whose geo-cultural difference are

liable to lead to the sense of pastiche analogously to that informing the spaghetti Western. (On British noir, see Williams (1999) and Spicer (2002: 175–203).)

42 Schiff (1993: 33): 'It's a pretty sexy picture, but the sexiness isn't all in the lovemaking scenes. It's also in the very idea of Matty, and in the atmosphere her presence in a modern movie conjures up.'

43 Jenny draws here on Marshall McLuhan: *From Cliché to Archetype* (New York: Viking, 1970).

44 I extrapolate this by analogy from Simon Dentith's discussion of parody and period (2000: 29).

45 Pfister's article qualifies this perception, partly by insisting that there has always been intertextuality, partly by suggesting that postmodern intertextuality is a product of post-structuralist theory and the huge expansion of academic literary studies:

An academic system that produces more literary theory, and even more *Hamlet* interpretations, than anyone can digest, encourages a type of literary production that is equally self-reflective and self-conscious, a literature, so to speak, that grows out of graduate seminars and provides them again with new material for analysis and research. (1991: 214)

46 I am grateful to Georgina Born for raising this point.

47 Although it emerged from collective discussions, I am especially grateful to Rahul Hamid in my NYU Pastiche class for focusing this issue.

5 The point of pastiche

So far in this book I have been concerned, first, to identify a particular kind of signalled imitation that can legitimately be termed pastiche and to distinguish it both from other uses of the word pastiche and also from other kinds of signalled imitation. Then, second, I have indicated some of the formal characteristics of pastiche, considered in terms of closeness to what is imitated, deformation (selection, accentuation, exaggeration, concentration) and discrepancy (inappropriateness, anachronism, self-reference, stylistic inconsistency and so on). Third, I have indicated some of the ways that pastiche may work historically.

I have not, however, been directly concerned with the question of value. As I've occasionally indicated, the word pastiche tends to have a negative overtone. Very commonly it is seen as, at best, fun or charming, at worst trivial. Even Marcel Proust and others in the French tradition of literary pastiche, who defend it, do so in ways that suggest its secondary value: as a way of getting influences out of one's system, improving one's style, practising criticism. Within debates about postmodernism, there is more disagreement, although in cultural theory Fredric Jameson's definition of pastiche as 'blank parody' has been especially influential. Charles Jencks' defence of pastiche in relation to postmodern architecture is more concerned with the pasticcio sense of pastiche and this is largely true of Ingeborg Hoesterey's wide-ranging study of contemporary culture. The latter is also interested in identifying progressiveness in postmodern pastiche practices (over against Jameson's and others' claim that pastiche is more or less intrinsically reactionary).[1] It is such issues of value that I want to explore in this chapter, but without the problematic of postmodernism and without assuming that pastiche is by definition either profound or trivial, progressive or reactionary, a good or a bad thing.

In what follows, I consider the question of the aesthetic and political value – the point – of pastiche through three groupings. First, I consider signalled imitation in the politically loaded context of cultural difference, considering white imitation of non-white dance in *The Nutcracker*, the Jewish production of black popular song, and the use of African-American music within the Western symphonic tradition (especially William Grant Still's *Afro-American*

Symphony). Second, I consider instances of critically negative pastiche and the attendant ambiguities of this, in the deployment of romanticism in *Madame Bovary* and of black street speak in *Erasure*. Finally, I turn to the issue of feeling, focusing on *Flaubert's Parrot* and *Far From Heaven*, works that do what theory has long maintained can't or shouldn't be done: to be at once moving and inescapably pastiching. The most valuable point of pastiche resides in its ability to move us even while allowing us to be conscious of where the means of our being moved come from, its historicity.

Pastiche and cultural difference: *The Nutcracker*, Jewish black music, *The Afro-American Symphony*

I look in this section at the use of pastiche in contexts of cultural difference. All three instances imitate specific formal traditions within another overarching one: classical ballet doing Spanish, Arabian, Chinese and Russian dance, and both Jewish composers and the symphony doing African-American music.

All pastiche implies formal difference between the pastiching work and the pastiched. Whether explicit (as, for instance, in texts within texts) or implicit (as in French literary pastiche), a pastiche is produced from within one formal tradition or moment with reference to another. The bulk of *Hamlet* is written differently from 'The Murder of Gonzago' and the former provides the framework with which to place and value the latter; Proust's Flaubert pastiche implies a way of writing different from Flaubert's, namely contemporary literary and journalistic norms. This generally unexceptionable dynamic acquires an edge in situations of more consequential cultural difference. One such situation is ethnicity, especially when ratcheted up by notions of race.

The issue is sensitive because in everyday life the perception of ethnic and racial difference can have such terrifyingly violent and impoverishing consequences. In cultural terms, it is also sensitive because of a presumed connection between forms and the people who have historically produced them. Formal qualities carry connotations borne of both the history of their development and the social place they occupy at any given time. These cannot just be shaken off, leaving a pure form that anyone can use how they like; they pose problems of familiarity (that is, of fully inhabiting a form, of, as it were, speaking like a native speaker) and of compatibility between forms at a given historical moment.

This is not to say that, in principle, there is something intrinsically ethnic, let alone racial, about given formal properties, but rather that, in practice, formal properties do not exist separately from their history and the peoples who invent and practice them. In terms of the work discussed in this section, ballet and the symphony are not, in terms of form, inevitably and ineluctably white, any more than the spirituals, blues and jazz are ineluctably black, and yet it is in practice impossible to disassociate the forms from their actual historical provenance and characteristic practitioners. Part of the meaning of

the form is one's knowledge of its history and who is producing or performing it; white ballet dancers dancing an Arabian dance, Jews producing blues, blacks writing symphonies are all always in some measure members of one group doing another's culture.

Two things further complicate the account. Firstly, the practice of forms are themselves not ethnically pure but usually hybrid from the word go (although this may not always be readily perceived). Ballet, for instance, is an elite form that drew on both classical imagery and peasant dance; black music was always at once African and American, black and white. Secondly, white forms especially aspire to the condition of universality. This means that there is much less controversy (though there was once) in a black person singing Lieder or opera than there is (often still) in a white person performing jazz or rap. The former affirms the universality of the form (anyone can work within it), in the process confirming the special genius of the white race in producing universal forms. In contrast, whites singing the blues or doing a rap are more likely to be perceived as appropriating, 'ripping off', the black form (and usually getting more acclaim for it – think Bing Crosby, Elvis Presley, Eminem).

All of this is at stake in the instances of pastiche discussed in this section. Each has a rather different power dynamic: in *The Nutcracker* a confident, elite form embraces subordinate cultures; with Jewish 'black' music, one ethnically marginal group passes and progresses by pastiching the culture of another; in *The Afro-American Symphony*, a member of a subordinate culture uses an ethnically hegemonic form to present something of that subordinate culture. All play variously on the power strategies of charm, teasing, generosity, opportunism, sympathy and advocacy.

The Nutcracker

First, four Spanish Dancers, fiery and proud and dressed in black velvet and scarlet silk, advance swiftly to perform a *Danse Espagnole* ... a lovely veiled girl now follows ... clad in filmy brown Eastern draperies, and sways languorously to the Oriental cadences of the *Danse Arabe*. Two comic Chinamen ... enter, one holding a sunshade over his head, the other carrying a fan. With nodding heads and flying pigtails, they perform an eccentric dance, with much somersaulting, which suddenly ends in a collision. Then, Bouffon, a clown like character ... executes a vigorous *Trepak*, a Russian folk dance, which grows faster and faster as it proceeds, finally ending in a great crescendo of sound as he leaps wildly in the air, drawing both feet up under him.

Pigeon Crowle: *Come to the Ballet* (1957: 43)

Spanish dancers have flair, Chinese are dexterous and delicate, Russians bound like Cossacks and Arabian dancers slink about regally.

Jennifer Fisher: *Nutcracker Nation* (2003: 11)

Figure 5.1 The Nutcracker. Finale showing couples from all four national dances (Vic-Wells Ballet 1937). Courtesy of V&A Images.

In the ballet *The Nutcracker*, a little girl travels to a magic land, where she is guest of honour at a dance spectacle, which includes four dances in the styles of particular countries: Spain, Arabia, China, Russia (Figure 5.1). The conceit is that the first three of these represent gifts, of chocolate, coffee and tea, respectively,* just as later she will receive a sugar plum and flowers. However, these national dances (as they are usually called) also very clearly evoke the dance style and cultural flavour of the countries concerned. They are sometimes lightly comic, always fun and delightful, but only to the most vestigial degree parodic. They are, within the framework of stereotypicality, realist, but there is no pretence that these are actual Spanish, Arabian, Chinese or even Russian dancers, they are classical ballet dancers doing Spanishness, Arabianness, Chineseness and Russianness. Forms of these dances were danced by people at balls in the nineteenth century (comparably perhaps to the Latin section of contemporary ballroom dancing, where there is commonly a sense of non-Latins putting on Latinness), and this enjoyment

* In Matthew Bourne's 1992 version (for Opera North with Adventures in Motion Pictures) they become, respectively, liquorice, Knickerbocker Glory and marshmallows and the Russian dance becomes gobstoppers.

in dancing other people's dancers also lies behind the *Nutcracker* national dances. Indeed, in an early proposal for the ballet, Marius Petipa had thought to have the children at the party with which the ballet opens dress up in fancy national dress and dance accordingly (Wiley 1985: 200) – the spirit of the national dances in the magic land is no different from this. The dances are charming, neither straight imitation nor mockery, and posited on imperialism.

There have been countless productions of *The Nutcracker*, from amateur to professional; it has been a mainstay of many companies, and there have been many variations, including American immigrant, African American and classical Indian *Nutcrackers* (Fisher 2003: 80–96). My discussion of the national dances, however, focuses on relatively classic versions, principally the following (abbreviated in the text as indicated): Petersburg Ballet 1892 (Petersburg), Kirov Ballet 1934 (Kirov), *Fantasia* 1940, San Francisco Ballet 1954/1967 (SFB), New York City Ballet 1958/1993 (NYCB), Royal Ballet, London 1968 (Royal Ballet) and Birmingham Royal Ballet 1990 (BRB).[2] There is a consistency of vision across the national dances in all these, despite considerable variation in, for instance, the number and gender of dancers involved. I include the cartoon *Fantasia*, which has mushrooms, fishes and thistles doing the national dances, for these are especially revealing: to make flora and fauna still carry national characteristics, the signs of the latter have to be simplified, exaggerated and intensified and thus become still more evident.

Each dance evokes its nation through a combination of well known musical, costume and choreographic cues. I indicate here the most clear cut and common of these across most versions, together with any especially telling details in particular versions. (As the young girl is called Masha in some versions, Maria or Clara in others, I have here referred to her simply as the girl.)

SPANISH

MUSIC: trumpet, castanets, repeated slightly snappy rhythmic phrases.

COSTUME: white or red on black; men have toreador-style small waistcoats, tight black trousers (for SFB, they were explicitly bullfighters (Anderson 1979: 112)); women have sheath skirts billowing out from below the knees, sometimes ornamental combs in their hair.

CHOREOGRAPHY: 'haughty' poses, angular arm positions, head thrown back; jerky movement, feet sketching patterns on floor on the spot, *pas de basque*. In BRB, the girl joins in, echoing the woman's hand movements and her shaking her skirt, and the woman herself (especially in Chenca Williams' performance) exaggerates the hauteur of the classic flamenco dancer.

ARABIAN

MUSIC: underlying 'hypnotic' 3:8 rhythmic drone; 'mysterious' harmonies; tambourine.

COSTUME: diaphanous tunics and balloon pants, often bare midriffs and legs (women) or torsos (men). In the Kirov, the women hold veils in their hands, further emphasising the undulating movement, and this is echoed and embellished in *Fantasia* by the use of fish with flowing fronds; in NYCB, the woman has finger cymbals, pinged in time to the music.

CHOREOGRAPHY: hands held above head in 'Oriental' (mosque shape) pose or to sides in Egyptian (bas relief) pose; slow, undulating movements; an 'effect of stylized Eastern languor' and 'an appropriate static quality' (Wiley 1985: 215); 'sultry extensions and backbends' (Fisher 2003: 104). In SFB, a magician makes a dancing girl disappear.

Fantasia especially brings out the sense of sensuous femininity. The fish are anthropomorphised as female, with long, batting eyelashes and big, lipsticked lips; they scurry teasingly away when they realise the camera has drawn near; one sequence shows them through an elaborate coral branch suggesting the screens in harems, while in another they group together and are seen from overhead as in a Busby Berkeley formation (Berkeley's numbers are themselves often suggestive of the Western equivalent of a harem). Royal Ballet explicitly depicts a Sultan in his harem.[3]

CHINESE

MUSIC: underlying, very regular stepping rhythm on bassoon and plucked strings; high flute, Glockenspiel.

COSTUME: tunics and short pants, coolie hats; men often have droopy mandarin moustaches; often fans, sometimes parasols. In *Fantasia*, the mushrooms' caps become big red coolie hats, the stalks are made to look like arms folded inside sleeves and the gills are turned into slit eyes.

CHOREOGRAPHY: pointed index finger,[4] little steps, prancing, bowing, side to side head movement, jack-in-the-box leaps. In SFB 1967, there is a fight with a paper dragon. At points in the Kirov, the woman is in front of the man and they do slightly jerky movements in time to the music that produces a comic effect, almost as of a four-armed person. In one version (NYCB), the girl moves her head from side to side in echo of the women dancers; in another (BRB), she toddles forward, index finger raised, then echoes the high stepping movement of one of the men, very clearly signalling how comic it all is.

RUSSIAN

MUSIC: fast and accelerating; leaping phrases; rhythm of the Cossack dance, the trepak.

COSTUME: men in Cossack shirts, loose pants tucked into boots; women (if they appear) in patterned, Ukrainian peasant dresses with boots; both may have straight-sided fur hats.

CHOREOGRAPHY: men: leaps, Cossack movements, such as kicking out legs
from a crouching position or while supporting upper body with hands on
the ground, and assuming a position with legs and arms outstretched in
an X shape; women: hands to waists, small feet movements; both: clap-
ping hands with broad arm strokes. In BRB, the girl joins in briefly,
clapping her hands.

In the Kirov and NYCB versions, this is done as a hoop dance, with no
Russian implications (except for the music). Sometimes Western companies
have imported Russian or Ukrainian performers to do the Russian dance
(Fisher 2003: 96), courting the auto-pastiche, or even auto-parody, common
when people put on their folklore for the benefit of others.

In these ways, an idea not only of the dance style of a given land, but also,
implicitly, the nation's characteristics are summed up: histrionic Spaniards,
sexy Arabs, comic Chinese and vigorous Russians. These are typifications,
that might now be condemned as stereotypes, but that does not mean that
they were perceived of as either unrealistic or derogatory (which is what we
would most likely mean now by labelling them stereotypes).[5]

The use of national dance in ballet has a history going back at least to such
spectacles as *Les Indes galantes* 1735 and notably strong in the Russian tradi-
tion, from the Oriental dances in *Russlan and Lyudmila* 1837–1842 and
Marius Petipa's wild extravaganza *The Pharaoh's Daughter* 1862[†] to the
1909 Ballets Russes ballets *Orientales*, *Shéhérazade* and *Le Dieu bleu*; Lev
Ivanov, choreographer of the first version of *The Nutcracker*, had previously
choreographed the Polovtsian dances in the opera *Prince Igor* 1890. This
tradition, stimulated by encounters with non-Western dance through explo-
ration, visitors and imperialism, did not see itself as unrealistic. Any given
imitation of a foreign art form, including dance, has an origin in an acquain-
tance with that form, an acquaintance always filtered through, but not
entirely shaped by, perception and preconception; the imitation based on this
acquaintance may then take on a life of its own, growing further and further
away from the original perception, yet it is still quite commonly taken as
accurate and is in practice tempered by renewed acquaintance with the art
form in question. If Chinoiserie, the fashion for Chinese-like things in the
arts beginning in the eighteenth century, was based on 'the European idea of
what oriental things were like, and ought to be like', it was also a conception
'gathered from imported objects and travellers' tales' (Impey 1977: 9).
Similarly, the national dances in *The Nutcracker* do not have nothing whatso-
ever to do with actual Spanish, Arabian, Chinese and Russian dancing and

[†] In *The Sleeping Beauty* (Petipa 1889), a ballet harking back in many particulars to the French court ballet,
the sarabande of national dances in Act III was based on peoples that would have been new and fascinating
to Versailles in the seventeenth century: Turks, Persians, Ethiopians and American Indians (Wiley 1985:
188), thus an evocation of an earlier imitation.

were, and are, performed in the context of some versions of these kinds of dancing being familiar to audiences: flamenco, belly dancing, Cossack displays. (Only Chinese dance has failed to establish itself in this kind of popular global repertoire.[6])

In the Romantic ballet of the first half of the nineteenth century, there was moreover a commitment to the idea of accurately dancing both the letter and the spirit of national dance styles. Carlo Blasis, one of the most influential teachers and writers on classical ballet, wrote in 1820 that dancers

> must devote themselves to a correct representation of national idiosyn-
> crasies and imbue each step and pose with the style and spirit of the
> peoples whose dance they are performing. (Quoted in Arkin and Smith
> 1997: 31.)

Marius Petipa, who gave instructions to Tchaikovsky and Ivanov on the national dances for *The Nutcracker*, put considerable care into studying national dances for his choreography, bringing in Caucasians from the Russian army to instruct him in a dance for *Russlan and Lyudmila* and learn-ing a fandango in Madrid to incorporate into a production of *Carmen* (Arkin and Smith 1997: 34–35). Such realism in choreography was also to be matched in costume and music.

In practice, even Blasis suggested that the important thing was to identify the key markers of different national dances, rather than their detail. Such dance 'was not truly expected to reproduce authentic folk dance in the modern-day ethnographic sense, but instead was distilled, its salient features thereby thrown into high relief and presented to the audience in a way that gave the impression of a well-wrought verisimilitude' (ibid.: 36). It is likely that already by 1892 and the first production of *The Nutcracker* many of the 'salient features' had become routinised, no longer checked against native dancing, but this does not mean they were perceived as sheer invention. Whatever our perception of them now, national dances in classical ballet were far from being assumed to be fantasies or perceived in a negative sense as stereotypes.

Yet they were of course always danced by classically trained ballet dancers. Petipa, though committed to national dances, was also decisive in the move towards a more abstract form of ballet, and it is thus at the very least likely that the sense of classical norms inflecting national ones was in place, in the habits and training of the dancers as much as in deliberate choreographic intention, underlining the sense of dancers doing Spanishness and so on (cf. ibid.: 55). There is, after all, never a question of using actual belly and flamenco dancers in the production: what we clearly see is people doing Spanishness, Arabness and so on. Nationality is signalled as put on, partly from the playful context (these are gifts, sweetmeats) but especially from continuities in the music and choreography with the rest of the ballet. The score may throw in castanets and finger cymbals or may use rhythms unusually

insistent for ballet, but it is basically within the norms of orchestral music of the period – the Spanish dance is not done just to guitar, castanets and stamping feet and the Chinese dance eschews entirely Chinese instrumentation and harmonics. Similarly, the national movement elements are always tempered by classical balletic norms. The feet in the Spanish dance may suggest downward movement (against the general feeling of upwardness in classical ballet) but they don't stamp, and the angular positions of the arms are mitigated by classical ballet's characteristic emphasis on softness in arm and hand positions (thus the hands are not crunched or splayed, as in flamenco, but held in the soft, slightly parted position of classical precept). The undulations of the Arabian dance may suggest belly dancing and centred movement, but it never is that, always still retaining a sense of ballet's vertical and reaching quality. In the trepak, there is for the most part a sense of adding in Cossack movements to signal the Russian flavour. In short, the national dances are danced with all the norms of dance that have been present throughout the rest of the ballet.

The *Nutcracker* national dances are then close to conceptions of the national dance styles in question, conceptions themselves exhibiting varying mixes of acquaintance and accretion and always modified and contained by being done according to the overriding norms of classical ballet. Apart from the Chinese dance, it is not mockery, and even there it is establishing difference but not distance. The very fact that a classical dancer can apparently bodily inhabit another dance form brings the latter closer, even while it is always clearly another kind of dancer, a ballet dancer, that is actually doing the getting close and is never being subsumed.

This closeness may set off many responses: envy of Arabian sensuality, say, teasing of Spanish hauteur, patriotic pride in Russian vigour and unabashed amusement at Chinese antics. There is the potential for homage, humour and sometimes something close to parody, but always in the context of these being delightful gifts for the heroine and always performed under the banner of the balletic ideals of grace, poise, line and taste. The significance of the closeness resides in the imperial context.

The Nutcracker was in its first production imperial in three senses. The Petersburg ballet was supported by the imperial court, part of its investment in refined display; in *The Nutcracker*, the dances are performed at the court of the magic land, with the onstage court in effect reflecting the real court that subsidised and patronised it; and the ballets are coming from lands that are either the most distant of fellow Europeans (Spain) or part of the Russian empire. Spain is distant not only in terms of geographic distance, but for two other reasons: its culture is marked by Moorish influence, something suggested in the 'seductive curves' of the dance, such that 'Spanish dance represented the Orient nestling in the bosom of Europe itself' (Garafola 1997: 3); and, in *The Nutcracker*, the Spanish dance represents a gift of chocolate, which had been introduced from Mexico into Europe by the Spanish (Anderson 1979: 185). Arabia and China were significant to Russia,[7] as the land just beyond

its Middle and Far Eastern territories (and the theme for the Arabian dance is based on one of the former, a lullaby from Georgia (Warrack 1979: 67–68)).[†] As for Russia, the trepak is a Cossack dance, that is, from territory (notably the Ukraine) that only became Russian when acquired by Moscow in the eighteenth century. Cossacks were recruited to be the Czar's elite guardsmen and the trepak was danced at court balls, an instance of the common process of flattering colonised peoples into an inclusion that still signals them as distinct: people at court were guarded by Cossacks – they might dance a Cossack dance, but still they were not themselves Cossacks.[8] In short, the national dances affirm the court's European identity through its ability to dance or have danced non or not quite European dances, using a dance form, ballet, bearing its Western European credentials[9] in the perennial context of Russian uncertainty over its belonging in Europe.

Away from the first production, the idea of a court performance and of gifts of dancing people from other lands take on a different resonance in the context of Western economic and cultural neo-imperialism, but the essential dynamic is not so very different. Pastiche closeness in imperialist context, however much felt as emulation, admiration, enchantment or affectionate teasing, is also always reinforcing the sense that there is a norm, centred on us, where we either sit and receive with pleasure the offerings of otherness or else demonstrate that we (or our dancing representatives) can make it part of our own movement without in the process becoming it.

Coda. In 1996 David Bintley used Duke Ellington's 1960 version of Tchaikovsky's *Nutcracker Suite* for a series of dances for Birmingham Royal Ballet based around the idea of kinds of confectionary, naming it *The Nutcracker Sweeties*. Each dance seems to play off against the backlog of versions of it discussed above. In the Spanish dance,[10] the costumes (by Jasper Conran) have especially loud and busy colours, the principal woman has a blowsy rosette headdress and the man bull's horns, and there is comic exaggeration (again, especially Chenca Williams' performance), with the man at one point dragging the woman along the floor in caveman fashion. The music for the Arab dance uses a bamboo flute, the dancers, all male, wear djalabas and fez, move their necks from side to side and whirl (as dervishes): it runs entirely counter to the emphasis on sensuality and sexiness in most versions. Similarly, against the prevailing comic treatment, the Chinese dance plays down the comedy and turns the number into a *pas de deux* between a white sailor and a high-kicking Chinese seductress with extended finger nails. The Russian dance is more conventional, but still exaggerated in its Russianness. The *Sweeties* is tongue in cheek, amused not by the quirks and quaintness of other people's dancing, but by that very tradition of amusement itself. It is a scintillating pastiche of a pastiche.

[†] It has, however, also been suggested that Tchaikovsky took as a model for the Arabian dance the music for Herod and his female slaves in *Hérodiade* Massenet 1883 (Locke 1998: 124).

Jewish black music

Many works that had a historical role in establishing African-American musical identity for a wider audience were produced by Jews, including:

'Alexander's Ragtime Band' Irving Berlin 1911[11]
'Swanee' George Gershwin and Irving Caesar 1919 (introduced in the show *Sinbad* by Al Jolson and thenceforth especially associated with him)
Rhapsody in Blue George Gershwin (and Ferde Grofé[12]) 1924
The Jazz Singer play: Samson Raphaelson 1925 with George Jessel; film: Warner Brothers (d. Alan Crosland) 1927 with Al Jolson (cf. Hoberman 2003a)
Show Boat Jerome Kern and Oscar Hammerstein II 1927 based on the novel by Edna Ferber
'I Got Rhythm' George and Ira Gershwin 1930
'Body and Soul' Johnny Green 1930
'Stormy Weather', 'I Gotta Right to Sing the Blues' Harold Arlen[13] (and Ted Koehler) 1932
'Supper Time' Irving Berlin 1933
Porgy and Bess George and Ira Gershwin (and DuBose Heyward) 1935 (theatre), 1958 (film)[14]
'Is It True What They Say About Dixie?' 1936, Irving Caesar, Sammy Lerner and David Marks.
'Bojangles of Harlem' Jerome Kern and Dorothy Fields 1936[15]
'Blues in the Night' Harold Arlen (and Johnny Mercer) 1942.

To these we should add the careers of Sophie Tucker, who was billed as 'the Mary Garden of Ragtime'[16] and 'the Queen of Jazz', and Benny Goodman, known as 'the King of Swing' from the mid-1930s on, one of whose greatest hits was 'Body and Soul'.[17]

We do not know to what extent audiences took much of this Jewish 'black' work (for once the scare quotes seem justified) as genuinely or virtually black, either just not knowing its Jewish provenance and presuming an African-American one, or else knowing the provenance (or just assuming it to be white gentile) but believing that the work had none the less got blackness accurately. Probably many did believe that 'Alexander's Ragtime Band' was a rag, 'Ol' Man River' from *Show Boat* a spiritual, and that Jolson was singing jazz in *The Jazz Singer*.[18] The take-up of the works by African-American performers may also have served to validate their blackness: 'Ol' Man River' is forever associated with Paul Robeson,[19] Ethel Waters said of 'Supper Time', a song about lynching with which she had a huge hit in the show *As Thousands Cheer*, that 'she felt she was singing it for her people' (Placksin 1985: 27), 'Stormy Weather' was a key work in the careers of Waters and Lena Horne[20] and gave its name in 1943 to one of Hollywood's first showcases for black entertainers,[21] and it has been estimated that the chord progression of

'I Got Rhythm' is second only to the blues as the basis for jazz improvisations.[22] Such take-up may also have involved degrees of irony, wresting the work from non-black assumptions and errors, troping, Signifyin' against the grain of the work,[23] but there remains the likelihood that this was not always so and that in any case whites generally did not get this. In short, many of these works could be taken straight, as genuine or accurate, thus suggesting their affinity, at least, with pastiche, whose closeness to its referent means that it may also be mistaken for it.

Much of the work though does also suggest that signalling the imitation is going on. To begin with, much of the material was introduced by white performers, and by the time of *Porgy and Bess*, whose cast was entirely African-American, Gershwin himself was a celebrated composer: if people did not necessarily know the Jewish involvement in the works, usually they did know they were not straightforwardly African-American productions; even where they thought they were accurately black, this means they treated them as good copies or likenesses, as good as, maybe some thought even better than, the real thing, but African-American product remained that real thing. Then, some of this work was introduced in blackface, in whose development Jewish entertainers played a major role (cf. Rogin 1996, Melnick 1999: 37–42, Slobin 2003): Weber and Fields, Jolson, Tucker, Eddie Cantor. For most people now blackface is assumed to have been so evidently a grotesque and offensive exaggeration of blackness that it was a signalling with a vengeance. However, it is worth noting, first, that sometimes – so it is claimed – audiences did mistake blackface performers (including Jolson and Tucker) for African-Americans (Melnick 1999: 85, 113–114).[24] Second, there was a range of exaggeration in the blacking up, some involving big white lips and crinkly toupees, but some quite naturalistic.[25] Third, blacking up is a form of stereotyping, and, as already noted, a given stereotype is only seen as a stereotype if that is what you think it is, otherwise you think it is an accurate representation; thus, if you think all blacks look the same (and like this), you think that a stereotypical representation of them (that is, all the same and like this) is a correct one. Jewish blackface worked for the most part on the assumption that audiences knew the performers were not African-Americans, but this merely makes the performance evident or known imitation, not necessarily – though, of course, sometimes – caricature.

Some of the works also play more specifically with the notion of imitation. Both 'Alexander's Ragtime Band' and 'Swanee' quote from Stephen Foster's 1851 song 'Swanee River' (aka 'The Old Folks at Home'); Foster's songs were among the first blackface minstrel hits and the reference both signals a continuity and registers a distance (with Berlin, says the song, you can now hear 'Swanee River' in ragtime, while the singer in the Gershwin/Caesar song longs to be back with the old folks at home).[26] *Rhapsody in Blue* juxtaposes (concert) piano and (jazz) orchestra, throwing both into relief (cf. Schiff 1997: 10, 27, 64ff.). In *Show Boat*, 'Can't Help Lovin' Dat Man' is first identified by one of the black characters as a song of 'colored folks', and is then performed both

beautifully by a character who turns out be passing for white and ineptly by the pure white ingénue.[27] 'Is It True What They Say About Dixie?' might be questioning the whole enterprise, while 'I Got Rhythm' and 'I Got a Right to Sing the Blues', in contrast, seem almost to be signalling a claim from someone not black to be able to do black, to have rhythm, to know from experience the meaning of the blues.

There are different, not necessarily incompatible, ways of understanding this widespread Jewish imitation of African-American music — music close to black, even on occasion mistaken for it, but never actually it and often signalling the fact. Some have suggested a close affinity between the Jewish and African-American experience of suffering and diaspora as well as of the shared city spaces of Jews and African-Americans; others discern as well musical correspondences between African-American blues and Jewish cantorial song, either in terms of the one being as full of melancholy feeling as the other ('the most popular scale of the Khassid has a blue note quite as cerulean or indigo as the black man's blues'[28]) or else sharing specific musical elements, such as 'the ubiquitous minor third, vocal wailing, spare harmonies [and] improvisation' (Giddins 1981: 154). Some version of this is the underlying rationale of the film *The Jazz Singer*, whose intertitles and inter-cutting suggest an equivalence between Rabbi Rabinowitz's singing in the Synagogue and his son Jack Robin's in vaudeville: both have what we might now call soul. All of this emphasises a commonality of experience and expression, a closeness to the point of identity between the two traditions; others though suggest the elements of distance that account for the pastiche quality of Jewish black music.

This can be linked in the first place to a wider feature of Jewish culture. As Fanny Brice put it, 'scholars have long determined that a variety of experiences, and a constantly changing environment have produced adaptability in the Jew, rarely possessed by other people'.[29] Early in his career, Irving Berlin wrote German, Irish, Italian and Jewish as well as Negro songs (Howe 1976: 561). Ronald Sanders suggests that the situation of Jews in America is the cultural ambivalence of America writ large, 'poised somewhere between a Europe past and a new world present' (1976: 202), producing a feeling for pastiche, for work that is not quite one thing or the other.[30] Imitation was a survival, and often assimilationist, strategy for Jewish entertainers; black music and dance were among the most popular entertainment forms and therefore most worth imitating. There was, however, more than this at stake in doing black entertainment specifically. Jews occupied an unstable place in the racial hierarchies of the period: not quite white, they were yet not black. Unlike the Irish or Italians, and also unlike the blacks, Jews had as it were no legitimate voice — no song, no music — of their own that would be recognised beyond the ghetto. Black music, in its emotional expressiveness, and with the weight of the experience of pain behind it, allowed Jews to express feeling in a way that they could not do on their own behalf: 'Black became a mask for Jewish expressiveness, with one woe speaking through the voice of another'

(Howe 1976: 563). Yet, while Jewish composers and performers had an ability to convey 'closeness to the cultural stuff of "Blackness"' there was also a simultaneous signalling of 'distance from actual African-Americans' (Melnick 1999: 43), and the upshot may have been 'not to express Jewishness at all but to hide it', enabling Jews to enter the (white gentile) cultural mainstream and leaving blacks behind (Rogin 1996: 99–100). In short, pastiche in Jewish 'black' music is a highly ambivalent strategy of survival, expression and evasion, at once enabling Jewish-American and African-American expression and diluting and disavowing it, work that simultaneously indicated and occluded its sources.

The Afro-American Symphony

There is a long line of attempts to put together African-American and European classical musical forms. Although not always readily separable, one might distinguish within this tradition between works coming out of European concert music and incorporating African-American melodies and instruments (as, for instance, Louis Moreau Gottschalk's *Symphony No 1: 'La Nuit des tropiques'* 1859, Antonin Dvořák's *Symphony No 9: 'From the New World'* 1895 or William Levi Dawson's *Negro Folk Symphony* 1934) and works that start out from African-American music and extend it in terms of length and instrumental forces, often named with rather loosely used[31] terms from the European concert tradition (George Gershwin's *Rhapsody in Blue* 1924, James P. Johnson's *Yamekraw – A Negro Rhapsody* 1926/27[32] and such works of Duke Ellington as *Creole Rhapsody* 1931, *Symphony in Black* 1935 and *Black, Brown and Beige* 1943/58[33]). Many of these works (Dvořák, Dawson, Johnson, Ellington) subsume one or other element into their overall flavour, but others retain a sense of both elements being in play and thus raise the possibility of throwing both into relief, which in turn suggests the possibility of pastiche.

Gottschalk's *Nuit des tropiques*, for instance, is in two movements, the first of which is wholly within the prevalent European style (notably Berlioz), while the second is quite different, a fugue built around a samba rhythm, with a terrific build-up of energy and tempo using non-European instruments such as bamboula, maracas and Afro-Cuban drums; if one were to apply the title literally, then one might say that the first movement expresses the feeling of being in the sultry heat of the tropics, while the second, seen from the perspective of the first, is a pastiche of the native music that the implicitly white subject of the first movement may hear, intoxicatingly, around.

Gottschalk's is a white take on the tropics. I want to consider here a work that for most of its length does not quite integrate its black and white elements, but to very different ends from Gottschalk (or, come to that, *Rhapsody in Blue*). This is William Grant Still's *Afro-American Symphony* 1930. Still had several musical languages at his fingertips: raised with black church music, he studied with the established classical composer George Whitefield Chadwick[34] and avant-gardist Edgar Varèse, arranged and performed with W.C. Handy

(the 'Father of the Blues') and arranged for, inter alia, Bing Crosby and Artie Shaw. This grounding enabled him to produce a symphony which plays forms off against one another, but not just for fun, rather as part of a serious histori- cal project. In what follows I begin by describing the symphony and the ways in which it deploys deliberate imitation, before turning to consider the point of its doing so.

The *Afro-American Symphony*[35] is a conventionally organised symphony in the Western classical tradition that draws many of its main musical elements from African-American music. It is organised according to the common pattern for a symphony: four separate movements, each with two principal musical themes, that are then the basis for variation, combination and repe- tition within the movement. Each movement has an overall quality of feeling and Still specifies in the score what these are, using both traditional musical terminology and everyday affective vocabulary: first movement moderato assai, longing; second adagio, sorrow; third animato, humour; fourth lento, con risoluzione, aspiration.[36] So far, so European. However, the musical themes are drawn from the blues, spirituals and minstrelsy, rhythm is often synco- pated and to the fore, and at one point, unprecedentedly, a banjo is used. If the architecture is white, the colour is black. What I want to suggest is that what is going on here is a signalling of those colours as black, a signalling for which there is no other word but pastiche.

The *Symphony* opens with a short horn solo suggestive of the main theme from the second movement of the *New World Symphony*, before moving, via a slurred bassoon phrase reminiscent of the sliding clarinet phrase at the start of *Rhapsody in Blue*,[37†] to a statement of a blues theme that is also the first main theme of the movement. All these are imitations of previous but still current forms, but the handling and thus implications of the first two are very different from that of the last.

The *New World Symphony* and the *Rhapsody in Blue* are non-African- American predecessors in the business of producing extended works using African-American musical materials. These were the pieces that had most decisively demonstrated that such works could be produced, yet they were produced from outside an African-American cultural milieu.[38] Still's allusion to them also potentially sets in motion chains of pastiche. Dvořák's theme is based perhaps on 'Swing Low Sweet Chariot', and almost certainly on the work of Harry T. Burleigh,[39] who collected, arranged and composed spiritu- als, an activity later viewed as a distortion and cleaning up of nineteenth century black sacred music – thus Dvořák might be deemed to have produced a pastiche of something that was already an adaptation of a specific musical tradition. Similarly, Gershwin was producing an imitation of jazz, a form that itself in part Signified upon white balladry and dance music. I do not know

† There is a similar clarinet glissando near the beginning of Ellington's *Creole Rhapsody*, part of what suggests it as 'a deliberate response' to the *Rhapsody* (Schiff 1997: 78).

how much of this Still is summoning up in his, in turn, pastiches of these pasticheurs, but there is clearly some sort of relationship being set up between his symphony and these white precursors – part homage, maybe, acknowledging their role in clearing the space that made his symphony possible, but also perhaps taking a distance, distinguishing what is to follow from Dvořák's ersatz spiritual and Gershwin's dodgy jazz.[40]

The allusions to the *New World Symphony* and the *Rhapsody in Blue* are fragments, but the blues theme that follows is a complete statement and is used throughout the symphony (in the introduction to the second movement and as the basis of its second theme, in the coda to the third movement, as the basis of the second theme of the last movement); it is central to the work's project of the validation of African-American music. Yet, though closer to its referent than his Dvořák or Gershwin (and, arguably, closer than either of them are to their referents), it is not straightforwardly a blues (something Still could very easily have produced from his experience with Handy). It adheres strictly to blues structure, to its harmonic progression and its call-and-response pattern (unlike *Rhapsody in Blue*, which uses the blues scale but not the blues structure). However, it is not sung (depriving the form of one of its most potent expressive dimensions), there is no guitar (the instrumental basis of the blues), it is not composed, as Duke Ellington, for instance, composed, on the assumption of particular players and their likely improvisations, and it is introduced in the context of a four movement symphony; moreover, the dragging underlying rhythm,[41] the syncopated beats on high hat at the breaks in the melody the first time through and the rather comically perky wind phrases in the (rather faster) second time through, all slightly, almost amusedly highlight characteristics of the blues. The blues theme is both a complete statement very close to the blues itself and yet still part of the 'stylized imitation' of the symphony's African-American elements (Floyd 1995: 109).

After the blues in the first movement, comes a second theme, an 'ersatz spiritual' (ibid.).[42] The spirituals were the black music of (respectable) choice in the nineteenth and early twentieth century music, partly in relation to a concern with authenticity, identified in what could be construed as a folk music, partly out of a developing 'ethnosympathy' of whites towards the suffering of black people (Cruz 1999). Musically cleaned up (by eliminating or diminishing their African harmonies, rhythmic complexity and call-and-response patterns), they were the acceptable face of black music, notably for white composers (including Dvořák) and audiences, with Zora Neale Hurston, among others, referring disparagingly to the result in 1934 as 'neo-spirituals' (Hurston 1970: 223–225).[43] Still's spiritual in the symphony's first movement could perhaps have been written by Dvořák, except that it 'bears sort of a relationship to the Blues theme'[44] in its underlying chord progression[45] and uses echoing phrases at breaks in the melody that suggest the call-and-response pattern of African-American music. Thus a sequential (the blues, then the spiritual) and also simultaneous (the blues handling of the spiritual theme)

compare-and-contrast relationship is set up between the spiritual and the blues, throwing both into relief.

The next movement also combines the spirituals and the blues, though here the former predominates, decorated and coloured by blues elements. The overall tone is sombre, painful (doloroso), the marking 'sorrow' evoking W.E.B. DuBois' discussion of the 'sorrow songs' in *The Souls of Black Folk* 1903 (1994: 155–164).[46] DuBois was referring specifically to the spirituals; Still's procedures brings them together with the blues, both under the sign of grief.

The third movement draws on minstrelsy, deploying a happy-go-lucky theme, whose main refrain suggests a 'Hallelujah!' shout, with banjo accompaniment. Minstrelsy may seem a surprising reference, associated as it is with white blackface mugging; yet minstrelsy (in which African-American themselves worked) involved the imitation of African-American music, much more of which survived in the performance than may now be apparent (cf. Locke 1936: 43–56, Gottschild 1998);[47] and many have argued that it has been common practice in African-American culture to take up the stereotypical role embodied by blackface for strategic reasons, at once donning the minstrel mask for the benefit of whites while all the while signalling to black perceivers what is really going on (cf. Baker 1987, Floyd 1995). There is once again a further twist to the chain of imitations that may be invoked here, since many of the African-American forms that whites mimicked had already involved black mimicry of white antics.[†]

The complexity of meaning that is impacted in the use of minstrelsy in an African-American symphony is further heightened by the quotation early on in the movement from George and Ira Gershwin's 'I Got Rhythm' (premiered in the musical *Girl Crazy* two weeks before Still started to work on the symphony (Smith 2000: 136)). Perhaps this references the suspicion that Gershwin had pinched the tune from one Still had himself written for the 1921 show *Shuffle Along* (ibid.: 136–141). Even if this is not so, Still's quotation evidently references one of the most famous popular songs of the day, suggestive of African-American music not only in its (if anything exaggerated) syncopation but in a title refrain that both calls on one of the commonest white views of the gifts of black people (that they all got rhythm) and appropriates it for white people (because now I got rhythm too). This evocation by Still of a specific non-African-American imitation of African-American music throws into relief the symphony's own African-American imitation of minstrelsy's imitation of African-American music, perhaps acknowledging that something African-American survives in minstrelsy, but also signalling that there is something distorted or superficial about it. This is further suggested by what Still does with his minstrel material, shifting it more towards blues

[†] The cakewalk is a famous instance – taken up by whites in minstrelsy and ragtime as a fun imitation of a black dance, the latter was itself the slaves' mocking imitation of the posh dances of white folks at the big house (Stearns (1968: 22–23, 123), Gottschild (1998: 114)).

harmonies in the second theme and in the process bringing it closer to the religious fervour suggested by the 'Hallelujah!' phrase in the tune, a transformation that finally undoes the minstrel mask (Smith 2000: 129–132).

The process of transformation – and, as it were, de-pastiching – that goes on in the third movement is fully accomplished by the fourth. This makes extensive use of blues and modal[48] harmonies, with the blues theme providing the basis for the movement's second theme (ibid.: 128–129); yet I have to admit that I can't really hear this in any of the performances, which sound to me far more within the conventional harmonics and orchestration of late romantic symphonies. The movement's affective register is solemnity, with slow tempi and dark orchestration, the blues subsumed into the language of Western concert music. In the last seconds, in the bass line of the score, there is an echo of the *New World Symphony* theme again, a last farewell to its project or an acknowledgment of having joined it?

A number of impulses informed the development of African-American symphonism. Western concert music saw itself as having achieved an abstract and universal musical language. At the same time, through the nineteenth century there developed a strong desire to give a national flavour to such music, something that would express the soul of a nation and show that it partook of the highest musical/cultural achievements of humanity. A common way of achieving this was through a recourse to folk music, a reservoir of autochthonous music seen to be untouched by commercialisation and industrialisation, which, incorporated into classical concert forms, would also effect a unified national identity (cf. the Lieder tradition in Germany and Austria,[49] Dvořák in Bohemia, Grieg in Norway, Vaughan Williams in Britain and Bartók in Hungary). In the USA some use was made to this end of both Native American and white settler folk music, but Dvořák, while working in the USA, announced in the *New York Herald* in 1883 that it was in 'the Negro melodies of America I discover all that is needed for a great and noble school of music' (Beckerman 2003: 100–101). Although many who took this on board were white,[50] it also legitimated African-Americans in classical music (and also burdened them with an expectation of producing black inflected music).[51] At the same time, there was something at stake for African-American musicians and theorists in demonstrating that their music, often demonised as primitive, vulgar or trivial, could be the basis for extended and profound musical works. This was part of Still's explicit purpose in composing the *Afro-American Symphony*:

> I wanted to prove conclusively that the Negro musical idiom is an important part of the world's musical culture. That was the reason I decided to create a musical theme in the Blues idiom and develop it into the highest of musical forms – the Symphony.[52]

There is also something further, found in African-American work in this tradition but not (as far as I can see) white: history. This may be chronological.

The three movements of Dawson's *Negro Folk Symphony* ('The Bond of Africa', 'Hope in the Night', 'O, Le' Me Shine like a Morning Star') sketch the taking of Africans from Africa, the experience of slavery and the birth of spiritual hope (Brown 1993: 77–78, Johnson 1999); Ellington's *Black, Brown and Beige*, subtitled 'A Tone Parallel to the History of the Negro in America', similarly moves from enslavement, through work, the black Church and the Spanish-American war to jazz age Harlem, and the *Afro-American Symphony* is part of a trilogy, dealing with Africa (*Africa* 1930), the American experience up to now (*Afro-American Symphony*) and the putative racially integrated society of the present (*Symphony # 2: Song of a New Race* 1937[53]). The notion of chronology is even notionally present in the *Afro-American Symphony* in the last movement's synthesis of the previous elements into, perhaps, a New Negro sensibility. History in African-American symphonism may however be closer to memory, not in the sense of a given person's memory but rather the way remembrance of the past is carried culturally in ways that are not linear and chronological, but cyclical, episodic, discontinuous, repetitive (cf. Barg n.d.[54]). Johnson's *Yamekraw*, for instance, uses spiritual, blues and musical comedy themes to suggest the life of the black settlement near Savannah, Georgia, that gives the piece its name; these constitute the historical memory of the work, but not arranged as a progression. In the *Afro-American Symphony*, before the last movement, there is no chronological logic to the ordering of elements (Dvořák, symphonic jazz, blues, spirituals, minstrelsy, musicals) but the juxtaposition, repetition and simultaneity of elements suggest the memory traces of history.

There is a particular edge to this deployment of history in African-American symphonism. On the one hand, the possibility of history had initially been denied Africans in America, by means of mixing up language groups and forbidding literacy, and subsequently whites had much invested in discouraging black Americans from remembering their past. On the other hand, music was one of the ways by which history had been passed on, in the survival of African musical elements, in the coded language of the spirituals and blues, all of which themselves became the things to be remembered. The defining importance of improvisation in African-American music also implies memory: you can only improvise – or Signify – on what you remember. To remember through music might be said to be – at any rate in the early part of the twentieth century – the African-American historical project par excellence.

The *Afro-American Symphony*, like other black made symphonic works but unlike the *New World Symphony* or *Rhapsody in Blue*, is concerned with history, implicitly chronological but primarily memorial, with all the pressure of the significance of remembering – and remembering musically – in the African-American context. However, unlike the *New World Symphony*, the *Negro Folk Symphony*, *Yamekraw* or *Black, Brown and Beige*, it does not fold all its elements into a harmonically or rhythmically homogenous whole, but holds them in relation to one another. This, together with the internal play, for instance,

with the stylisation of the blues, the slight bluesification of the spiritual and the winking use of 'I Got Rhythm', means that the historical elements remain signalled as historical.

They are signalled within a white overarching structure that, though subtly modified by the African-American elements (Moe 1986, Smith 2000), is not in any way pastiched. The effect of showcasing African-American music within the universal, aka white, symphonic tradition is to celebrate and historicise the former, but it leaves the historical specificity of the symphonic tradition itself untouched, as if it really is a universal achievement of all humanity. Pastiche has the effect here of marking the African-American as coloured and leaving the European-American as apparently colourless.

There is something uneasy, even embarrassing, about much of the work discussed in the three cases above. This is partly something that emerges with time. When classical ballet is not itself questioned as the mode of high cultural dance, when black music that is not black music is heard as if it might as well be, when the symphony is accepted as a universally appropriate musical language, pastiche is able to work relatively straightforwardly as closeness and difference. It is only when the frameworks themselves are problematised that the pastiches become embarrassing or offensive. It's possible that the moment of pastiche played its role in allowing the specificity of the formal tradition that provided the framework to become apparent, but along the way the pastiche itself is revealed as problematic precisely because of its role in shoring up an unquestioned hegemonic cultural position.

But uneasy is not disgraceful, embarrassing is not unforgivable. There are worse attitudes than finding the movements of others charming and wanting to embody them, worse strategies than sinking one's own woes in another's and seeking thereby to give both a voice, worse aspirations than to historicise one's past and synthesise it with a present one wishes to claim as one's own. Circumstances not of our own choosing produce cultural differences and the results carry those historically produced meanings and feelings. Pastiche cannot dissolve such differences, but it can try to consort across them, with all the attendant problems of attitude – patronising, teasing, longing.

Such consorting looks rather different when approached from the other side, as it were. The examples above are of white hegemonic forms used as the vehicle for presenting non-white, subordinated ones. Pastiche within subordinated cultural production itself inhabits very different power dynamics when the referent is hegemonic forms.[55] In post-colonial contexts, for instance, pastiche may express a complex, controversial and painful sense of both a necessary rejection of the colonising culture and a recognition of inevitable continuity with it, of resistance and dependency (Franco 1990, Naficy 2001: 269–287); it may be conceptualised as a form of mimicry, playing ambivalently within subservience and insolence, making it possible to get away with the latter (Bhabha 1994); it might be an aspect of tropicalist anthropaphagy (cf. chapter 1, p. 16), ingesting colonial left-overs and

transforming them into nourishment; the uncertainty produced by its posi-
tion of closeness to what it imitates may be part of a 'destabilisation ... of a
repressive European archive' (Tiffin 1991: x); it can even 'constitute a sympa-
thetic relation with the past which may act as a pointed critique of the present'
(Franco 1990: 97). Closeness to the forms of the colonising culture may feel
perilously like voluntarily ceding to its previously imposed authority, yet the
act of pastiching is also always an affirmation of the position of the pasticheur,
as much in post-colonial works as in *Hamlet*, Proust's Goncourt, *Man of Marble*,
Once Upon a Time in the West, the *Nutcracker* or *Madame Bovary*; it may form part
of a politics of undermining and overthrow or also one of conciliation.

Pastiche and negative criticism: *Madame Bovary, Erasure*

The works discussed in the previous section all imitated in the register of
affective closeness but in contexts of cultural difference. None could be said
to be clearly critical of what it imitates. One might discern disdain in the
Chinese dance and there is ambivalence in Still's allusions to Dvořák and
Gershwin (acknowledgement? farewell? accusation?), but in neither case does
this amount to outright condemnation or rejection. Similarly, with the excep-
tion of *Man of Marble*, none of the examples considered earlier in the book are
straightforwardly condemnatory. They may imply that the pastiched form is
out-moded ('The Murder of Gonzago', Proust's Goncourt pastiche) or ques-
tion its truth claims ('News on the March', *Once Upon a Time in the West*), but
that hardly constitutes critique.

This may not be surprising. One of the connotations of the word 'pastiche',
perhaps always, certainly since Jameson's discussion of it in the context of
postmodernism (1984), is that it cannot be critical, indeed that its very close-
ness to what it imitates prevents it from having the distance necessary to
critique. Certainly pastiche is not, like parody, by definition critical (or, come
to that, like homage, by definition evaluative in a positive sense). None the
less, that does not mean that it cannot be used critically. Ludovica Koch
(1983: 11) maintains that pastiche is always subversive: beneath its apparent
elegance, pastiche is always 'bringing to light the arbitrariness, generic basis
and indifference' of the forms it imitates, qualities that otherwise give the
illusion of life and originality to art. I would not want to go as far as always,
but I do want to show that pastiche can be used critically. To this end, I look
here at two instances that are unequivocally critical of what they pastiche, the
novels *Madame Bovary* (Gustave Flaubert 1856) and *Erasure* (Percival Everett
2001). It would be possible to argue – and the looseness of the terms would
not make it incorrect usage – that just because the imitations in these works
are critical, they should be considered parodies. However, I want to suggest
that pastiche, with its sense of closeness – and openness – to what it imitates,
is more revealing about how these critiques work and also suggests some-
thing about the politics of pastiche and parody, which is to say, of closeness
and distance.

Madame Bovary

In 1857 Gustave Flaubert was put on a trial for the immorality of *Madame Bovary*; he was acquitted on the grounds that, while the novel depicted adultery, it did not celebrate it. Courts today would not consider that it merited banning or censure even if it did celebrate adultery, but the prosecution in the 1857 trial was right in terms of contemporary values to raise the question of whether it did: it is not so easy to tell what the novel's attitude towards adultery is, and this has in part to do with a very particular use of pastiche.

The argument against the supposed celebration of adultery in *Madame Bovary* turned partly on Emma Bovary's sorry end, but much more importantly on the interpretation of passages that the prosecutor designated 'the poetry of adultery'.[56] One such concerns Emma's feelings as she looks in her mirror after her first night of adulterous love with Rodolphe:[57]

> She repeated to herself: "I have a lover! a lover!", revelling in this idea as if she were once again in the first flush of adolescence. At last she was going to know those delights of love, that fever of happiness of which she had despaired. She was entering on something marvellous, where all would be passion, ecstasy, delirium ... (230/175[58])

The prosecutor saw this as Emma 'glorifying adultery, singing the song of adultery, its poetry, its sensual delights', something worse in his view than the fact of having succumbed to it (Flaubert 1998: 492–493), but by the end of his summing up it has slipped from being Emma's to being the author's song of sensuality. This is a solecism of literary study, the conflation of author/narrator with character, but it is an understandable one. The passage in question is an example of the free indirect style,[59] where what a character thinks and feels is rendered stylistically in their terms but grammatically in the third person rather than the first; thus, it is not

> "At last I'm going to know those delights of love I've despaired of!"

nor

> She felt that she was at last going to know the delights of love of which she had despaired.

but

> At last she was going to know those delights of love ... of which she had despaired.

The result is ambiguous: it does not endorse what the character feels, but nor does it clearly hold itself apart, and it thus lends itself to the trial prosecutor's

slide from what Emma feels to what the narrator does, and from that to what Flaubert does.

The technique of free indirect style has affinities with pastiche, in that it imitates something while signalling that it is different from it and tends to 'commit the narrator to attitudes of sympathy or irony' (Cohn 1983: 117), much of the affective territory of pastiche. However, free indirect style most commonly involves imitating the speech of characters, speech that has itself been invented by the author. What makes the case of *Madame Bovary* interesting for my purposes is that it also involves the imitation of works outside of itself.

In the passage quoted above, the narrator falls into Emma's interior speech patterns. However, as it proceeds, in a passage not quoted at the trial, something else happens (230/175).

> A bluish immensity lay around her, summits of feeling sparkled in her thoughts, and ordinary existence figured only in the distance, down below, in the shadows, in the gaps between those heights.

Here the language becomes quite literary, not to say purple, with vague, and vaguely metaphysical, metaphors taken from nature. What is being imitated is the kind of Romantic writing that took spiritual meaning from mountains and skies, that saw sublimity in immensity, a kind of writing that we know has been dear to Emma and which *Madame Bovary* views with suspicion and disdain.

Chapter I.6 tells of Emma's discovery of literary sensibility. It follows Emma's disappointment within a few days of wedding dull, complacent Charles Bovary, a disappointment that leads her 'to wonder just what was meant in life by the words "happiness", "passion" and "rapture" that had seemed so beautiful to her in books' (55/47). These are the last words of the previous chapter and I.6 starts straight in with 'She had read *Paul and Virginie*'. This hugely successful novel of 1788 by Bernardin de Saint-Pierre was a prototype for the evocation of heterosexual bliss in a vibrant and idyllic setting. Having established it as the representative source of the beautiful notions that Emma's marriage fails to live up to, the chapter then tells us of her reading as an adolescent at convent school: romantic ballads, Walter Scott, historical, Gothic and Orientalist novels, the lachrymose poetry of Lamartine.[60] Right from the start, the account mixes designation of what Emma reads with imitation of it, as well as how she reads it and how she makes it into the vocabulary of her dreams and aspirations. We are told directly that she is a great reader, that an old seamstress at the convent lends her and the other girls romantic novels, that she turns to Lamartine when her mother dies. This reading though is also evoked in thumbnail pastiches. Of the seamstress's romantic novels, for instance (58–59/50):

> It was nothing but loves, lovers, beloveds, damsels in distress fainting in lonely pavilions, postillions slaughtered at every juncture, horses worked

to the ground on every page, dark forests, troubles of the heart, vows, sobs, tears and kisses, little boats by moonlight, nightingales in glades, gentlemen brave as lions, sweet as lambs, virtuous like you don't see them, always well turned out and weeping like funeral urns.

This might also be how Emma reads the novels and elsewhere we have evoked her response to literature, in language that is itself purple with literariness. Thus even the Christian readings at the convent are able to stir her (57/49):

How she listened, the first times, to the sonorous lamentation of romantic melancholy redounding to all the echoes of earth and eternity!

Some of that language might be from the readings, but the exclamation mark and the romanticism are Emma's. When she turns to Lamartine, it is hard to disentangle what is Flaubert's pastiche of the latter's style and what is the way Emma takes it (61/52):

She let herself drift into the meanderings of Lamartine, heard the harps on the lakes, all the songs of dying swans, every leaf that fell, pure virgins ascending to heaven and the voice of the Eternal holding forth in the valleys.

Here, as in the example above of Emma at the mirror after her first night with Rodolphe, Emma wants to see herself in a certain way: she writes to tell her father that when the time comes she wants to be buried in the tomb with her mother, and when in response he comes to see her, thinking she must be raving, she is gratified that she can now appear someone who has achieved 'that rare ideal of pallid existence that mediocre hearts could never reach' (ibid.). Then follows the passage above, where she reaches for suitable literature to affirm and amplify her finer mourning (even though in fact she soon finds it boring and only perseveres with it 'from vanity'). Thus the passage is part pastiche Lamartine, part the way Emma reads it, and also at points perhaps parodic: Lamartine meanders, every leaf falls, the voice of the Eternal drones on.

Although in all this the elements of pastiche, together with the third person narration and past tense, all carry the voice of the narrator, the language is also at once (because it's pastiche) Bernardin, Scott, Lamartine, Chateaubriand et al. and (because it's free indirect style) Emma. There's a sense too that, however equivocally, however much also the narrator's and the writer's, most of the chapter can be returned to Emma's consciousness, to what in some sense or other she thinks and feels, while all the while indicating – and

critiquing – where those terms comes from. Later in the book, this anchoring in Emma's inner speech is less clear.

During their affair, Emma and Rodolphe meet in the evenings in the garden of her home after husband Charles has gone to sleep (239/181). Rodolphe wraps them both in a big cloak; the stars shine brightly, there are the sounds of the night evocatively described.

> ... their eyes, which they could only half see, seemed larger to them, and, in the midst of the silence, there were words spoken low which fell upon their souls with a crystalline sonority and spread out in vibrating echoes.

The language is again that of Romanticism and we know by now this is how Emma likes to think and feel about herself and the situations in which she finds and puts herself. Yet this is not indicated as what she is saying inwardly; and while it is not indicated as Rodolphe's thoughts either, it does use the kind of language we have earlier seen Rodolphe have recourse to in order to enchant Emma. In short, the language belongs to no-one in particular but to the scene itself.

This effect reaches its peak in what is also, unbeknownst to Emma, their last night together (278/210). She thinks they are going to run away together and tells him not to be sad that they are leaving, that she will be everything to him, family, country.

> "How sweet you are!", he said, taking her in his arms.
> "Honestly?", she said with a voluptuous laugh. "Do you love me? Swear it!"
> "If I love you! If I love you! But I adore you, my love!"
> The moon, at the full and the colour of purple, came up from behind the horizon in the depths of the meadow. It rose swiftly between the branches of the poplar trees, which hid it in places, like a torn black curtain. Then it appeared, bursting out all white, illuminating the empty sky; and then, slowing down, it cast a great shaft of light onto the river, sending up an infinity of stars; and this silver light seemed to twist right down, like a headless snake covered with luminous scales. It was like those monstrous candelabras, from which melting diamond drops fall all night long. The soft night spread out around them; shadows layered the foliage. Emma, her eyes half closed, breathed in deeply the cool wind that blew by. They did not speak, too caught up as they were in the reverie that had overtaken them. The tenderness of the old times came back into their hearts, full and silent as the river that ran past, soft and sweet as the scent of the seringas, casting over their memories shadows more vast and melancholy than those of the motionless willows on the grass. Often some night creature, hedgehog or weasel, foraging, disturbed the leaves or even sometimes one could hear a ripe peach fall singly from the espalier.
> "What a lovely night!", said Rodolphe.

This is Emma, living out the lovers-in-the-moonlight role; it is Rodolphe, who knows his part even if his language is not up to it ("What a lovely night!"); it is Paul and Virginie and the rest;[†] and it is the narrator and it is Flaubert. By this point the narration of the novel is entirely invaded by the vocabulary, cadences and tone of the Romantic writing and cheap feminine susceptibility the novel is critiquing. And it is beautiful. For all its signalling of its kitsch quality, its dramatisation of the moon, its questionable notes (the headless snake, the hedgehog and weasel), the banality of Rodolophe's attempt to put it into words, it is lovely. One commentator suggests it is based on Flaubert's own experience of watching the moon from his balcony in Croisset (Mayniel in Flaubert 1961: 440), which may or may not be true but certainly indicates that the passage can be read straight, as if untouched by the novel's critical view of romanticism. In short, *Madame Bovary* has told us where this kind of language and perception has come from and what to think of it, and yet sometimes, when pastiching it, can't stop it carrying some of its lyrical charge.

Even in the earlier passages, where the pastiche is more clearly linked to Emma's credulousness, more pointedly underlining the cliché quality of her reading and her imagination, connecting it more directly to her disappointment at reality, the fact that it is pastiche means it is able also to get inside the feelings such literature mobilises. The novel would probably become intolerable if it didn't, too remorselessly clever, cynical and misogynistic to function at all at the level of either storytelling or Flaubert's ideal of impersonal realism. In the process it allows for a range of responses. I recall reading it as a young man, full of Keats and Rousseau, and very much identifying with Emma, with her kitschy taste and romantic longings, but also aware of the limitations and illusoriness of these and thus able to take on the pastiche in the free indirect style ruefully, ironic with myself. Re-reading it 30-odd years later for the purposes of this study, I was struck by the author's contempt for all the characters and found the book, though still breathtakingly beautiful, rather hateful too; now though the pastiche in the free indirect style seemed to soften the dyspepsia, allowing, against the novel's better judgement, a sense of sentiment's loveliness to creep in. I do not offer either of these responses as the correct ones, but more as an indication of the kind of thing the interplay of pastiche and free indirect style (and of course everything else about the writing) make possible for the reader.

Free indirect speech in general tends to facilitate this kind of range of relations between the reader and a character. The use of pastiche within free indirect

[†] It especially recalls Chateaubriand, of whom Flaubert wrote a pastiche in his travel book *Par les champs et les grèves* (*Over the Fields and Along the River Banks*), written between 1847 and 1848 (Flaubert 1987: 591–592). Adrianne J. Tooke (in ibid.: 37–38) suggests that in it Flaubert 'was making an effort ... to destroy in himself what he loved most, a certain outpouring of style, a certain lyricism'. My argument in this paragraph is that Flaubert is unable in the passage from *Madame Bovary* to banish entirely this feeling for the lyrical any more than he entirely succeeds in doing so in the *Par les champs et les grèves* pastiche.

speech in *Madame Bovary* adds two further elements. First, in indicating where Emma's emotional vocabulary comes from, it suggests the way that more generally interior consciousness is shaped by reading (and, we may extrapolate, all forms of culture). Second, it makes a specific point (in many ways a rather unsympathetic one) about the dangers of Romantic fiction, especially in the minds of foolish young women, especially in the context of love. It could do this by simply telling us of Emma's susceptibilities and their consequences, but by using pastiche in the free indirect mode it allows us to experience the fiction and the response to it while simultaneously indicating its shallowness and showing its illusoriness. It is none the less critical for allowing us to feel the pull of the fiction – if Romantic literature did not have an affective draw, it would not really matter, would hardly be worth critiquing. *Madame Bovary* suggests not just that pastiche can be used to be critical, but that it is precisely by drawing close to what it critiques that it is able to convey most forcefully why that needs to be critiqued, namely, because it works.

Erasure

In *Madame Bovary* an impersonal narration is from time to time coloured by the consciousness of one of its characters, a consciousness itself shaped by her reading. *Erasure*, in contrast, appears to want to maintain a strict division between the author on the cover, Percival Everett, and the novel's narrator, Thelonius Ellison, and between the latter and the narrator of the novel he, Ellison, writes in the course of *Erasure* itself. Where *Madame Bovary* has contempt for what it imitates, *Erasure* has anger, but it too plays on the possibility of closeness even while signalling distance.

Erasure (Everett 2004) concerns a published but not particularly successful novelist and University professor, Thelonius Ellison. People tell him he is not successful because his books are not black enough. At a party, one book agent

> told me that I could sell many books if I'd forget about writing retellings of Euripides and parodies of poststructuralists and settle down to write the true, gritty real stories of black life. (4)

One day, desperate for cash to pay for his aged mother's nursing home, he dashes off a novel, narrated as if by a violent ghetto kid, Van Go Jenkins, and publishes it with the title *Fuck* under the pseudonym of Stagg R. Leigh. It is an instant bestseller and is nominated by the National Book Association for its annual Book Award. Ellison, whom only his agent knows to be the author, is asked to be on the panel of judges for the award; all his fellow panellists, all white, think *Fuck* a masterpiece; only Ellison does not vote for it and it wins the award.

It would be hard to think of a novel that signals its intertextuality more than *Erasure*. The narrator's name is an amalgam of two of the canonical

figures of African-American high culture, Thelonius Monk and Ralph Ellison, and the first paragraph ends: 'Call Me Monk' (which recalls the opening sentence of a canonical white American – but racially resonant – novel, *Moby Dick* 1851: 'Call me Ishmael'). Thelonius Monk is one of the most intellectually demanding of bebop musicians, while Ellison's most famous novel, *Invisible Man*, plays, like *Erasure*, on the question of being and not being seen by white society (and, as Margaret Russett points out (n.d.: 5), the titles of the two books have 'an allusive link'). The beach house his family own is near one owned by the grandson of Frederick Douglass, in which James Weldon Johnson had once used to write (thus bringing together two founding voices of black American writing). In an inserted sequence, about a black man applying to be on a quiz show, the protagonist fills in his name as Tom Himes, an amalgam of Harriet Beecher Stowe's Uncle Tom and Chester Himes, founder of the black ghetto detective thriller. The name of the pseudonymous author of *Fuck* references Stagger Lee, a criminal hero figure and recurrent subject of the blues;[61] the name of its first person narrator is an amalgam of Van Gogh, a by-word for masculine anguish, rebelliousness and lust for life, and (Juanita Mae) Jenkins, author of *We's Lives in Da Ghetto*, a bestselling ghetto novel (invented by Everett), whose success Monk has earlier despised; Van Go's mother's name is Clareece, virtually the same as Claireece, the protagonist of the actual 1996 novel *Push* by Sapphire, a bestseller about harrowing ghetto life written initially in the female equivalent of *Fuck*'s 'hood dialect and often assumed to be another implicit reference point for it; and *Fuck*'s content draws on *Native Son* 1940, Richard Wright's canonical novel of black ghetto life and violent masculinity, for long taken as a definingly authentic statement of African-American experience. The narrative overlay between *Fuck* and *Native Son* is quite detailed (where the latter differs, I indicate it here in square brackets):

> Van Go [Bigger] lives, and rows, with his mother and younger sister [Bigger also has a brother] and hangs out with friends in a poolroom. He gets a job as a driver to a white [rich black] family, the Daltons, and takes the daughter of the house, Penelope [Mary] and her would-be radical boyfriend out for a drive. They get him to take them to a 'hood hangout; when he takes Penelope [Mary] home, she is so drunk [high] that he has to take her indoors and cannot resist touching her breasts; he is interrupted in this by her mother coming in, but he realises that she is blind and can't see what he has done; when the mother leaves, Van Go [Bigger] finds that Penelope [Mary] is dead in his arms. He gets away. The next day he finds himself invited onto a daytime talk show, *The Snookie Cane Show*, where he is confronted with his four children and their four mothers; during the show, the police come in to arrest him for rape and murder but he makes an escape. [None of this last sentence is in *Native Son*, where, however, Bigger returns to Mary's house to find it swarming with journalists, the equivalent media of the day, and runs off when

evidence of Mary's body is found in the house.} He is chased across town and eventually shot [arrested and condemned to death].

Unlike *Fuck*, *Native Son* is written in the third person, but it does make extensive use of African-American dialect. Monk himself suggests both *The Color Purple* and *Amos and Andy* as precedents in his head (70), hugely successful examples of putatively black language produced by black artists, in respectively a novel and a radio/television act, and Van Go's 'hood speak also recalls for instance the language of early Eddie Murphy, the Spike Lee of *Do the Right Thing* and *Clockers* and many rap-based movies.

This concatenation of extratextuality also works out from the text of *Erasure* itself, back to the author and forwards to its reception. Everett is, like Monk, a University professor who publishes novels, better thought of than Monk's perhaps, but not best-sellers; like Monk, he has written novels reworking Greek myth. He is also, like Monk's namesake Thelonius, a jazz musician. In *Erasure* (18–22), Monk delivers a paper entitled 'F/V: Placing the Experimental Novel' at a meeting of the *Nouveau roman* Society, analysing Roland Barthes' *S/Z* along the lines Barthes analyses Balzac in that book; the paper, excerpted in *Erasure*, is from the one published by Everett under his own name in the African-American studies journal *Callaloo* (Everett 1999). In terms of reception, the book was the winner of the 2002 Hurston/Wright Legacy Award for Fiction, an award named for two African-American writers especially concerned with issues of specificity and authenticity in African-American writing, the second of whom is the model for Monk's/Everett's pastiche.

All this suggests we should take nothing in *Erasure* straightforwardly. There is no authentic voice or stable position from which to judge either *Fuck* or Everett. The criticism of *Fuck*, on the part of both Everett and Monk, may well be fuelled by a sense of the untruthfulness of its kind of representation of black urban existence, but at no point does the novel draw on the discourse of realism, of measuring a representation up against what what it represents is like in the real world, which is the most familiar form of cultural criticism. Monk tells us that the editor at Random House says that *Fuck* is "true to life" and "magnificently raw and honest" (155) and that talk show host Kenya Dunston, having read out a passage, says "let me tell you, it doesn't get any more real than this" (280), but, apart from the fact that Monk is not and has never been a poor, violent ghetto kid and recalls that he could never speak 'hood speak, 'talk the talk', convincingly (189–190), he does not actually voice the view that *Fuck* is bullshit because it is untrue or unreal. It is rather the sense of such views defining and delimiting what it means to be African-American, even of them framing the sense that there should be a specific African-American meaning, that angers Monk. What riles him is the kind of review he reads of *We's Lives in Da Ghetto*, which affirms, 'One can actually hear the voices of [the author's] people as they make their way through the experience which *is and can only be* Black America' (46, my emphasis).

Yet what *Erasure* also shows is the power, and even a sense of the ineluctability, of such representations. It does this through the pastiche of *Fuck* and its connection to the rest of the book.

Monk and his agent refer to *Fuck* as a parody (151), but, as noted in chapter 1, this is a common defence of hoaxers. A hoax that really uses parody is liable to give the game away (and Monk risks this when he has Leigh have Van Go reveal that his children's names are Aspireene, Tylenola, Dexatrina and Rexall). Moreover, because Monk and we know that he has written it in a fit of rage with the likes of *We's Lives in Da Ghetto*,[62] *Native Son*, *The Color Purple* and *Amos and Andy* (70) in mind, we are in on the hoax. Yet *Fuck* also works as a narrative. When Monk observes, '[*Fuck*] was a parody, certainly, but so easy had it been to construct that I found it difficult to take it seriously even as that' (182), we might consider the implications of that ease, that sense of slipping into a mode so readily that it takes on a life of its own. Partly because of its literary resonances, partly because of the fit of rage that gives rise to it, partly because of the generic potential for drive and wit in violent action novels and 'hood speak, *Fuck* has terrific energy and momentum. Margaret Russett notes that 'more than one reader of *Erasure* has commented on finding [*Fuck*] its most gripping part' (n.d.: 5). *Fuck* is close to what it imitates.

It had better be so. Taking up nearly a third of *Erasure*, the latter would be intolerable if *Fuck* were unreadable. Moreover, Monk's fellow jurors on the Book Prize would be merely, and uninterestingly, stupid and racist if they fell for anything that could never be convincing. *Fuck* has to work for *Erasure* to work. Yet in its relation to the rest of the novel, it also has wider implications.

One index of this is its title. Monk originally plans to call it *My Pafology*, a clever title that might work backwards to Monk and his rage and inwards to Van Go and his pathological masculinity; but it would also indicate a self-awareness on the part of Van Go that is nowhere else suggested and might alert the reader to the dubious status of this ghetto memoir. Without explanation, Monk decides to change the name to *Fuck*. Not only is the novel called *Fuck*, but that is one of the commonest words in it, with one exchange between Van Go and his friend Yellow consisting of nothing but sixteen lines of "Fuck you" (86). However, the issue of the word, and other such, runs throughout *Erasure*. Early on, before he has thought of writing *Fuck*, Monk visits his mother and in the course of the evening she asks him 'as she always did if there wasn't a better word for *fuck* than *fuck*' (13); much later, he recalls his mother reprimanding him for saying "crap" when he was about 12 (163). In *Fuck*, Van Go's mother reprimands him, "Boy, don't you be using no language up in here", and when he tells her to "Shut the fuck up", she slams the cabinet and 'stare at me with fire in her eyes' (90). Though in *Fuck* it is exaggerated to the point of pathology, the narrators of *Erasure* and *Fuck* are not so utterly distinct in their routinised obscenity.

Whether as an effect of reading *Fuck*, or because there really is a change in the writing, it seems to me that *Erasure* also picks up pace, energy and frustration after *Fuck*, as if Monk's style has become infected by Stagg's/Van Go's. Even

if that is not demonstrably so, there is a strong sense of Monk's life becoming like Van Go's. With *Fuck* so phenomenally successful, it is selected by top talk show host Kenya Dunston to be featured on her show. Monk, who has shunned all publicity up to now, gives in and agrees to appear on it. He disguises himself as Stagg Leigh, dressing in black from head to toe (272); in other words, he produces himself as a black stereotype for television. This is the culmination of references to the televisual construction of blackness. In *Fuck*, when Van Go goes to the television studios for *The Snookie Cane Show*, the make-up man insists on putting Vaseline on his face to "make you shine like a proper TV nigger" (130). In the interpolated story about Tom Himes, when Himes gets on to the quiz show, a make-up woman rubs brown cream onto his face, saying "You ain't quite dark enough darlin' ... This is TV stuff" (197). Van Go and Tom Himes are caught up in the media circus, but Monk constructs himself as black stereotype (albeit a different, intellectual one). Interviewed by Dunston, he clams up, uttering only monosyllables. If the disguise erases Monk, the talk show performance also in turn erases Stagg. Eventually comes the Book Award event. Monk comes into the journalists' lobby not in disguise and is asked what has won. He goes mad, finally turning to one of the TV cameras and saying "Egads, I'm on television" (294), just as at the end of *Fuck*, Van Go, mortally wounded, turns to the television camera and greets his mother and little sister: "Look at me. I on TV" (150).

At one point (159), Monk observes, of his practice in general,

> In my writing my instinct was to defy form, but I very much sought in defying it to affirm it, an irony that was difficult enough to articulate, much less defend.

Erasure explores, and indeed risks, this irony. A more extremely parodic fake ghetto novel would take less risks, would distance Monk more decisively from it. The point is the insidiousness of the cultural assumptions within which he finds himself. To show this (and not just state it), *Fuck* has to be so 'easy' to do and do effectively, has to turn out close and become closer to Monk's life, has to be pastiche.

Erasure raises, as does *Madame Bovary*, the issue of the politics of closeness. There is no doubt in either of the object of their critique, yet closeness to it – readiness to risk contamination by it, to being penetrated by it[63] – is crucial to their strategy; the object infects *Madame Bovary*, engulfs *Erasure*. The narrative outcome in both cases leaves little doubt about the critique and yet along the way Romanticism is lovely and tales from the hood gripping. This runs counter to the conventional wisdom regarding progressive art, beginning with the Enlightenment prizing of aesthetic contemplation and becoming politically hardened in the twentieth century, emblematically in Brecht's notion of Verfremdungseffekt, procedures of estrangement that supposedly

force the audience to stand back from the work and consider it ideologically. *Madame Bovary* and *Erasure* do allow for the kind of readerly superiority implied by such views – we can think how clichéd Emma's reading is, how offensive everything *Fuck* stands for is – but if we don't get inside the feelings of culture and values that we find problematic, we risk not understanding them and alienating ourselves from those who do respond to them. Then critical cultural politics runs the risk of being irrelevant and impotent.

Pastiche and feeling: *Flaubert's Parrot, Far From Heaven*

Throughout this study I have noted cases where pastiche can be moving: the Aeneas speech in *Hamlet*, the something 'serious and interesting' about Fae Richards in *Watermelon Woman*, the four final numbers in *Follies*, the arrival of Jill at Flagstaff in *Once Upon a Time in the West*, the sexual charge of *Body Heat*, the yearnings of Emma Bovary, the energy of *Fuck*. If nothing else, these examples show that pastiche is compatible with the expression of feeling, over and against the perception of its intrinsic triviality or the modernist assumption that any kind of formal distancing, even as slight as pastiche's, must involve emotional distance. In this final section I want to look more directly at the relationship between pastiche and affect in two specific instances. In one, *Flaubert's Parrot*, a character's recourse to pastiche is used to convey a sense of his grief and anger, whereas the other, *Far From Heaven*, is a sustained and direct use of pastiche to elicit emotional response. In both cases, pastiche conveys a sense of the cultural construction of emotional expression, the limits of cultural frameworks (*Flaubert's Parrot*), their historicity (*Far From Heaven*). This though is not just building in historical awareness as an added extra; it is rather constitutive of the affects they aim for.

Flaubert's Parrot

Flaubert's Parrot (FP[64]) is for part of the time a first-person novel, in which 'amateur Flaubert scholar' Geoffrey Braithwaite gives an account of his visit to sites associated with Flaubert, including looking for the stuffed parrot that the latter had on his work-table while he was writing his story, *Un Cœur simple* ('A Simple Heart' 1877), in which a parrot figures centrally. It turns out that there are two stuffed parrots in different museums, both claimed as this parrot. Geoffrey decides to investigate by writing to academics and other interested parties but this produces 'nothing useful'. He returns to the area and finally realises (for reasons explained below) that he will never be able to determine which, if either, of the birds is Flaubert's.

This novelistic account, with various digressions, is punctuated by a number of other items. These include three chronologies of Flaubert's life, various annotated lists to do with Flaubert (e.g. the incidence of animals in his life and work, commonplaces of criticisms against him), an account by Louise Colet of her affair with him and an examination paper. Sometimes

Geoffrey makes explicit the fact that he is writing these and what his referent is: at one point he provides a thumbnail description of himself in the form of one of 'those personal advertisements in magazines like the *New Statesman*' (106); chapter 12 is entitled 'Braithwaite's Dictionary of Accepted Ideas', directly alluding to Flaubert's *Dictionnaire des idées reçues*, which was to have formed the second part of Flaubert's last novel, *Bouvard et Pécuchet* 1881 and would thus have consisted of the results of the eponymous central characters' obsessive compilations of knowledge. Even where it is not made explicit, it is evident that Geoffrey is the author of these various items because of the continuity of voice across them and the first person narration.

These items are all to some degree pastiches. Some, however, are quite far removed from any referent. It is hard to imagine that anyone in the nineteenth century would have written the way Geoffrey has Louise Colet write, while the lists are, from the word go, far too discursive and digressive to be mistaken for pure compilation. One of them is headed 'The Train-spotter's Guide to Flaubert', alluding to the kind of list-making mentality now often referred to as train-spotting, and both conforming to this, even to excessive literalness (in so far as it is indeed a listing of all the ways in which trains figured in Flaubert's life and work), and yet departing from it in asides and ruminations.

Other pastiches keep their broad generic template more firmly in view, all the more strikingly to depart from it. Geoffrey's small ad self-description is impeccable in its likeness to such things but then peters out on the word 'seeks', because, as he comments, he is not sure if he seeking, and if he is, what. The pastiche chronologies conform to the style common in French scholarly and student editions of classic literature – that is, a list of dates with information about major events and publications in the author's life – except that they overflow the limits of the convention and thus signal themselves as imitating the convention by the very act of breaking away from it (a particular form of discrepancy). There are three of them, the first relatively factual and up-beat, the second much more negative and the third consisting of mainly dyspeptic quotes from Flaubert. The difference between the first three and also a standard version of a Flaubert chronology (from the 1998 Gallimard paperback edition of *Madame Bovary*) is clear from their account of his death:

Gallimard	1880	8th May, death of Flaubert, at Croisset, from a cerebral haemorrhage. (532)
I	1880	Full of honour, widely loved, and still working hard to the end, Gustave Flaubert dies at Croisset. (*FP* 21)
II	1880	Impoverished, lonely and exhausted, Gustave Flaubert dies. Zola, in his obituary notice, comments that he was unknown to four-fifths of Rouen, and detested by the other fifth. He leaves *Bouvard et Pécuchet* unfinished.

> Some say the labour of the novel killed him ...
> (*FP* 27; continues for half a page more.)

| III | 1880 | When will the book be finished? That's the question. If it is to appear next winter, I haven't a minute to lose between now and then. But there are moments when I'm so tired that I feel I'm liquefying like an old Camembert. (*FP* 34) |

Even I is probably too, albeit positively, appraising to be consonant with the dry factuality of a chronology, perhaps to suggest the implicit hagiography of even such neutral procedures. II, throughout more thanatological than biographical, emphasises the contempt and indifference that greets Flaubert's death, while III is sour and self-disgusted. The difference is even clearer in the account of the young Flaubert's first love affair (not covered by the third Braithwaite version):

| Gallimard | 1836 | In the summer at Trouville meets Elisa Schlésinger, then twenty-six, who inspires a great passion in him (cf. *Mémoires d'un fou* as well as the first and second *Éducation sentimentale*). (528) |

| I | 1836 | Meets Elisa Schlesinger, wife of a German music publisher, in Tourville and conceives an 'enormous' passion for her. The passion illuminates the rest of his adolescence. She treats him with great kindness and affection: they remain in touch for the next forty years. Looking back, he is relieved she didn't return his passion: 'Happiness is like the pox. Catch it too soon, and it wrecks your constitution'. (*FP* 18) |

| II | 1836 | The start of a hopeless, obsessive passion for Elisa Schlesinger, which cauterises his heart and makes him incapable of ever fully loving another woman. Looking back, he records: 'Each of us possesses in his heart a royal chamber. I have bricked mine up'. (*FP* 22) |

This sense in Braithwaite's chronologies of the account going off the rails, of other emotions intruding, is stronger still in the examination paper. Here there is a mad humour, beginning with the rubric:

> All marks will be awarded for the correctness of the answers; none for presentation or handwriting. Marks will be deducted for facetious or conceitedly brief answers. (204)

This is written in the style of examination instructions, though such points would never actually be made. Yet it is also a thumbnail sketch of examiners' prejudices, characteristically pointing in different directions. It is self-evident that marks can only be awarded for correct answers and examiners must be committed to this; yet what is a correct answer in a subject like literature and, a fortiori, in relation to the barmy questions that follow? Besides, candidates whose handwriting is clear do in practice get better marks and some displays of clever dickery ('facetious or conceitedly brief answers') go down well with some kinds of examiner. There is something splenetic about this and that feeling is reinforced by the examination questions themselves. As with the rubric, the language of examinations is adhered to, but the questions are over-elaborated (the first question begins with a disquisition on notions of Art and Life and then asks the candidate to compare 'any *two* of the following statements and situations' in terms of 'the relationship between Art and Life' (205)), often a long rigmarole of a quotation, whose point is obscure, ends with the instruction 'Discuss', and the paper winds up with a section on 'History (with Astrology)'.

Geoffrey has earlier in the novel expressed his contempt for academia and this is betrayed in his treatment of both the chronologies and the examination paper. Yet there is more at stake than this and more that has to do with the use of pastiche.

Flaubert's Parrot might be described as a study in frustration. Geoffrey wants to find something out, yet the moment of finding out is always and forever deferred. One index of this is the parrot. Towards the end of the book, Geoffrey thinks he has solved the mystery: he takes photographs of the two birds on show, compares them with the description in *Un Cœur simple* and determines which is the better match and thus the one that was really Flaubert's parrot. However, 'the oldest surviving member of the Société des Amis de Flaubert' points out to him that Flaubert would not necessarily have written an exact description ('"He was a writer of the imagination. [...] Just because he borrowed a parrot, why should he describe it as it was?"' (226)) and also tells him that when both museums were set up the curators went and chose a parrot from the mass of stuffed birds in the collection of the Museum of Natural History in Rouen (whence Flaubert had borrowed his) – there is no guaranteeing which, if either, of the birds is the one Flaubert had and the book ends with Geoffrey visiting the museum itself and seeing its massed ranks of stuffed birds. Thus just when Geoffrey thinks he has worked out which is the real parrot, he is faced with the fact that his grounds for determining this are shaky and that, confronted with row upon row of barely distinguishable birds, he will never be able to know for sure which is the right one.

The frustration of such a desire to know – both that such desire must be frustrated and that that is an emotionally frustrating experience – is suggested also by Geoffrey's account of an encounter with an acquaintance of his, Ed Winterton, who claims to have acquired an exchange of letters between

Flaubert and a young English woman, Juliet Herbert. Geoffrey asks Ed to tell him what's in them and Ed does so, and what he conveys is what it is easy to imagine Flaubert would have written. What Geoffrey (and we) thus have is a second-hand account of an unpublished text (to set beside the list Geoffrey subsequently provides of Flaubert's known apocrypha of lost manuscripts, projects and so on (133–146)). It turns out, however, that Ed has burnt the letters, that this is what Flaubert had instructed Juliet Herbert to do and thus that Ed is only doing what the latter failed to do, and that he is telling Geoffrey 'just for the record' (46). Is this an elaborate hoax on Ed's part, a lark, playing on Geoffrey's vulnerabilities (his train-spotter's completist attitude towards documents, his desire to make a name in the field by presenting the find in the *Times Literary Supplement*, his interest in illicit love affairs)? Or is it scrupulously principled (an accurate account of the letters, obedience to an author's wishes (albeit only one author's, since Herbert had apparently wanted to preserve them), fastidiousness vis-à-vis the record)? Either way it involves a sort of embryonic pastiche (cf. Bouillaguet 1996a: 59); embryonic because all we have is Ed's, very plausible, account of the letters,[65] pastiche because Ed/Julian Barnes is producing this plausibility and we know it. Ed also provides a gloss on what he is doing. He tells Geoffrey that the letters also contained the following words (presented ambiguously as verbatim memory or Ed's paraphrase, interposing yet another layer of uncertainty):

> If anyone asks you what my letters contained ... please lie to them. Or rather, since I cannot ask you of all people to lie, just tell them what it is you think they want to hear. (47)

This is what fakers, forgers and hoaxers play on (vide van Meegeren, Ossian, Ern Malley, *Roots*), but it also invades all pastiching. We do not have to conceive this in as Machiavellian a way as Ed puts it, but pastiching always involves hearing and producing a version of the referent informed by the expectations and frameworks of understanding available, it involves producing what you want to, or at any rate can, hear in the referent and, usually, what you presume others hear in it.

All of the above conveys the feeling that any one might have with the problem of knowing, and especially someone of Geoffrey's disposition. Yet what gives the novel an intensity beyond this is the gradual revelation to the reader as the novel progresses of something Geoffrey knows from the start, that his wife Ellen betrayed him repeatedly and eventually killed herself. This of course makes the whole book echo *Madame Bovary*: Geoffrey, like Charles, is a doctor and a decent but dull old stick; Ellen, like Emma, was a serial adulterer and suicidal. Just as Geoffrey writes Louise Colet's version of her relationship with Flaubert, so Geoffrey, that is, Barnes in some measure writes Charles Bovary's version of *Madame Bovary*. What it reveals is Geoffrey's complete inability to understand why she did it. Perhaps he is too unimaginative,

perhaps too unable to see how dull he is; perhaps, like Buddy and Ben in *Follies*, like most men in Western society, he lacks an adequate emotional vocabulary; but perhaps it is the human condition, never quite to grasp what anything means, what anyone else feels, what we ourselves feel, whether there were letters, which is the parrot. Pastiche becomes here the feeling form of what at the level of theory is endless Derridean deferral or Butlerian performativity, the perception that everything in the end is a copy of something else and we know it and can never get out of it. This may (or may not) be a source of interest or anguish at the level of philosophical generality, but it becomes anger, anguish and dyspepsia faced with the incommensurability of betrayal and grief.

When Geoffrey gives a description of himself in the form of a personal ad, words fail him, in two senses. First, he breaks off, unable to say what, if anything, he seeks. Second, he reflects on the way that the form of the ad itself distorts the possibility of saying anything sincere or truthful: 'the column distorts the way the advertisers describe themselves' (107). This is Geoffrey's problem writ small and also the problem of all writing (or any other kind of expression) tout court. Which brings us back to the parrot. Near the beginning of the book, Geoffrey muses on parroting:

> You could say the parrot, representing clever vocalisation without much brain power, is Pure word. [...] Is the writer much more than a sophisticated parrot? (10)

Perhaps none of us ever do anything but repeat, uncontrollably, without understanding, what we have picked up as available to repeat. Such is even true of Flaubert:

> Words came easily to Flaubert, but he also saw the underlying inadequacy of the word. [...] Remember his sad definition from *Madame Bovary*: 'Language is like a cracked kettle on which we beat out tunes for bears to dance to, while all the time we long to move the stars to pity.' (11)

The gap between what Geoffrey can express and the meanings and feelings he dimly apprehends in relation to Ellen is that between mindless tunes and the sublime. This is why his pastiches flounder in spluttering digressions, why there is always another pastiche in the endless hopeless attempt to pin something down, why there is always another clever bit of parroting saying nothing worth saying. *Flaubert's Parrot* uses pastiche both to convey feeling, as it were despite Geoffrey's self (for he is ostensibly dealing with unemotional information), and also to reflect on the limits of the means to convey feeling, and uses the frustrating awareness of those very limits, enabled by pastiche, to intensify the feeling.

Far From Heaven

> With Julianne Moore blazing at its center in red and gold, like a bouquet of autumnal foliage in a fine china vase, Todd Haynes' *Far From Heaven* is an explosion of synthetic delights. Which is not to say it lacks emotional impact – far from it. *Far From Heaven* is a movie for hardcore film geeks and regular folk alike, a stunning, and stunningly improbable, fusion of postmodern pastiche and old-school Hollywood melodrama. It's both a marvellous technical accomplishment and a tragic love story that sweeps you off your feet.
>
> Andrew O'Hehir[66]

The first time I saw *Far From Heaven* (USA Todd Haynes 2002), there were moments when I could not see the screen for crying. On the other hand, I was fully conscious of the way the film was doing 1950s Hollywood melodrama, was pastiche. Obviously it could be the case that my response was aberrant, but the film was successful (relatively speaking) at the box office, most critics registered something like the same response[67] as did most people I know. This does not mean that crying as you get the pastiche is the only possible response – for some people, the pastiche may indeed interfere with the possibility of responding emotionally – but there are enough of us about to indicate that this is a possible and legitimate one. At a minimum, *Far From Heaven* is an especially strong vindication of the proposition that pastiche and emotion are not incompatible.

In the film, set in a suburb of Hartford, Connecticut in the 1950s, middle-class white couple Cathy and Frank Whitaker (Julianne Moore and Dennis Quaid) are regarded as the perfect couple, 'Mr and Mrs Magnatech' (the name of the company he works for). In the course of the film, however, Cathy discovers that Frank is homosexual; as they drift apart, she finds that the only person she feels at ease with is Raymond, their black gardener (Dennis Haysbert). The two strike up a friendship, but the town is scandalised: her friends are appalled, her daughter's friends and their mothers shun her, his daughter is attacked by white boys and his black neighbours throw stones at his house. The couple realise that they must stop seeing each other. Frank leaves home to live with another man; Raymond goes to Baltimore, a city with a larger black community; Cathy is left alone with the two young children and her reliable and selfless black maid Sybil (Viola Davis).

Far From Heaven is highly palimpsestic, layered over at least three previous films, each of which shows through: *The Reckless Moment* (USA Max Ophüls 1949), *All That Heaven Allows* (USA Douglas Sirk 1955), *Fear Eats the Soul* (*Angst essen Seele auf* Germany Rainer Werner Fassbinder 1974), the last itself a conscious reworking of *All That Heaven Allows*. Each echoes while altering a basic narrative situation: a middle-class white married woman without a husband[68] forms a relationship with a socially inferior man (Irish immigrant petty criminal (*The Reckless Moment*), labourer (*All That Heaven Allows*), Arab

migrant worker (*Fear Eats the Soul*), African-American (*Far From Heaven*)), which does not work out due to social attitudes.[69] *Far From Heaven* also makes specific visual and verbal references to its antecedents: for instance, to the shot of the main character weeping on her bed in *The Reckless Moment*, to the symbol of a branch of autumnal foliage in *All That Heaven Allows*, to Emmy's bald statement to Ali in *Fear East the Soul*, "You are beautiful" (which Cathy says to Raymond). There are also more pervasive stylistic links, above all the use of colour in Sirk's work, splitting the screen into warm and cold areas (something that also characterises the Fassbinder film).[70]

Given the looseness of the word, it would mean something to refer to all of the above as pastiche, but in relation to the concept of pastiche canvassed in this book, they are more usefully considered echoes, references, quotations and remakings. What makes *Far From Heaven* also, and primarily, pastiche is its thoroughgoing imitation of the attitude, *mise en scène* and look of the films made by Douglas Sirk for Ross Hunter in the 1950s, including *All That Heaven Allows* as well as *Magnificent Obsession* 1954, *Written on the Wind* 1957 and *Imitation of Life* 1959. There are all sorts of ways in which *Far From Heaven* differs from these, including the contemporary cast, different aspect ratio, the explicit treatment of homosexuality and inter-racial desire, the cutting ratio[71] and the music,[72] and perhaps Cathy's skirts are slightly fuller and the silences between people more achingly awkward.[73] Yet in many more ways the film is very close: the painstakingly recreated style of settings and costumes (not based, as in heritage cinema, on study of the interior design and couture of the period but these as they appear in the movies), the use of lighting, the predominance of two-shots over close-ups, the held-in style of performance, the use of overt symbols (Cathy's mauve scarf that flies off in the wind and leads her to Raymond, the branch of glowingly autumnal foliage that reminds her of him), the concern with the interface between inner feeling and social attitudes. In short, between *Far From Heaven* and the Ross Hunter Sirks there is extreme closeness with elements of discrepancy and slight distortion, very like but not quite.

Far From Heaven could hardly work as a mainstream film if it depended on so precise a knowledge of Sirk. His films are major points of reference within academic film studies and they have had a camp following (Klinger 1994), but most people are not film studies students and by the 2000s Sirk melodramas were not even shown so very much on television, making both a camp take-up and a very widespread awareness of them much less strong. Yet enough people clearly did get *Far From Heaven* for it to have adequate box office success. There is almost certainly a hierarchy of knowledge in play. At a minimum, anyone would recognise that the film does not work in the ways other recent films do that deal with domestic dramas, not glossy late women's films (*The Mirror Has Two Faces* 1994, *Waiting to Exhale* 1995), not understated semi-independents (*You Can Count On Me* 2000, *In the Bedroom* 2001, *The Shipping News* 2001), not heritage style (*The End of the Affair* 1999, *The Hours* 2002), not problem-of-the-week made-for-tv movies, not soap opera.

Yet one might not be able to place it beyond this,† and one friend of mine just said she found it 'peculiar'. Equally even many 'hardcore film geeks' will not pick up on every detail of the pastiche: when I first saw *Far From Heaven*, I did not make the connection to *The Reckless Moment*, nor did I think about the resonance from *Imitation of Life* of the nurturing relationship between the white woman and her black maid, nor did I know about the relative difference in the editing speed. I suspect responses to the film operate mostly somewhere between bafflement at its difference and geekish noting of every Sirkian nuance, in a general recognition of 1950s clothes and settings, of colour that no longer accords with our ideas of realism, of unironic emotional intensity, of the idea of weepies and women's pictures, in short, a broad sense of the way they made movies then about things like this.

What is the effect of doing this story this way? I want to suggest a number of answers that cover some of the responses that the film makes possible.

It enables the film to tell the story in the particularly intense and moving way characteristic of this kind of melodrama.

In itself, this is to say nothing of it as pastiche. It simply means that the film uses the genre's generative powers to create a certain kind of world and feeling. However, the fact of the hard-to-ignore elements of distortion and discrepancy already noted, and, even more, the fact that this kind of story has not been told in this kind of way for over thirty years, bring even this most direct function of using the style into the orbit of pastiche.

It enables the film to tell a story of the 1950s in a style of the 1950s.

Hollywood melodramas of the 1950s did not tell stories of homosexuality and mutual inter-racial desire,[74] yet *Far From Heaven* tells such a story, respecting 1950s social norms, in that very mode. The sense of period mode is also reinforced by drawing upon aspects of the way such stories were about to be told in cinema. It borrows its imagery for the gay bar from *Advise and Consent* 1961,[75] thus a film made only a few years later than when *All That Heaven Allows* was made and when *Far From Heaven* itself is set, 1957; its colouring also reminds me of the covers of US gay pulp novels of the period. The held-off quality of the performances in the scenes between both Quaid (Frank) and Nicholas Joy (Frank's unnamed live-in lover) and Moore (Cathy) and Haysbert (Raymond) also recall those in progressive and studiedly unraunchy treatments of both kinds of relationship, notably in the films of Sidney Poitier (including *Guess Whose Coming*

† Seen in more of an art cinema context, it might be easier to relate *Far From Heaven* to Fassbinder, Pedro Almodóvar, François Ozon and of course Haynes' earlier films (*Superstar: The Karen Carpenter Story* 1987, *Poison* 1991, *{Safe}* 1995, *Velvet Goldmine* 1998).

to Dinner?). The violence of the racist response to Cathy and Raymond's friendship has some echo of that depicted in Sirk's *Imitation of Life*, when Frankie (Troy Donahue), the white boyfriend of Sarah Jane (Susan Kohler), beats her up on learning that she is a black woman passing for white.

Yet we know that *Far From Heaven* was not made in the 1950s and probably could not have been made then using this mode. This is not just a question of censorship but of the mode itself. What is not imagined in a mode of representation may also have been unimaginable, may have been framed precisely as that which cannot be seen or heard, nor evidently thought and felt. The contours of a structure of feeling are delineated by what is excluded, the emotional pressures at work feel like they do precisely because some of them are implicit. The moment fifties melodrama started including homosexual and inter-racial desire and rendering them explicit, it would no longer have been 1950s melodrama as it actually was.

Far From Heaven is then inescapably poised between a sense of telling a 1950s story in a 1950s way and a recognition that a 1950s way could not tell that story and remain a 1950s way. This can then set in train the question of how the film mediates our relationship to the 1950s. On the one hand, it may bring us in imagination closer to the people of the 1950s. Done without parody or irony, we may feel encouraged to feel the feelings of the 1950s through the expressive modes available then, to feel what it was possible to feel. On the other hand, the very fact of pastiche – that it is not quite like an actual film of the period – ought also to alert us to the limitations of this historical imagining. *Far from Heaven*'s pastiche thus simultaneously in its likeness enables us in imagination to feel with the 1950s in the terms of the 1950s while in its not-quite-likeness conveying the epistemological difficulty of such imagining. To put it the other way round, pastiche reminds us that a framework is a framework, and also that this is enabling as well as limiting – enabling and setting limits to the exercise of transhistorical sympathy.

It reminds us, however, that they don't make films like this anymore.

The feeling of the dialectic of sameness and difference vis-à-vis the past that the pastiche enables is almost bound also to remind us that the classic Hollywood melodrama's way of doing emotion is not contemporary cinema's, that there are not films like *All That Heaven Allows* or *The Reckless Moment* anymore.[76] Moreover, *Far From Heaven*, though it is so much like them, none the less in its exceptionality and its pastiche distortions and discrepancies actually affirms that such films are not made anymore. Some of the intensity of the emotional response to the film feels like a longing for there to be such films and a gratitude for having given us one now in which some of the elements we may stumble over in them (because of changing attitudes and tastes) have been dealt with, but then, just because

of the differences, an intensification of regret that such films are not made. What happens in the film is sad but we may also be sad for there not being films that do sadness like this anymore. In particular, the desire for unaffected, unalloyed, unironic emotional intensity in the depiction of interpersonal relationships seems harder to come by now, pushed to the margins of action films or else rendered too directly, easily and vacuously in close-ups of people saying 'I love you'. There is something about the difficulty of emotion in 1950s melodrama, not least in its interface with social expectation, that gives it a special intensity, and it seems a cultural loss no longer to have this at one's disposal. The pastiche of *Far From Heaven* reminds us experientially of what we have lost even while confirming that it is lost, which only makes it all the more poignant as well as being, perhaps, critical of today's emotional economy.

It sets in play our relationship to the past.

The mixture described above specifically in relation to the 1950s – of sympathetic imagining and registering of difference – also embodies the dialectic of our relationship to the past more generally. It suggests that we can enter into the feelings of our forbears through immersion in their art but also reminds us that this is a highly limited and circumscribed activity. This itself is a variation at the level of affect on the perennial ambiguity of our relationship to the past, in that irresolvable tension between a sense that people in the past were people like ourselves, with desires, dreams, hopes and fears like us, and yet that we cannot know that for sure, and moreover that much of what they felt seems strange, opaque, other. Pastiche can embody that tension at the level of how we feel about people in the past.

At the same time, a pastiche like *Far from Heaven* may also serve as a reminder that what we know of the past, above all of the feelings of the past, we know through the art that is left behind. We can't read off the 1950s from its melodramas, but not only did the latter none the less constitute one of the major frameworks of feeling available in the period, they are also one of the things we have got that enable us to make some move toward connection with the past, our past. (Obviously the extent to which we feel it is our past depends on who we are, and the intensity and poignancy of the relationship to a past is in turn affected by what investments we have in it.)

It suggests the way in which feeling is shaped by culture.

Recognising that what we know about how things felt in the 1950s comes – problematically but only – from cultural artefacts (and in this case films) may also enable us to reflect on the fact that how we feel right now is itself framed by the traditions of feeling we inherit, mobilise and hand on. In other words, the pastiche of *Far From Heaven* not only makes the historicity of its affect evident but can also allow us to realise the historicity of our own feelings.

It is hard to experience our feelings historically: they seem – and, in terms of the exercise of our conscious will, largely are – unbidden, unconscious, visceral, unruly. Yet just as *Far From Heaven* suggests a way of feeling intensely that is at once recognisable and other, so it also allows us to extrapolate from that to the historical shaping of our feelings. If in the 1950s frameworks of feelings structured how people felt, then it must be so now. To know this is also to be able to reflect upon it.

• • •

Pastiche is close, close to other kinds of imitation (plagiarism, copying, homage, parody), close to what it imitates. This is why it can both be hard to determine whether such and such is pastiche (rather than, say, plagiarism or parody) and also why it is sometimes easy to mistake a pastiche for what it pastiches (vide genre).

To be close to something (as pastiche is to its referent) is to be neither identical to it nor distinct from it, neither subsumed by nor aloof from. Pastiche, by virtue of closeness, is thereby social and sociable. It is social: it always accepts and indicates what is really the case in all cultural production, that it exists by virtue of the forms and frameworks of meaning and affect available to it; it acknowledges itself as being in the realm of the already said.[77] It is also sociable: in acknowledging where it comes from, it is comparable 'to the game of adaptation and half-echoing that goes on all the time in a conversation' (as opposed to parody, 'the act of perfect mimicking that can bring a conversation to a self-conscious halt') (Bromwich 1985: 328). Pastiche embraces closeness: it accepts the possibility of being seduced, penetrated, dependent or ventriloquised, without seeing this as a significant and anxiety-producing loss of autonomy.

As a result though, pastiche is unstable in relation to the expression of a fixed or certain point of view. In broad terms, it affirms the position from which it is produced ('The Murder of Gonzago' demonstrates *Hamlet*'s modernity, *The Afro-American Symphony* advocates the universal applicability of symphonic form, *Far From Heaven* confirms, even as it makes a film like that, that they don't, and can't, make films like that any more), but its attitude towards what it is imitating is all the same not clear-cut. Even when the judgement that may frame the pastiche is hardly in doubt (*Man of Marble*, *Madame Bovary*, *Erasure*), the pastiche itself is liable to get out from under – in getting close, the pastiching work is liable to give the pastiched form its head, even while keeping its own.

Pastiche is especially apt to occur when, for one reason or another (or more), the frameworks of understanding and feeling available in a culture are more evident (cf. the final section of chapter 4), often in circumstances of geographic, temporal, ideological, gendered or cultural dislocation (Westerns in Italy, women in Westerns, ballet in Russia, blues in symphonies, 1950s melodrama in 2002). It also seems to have been especially congenial to social groupings or individuals within them who feel marginal to but not entirely

excluded from the wider society (cf. *Watermelon Woman*, *Follies*, Jewish 'black' music, African-American symphonism, *Far From Heaven*). However, those circumstances and groupings may also simply make people more alert to a fact of the human condition: that we think and feel for ourselves and yet only by means of the frameworks of thought and feeling available to us, frameworks that limit what can be thought and felt but are also the only things that make it possible to think and feel at all beyond the most disorganised sense impressions.

To say this though in the era of originality that we still inhabit can seem threatening. Contemporary cultural values for the past couple of centuries put a premium on thinking and feeling autonomously out of the inner imperatives of the self; what's more, if you occupy positions of power and privilege in society, you may also glimpse – or even in certain psychotic cases permanently maintain – the sense that you are the only begetter of what you think and feel, that you are the centre and author of discourse. Yet surely few actually experience thought and feeling like that in any sustained way. If you have something invested in experiencing it like that, in occupying the originating position of knowledge and authority, then accepting that you are in the realm of the already said may be a source of anguish, but for others – in given circumstances, in given groupings – it is no more than what life is like and one had better get used to it. Pastiche articulates this sense of living permanently, ruefully but without distress, within the limits and potentialities of the cultural construction of thought and feeling.

Pastiche articulates this not through intellectual reflection on it but by conveying it affectively. It imitates formal means that are themselves ways of evoking, moulding and eliciting feeling, and thus in the process is able to mobilise feelings even while signalling that it is doing so. Thereby it can, at its best, allow us to feel our connection to the affective frameworks, the structures of feeling, past and present, that we inherit and pass on. That is to say, it can enable us to know ourselves affectively as historical beings.

Notes

1 See also, inter alia, Kaplan (1988), Wolff (1990), Creed (1997), Brooker and Brooker (1997b), Dika (2003), Constable (2004).

2 For more detail, see appendix 2.

3 The *Harlem Nutcracker* (Donald Byrd 1996) turned the Arab dance into 'an overblown body-building fantasy', while *The Hard Nut* (Mark Morris 1991) made it 'a drag fantasy worthy of a B-movie desert oasis' (Fisher 2003: 106), both thus drawing on but also 'camping up' the sexuality of the standard versions.

4 On the oddness and possible sources of this convention, 'widely entrenched nowadays as *the* balletic emblem of Chineseness', see Fisher (2003: 97–99).

5 In common usage, as soon as one designates a representation a stereotype, one considers it by definition inaccurate, reductive and probably demeaning; however, when stereotypes work as they are supposed to, they ask to be taken as correct representations, founded on the assumption that indeed all such and such are like this and, often but not always, really are risible or contemptible.

6 Fisher (2003: 98–100) notes the way that even the Chinese dance can be connected to actual Chinese classical, folk and opera dance forms.

7 On Orientalism in Russian music, see Taruskin (1998).

8 Territorially Russian dances of this kind were a feature of other ballets of the period. For the very popular *The Little Humpbacked Horse* (Arthur St-Léon 1864), a divertissement was devised showing 'the different nationalities who populate Russia' (as Sergei Nikolaevich Khudekov wrote in 1896 (Wiley 1990: 274)), including Ukrainians, Letts and Cossacks. The last was danced by Lev Ivanov, the choreographer of the first *Nutcracker*.

9 On the ethnic character of ballet, see Kealiinohomoku (1983).

10 This uses Ellington's version of the 'Waltz of the Flowers'; the Spanish Dance does not appear in Tchaikovsky's *Suite* nor, therefore, in Ellington's.

11 He had already written *A Rag-Time Instructor* in 1897.

12 See Schiff (1997: 10–11) for discussion of the role of Grofé as orchestrator of *Rhapsody in Blue*.

13 Arlen is perhaps the doyen of Jewish writers of black music: other songs include 'Get Happy' (whose verse establishes it as a song about a black revivalist gathering), he wrote black cast musicals such as *St Louis Woman* 1946, *House of Flowers* 1954 and *Jamaica* 1957 and his work was much prized by Duke Ellington. See Melnick (1999: 51).

14 On the Jewishness of *Porgy and Bess*, see Gill (2001). Gill points out that for the film version the producer (Samuel Goldwyn), two of the directors (Rouben Mamoulian and Otto Preminger), the screenwriter (N. Richard Nash) and one of the stars (Sammy Davis Jr) were all Jewish. (Mamoulian also directed the first stage production, but was taken off the film in the early stages of production.)

15 Written for, and sung and danced by, Fred Astaire as a tribute to tap dancer Bill 'Bojangles' Robinson in the film *Swing Time*.

16 Mary Garden was a leading opera singer of the day.

17 Two other key players in the mainstreaming of jazz – Paul Whiteman, for a time known as 'the King of Jazz', who commissioned and first performed *Rhapsody in Blue*, and Ethel Merman, who introduced, and shot to stardom with, 'I Got Rhythm' – were rumoured (Whiteman) or widely assumed (Merman) to be Jewish.

18 In a 'Preface to "The Jazz Singer"', published in a souvenir programme for the film version (and reproduced in Hoberman and Shandler (2003: 82)), Samson Raphaelson, the author of the play, declares:

> Jews are determining the nature and scope of jazz more than any other race – more than the negroes, from whom they have taken jazz and given it a new color and meaning. Jazz is Irving Berlin, Al Jolson, George Gershwin, Sophie Tucker.

19 Robeson was a leading singer and populariser of the spirituals and an emblematic figure of 'race pride'; 'Old Man River' was written with him in mind, although he did not perform it until the London production; in later years, he changed the lyrics, removing what he saw as the cod dialect and the emphasis on resignation rather than resistance, and showing signs of finding the song itself a burden (cf. Dyer 2004: 64–136).

20 In her one woman show based on her career, *Lena Horne: The Lady and Her Music* 1981–1982, Horne was partly concerned to affirm her blackness, and one of the main ways in which she did this was through soulful performances of 'Stormy Weather'.

21 Featuring, among others, Lena Horne, Cab Calloway, Bill Robinson, James Europe and Katherine Dunham, who used 'Stormy Weather' as the basis for a primitivist dance number.

22 See Schiff (1997: 84), who draws on Crawford (1993).

23 Cf. Gates (1984), Floyd (1995) and, especially relevant in this context, Arthur Knight's discussion (2001) of black jazz artists' versions of *Porgy and Bess*.

24 Sophie Tucker's signature tune, 'Some of These Days' 1926, was written by an African-American composer, Shelton Brooks (Melnick 1999: 57).

25 Corin Willis' work (2002) on blackface in late silent and early sound films throws up numerous instances where blackfaced white performers share the screen with actual

African-Americans, in scenarios where it assumed the audience will not be able to tell the difference (e.g. *The Birth of a Nation* 1916) or where the characters cannot do so (e.g. *Pardon Us* 1931, where Laurel and Hardy, on the run, black up to disguise themselves, and are accepted as black by a group of African-Americans).

26 William Grant Still twice arranged 'Swanee River', without any apparent parodic intent, once for piano 1939, once for unaccompanied chorus (?1960s), suggesting the sense in which it may have been perceived to have got something right.

27 It is first heard sung by Julie, star of the show boat; the (black) cook, Queenie, is surprised, since it is a song only 'colored folks' know, but Julie continues with it, joined by Queenie, Joe (Queenie's husband) and Magnolia (the daughter of the (white) show boat captain). Julie, Queenie and Joe sing and move to it unaffectedly, but Magnolia's dancing (imitating black shuffle dance) is a cause of great hilarity. It comes out later that Julie is of mixed race and therefore, in the terms of the world they inhabit, passing for white but 'really' black, so, by this logic, of course she can sing 'Can't Help Lovin' Dat Man' authentically, just as truly white Magnolia can only produce an inept version of it.

28 Goldberg, Isaac in *George Gershwin: A Study in American Music* 1931, quoted in Melnick (1999: 258).

29 In an interview in the *Jewish Tribune*, 28 December 1928, quoted in Hoberman (2003b: 154).

30 Sanders traces this through the work of other Jewish American songwriters (e.g. Richard Rodgers, Lorenz Hart, Fritz Loewe, Leonard Bernstein) and not only in the pastiching of black music. With *Fiddler on the Roof* 1959, Jerome Bock and Sheldon Harnick produced 'pastiche of their all-but-lost heritage of Yiddish song' (1976: 215). Had Sanders been writing later, he would surely have included Sondheim and, a fortiori, *Follies*.

31 In fact, the use of these terms returns them to their original meanings. Although by the nineteenth century, the term 'symphony' had acquired quite set formal expectations, it only originally meant the sounding together of many instruments and Arthur Jacobs (1958: 366) defines it simply as 'an orchestral work of a serious nature and a substantial size'. 'Rhapsody', a much more recent term in music, never acquired precise formal parameters and Percy Scholes (1970: 872) defines it as 'usually ... a free-ranging and ebullient fantasia on folk or folk-like melodies', making understandable the preference for this term for what would then have been called Negro concert works.

32 Composed for solo piano, then orchestrated (by William Grant Still) and this version first performed (by Fats Waller) in 1927.

33 First performed (at Carnegie Hall) in January 1943, then substantially reworked for the 1958 Columbia Records recording. On *Black, Brown and Beige*, see Tucker (1993a), Barg (n.d.).

34 Harmonically conservative, but interested in ideas of national music and making use of Negro material in his fourth string quartet 1896.

35 The Symphony has been recorded several times, including by the Vienna Opera Orchestra (conductor Karl Krueger) 1952, the Royal Philharmonic Orchestra (Karl Krueger) 1965, the Detroit Symphony Orchestra (Neeme Järvi) 1993, Cincinnati Philharmonia Orchestra (Jindong Cai) 1997, the Chicago Sinfonietta (Paul Freeman) 2000 and the Fort Smith Symphony Orchestra (John Jeter) 2005. I have listened to all but the very first of these. The most complete description of the work is Slattery (1972). For a brief introduction to Still and the symphony, see Brown (1993: 72–78).

36 The musical terms mean, respectively and roughly, fairly evenly paced, slow and smooth, lively, slow and resolutely.

37 Sliding (*glissando, portamento*) on wind instruments (i.e. not keeping the notes separate but slithering from one to another, thus covering tones not recognised in the Western concert tradition) was seen by some in the period as the defining characteristic of jazz (Schiff 1997: 31–32), thus making the spectacular clarinet opening of *Rhapsody in Blue* emblematic of a white perception of jazz. I should say that as (a) the bassoon glissando in the *Afro-American Symphony* is much shorter than the clarinet one in the *Rhapsody*, moving downwards and on a different instrument, (b) it is much more to the fore in the RPO/Krueger performance than any of the others and (c) no commentators on the *Symphony* make the connection, I do not insist on it.

38 All the same, Alain Locke found in Dvořák's theme 'the true atmosphere of a Negro spiritual' (1936: 106).

39 Burleigh was Dvořák's secretary and sang spirituals to him, only later publishing his settings of them. On Dvořák, Burleigh and the spirituals, see Burgett (1993: 31–32) and Beckerman (2003: 125–137).

40 In the *Oxford Companion to Popular Music*, Peter Gammond describes *Rhapsody in Blue* as 'one of the most successful pieces of jazz pastiche ever written' (1991: 220), and Gershwin himself spoke of his practice (specifically in the context of *Porgy and Bess*) as a form of pastiche, meaning an ability to get real close his musical sources (Jablonski (1992: 107), quoted in Melnick (1999: 73)). Rather more hostilely, Schiff notes that black and white writers on jazz have tended to consider the *Rhapsody* 'fake jazz' (1997: 3) and Ken Rattenbury, in a study of Duke Ellington, considers that Gershwin's blue notes 'are blue notes that impersonate the real thing, a little too good to be true (or perhaps more accurately a little too true to be good)' (1990: 30). The question of Gershwin's relation to African-American music has continued to revolve around this question of it being very like but not quite and has also led to perceptions of plagiarism: Duke Ellington claimed that passages of *Rhapsody in Blue* were taken from the African-American song 'Where Has My Easy Rider Gone?' (Tucker 1993b: 116); Floyd (1995: 218) describes the way in which 'Summertime' from *Porgy and Bess* is an adaptation of 'Sometimes I Feel Like a Motherless Child'; and see also the discussion of 'I Got Rhythm' and William Grant Still in the present chapter.

41 Again, more evident in the RPO/Krueger recording.

42 In contrast, Dawson's *Negro Folk Symphony* makes extensive use of actual spirituals.

43 'There never has been a presentation of genuine Negro spirituals to any audience anywhere' (Hurston 1970: 224).

44 Still, in a speech to the Composer's Workshop 1967, quoted in Slattery (1972: 19).

45 On blues harmonic progression, see, among others, Keil (1966: 51–53) and McClary (2000: 38–41).

46 Cf. Anderson (2001: 13–58).

47 I am grateful to Corin Willis for drawing my attention to this work as well as for picking my way through current debates on minstrelsy and its relation to white American and African-American cultures (cf. Willis 2002).

48 That is, the harmonic arrangements underlying plainsong and folk music, but not used within the European concert music tradition (unless in deliberate reference to those forms).

49 In a discussion of the meaning of the word 'pastiche', Leif Ludwig Albersten (1971) argues that it should be applied to German romanticism, of which the Lied was an essential part, by virtue of the latter's extensive use of folk material.

50 For example, Dvořák, Chadwick's *Fourth String Quartet*, Henry Gilbert (*Comedy Overture on Negro Themes* 1905, *Negro Rhapsody* 1915), Daniel Gregory Mason (*String Quartet in G minor on Negro Themes* 1920).

51 Still, Dawson's *Negro Folk Symphony*, Robert Nathaniel Dett (Canadian by birth; *The Chariot Jubilee* 1919 and *The Ordering of Moses* 1932 (Ryder 1993)) and Florence Price, whose work included two *Concert Overtures on Negro Spirituals*, four symphonies and the orchestral works *The Oak* c.1936 and *Mississippi River Suite* c.1934 all of which use, but to greatly varying degrees, African-American melodic elements (Brown 1993: 78–84).

52 From a speech delivered at an Honours Luncheon at the Association of the Presentation and Preservation of the Arts, quoted in Murchison (2000: 52). Murchison argues (ibid.: 64) that Still's earlier pronouncements are consonant with this. It may be suggestive that Still speaks of a theme 'in the Blues idiom', rather than simply of writing a Blues.

53 Murchison (2000: 57) emphasises Still's optimism about 'America's basically democratic spirit' and improving race relations.

54 Barg draws on the work of Melvin Dixon (1994).

55 Mukherjee (1990) argues that the hybridity of much contemporary Third World cultural production works with its own local inheritances rather than always referencing metropolitan outputs.

56 From the prosecutor's summing up, reprinted in Flaubert (1998) (passage cited, page 494). On the trial, see LaCapra (1982).

57 All quotations from *Madame Bovary* are translated from Flaubert (1998). In each case I give first the page number in that edition, and then the page number in the Penguin translation (Flaubert 1950). The latter does not include the transcript of the trial, which can be found in English in Flaubert (1964).

58 Flaubert (1998: 492) for where it is quoted in the trial transcript.

59 See Ullmann (1964: 94-120), Pascal (1977), Cohn (1983: 99–140), Ginsburg (1982), LaCapra (1982: 126–149). Cohn, who uses the term 'narrated monologue', defines it as 'the technique for rendering a character's thought in his own idiom while maintaining the third-person reference and the basic tense of narration' (1983: 100). Pascal traces it back to the early nineteenth century, though identifying the first use of the term by Charles Bally in 1912; Ginsburg (1982: 147) indicates earlier precedents. Flaubert is among its most celebrated exponent and is the subject of Ullmann's chapter.

60 Lamartine's two most – and extremely – successful volumes of poetry were *Méditations poétiques* 1820 and *Nouvelles méditations poétiques* 1823.

61 Usually assumed to refer Lee Sheldon (aka 'Stag' Lee), who shot William Lyons in a brawl in St. Louis in 1895; however, his story has been embroidered subsequently and amplified into a folkloric figure. There are at least 63 recordings of various versions of his story in song, where he is usually presented as 'the baddest nigger that ever lived' (Julius Lester: *Black Folktales*, New York: Grove, 1969, 113, quoted in Kullen (1997: 2)). Black Panther Bobby Seale is said to have 'named his son after Stagger Lee, who he said was a positive role model for black men' (ibid.: 5).

62 This title seems to me far more parodic than anything in *Fuck*, as does the short opening paragraph of it Monk gives us (34), which begins
My fahvre be gone since time I's borned and it be just me an' my momma an' my baby brover Juneboy.

63 Yet this is presented as a non-hoax novel in the fictional world of *Erasure*.

64 Still and Worton (1990: 29–33) discuss the notion of penetration (and fear of it) in relation to intertextuality.

65 All page references refer to Barnes (1985).

66 There is evidence that such a correspondence did take place, which means that it might conceivably be found one day (Bouillaguet 1996a: 64fn).

67 Available online at: http://www.salon.com/ent/movies/review/2002/11/08/far_from_heaven/

68 Cf. the views collected online at: http://www.rottentomatoes.com/m/far_from_heaven/. For more extensive critiques see Taubin (2002), Hilderbrand (2002), Murray (2003), Mulvey (2003), Willis (2003), Cook (2004: 11–15), Joyrich (2004).

69 Two are widows; in *The Reckless Moment*, the husband is away on business throughout the film; in *Far From Heaven*, Frank leaves Cathy in the course of the film.

70 *All that Heaven Allows* and *Fear Eats the Soul* have endings that do suggest the couple may have a future together.

71 On the use of colour in the film, see Willis (2003: 148–153) as well as Todd Haynes' DVD commentary.

72 Much quicker than in Sirk (editor James Lyons in 'Anatomy of a Scene' on DVD of *Far From Heaven*).

73 The composer for the Sirk films was Frank Skinner, who produced pasticcios of classical music melodies (*All That Heaven Allows*, for instance, combines inter alia 'Warum?' from Schumann's *Fantasiestücke*, Liszt's 'Consolation' and Brahms' First Symphony); Elmer Bernstein's score for *Far From Heaven* is in this sense wholly original, and more chromatically lush.

74 James Zborowski's 2005 MA dissertation discussed at length the way that similar devices in Sirk and *Far From Heaven* are often put to different aesthetic ends. See also Willis (2003), notably her discussion of stammering (153–158).

75 Homosexuality was implicit and/or marginal in films, including melodramas, through most of Hollywood's history, and it is the unspoken but quite evident focus of *Tea and Sympathy* 1956. However, explicit, and still quite restricted, treatments only really begin with, for instance, *Suddenly Last Summer* 1959, *Advise and Consent* 1961, *A Walk on the Wild Side* 1962 and *The Children's Hour* 1962. Mutual inter-racial desire (as distinct from black-on-white rape scenarios) is treated in two films at the end of the 1950s that, however, remove it from, respectively, the USA and the present: *Island in the Sun* 1959, set on a Caribbean island, and *The World, The Flesh and the Devil* 1958, set in a world almost entirely annihilated by germ warfare. Such desire did not become a fit subject for sympathetic or central characters in Hollywood movies until *Guess Who's Coming to Dinner?* 1967.

76 Haynes refers to this in his DVD commentary (chapter 6).

77 Cf. the discussion at the end of chapter 3 above of the variety of responses that 'they don't make them like that anymore' may engender.

78 I take the last phrase from Billi (1993: 38), who draws here on Bakhtin's discussion of parody, where the term is used broadly enough to encompass pastiche in the sense I have been arguing for.

Appendix 1

Marcel Proust: '"The Lemoine Affair" by Gustave Flaubert'

The heat was becoming stifling, a bell rang, turtledoves took flight, and, as the windows had been closed on the orders of the presiding judge, an odour of dust spread through the room. He was old, with a clownish face, a robe too tight for his bulk, and pretensions of wit; and his uniform side-boards, stained with tobacco residue, made his whole person seem decorative and common. As the break in the hearing dragged on, acquaintances began to form; to start up conversations, some crafty types complained in loud voices about the lack of air, and, someone having said they recognized a gentleman leaving the room as the Minister of the Interior, a reactionary whispered: "Poor France!" By taking an orange out of his pocket, a negro drew attention to himself, and, wanting to make himself popular, offered segments to his neighbours, apologetically, on a newspaper: firstly to a clergyman, who declared he had "never tasted anything so good, an excellent fruit, refreshing"; but a dowager assumed an offended expression and forbade her girls from accepting anything "from someone they didn't know", whilst other people, not knowing whether the newspaper would get as far as them, strove for a suitable expression: some took out their watches, a lady took off her hat. It was surmounted with a parrot. Two young people were astonished by it and wondered whether it had been placed there as a keepsake or simply by virtue of eccentric taste. Already the wags were starting to call to each other from one bench to the next, and the women, looking at their husbands, were stifling their laughter with their handkerchiefs, when silence descended, the judge seemed to be lost in asleep, and Werner's counsel made his case. He had begun in an emphatic tone, spoke for two hours, seemed dyspeptic, and every time he said "Monsieur le Président" prostrated himself in such a low bow that one would have thought him a young girl before a king, a deacon leaving the altar. It was terrible for Lemoine, but the elegance of the formulations made up for the grimness of the indictment. And his clauses followed on each other without interruption, like water in a waterfall, like unwinding a ribbon. At one point the monotony of his address was such that it could

barely be distinguished from silence, like the persistence of a bell's vibration, like a fading echo. To conclude, he called upon the portraits of presidents Grévy and Carnot which hung above the tribunal; and everyone, having lifted their heads, noted that mouldiness had got the better of them in this official and dirty room which displayed our glories and smelled fusty. A large bay divided it down the middle, benches were lined up right to the foot of the tribunal; there was dust on the floor, spiders in the corners of the ceiling, a rat in every hole, and it needed to be ventilated frequently because of the proximity of the stove, sometimes because of a more nauseating smell. Lemoine's counsel was brief in his reply. But he had a Southern accent, appealed to noble passions, constantly removed his spectacles. Listening to him, Nathalie felt that disturbance that accompanies eloquence; a nice feeling spread through her and as her heart swelled, the batiste of her blouse palpitated, like grass by a spring about to gush forth, like the plumage of a pigeon about to take flight. Eventually the judge made a sign, a murmur rose, two umbrellas fell over: we were going to hear from the accused again. Immediately angry gestures from the witnesses were aimed at him; why had he not told the truth, manufactured diamonds, divulged his invention? Everyone, down to the most poor, would have known – this was certain – how to make millions from it. They even saw them before their very eyes, with that excessive regret when we believe we possess what we lament. And many gave themselves up once more to the sweetness of the dreams they had conceived, when they had caught a glimpse of a fortune, on the news of the discovery, before they'd tracked down the swindler.

For some it was giving up work, a house on the avenue du Bois, influence in the Academy; and even a yacht that would have taken them in the summer to cool places, not to the Pole obviously, which is intriguing, but the food there tastes of oil, twenty four hours of daylight must be inconvenient for sleeping, and then how do you keep out of the way of the white bears?

For others, millions were not be enough; straight away they would have played the stock market; and buying at their lowest value the very day before they rose – a friend would have kept them informed – they would see their capital increase a hundredfold in a few hours. Then, rich as Carnegie, they would take care not to throw it away on some humanitarian Utopia. (Besides what good does it do? It has been calculated that a thousand million shared between everyone in France would not make one single person any richer.) But, leaving luxury to the vain, they would seek only comfort and influence, have themselves nominated President of the Republic, ambassador to Constantinople, have their bedroom lined with cork to deaden the noise from the neighbours. They would not join the Jockey Club, making their own judgement as to the value of the aristocracy. They'd be more attracted by a papal title. Perhaps you can get one without having to pay. But in that case what good were so many millions? In short, they would be swelling St Peter's coffers while rebuking the institution. What can the Pope do with five million lace collars and so many rural priests dying of hunger?

But some, dreaming of how riches could have come their way, felt as if they were going to faint; because they would have thrown themselves at the feet of a woman by whom they had been disdained until then, and who would have finally given up to them the secret of her kiss and the softness of her body. They pictured themselves with her, in the country, till the end of their days, in a house all of white wood, on the melancholy banks of a great river. They would have become familiar with the cry of the petrel, the coming of the mists, the vibration of the ships, the formations of the clouds, and would have remained for hours with her body on their knees, watching the tide rise and the moorings knocking together, on the terrace, in a wicker armchair, under a blue-striped awning, between metal balls. And they would end up seeing nothing but two branches of violet flowers, hanging down to the fast-moving water that they almost touch, in the harsh light of a sunless afternoon, along the length of a reddish wall that is crumbling away. For them, the excess of their distress undermined the force of their damnation of the accused; but they all hated him, feeling that he had cheated them of debauchery, honours, celebrity, genius; sometimes of those more indefinable chimera, of that deep and sweet thing that each concealed, ever since childhood, in the particular stupidity of their own dream.

(Translated from Proust 2002: 22-26.[1])

Note

1 Another translation can be found at the Marcel Proust Ephemera Site (www.yorktaylors.free-online.co.uk/), which also has translations of the other Lemoine pastiches.

Appendix 2

Nutcracker productions

My discussion of the national dances in *The Nutcracker* is based on the following versions:

- 1892
 Petersburg Ballet
 Lev Ivanov, Marius Petipa
 The first production, conceived by Petipa but choreographed when he fell ill by Ivanov, his second-in-command.[1] I base my discussion entirely on the detailed description in Wiley (1985), which is based in turn on the available contemporary documentary evidence (in which choreographic detail is limited).
- 1934
 Kirov Ballet
 Vasily Vainonen
 Sometimes considered the nearest to the above of the now performed versions. Filmed at a 1994 performance in the Mariinsky Theatre, St. Petersburg, the basis of my account.
- 1940 *Fantasia*
 Walt Disney
 Samuel Armstrong
 The second section of the film, using Tchaikovsky's Suite from *The Nutcracker*. Flora and fauna are substituted for dancers in the (unnamed) national dances as follows:

 Chinese: mushrooms
 Arabian: fish
 Russian: thistles and bell-like flowers.

 As in the Suite, there is no Spanish dance.
- 1954/1967
 San Francisco Ballet
 Lew Christensen

The second version was a substantial revision of the first. My references are based on Anderson (1979: 112–121).

- 1957/1993
 New York City Ballet
 George Balanchine
 First produced for live television broadcast, made into a film in 1993 (and this is the version I have watched).
- 1968
 Royal Ballet
 Rudolph Nureyev
 My reference is Anderson (1979: 146–152).
- 1990
 Birmingham Royal Ballet
 Peter Wright
 This was Wright's second version of the ballet. Filmed at a performance at Birmingham Hippodrome in December 1994 (which, as it happens, I also attended).

On the history of *Nutcracker* productions, see Anderson (1979) and Fisher (2003).

Note

1 See Wiley (1985: 200–204 and 308–309 fn22) for discussion of the relative importance of Ivanov and Petipa in the production and choreography.

Bibliography

Abastado, Claude (1976) 'Situation de la parodie', *Cahiers du vingtième siècle* 6, 9–37.

Abel, Lionel (1963) *Metatheatre: A New View of Dramatic Form*, New York: Hill and Wang.

Ades, Dawn (1976) *Photomontage*, London: Thames and Hudson.

Albalat, Antoine (1934) *La Formation du Style par l'Assimilation des Auteurs*, Paris: Armand Colin.

Albersten, Leif Ludwig (1971) 'Der Begriff des Pastiche', *Orbis Litterarum* 26, 1–13.

Allen, Graham (2000) *Intertextuality*, London: Routledge.

Almansi, Guido and Fink, Guido (1991 [1976]) *Quasi come*, Milan: Bompiani.

Altman, Rick (1999) *Film/Genre*, London: British Film Institute.

Anderson, Jack (1979) *The Nutcracker Ballet*, New York: Mayflower Books.

Anderson, Paul Allen (2001) *Deep River: Music and Memory in Harlem Renaissance Thought*, Durham, NC: Duke University Press.

Aristotle (1965) 'On the Art of Poetry', in Dorsch, T. S. (ed. and trans.) *Classical Literary Criticism*, Harmondsworth: Penguin, pp. 31–75.

Arkin, Lisa C. and Smith, Marian (1997) 'National Dance in the Romantic Ballet', in Garafola, Lynn (ed.) *Rethinking the Sylph: New Perspectives on the Romantic Ballet*, Hanover NH: Wesleyan University Press/University Press of New England, pp. 11–68, 245–252.

Arnold, Denis (ed.) (1983) *The New Oxford Companion to Music*, Oxford: Oxford University Press.

Austin-Smith, Brenda (1990) 'Into the Heart of Irony', *Canadian Dimension* 24:7, 51–52.

Baird, Robert (1998) 'Going Indian: Discovery, Adoption and Renaming toward a "True American", from *Deerslayer* to *Dances with Wolves*', in Kitses, Jim and Rickman, Gregg (eds) *The Western Reader*, New York: Limelight Editions, pp. 277–292.

Baker, Houston (1987) *Modernism and the Harlem Renaissance*, Chicago: University of Chicago Press.

Bakhtin, Mikhail (1984 [1929]) *Problems of Dostoyevsky's Poetics*, Minneapolis: University of Minnesota Press.

Baldick, Chris (1990) *The Concise Oxford Dictionary of Literary Terms*, Oxford: Oxford University Press.

Banfield, Stephen (2001) *Sondheim's Broadway Musicals*, Ann Arbor: University of Michigan Press.

Barg, Lisa D. (n.d.) 'Race, Narrative and Nation in Duke Ellington's *Black, Brown and Beige*' in Walser, Robert (ed.) *Playing Changes: New Jazz Studies*, Durham: Duke University Press (forthcoming).

Barnes, Julian (1985 [1984]) *Flaubert's Parrot*, London: Picador.

Bassnett, Susan (2002 [1980]) *Translation Studies* (revised edition), London: Routledge.

Bassnett, Susan and Trivedi, Harish (eds) (1999) *Post-Colonial Translation: Theory and Practice*, London: Routledge.

Bate, Jonathan (1997) *The Genius of Shakespeare*, London: Picador.

Battaglia, Salvatore (1984) *Grande Dizionario della lingua italiana*, Turin: Unione Tipografico Torinese.

Bazin, André (1975 [1945]) *'Boule de Suif'* in *Le Cinéma de l'Occupation et de la Résistance*, Paris: Union Général d'Édition, pp. 145–146. (First published *Parisien Libéré*, 22 October 1945.)

Bazin, André (1971) 'The Evolution of the Western' in Bazin, André (Gray, Hugh (ed. and trans.)) *What Is Cinema? Vol II*, Berkeley: University of California Press, pp. 149–157.

Beckerman, Michael (2003) *New Worlds of Dvořák: Searching for America in the Composer's Inner Life*, New York: W.W. Norton.

Belfrage, Cedric (1996 [1941]) 'Orson Welles' *Citizen Kane'*, in Gottesman, Ronald (ed.) *Perspectives on Citizen Kane*, New York: G.K. Hall, pp. 44–48. (First published in *The Clipper*, May 1941.)

Bellman, Jonathan (ed.) (1998) *The Exotic in Western Music*, Boston: Northeastern University Press.

Ben-Porat, Ziva (1976) 'The Poetics of Literary Allusion', *PTL: A Journal for Descriptive Poetics and Theory of Literature* 1, 105–128.

Ben-Porat, Ziva (1979) 'Method in *Mad*ness: Notes on the Structure of Parody, Based on *Mad* TV Satires', *Poetics Today* 1: 1–2, 245–272.

Bhabha, Homi (1994) 'Of Mimicry and Man: The Ambivalence of Colonial Discourse', in *The Location of Culture*, New York: Routledge, pp. 85–92.

Billi, Mirella (1993) *Il testo riflesso: la parodia nel romanzo inglese*, Naples: Liguori.

Bilous, Daniel (1983) 'Intertexte/pastiche, l'intermimotexte', *Texte* 2, 135–160.

Block, Geoffrey (1997) *Enchanted Evenings: The Broadway Musical from Show Boat to Sondheim*, New York: Oxford University Press.

Bloom, Harold (1973) *The Anxiety of Influence: A Theory of Poetry*, Oxford: Oxford University Press.

Bogdanovich, Peter and Welles, Orson (1996 [1992]) 'From *This Is Orson Welles'*, in Gottesman, Ronald (ed.) *Perspectives on Citizen Kane*, New York: G.K. Hall, pp. 527–568. (Extracted from Rosenbaum, Jonathan (ed.) (1992) *This Is Orson Welles*, New York HarperCollins (based on an interview originally conducted in 1982).)

Böker, Uwe (1991) 'The Marketing of Macpherson: The International Book Trade and the First Phase of German Ossian Reception', in Gaskill, Howard (ed.) *Ossian Revisited*, Edinburgh: Edinburgh University Press, pp. 73–93.

Bordwell, David (1976) *'Citizen Kane'*, in Nichols, Bill (ed.) *Movies and Methods*, Berkeley: University of California Press, pp. 273–290.

Borello, Rosalma Salina (1996) *Testo, Intertesto, Ipertesto. Proposte teoriche e percorsi di letteratura*, Rome: Bulzoni.

Bouillaguet, Annick (1996a) *L'Écriture imitative. Pastiche Parodie Collage*, Paris: Nathan.

Bouillaguet, Annick (1996b) *Proust et les Goncourt: Le pastiche du Journal dans Le Temps retrouvé*, Paris: Lettres Modernes.

Boujout, Michel (1984) 'Noir comme le jazz?', *L'Avant-scène du cinéma* 329–330: 24–29.

Bourne, Matthew and Macaulay, Alastair (1999) *Matthew Bourne and His Adventures in Motion Pictures*, London: Faber and Faber.

Boyne, Roy and Rattansi, Ali (eds) (1990) *Postmodernism and Society*, London: Macmillan.

Brand, Peggy Zeglin (1998) 'Parody', 'Pastiche', in Kelly, Michael (ed.) *Encylopedia of Aesthetics*, Oxford: Oxford University Press, pp. 441–445.

Bromwich, David (1985) 'Parody, Pastiche and Allusion', in Hošek, Chaviva and Parker, Patricia (eds) *Lyric Poetry: Beyond New Criticism*, Ithaca NY: Cornell University Press, pp. 328–344.

Brooker, Peter and Brooker, Will (eds) (1997a) *Postmodern After-Images: A Reader in Film, Television and Video*, London: Arnold.

Brooker, Peter and Brooker, Will (eds) (1997b) 'Pulpmodernism: Tarantino's Affirmative Action', in Brooker, Peter and Brooker, Will (eds) *Postmodern After-Images: A Reader in Film, Television and Video*, London: Arnold, pp. 89–100.

Brown, Rae Linda (1993) 'William Grant Still, Florence Price, and William Dawson: Echoes of the Harlem Renaissance', in Floyd, Samuel A (ed.) *Black Music in the Harlem Renaissance*, Knoxville: University of Tennessee Press, pp. 71–86.

Brownrigg, Mark (2003) Film Music and Film Genre. PhD thesis, University of Stirling (unpublished).

Brühl, Étienne (1951) *Variantes, nouvelles et pastiches*, Paris: Arthaud.

Brunette, Peter (ed.) (1993) *Shoot the Piano Player: François Truffaut, Director*, Oxford: Roundhouse Publishing.

Buning, Marius, Matthijs Engelberts and Sjef Houppermans (eds) (2002) *Samuel Beckett Today/Aujourd'hui 12: Pastiches, Parodies and Other Imitations*, Amsterdam: Rodopi.

Burgett, Paul (1993) 'Vindication as a Thematic Principle in the Writings of Alain Locke on the Music of Black Americans', in Floyd, Samuel A (ed.) *Black Music in the Harlem Renaissance*, Knoxville: University of Tennessee Press, pp. 29–40.

Buscombe, Edward (1992) *Stagecoach*, London: British Film Institute.

Buscombe, Edward (ed.) (1988) *The BFI Companion to the Western*, London: André Deutsch/ British Film Institute.

Buscombe, Edward and Pearson, Roberta (eds) (1998) *Back in the Saddle Again*, London: British Film Institute.

Butler, David (2002) *Jazz Noir: Listening to Music from Phantom Lady to The Last Seduction*, Westport: Praeger.

Butler, Judith (1990) *Gender Trouble: Feminism and the Subversion of Identity*, New York: Routledge, Chapman and Hall.

Butler, Judith (1991) 'Imitation and Gender Insubordination' in Fuss, Diana (ed.) *Inside/Out: Lesbian Theories, Gay Theories*, New York: Routledge, Chapman and Hall, pp. 13–31.

Callow, Simon (1995) *Orson Welles: The Road to Xanadu*, London: Jonathan Cape.

Cameron, Ian (ed.) (1992) *The Movie Book of Film Noir*, London: Studio Vista.

Cameron, Ian and Pye, Douglas (eds) (1996) *The Movie Book of the Western*, London: Studio Vista.

Cantril, Hadley (1940) *The Invasion from Mars: A Study in the Psychology of Panic*, Princeton: Princeton University Press.

Caradec, François (1971) *Trésors du pastiche. Imitation et parodies de nos grands écrivains – de Villon à Robbe-Grillet*, Paris: Pierre Horay.

Carringer, Robert L (1985) *The Making of Citizen Kane*, London: John Murray.

Carvalhal, Tania Franco (1997) 'La Tradition de la parodie et la parodie de la tradition dans les littératures latino-américaines', in Mildonian, Paola (ed.) *Parodia, Pastiche, Mimetismo*, Rome: Bulzoni, pp. 297–302.

Charney, Leo (1990) 'Historical Excess: *Johnny Guitar*'s Containment', *Cinema Journal* 29, 23–34.

Chatelain, Nicolas (1855) *Pastiches, ou imitations libres de style de quelques écrivains des 17me et 18me siècle*, Paris: Cherbuliez

Clarke, Donald (1990) *The Penguin Encyclopedia of Popular Music*, London: Penguin.

Cleto, Fabio (ed.) (1999) *Camp: Queer Aesthetics and the Performing Self*, Edinburgh: Edinburgh University Press.

Cohen-Stratyner, Barbara Naomi (1994) 'Welcome to "Laceland": An Analysis of a Chorus Number from *The Ziegfeld Follies* of 1922, as Staged by Ned Wayburn', in Loney, Glenn (ed.) *Musical Theatre in America*, Westport CT: Greenwood Press, pp. 315–321.

Cohn, Dorrit (1983 [1978]) *Transparent Minds: Narrative Modes for Presenting Consciousness in Fiction*, Princeton: Princeton University Press.

Collins English Dictionary (1992) Glasgow: Harper Collins.

Connor, Steven (2000) *Dumbstruck: A Cultural History of Ventriloquism*, Oxford: Oxford University Press.

Constable, Catherine (2004) 'Postmodernism and Film', in Connor, Steven (ed.) *The Cambridge Companion to Postmodernism*, Cambridge: Cambridge University Press, pp. 43–61.

Cook, Pam (1988) 'Women', in Buscombe, Edward (ed.) *The BFI Companion to the Western*, London: André Deutsch/British Film Institute, pp. 240–243.

Cook, Pam (2004) *Screening the Past: Memory and Nostalgia in Cinema*, London: Routledge.

Copjec, Joan (ed.) (1993) *Shades of Noir*, New York: Verso.

Corneille, Pierre (1937 [1692]) *L'Illusion comique*, Paris: Larousse.

Corneille, Pierre (1963 [1638]) *Le Cid* (ed. Georges Griffe), Paris: Bordas.

Countryman, Edward and von Heussen-Countryman, Evonne (1999) *Shane*, London: British Film Institute.

Covey, William (2003) 'The Genre Don't Know Where It Came From: African American Neo-Noir Since the 1960s', *Journal of Film and Video* 22: 2–3, 59–72.

Crawford, Richard (1993) *The American Musical Landscape*, Berkeley: University of California Press.

Creed, Barbara (1997 [1987]) 'From Here to Modernity', in Brooker, Peter and Brooker, Will (eds) *Postmodern After-Images: A Reader in Film, Television and Video*, London: Arnold, pp. 43–54. (First published in *Screen* 28:2, 47–67.)

Crowle, Pigeon (1957) *Come to the Ballet*, London: Faber and Faber.

Cruz, Jon (1999) *Culture on the Margins: The Black Spiritual and the Rise of American Cultural Interpretation*, Princeton: Princeton University Press.

Curry, Ramona (1990) 'Madonna from Marilyn to Marlene – Pastiche and/or Parody?', *Journal of Film and Video*, 42, 15–30

Curtis, David (1971) *Experimental Film: A Fifty Year Evolution*, London: Studio Vista.

Deffoux, Léon (1932) *Le Pastiche littéraire. Des origines à nos jours*, Paris: Delagrave.

Delepierre, Octave (1872) *Supercheries littéraires, pastiches, suppositions d'auteur, dans les lettres et dans les arts*, London: N. Trübner.

Dentith, Simon (2000) *Parody*, London: Routledge.

D'Haen, Theo (1997) 'Marina Warner's *Indigo* and Caribbean Discourse', in Mildonian, Paola (ed.) *Parodia, Pastiche, Mimetismo*, Rome: Bulzoni, pp. 403–410.

Diawara, Manthia (1993) 'Noir by Noirs: Towards a New Realism in Black Cinema', in Copjec, Joan (ed.) *Shades of Noir*, New York: Verso, pp. 261–278.

Dika, Vera (2003) *Recycled Culture in Contemporary Art and Film: The Uses of Nostalgia*, Cambridge: Cambridge University Press.

Dixon, Melvin (1994) 'The Black Writer's Use of Memory', in Fabre, Genevieve and O'Meally, Robert (eds) *History and Memory in African-American Culture*, New York: Oxford University Press, pp. 18–27.

Doane, Mary Ann (1982) 'Film and the Masquerade: Theorising the Female Spectator', *Screen* 23:3–4, 74–87.

Doane, Mary Ann (2004) 'Pathos and Pathology: The Cinema of Todd Haynes', *Camera Obscura* 57 (19:3), 1–22.

Dorsch, T. S. (ed. and trans.) (1965) *Classical Literary Criticism*, Harmondsworth: Penguin.

DuBois, W. E. B. (1994 [1903]) *The Souls of Black Folks*, Mineola, NY: Dover. [Chicago: McClury, 1903.]

Dubrow, Heather (1982) *Genre*, London: Methuen.

Durgnat, Raymond (1970) 'Paint It Black: The Family Tree of Film Noir', *Cinema* (UK) 6–7, 48–56. (Reprinted in Silver, Alain and Ursini, James (eds) (1996) *Film Noir Reader*, New York: Limelight, pp. 37–52.)

Dutton, Denis (ed.) (1983) *The Forger's Art: Forgery and the Philosophy of Art*, Berkeley: University of California Press.

Dyer, Richard (2001) 'The Notion of Pastiche', in Gripsrud, Jostein (ed.) *The Aesthetics of Popular Art*, Kristiansand: Høyskoleforlaget, pp. 77–90.

Dyer, Richard (2002) 'Genre/Pastiche', *Communicazione sociali* 24:II(2), 155–164.

Dyer, Richard (2004 [1986]) *Heavenly Bodies: Film Stars and Society* (revised edition), London: Routledge.

Early, Gerald (1994) 'Pulp and Circumstance: The Story of Jazz in High Places', in *The Culture of Bruising: Essays on Prizefighting, Literature and Modern American Culture*, Hopewell, NJ: Ecco Press, pp. 163–205.

Eco, Umberto (1977) *A Theory of Semiotics*, London: Macmillan.

Eco, Umberto (1994) 'Fakes and Forgeries', in *The Limits of Interpretation*, Bloomington: Indiana University Press, pp. 174–202.

Eleftheriotis, Dimitris (2001) *Popular Cinemas of Europe: Studies of Texts, Contexts and Frameworks*, London: Continuum.

Eliot, T. S. (1920) *The Sacred Wood*, London: Methuen.

Elsaesser, Thomas with Barker, Adam (eds) (1990) *Early Cinema: Space, Frame, Narrative*, London: British Film Institute.

Engel, Lehman (1967) *The American Musical Theater*, New York: Macmillan/CBS.

Erickson, Todd (1996) 'Kill Me Again: Movement Becomes Genre', in Silver, Alain and Ursini, James (eds) *Film Noir Reader*, New York: Limelight, pp. 307–329.

Everett, Percival (1999) 'F/V: Placing the Experimental Novel', *Callaloo* 22:1, 18–23.

Everett, Percival (2004 [2001]) *Erasure*, London: Faber and Faber. (Hanover: University Press of New England.)

Fairlamb, Brian (1996) 'Tough Guys and Fairy-Tales: a Case Study of the Influence of the Films of Nicholas Ray upon Truffaut's *Tirez sur le pianiste*', *French Cultural Studies* 7, 49–62.

Falkowska, Janina (1996) *The Political Films of Andrzej Wajda: Dialogism in Man of Marble, Man of Iron and Danton*, Oxford: Berghahn.

Ferrara, Fernando, Ludovica Koch, Erilda Melillo Reali and Luciano Zagari (eds) (1983) *Le lettere rubate. Studi sul Pastiche letterario*, Naples: Istituto Universitario Orientale.

Fielding, Raymond (1972) *The American Newsreel 1911–1967*, Norman, OK: University of Oklahoma Press.

Fisher, Jennifer (2003) *'Nutcracker' Nation*, New Haven: Yale University Press.

Flaubert, Gustave (1950) *Madame Bovary* (trans. Alan Russell), Harmondsworth: Penguin.

Flaubert, Gustave (1961 [1856]) *Madame Bovary* (ed. Édouard Maynial), Paris: Garnier.

Flaubert, Gustave (1964) *Madame Bovary* (trans. Mildred Marmur), New York: New American Library.

Flaubert, Gustave (1987 [1886]) *Par les champs et par les grèves* (ed. Adrianne J Tooke), Geneva: Droz.

Flaubert, Gustave (1998 [1856]) *Madame Bovary*, Paris: Gallimard.

Floyd, Samuel A. (ed.) (1993) *Black Music in the Harlem Renaissance*, Knoxville: University of Tennessee Press.

Floyd, Samuel A. (1995) *The Power of Black Music: Interpreting Its History from Africa to the United States*, New York: Oxford University Press.

Fowler, Roger (1973) *A Dictionary of Modern Critical Terms*, London: Routledge and Kegan Paul.

Franco, Jean (1990) 'Pastiche in Contemporary Latin American Literature', *Studies in Twentieth Century Literature* 14: 1, 96–107.

Frayling, Christopher (1981) *Spaghetti Westerns: Cowboys and Europeans from Karl May to Sergio Leone*, London: Routledge and Kegan Paul.

Frayling, Christopher (2000) *Sergio Leone: Something to Do with Death*, London: Faber and Faber.

Frayling, Christopher (2005) *Sergio Leone: Once Upon a Time in Italy*, London: Thames and Hudson.

Gaines, Jane Marie and Herzog, Charlotte Cornelia (1998) 'The Fantasy of Authenticity in Western Costume', in Buscombe, Edward and Pearson, Roberta (eds) *Back in the Saddle Again*, London: British Film Institute, pp. 172–181.

Gallafent, Edward (1992) 'Echo Park: Film Noir in the 'Seventies', in Cameron, Ian (ed.) *The Movie Book of Film Noir*, London: Studio Vista, pp. 254–266.

Gammond, Peter (1991) *The Oxford Companion to Popular Music*, Oxford: Oxford University Press.

Garafola, Lynn (ed.) (1997) *Rethinking the Sylph: New Perspectives on the Romantic Ballet*, Hanover NH: Wesleyan University Press/University Press of New England

Garis, Robert (2004) *The Films of Orson Welles*, Cambridge: Cambridge University Press.

Gaskill, Howard (ed.) (1991) *Ossian Revisited*, Edinburgh: Edinburgh University Press.

Gates, Henry Louis Jr. (1984) 'The Blackness of Blackness: a critique of the Sign and the Signifying Monkey', in Gates, Henry Louis Jr. (ed.) *Black Literature and Literary Criticism*, New York: Methuen, pp. 285–321.

Gates, Henry Louis Jr. (1992) 'Tell Me, Sir, ... What *Is* "Black" Literature?', in *Loose Canons: Notes on the Culture Wars*, New York: Oxford University Press, pp. 87–104.

Genette, Gérard (1982) *Palimpsestes. La littérature au second degree*, Paris: Éditions du Seuil.

Genette, Gérard (1997) *Paratexts: Thresholds of Interpretation,* Cambridge: Cambridge University Press.

Giddins, Gary (1981) *Riding on a Blue Note: Jazz and American Pop*, New York: Oxford University Press.

Gill, Jonathan (2001) '"Hollywood Has Taken on a New Color": The Yiddish Blackface of Samuel Goldwyn's *Porgy and Bess*', in Wojcik, Pamela Robertson and Knight, Arthur (eds) *Soundtrack Available: Essays on Film and Popular Music*, Durham: Duke University Press, pp. 347–371.

Ginsburg, Michael Peled (1982) 'Free Indirect Discourse: A Reconsideration', *Language and Style* XV: 2, 133–149.

Gledhill, Christine (2000) 'Rethinking Genre', in Gledhill, Christine and Williams, Linda (eds) *Reinventing Film Studies*, London: Arnold, pp. 221–243.

Goldman, James and Sondheim, Stephen (2001) *Follies*, New York: Theatre Communications Group.

Gontarski, S. E. (2002) 'Style and the Man: Samuel Beckett and the Art of Pastiche', in Buning, Marius, Matthijs Engelberts and Sjef Houppermans (eds) *Samuel Beckett Today/Aujourd'hui 12: Pastiches, Parodies and Other Imitations*, Amsterdam: Rodopi, pp. 11–20.

Gottesman, Ronald (ed.) (1996) *Perspectives on Citizen Kane*, New York: G. K. Hall.

Gottschild, Brenda (1998) *Digging the Africanist Presence in American Performance: Dance and Other Contexts*, Westport: Praeger.

Grist, Leighton (1992) 'Moving Targets and Black Widows: Film Noir in Contemporary Hollywood', in Cameron, Ian (ed.) *The Movie Book of Film Noir*, London: Studio Vista, pp. 267–285.

Groom, Nick (2002) *The Forger's Shadow: How Forgery Changed the Course of Literature*, London: Picador.

Guérif, François (n.d.) 'Film Noir ... Série Noire ... Nouvelle Vague', in Wooton, Adrian and Taylor, Paul (eds) (n.d.) *David Goodis/Pulps Pictured: For Goodis' Sake*, London, British Film Institute (dossier).

Guillory, Monique (1998) 'Black Bodies Swingin': Race, Gender and Jazz', in Guillory, Monique and Green, Richard C. (eds) *Soul: Black Power, Politics and Pleasure*, New York: New York University Press, pp. 191–215.

Gunning, Tom (1990) 'The Cinema of Attractions: Early Film, its Spectator and the Avant-Garde', in Elsaesser, Thomas with Barker, Adam (eds) *Early Cinema: Space, Frame, Narrative*, London: British Film Institute, pp. 56–62.

Haas, Robert Bartlett (ed.) (1972) *William Grant Still and the Fusion of Cultures in American Music*, Los Angeles: Black Sparrow Press.

Hall, Mary Katherine (2001) 'Now You Are a Killer of White Men: Jim Jarmusch's *Dead Man* and Traditions of Revisionism in the Western', *Journal of Film and Video* 52: 4, 3–14.

Hall, Stuart (1970) 'A World at One with Itself', *New Society* 18 June, 1056–1058.

Hapgood, Robert (ed.) (1999) *Hamlet* (Shakespeare in Production Series), Cambridge: Cambridge University Press.

Harries, Dan (2000) *Film Parody*, London: British Film Institute.

Harvey, David (1989) *The Condition of Postmodernity: An Enquiry into the Origins of Cultural Change*, Oxford: Basil Blackwell.

Haywood, Ian (1986) *The Making of History: A Study of the Literary Forgeries of James Macpherson and Thomas Chatterton in Relation to Eighteenth-century Ideas of History and Fiction*, Cranbury NJ: Associated University Presses.

Hebel, Udo J. (1991) 'Towards a Descriptive Poetics of *Allusion*', in Plett, Heinrich (ed.) *Intertextuality*, Berlin: De Gruyter, pp. 135–164.

Hempel, Wido (1965) 'Parodie, Travestie und Pastiche', *Germanische-Romanische Monatsschrift*, 15 (neue Folge), 150–176.

Hermerén, Göran (1975) *Influence in Art and Literature*, Princeton: Princeton University Press.

Heyward, Michael (1993) *The Ern Malley Affair*, London: Faber and Faber.

Hibbard G R (ed.) (1987) *Hamlet*, Oxford: Oxford University Press.

Hilderbrand, Lucas (2002) 'All That Haynes Allows', available online at: www.popmatters.com/film/reviews/f/far-from-heaven.shtml

Hirsch, Foster (1999) *Detours and Lost Highways*, New York: Limelight.

Hoberman, J. (2003a) 'On *The Jazz Singer*' and '*The Jazz Singer*: A Chronology', in Hoberman, J. and Shandler, Jeremy (eds) *Entertaining America: Jews, Movies and Broadcasting*, New York: The Jewish Museum/Princeton: Princeton University Press, pp. 77–92.

Hoberman, J. (2003b) 'Fanny Brice', in Hoberman, J. and Shandler, Jeremy (eds) *Entertaining America: Jews, Movies and Broadcasting*, New York: The Jewish Museum/Princeton: Princeton University Press, pp. 154–155.

Hoberman, J. and Shandler, Jeremy (eds) (2003) *Entertaining America: Jews, Movies and Broadcasting*, New York: The Jewish Museum/Princeton: Princeton University Press.

Hoesterey, Ingeborg (2001) *Pastiche: Cultural Memory in Art, Film, Literature*, Bloomington, IN: Indian University Press.

Holstein, Jonathan (1973) *The Pieced Quilt*, Boston MA: New York Graphic Society.

Horace (1965) 'On the Art of Poetry', in Dorsch, T. S. (ed. and trans.) *Classical Literary Criticism*, Harmondsworth: Penguin, pp. 77–95.

Householder, Fred W. Jr. (1944) 'παρωδια', *Classical Philology* 39:1, 1–9.

Howe, Irving (1976) *The Immigrant Jews of New York: 1881 to the Present*, London: Routledge and Kegan Paul. (Published in the USA as *The World of Our Fathers*.)

Hughes, Howard (2004) *Once Upon a Time in the Italian West: The Filmgoers' Guide to Spaghetti Westerns*, London: I. B. Tauris.

Hurston, Zora Neale (1970 [1934]) 'Characteristics of Negro Expression' and 'Spirituals and Neospirituals', in Cunard, Nancy (ed.) *Negro: An Anthology* (edited and abridged by Hugh Ford), New York: Frederick Ungar, pp. 24–31, 223–225. [London: Wishart, 1934.]

Hutcheon, Linda (1985) *A Theory of Parody: The Teachings of Twentieth-Century Art Forms*, London: Methuen.

Hutcheon, Linda (1989) *The Politics of Postmodernism*, London: Routledge.

Hutcheon, Linda (1994) *Irony's Edge: The Theory and Politics of Irony*, London: Routledge.

Imbert, Pernette (1991) *Enrichir son style par les pastiches: grâce à Maupassant, Balzac, Zola, Proust, Colette, Céline, Duras*, Paris: Retz.

Impey, Oliver (1977) *Chinoiserie: The Impact of Oriental Styles on Western Art and Decoration*, London: Oxford University Press.

Jacobs, Arthur (1958) *A New Dictionary of Music*, Harmondsworth: Penguin.

Jablonski, Edward (ed.) (1992) *Gershwin Remembered*, Portland, OR: Amadeus.

Jameson, Fredric (1983) 'Postmodernism and Consumer Society', in Foster, Hal (ed.) *The Anti-Aesthetic: Essays on Postmodern Culture*, Port Townsend WA: Bay Press, pp. 111–125.

Jameson, Fredric (1984) 'Postmodernism, or the Cultural Logic of Late Capitalism', *New Left Review* 146, 53–92.

Jameson, Fredric (1991) *Postmodernism, or the Cultural Logic of Late Capitalism*, London: Verso.

Jameson, Richard T. (ed.) (1993) *They Went Thataway: Redefining Film Genres*, San Francisco: Mercury House.

Jay, Karla and Young, Allen (eds) (1994) *Lavender Culture* (revised edition), New York: New York University Press.

Jencks, Charles (1984) *The Language of Post-Modern Architecture*, New York: Rizzoli.

Jencks, Charles (1986) *What Is Post-Modernism?* London: Academy Editions.

Jenny, Laurent (1982) 'The Strategy of Form', in Todorov, Tzvetan (ed.) *French Literary Theory Today*, Cambridge: Cambridge University Press, pp. 34–63.

Johnson, John Andrew (1999) 'William Dawson, "The New Negro", and His Folk Idiom', *Black Music Research Journal*, 19:1, 43–60.

Johnson, Randal (1995) 'Cinema Novo and Cannibalism: *Macunaíma*', in Johnson, Randal and Stam, Robert (eds) *Brazilian Cinema* (expanded edition), New York: Columbia University Press, pp. 178–190.

Johnson, Randal and Stam, Robert (eds) (1995) *Brazilian Cinema* (expanded edition), New York: Columbia University Press.

Jones, Leroy [Baraka, Amiri] (1963) *Blues People*, New York: Morrow.

Jones, Mark (ed.) (1990) *Fake? The Art of Deception*, London: British Museum.

Joyrich, Lynne (2004) 'Written on the Screen: Mediation and Immersion in *Far from Heaven*', *Camera Obscura* 57 (19: 3): 187–218.

Kachur, Lewis (1996) 'Collage' in Turner, VII: 557–558.

Kaplan, E. Ann (ed.) (1988) *Postmodernism and Its Discontents*, London: Verso.

Kaplan, E. Ann (ed.) (1998 [1978]) *Women in Film Noir* (revised edition), London: British Film Institute.

Karrer, Wolfgang (1977) *Parodie, Travestie, Pastiche*, Munich: Wilhelm Fink.

Kawin, Bruce F. (1972) *Telling It Again and Again*, Ithaca, NY: Cornell University Press.

Kealiinohomoku, Joann (1983) 'An Anthropologist Looks at Ballet as a Form of Ethnic Dance', in Copeland, Roger and Cohen, Marshall (eds) *What Is Dance?*, Oxford: Oxford University Press, pp. 533–549.

Keil, Charles (1966) *Urban Blues*, Chicago: University of Chicago Press.

Kiremidjian, G. D. (1969–70) 'The Aesthetics of Parody', *Journal of Aesthetics and Art Criticism* 28: 2, 231–242.

Kitses, Jim (1998) 'Introduction: Post-modernism and the western', in Kitses, Jim and Rickman, Gregg (eds) *The Western Reader*, New York: Limelight Editions, pp. 15–31.

Kitses, Jim and Rickman, Gregg (eds) (1998) *The Western Reader*, New York: Limelight Editions.

Klinger, Barbara (1994) *Melodrama and Meaning: History, Culture and the Films of Douglas Sirk*, Bloomington: Indian University Press.

Knight, Arthur (2001) '"It Ain't Necessarily So That It Ain't Necessarily So": African American Recordings of *Porgy and Bess* as Film and Cultural Criticism', Wojcik, Pamela Robertson and Knight, Arthur (eds) *Soundtrack Available: Essays on Film and Popular Music*, Durham: Duke University Press, pp. 319–346.

Koch, Ludovica (1983) 'Sul *pastiche*: piaceri e sapori', in Ferrara, Fernando, Ludovica Koch, Erilda Melillo Reali and Luciano Zagari (eds) (1983) *Le lettere rubate. Studi sul Pastiche letterario*, Naples: Istituto Universitario Orientale, pp. 7–26.

Krauss, Rosalind (1986) 'Originality as Repetition', *October* 37, 35–40.

Kudelin, Aleksander (1997) 'Statut du pastiche dans les littératures médiévales du Moyen-Orient', in Mildonian, Paola (ed.) (1997) *Parodia, Pastiche, Mimetismo*, Rome: Bulzoni, pp. 57–63.

Kuhn, Hans (1974) 'Was parodiert die Parodie?', *Neue Rundschau* 85:4, 600–618.

Kullen, Tony (1997) 'Stagger Lee: A Historical Look at the Urban Legend', *MUS* 199, available online at: http://www3.clearlight.com/~acsa/stagroot.htm

LaCapra, Dominick (1982) *Madame Bovary on Trial*, Ithaca, NY: Cornell University Press.

Lacasse, Serge (2000) 'Intertextuality and Hypertextuality in Recorded Popular Music', in Talbot, M (ed.) *The Musical Work: Reality or Invention?* Liverpool: Liverpool University Press, pp. 35–58.

Lajtha, Terry (1981) 'Brechtian Devices in Non-Brechtian Cinema: *Culloden*', *Literature/Film Quarterly* 9:1, 9–14.

Laurette, Pierre (1983) 'À l'ombre du pastiche. La réécriture: automatisme et contingence', *Texte* 2, 113–134.

Lavin, Maud (1993) *Cut with the Kitchen Knife: The Weimar Photomontages of Hannah Höch*, New Haven: Yale University Press.

Lefevere, André (1992) *Translation, Rewriting, and the Manipulation of Literary Fame*, London: Routledge.

Leitch, Thomas M (2000) '101 Ways to Tell Hitchcock's *Psycho* from Gus Van Sant's', *Literature/Film Quarterly*, 28:4, 269–273.

Lelièvre, F. J. (1954) 'The Basis of Ancient Parody', *Greece and Rome* Series 2: 1–2, 66–81.

Lenain, Thierry (1989 'Jacques Charlier, "Peintures": le pastiche radical comme art du chaud-froid', *Annales de l'histoire de l'art et de l'archéologie* 11, 125–137.*

Leutrat, Jean-Louis (1985) *Le Western: Archéologie d'un genre*, Lyons: Presses Universitaires de Lyon.

Leutrat, Jean-Louis (1995) *L'Homme qui a tué Liberty Valance*, Paris: Nathan.

Levitin, Jacqueline (1982) 'The Western: Any Good Roles for Feminists?', *Film Reader* 5, 95–108.

Locke, Alain (1936) *The Negro and His Music*, Washington DC: The Associates in Negro Folk Education.[1]

Locke, Ralph P. (1998) 'Cutthroats and Casbah Dancers, Muezzins and Timeless Sands: Musical Images of the Middle East', in Bellman, Jonathan (ed.) *The Exotic in Western Music*, Boston: Northeastern University Press, pp. 104–136.

Lockspeiser, Edward (1980 [1936]) *Debussy* (revised edition), London: Dent.

Longinus (1965) 'On the Sublime', in Dorsch, T. S. (ed. and trans.) (1965) *Classical Literary Criticism*, Harmondsworth: Penguin, pp. 97–158.

Lott, Eric (1997) 'The Whiteness of Film Noir', in Hill, Mike (ed.) *Whiteness: A Critical Reader*, New York: New York University Press, pp. 81–101.

Lucas, Blake (1998) 'Saloon Girls and Rancher's Daughters: The Woman in the Western', in Kitses, Jim and Rickman, Gregg (eds) (1998) *The Western Reader*, New York: Limelight Editions, pp. 301–320.

Lucie-Smith, Edward (1984) *The Thames and Hudson Dictionary of Art Terms*, London: Thames and Hudson.

Mackay, Harper (1994) 'Potluck: Harper Mackay Takes a Look at the Cut-and-Paste Art of Pasticcio', *Opera News*, 16 April, pp. 20–23.

Madsen, Axel (1998) *The Sewing Circle: Female Stars Who Loved Other Women*, London: Robson Books.

Mallon, Thomas (2001 [1989]) *Stolen Words*, San Diego: Harcourt.

Mander, Raymond and Mitchenson, Joe (eds) (1955) *Hamlet through the Ages: A Pictorial Record from 1709*, London: Rockliff (second edition).

Mankiewicz, Herman J and Welles, Orson (1990 [1939]) *'Citizen Kane'*, in Thomas, Sam (ed.) *Best American Screenplays 2*, New York: Crown.

Mann, William J. (2002) *Behind the Screen: How Gays and Lesbians Shaped Hollywood 1910–1969*, New York: Penguin.

Marie, Michel (2003 [1997]) *The French New Wave: An Artistic School*, Oxford: Blackwell. (Translated by Richard Neupert; first published Paris: Nathan.)

Martin, Judy (1986) *The Longman Dictionary of Art*, London: Longman.

Martin, Richard (1997) *Mean Streets and Raging Bulls: The Legacy of Film Noir in Contemporary American Cinema*, Lanham, MD: Scarecrow.

Massinger, Philip (2002 [1629]) *The Roman Actor*, London: Nick Hern Books.

McArthur, Colin (1980) *Television and History*, London: British Film Institute.

McBride, Joseph (2003) *Searching for John Ford*, London: Faber and Faber.

McClary, Susan (2000) *Conventional Wisdom: The Content of Musical Form*, Berkeley: University of California Press.

McFarlane, Brian (2000) '"It wasn't like that in the book"', *Literature/Film Quarterly*, 28:3, 163–169.

McLellan, Diana (2000) *The Girls: Sappho Goes to Hollywood*, Los Angeles: LA Weekly Books.

McWillie, Judith (1996) 'Traditions and Transformations: Vernacular Art from the Afro-Atlantic South', in King, Richard H. and Taylor, Helen (eds) *Dixie Debates: Perspectives on Southern Cultures*, London: Pluto, pp. 193–217.

Medhurst, Andy (1992) 'Carry On Camp', *Sight and Sound* 2: 4 (NS), 16–19.

Meilach, Dona Z. and Hoor, Elvie Ten (1973) *Collage and Assemblages: Trends and Techniques*, London: George Allen and Unwin.

Melling, John Kennedy (1996) *Murder Done to Death: Parody and Pastiche in Detective Fiction*, Lanham, MD: Scarecrow Press.

Melnick, Jeffrey (1999) *A Right to Sing the Blues: African Americans, Jews and American Popular Song*, Cambridge, MA: Harvard University Press.

Mercer, Kobena (1994) 'Diaspora Culture and the Dialogic Imagination: The Aesthetics of Black Independent Film in Britain', in *Welcome to the Jungle: New Positions in Black Cultural Studies*, New York: Routledge.

Merck, Mandy and Townsend, Chris (eds) (2002) *The Art of Tracey Emin*, London: Thames and Hudson.

Miceli, Sergio (1994) *Morricone, la musica, il cinema*, Modena: Mucchi.

Mildonian, Paola (1997) 'Il gioco necessario. Quasi una premessa', in *Parodia, Pastiche, Mimetismo*, Rome: Bulzoni, pp. 9–22.

Mildonian, Paola (ed.) (1997) *Parodia, Pastiche, Mimetismo*, Rome: Bulzoni.

Milly, Jean (ed.) (1970) *Les Pastiches de Proust*, Paris: Armand Colin.

Moe, Orin (1986) 'A Question of Value: Black Concert Music and Criticism', *Black Music Research Journal* 6, 57–66.

Moore, Allan F (2001) *Rock: the Primary Text* (second edition), Aldershot: Ashgate.

Mortier, Roland (1971) 'Pour une histoire du Pastiche littéraire au XVIIIᵉ siècle', in *Beiträge zur französichen Aufklärung ... Festgabe für Werner Krauss*, Berlin, pp. 203–217.

Mouniama, Maï (1983) 'Le Vol des voix', in Ferrara, Fernando, Ludovica Koch, Erilda Melillo Reali and Luciano Zagari (eds) *Le lettere rubate. Studi sul Pastiche letterario*, Naples: Istituto Universitario Orientale, pp. 27–42.

Mukherjee, Arun (1990) 'Whose Post-colonialism and Whose Postmodernism?' *World Literature in English* 30:2, 7–12.

Mulvey, Laura (1992) *Citizen Kane*, London: British Film Institute.

Mulvey, Laura (2003) '*Far From Heaven*', *Sight and Sound* 13: 3 NS, 40–41.

Munt, Sally (1992) '"Somewhere Over the Rainbow...": Postmodernism and the Fiction of Sarah Schulman' in Munt, Sally (ed.) *New Lesbian Criticism: Literary and Cultural Readings*, Hemel Hempstead: Harvester, pp. 33–50.

Murchison, Gayle (2000) '"Dean of Afro-American Composers" or "Harlem Renaissance Man": The New Negro and the Musical Poetics of William Grant Still', in Smith, Catherine Parsons (2000) *William Grant Still: A Study in Contradictions*, Berkeley: University of California Press, pp. 39–65.

Murphet, Julian (1998) 'Film Noir and the Racial Unconscious', *Screen* 39: 1, 22–35.

Murray, Gabrielle (2003) 'The Last Place in the World ... A Review of *Far From Heaven*', available online at: www.sensesofcinema.com/contents/03/25/far_from_heaven.html

Musser, Charles (1990) 'The Travel Genre in 1903–1904: Moving Towards Fictional Narrative', in Elsaesser, Thomas with Barker, Adam (eds) *Early Cinema: Space, Frame, Narrative*, London: British Film Institute, pp. 123–132.

Musser, Charles (1991) *Before the Nickelodeon: Edwin S Porter and the Edison Manufacturing Company*, Berkeley: University of California Press.

Naficy, Hamid (2001) *An Accented Cinema: Exilic and Diasporic Filmmaking*, Princeton: Princeton University Press.

Naremore, James (1996 [1978]) 'On *Citizen Kane*', in Gottesman, Ronald (ed.) *Perspectives on Citizen Kane*, New York: G. K. Hall, pp. 268–294. (Extracted from *The Magic World of Orson Welles*, New York: Oxford University Press.)

Naremore, James (1998) *More Than Night: Film Noir in Its Contexts*, Berkeley: University of California Press.

Naremore, James (ed.) (2000a) *Film Adaptation*, London: Athlone Press.

Naremore, James (2000b) 'Introduction: Film and the Reign of Adaptation', in *Film Adaptation*, London: Athlone Press, pp. 1–16.

Neale, Steve (1990) 'Questions of Genre', *Screen* 31:1, 45–66.

Neale, Steve (2000) *Genre and Hollywood*, London: Routledge.

Neale, Steve (ed.) (2002) *Genre and Contemporary Hollywood*, London: British Film Institute.

Nelson, Robert J. (1958) *The Play within a Play: The Dramatist's Conception of His Art: Shakespeare to Anouilh*, New Haven: Yale University Press.

Neubauer, John (1997) 'Uncanny Pastiche: A. S. Byatt's *Possession*', in Mildonian, Paola (ed.) *Parodia, Pastiche, Mimetismo*, Rome: Bulzoni, pp. 383–392.

Nichols, Bill (1981) *Ideology and the Image*, Bloomington: Indiana University Press.

Nieland, Justus J. (1999) 'Race-ing Noir and Re-placing History: The Mulatta and Memory in *One False Move* and *Devil in a Blue Dress*', *The Velvet Light Trap* 43, 63–77.

O'Brien, Charles (1996) 'Film Noir in France: Before the Liberation', *Iris* 21, 7–20.

OED (Oxford English Dictionary) (1989), Oxford: Clarendon Press.

Oliver, Kelly and Trigo, Benigno (2003) *Noir Anxiety*, Minneapolis: University of Minnesota Press.

Orr, John and Ostrowski, Elzbieta (eds) (2003) *The Cinema of Andrzej Wajda: The Art of Irony and Defiance*, London: Wallflower.

Parkinson, Michael and Jeavons, Clyde (1972) *A Pictorial History of the Western*, London: Hamlyn.

Pascal, Roy (1977) *The Dual Voice: Free Indirect Speech and its Functioning in the Nineteenth Century European Novel*, Manchester: Manchester University Press.

Pearce, Lynn (1994) *Reading Dialogics*, London: Edward Arnold.

Pearsall, Derek (2003) 'Forging Truth in Medieval England', in Ryan, Judith and Thomas, Alfred (eds) *Cultures of Forgery: Making Nations, Making Selves*, Routledge: New York, pp. 3–14.

Perkins, Victor (1996) '*Johnny Guitar*', in Cameron, Ian and Pye, Douglas (eds) *The Movie Book of the Western*, London: Studio Vista, pp. 221–228.

Perri, Carmela (1978) 'On Alluding', *Poetics* 7, 289–307.

Peterson, Jennifer (1998) 'The Competing Tunes of *Johnny Guitar*: Liberalism, Sexuality, Masquerade', in Kitses, Jim and Rickman, Gregg (eds) *The Western Reader*, New York: Limelight Editions, pp. 321–339.

Petric, Vlada (1984) 'Esther Shub: Film as a Historical Discourse', in Waugh, Thomas (ed.) *'Show Us Life': Toward a History and Aesthetics of the Committed Documentary*, Metuchen, NJ: Scarecrow Press.

Pfister, Manfred (1991) 'How Postmodern is Intertextuality?', in Plett, Heinrich (ed.) *Intertextuality*, Berlin: De Gruyter, pp. 207–224.

Pidduck, Julianne (2003) 'After 1980: Margins and Mainstreams', in Dyer, Richard with Pidduck, Julianne, *Now You See It: Studies on Lesbian and Gay Film* (second edition), London: Routledge, pp. 265–294.

Place, Janey A. (1998 [1978]) 'Women in Film Noir', in Kaplan, E. Ann (ed.) *Women in Film Noir* (revised edition), London: British Film Institute, pp. 47–68.

Placksin, Sally (1985 [1982]) *Jazzwomen: 1900 to the Present, Their Words, Lives and Music*, London: Pluto. (First published as *American Women in Jazz*, New York: Wideview Books, 1982.)

Plantinga, Carl R. (1997) *Rhetoric and Representation in Nonfiction Film*, Cambridge: Cambridge University Press.

Plett, Heinrich (ed.) (1991) *Intertextuality*, Berlin: De Gruyter.

Pollard, Lawrence (2004) 'Even Better than the Real Thing' *The Guardian* (Review), 30 January 2004, pp. 8–9.

Potter, Russell (1995) *Spectacular Vernacular: Hip-hop and the Politics of Postmodernism*, Albany, NY: SUNY Press.

Proust, Marcel (1954) *Contre Sainte-Beuve*, Paris: Gallimard. [Written 1908–1910, published posthumously.]

Proust, Marcel (1989 [1927]) *Le Temps retrouvé* (Pléiade edition), Paris: Gallimard

Proust, Marcel (1996) *Time Regained* (trans. Andreas Mayor and Terence Kilmarton, revised by D. J. Enright), London: Vintage.

Proust, Marcel (2002 [1919]) *Pastiches et mélanges*, Paris: Gallimard.

Puppa, Paolo (1997) 'Teorie e pratiche del metateatro', in Mildonian, Paola (ed.) *Parodia, Pastiche, Mimetismo*, Rome: Bulzoni, pp. 425–433.

Pye, Douglas (1996) 'Genre and History: *Fort Apache* and *The Man Who Shot Liberty Valance*', in Cameron, Ian and Pye, Douglas (eds) (1996) *The Movie Book of the Western*, London: Studio Vista, pp. 111–122.

Randall, Marilyn (2001) *Pragmatic Plagiarism: Authorship, Profit and Power*, Toronto: University of Toronto Press.

Rattenbury, Ken (1990) *Duke Ellington: Jazz Composer*, New Haven: Yale University Press.

Raven, S. D. (1966) *Poetastery and Pastiche*, Oxford: Blackwell.

Rentschler, Eric (2003) 'The Fascination of a Fake: *The Hitler Diaries*', in Ryan, Judith and Thomas, Alfred (eds) *Cultures of Forgery: Making Nations, Making Selves*, Routledge: New York, pp. 199–212.

Replogle, Carol (1969–70) 'Not Parody, Not Burlesque: The Play Within the Play in *Hamlet*', *Modern Philology* 67:2, 150–159.

Rickman, Gregg (1998) 'The Western under Erasure: *Dead Man*', in Kitses, Jim and Rickman, Gregg (eds) *The Western Reader*, New York: Limelight Editions, pp. 381–404.

Riffaterre, Michael (1980) 'La trace de l'intertexte', *La Pensée* CCXV, 4–18.

Rivière, Joan (1986 [1929]) 'Womanliness as a Masquerade', in Burgin, Victor, James Donald and Cora Kaplan (eds) *Formations of Fantasy*, London: Methuen, pp. 35–44. [*International Journal of Psychoanalysis* 10.]

Robertson, Pamela (1996) 'Camping under Western Stars: Joan Crawford in *Johnny Guitar*', in *Guilty Pleasures: Feminist Camp from Mae West to Madonna*, Durham, NC: Duke University Press, pp. 85–114.

Rogin, Michael (1996) *Blackface, White Noise: Jewish Immigrants in the Hollywood Melting Pot*, Berkeley/Los Angeles: University of California Press.

Rosar, William H. (2001) 'The *Dies Irae* in *Citizen Kane*: Musical Hermeneutics Applied to Film Music', in Donnelly, K. J. (ed.) *Film Music: Critical Approaches*, Edinburgh: Edinburgh University Press, pp. 103–117.

Roscoe, Jane and Hight, Craig (2001) *Faking It: Mock-documentary and the Subversion of Factuality*, Manchester: Manchester University Press.

Rose, Margaret A. (1993) *Parody: Ancient, Modern and Post-modern*, Cambridge: Cambridge University Press.

Rose, Tricia (1994) *Black Noise: Rap Music and Black Culture in Contemporary America*, Hanover NH: Wesleyan University Press.

Rosenbaum, Jonathan (2000) *Dead Man*, London: British Film Institute.

Rosenberg, Marvin (1992) *The Masks of Hamlet*, Newark: University of Delaware Press/Cranbury, NJ: Associated University Presses.

Ross, Andrew (1989) *No Respect: Intellectuals and Popular Culture*, New York: Routledge.

Russett, Margaret (n.d.) 'Percival Everett: The African-American Novelist under *Erasure*', available online at: http://usconsulate-istanbul.org.tr/reppub/newamstud/mrussett.html.

Russett, Margaret (2005) 'Race under *Erasure*: for Percival Everett, "a piece of fiction"', *Callaloo* 28:2, 358–368.

Ryan, Judith (1990) 'The Problem of Pastiche: Patrick Süskind's *Das Parfum*', *German Quarterly* 63: 3–4, 396–403.

Ryan, Judith and Thomas, Alfred (eds) (2003) *Cultures of Forgery: Making Nations, Making Selves*, Routledge: New York.

Ryder, Georgia A. (1993) 'Harlem Renaissance Ideals in the Music of Robert Nathaniel Dett', in Floyd, Samuel A. (ed.) *Black Music in the Harlem Renaissance*, Knoxville: University of Tennessee Press, pp. 41–54.

Salt, Barry (1983) *Film Style and Technology: History and Analysis*, London: Starword.

Sanders, Ronald (1976) 'The American Popular Song', in Villiers, Douglas (ed.) *Next Year in Jerusalem: Jews in the Twentieth Century*, London: Harrap, pp. 197–219.

Sayce, R. A. (1973) 'The Goncourt Pastiche in *Le Temps retrouvé*', in Price, Larkin B. (ed.) *Marcel Proust: A Critical Panorama*, Urbana: University of Illinois Press, pp. 102–123.

Scharf, Aaron (1974) *Art and Photography* (revised edition), Harmondsworth: Penguin.

Schiff, David (1997) *Gershwin: Rhapsody in Blue*, Cambridge: Cambridge University Press.

Schiff, Stephen (1993 [1981]) '*Body Heat*', in Jameson, Richard T. (ed.) *They Went Thataway: Redefining Film Genres*, San Francisco: Mercury House, pp. 31–35. (From *Boston Phoenix*, 22 September 1981.)

Schmitz, E. Robert (1950) *The Piano Works of Claude Debussy*, New York: Dover.

Schneider, Michel (1985) *Voleurs de mots. Essai sur le plagiat, la psychanalyse et la pensée*, Paris: Gallimard.

Schneider, Tassilo (1998) 'Finding a New *Heimat* in the Wild West: Karl May and the German Westerns of the 1960s', in Buscombe, Edward and Pearson, Roberta (eds) *Back in the Saddle Again*, London: British Film Institute, pp. 141–159.

Scholes, Percy (1970 [1938]) *The Oxford Companion to Music*, Oxford: Oxford University Press. (Revised edition, edited by John Owen Ward.)

Schulman, Sarah (1998) *Stagestruck: Theater, AIDS, and the Marketing of Gay America*, Durham: Duke University Press.

Schulze-Engler, Frank (2002) 'Exceptionalist Tendencies – Disciplinary Constraints: Postcolonial Theory and Criticism', *Euorpean Journal of English Studies* 6:3, 289–305.

Sconce, Jeffrey (2000) *Haunted Media: Electronic Presence from Telegraphy to Television*, Durham NC: Duke University Press.

Secrest, Meryle (1998) *Stephen Sondheim: A Life*, London: Bloomsbury.

Segall, J. B. (1966 [1907]) *Corneille and the Spanish Drama*, New York: AMS Press. [New York: AMS Press, 1907.]

Seitz, William C. (1961) *The Art of Assemblage*, New York: Museum of Modern Art.

Shuker, Roy (1998) *Key Concepts in Popular Music*, London: Routledge.

Silver, Alain (1996) 'Son of *Noir*: Neo-*Film Noir* and the Neo-B Picture', in Silver, Alain and Ursini, James (eds) *Film Noir Reader*, New York: Limelight, pp. 331–338.

Silver, Alain and Ursini, James (eds) (1996) *Film Noir Reader*, New York: Limelight.

Silver, Alain and Ursini, James (eds) (1999) *Film Noir Reader 2*, New York: Limelight.

Silver, Alain and Ward, Elizabeth (1988) *Film Noir: An Encyclopedic Reference Guide* (revised edition), London: Bloomsbury.

Simmon, Scott (2003) *The Invention of the Western Film: A Cultural History of the Genre's First Half-Century*, Cambridge: Cambridge University Press.

Slattery, Paul Harold (1972) 'A Comprehensive Study of the *Afro-American Symphony*', in Haas, Robert Bartlett (ed.) *William Grant Still and the Fusion of Cultures in American Music*, Los Angeles: Black Sparrow Press, pp. 11–40.

Slobin, Mark (2003) 'Putting Blackface in Its Place', in Hoberman, J. and Shandler, Jeremy (eds) (2003) *Entertaining America: Jews, Movies and Broadcasting*, New York: The Jewish Museum/Princeton: Princeton University Press, pp. 93–99.

Smith, Catherine Parsons (2000) *William Grant Still: A Study in Contradictions*, Berkeley: University of California Press.

Smith, Steven C. (1991) *A Heart at Fire's Centre: The Life and Music of Bernard Herrmann*, Berkeley: University of California Press.

Smith, Valerie (1998) *Not Just Race, Not Just Gender: Black Feminist Readings*, New York: Routledge.

Sontag, Susan (1967) 'Notes on "Camp"', in *Against Interpretation*, London: Eyre and Spottiswoode, pp. 275–292.

Sørenssen, Bjørn (2003) '"Visual Eloquence" and Documentary Form: Meeting Man of Marble in Nowa Huta', in Orr, John and Ostrowski, Elzbieta (eds) *The Cinema of Andrzej Wajda: The Art of Irony and Defiance*, London: Wallflower, pp. 103–115.

Spicer, Andrew (2002) *Film Noir*, Harlow: Pearson Longman.

Stafford, Fiona (1988) *The Sublime Savage: James Macpherson and the Poems of Ossian*, Edinburgh: Edinburgh University Press.

Stafford, Fiona J. (1991) '"Dangerous Success": Ossian, Wordsworth, and English Romantic Literature', in Gaskill, Howard (ed.) *Ossian Revisited*, Edinburgh: Edinburgh University Press, pp. 49–72.

Stallybrass, Peter and White, Allon (1986) *The Politics and Poetics of Transgression*, Ithaca, NY: Cornell University Press.

Stam, Robert (1989) *Subversive Pleasures: Bakhtin, Cultural Criticism and Film*, Baltimore, MD: Johns Hopkins University Press.

Stam, Robert (2000) 'Beyond Fidelity: The Dialogics of Adaptation', in Naremore, James (ed.) *Film Adaptation*, London: Athlone Press, pp. 54–76.

Stam, Robert, João Luiz Vieira and Ismail Xavier (1995) 'The Shape of Brazilian Cinema in the Postmodern Age', in Johnson, Randal and Stam, Robert (eds) *Brazilian Cinema* (expanded edition), New York: Columbia University Press, pp. 389–472.

Stanfield, Peter (2002) '"Film Noir Like You've Never Seen Before": Jim Thompson Adaptations and Cycles of Neo-noir', in Neale, Steve (ed.) *Genre and Contemporary Hollywood*, London: British Film Institute, pp. 251–268.

Stearns, Marshall and Jean (1968) *Jazz Dance: The Story of American Vernacular Dance*, New York: Macmillan.

Stern, Kenneth (1994) 'Pasticcio', in Sadie, Stanley (ed.) *The New Grove Dictionary of Opera*, London: Macmillan, pp. 907–910.

Still, Judith and Worton, Michael (eds) (1990) *Intertextuality: Theories and Practices*, Manchester: Manchester University Press.

Stuart, Andrea (1997) '*The Watermelon Woman*', *Sight and Sound* 7: 10 NS, 63–64.

Studlar, Gaylyn (1998) 'Wider Horizons: Douglas Fairbanks and Nostalgic Primitivism', in Buscombe, Edward and Pearson, Roberta (eds) (1998) *Back in the Saddle Again*, London: British Film Institute, pp. 63–76.

Studlar, Gaylyn and Bernstein, Matthew (eds) (2001) *John Ford Made Westerns: Filming Beyond the Legend in the Sound Era*, Bloomington: Indiana University Press.

Sutton, Dana (1980) *The Greek Satyr Play*, Meisenheim am Glan: Anton Hain.

Suvin, Darko (1997) 'Against Originals: *Honkadori* and the Horizons of Pastiche', in Mildonian, Paola (ed.) *Parodia, Pastiche, Mimetismo*, Rome: Bulzoni, pp. 65–80.

Taruskin, Richard (1998) '"Entoiling the Falconet": Russian Musical Orientalism in Context', in Bellman, Jonathan (ed.) *The Exotic in Western Music*, Boston: Northeastern University Press, pp. 194–217.

Taubin, Amy (2002) 'In Every Dream Home', *Film Comment* September–October, 22–26.

Taylor, Helen (2001) *Circling Dixie: Contemporary Southern Culture through a Transatlantic Lens*, New Brunswick: Rutgers University Press.

Thomas, Deborah (2000) *Beyond Genre: Melodrama, Comedy and Romance in Hollywood Films*, London: Cameron and Hollis.

Thomas, Rosie (1985) 'Indian Cinema: Pleasures and Popularity', *Screen*, 26:3–4, 34–57.

Tiffin, Helen (1991) 'Introduction', in Adam, Ian and Tiffin, Helen (eds) *Past the Long Post: Theorizing Post-Colonialism and Post-Modernism*, Hemel Hempstead: Harvester Wheatsheaf, pp. vii–xv.

Tillotson, Geoffrey (ed.) (1941) *The Rape of the Lock*, London: Methuen.

Török, Jean-Paul (1993 [1961]) 'The Sensitive Spot', in Brunette, Peter (ed.) *Shoot the Piano Player: François Truffaut, Director*, Oxford: Roundhouse Publishing, pp. 228–234. ['Le Point sensible', *Positif* 38, 39–47.]

Trevor-Roper, Hugh (1983) 'The Invention of Tradition: The Highland Tradition of Scotland', in Hobsbawm, Eric and Ranger, Terence (eds) *The Invention of Tradition*, Cambridge: Cambridge University Press, pp. 15–42.

Truffaut, François (1993 [1961]) 'Should Films be Politically Committed?', in Brunette, Peter (ed.) *Shoot the Piano Player: François Truffaut, Director*, Oxford: Roundhouse Publishing, pp. 134–136. (Extract from 'Questions à l'auteur', *Cinéma 61* 52, 7–11.)

Tucker, Mark (ed.) (1993a) *Duke Ellington's Black, Brown and Beige*, Special Issue of *Black Music Research Journal*, 13:2.

Tucker, Mark (ed.) (1993b) *The Duke Ellington Reader*, New York: Oxford University Press.

Turim, Maureen (2003) 'Remembering and Deconstructing: The Historical Flashback in *Man of Marble* and *Man of Iron*', in Orr, John and Ostrowski, Elzbieta (eds) *The Cinema of Andrzej Wajda: The Art of Irony and Defiance*, London: Wallflower, pp. 93–102.

Turner, Jane (ed.) (1996) *The Dictionary of Art*, London: Macmillan (Grove).

Tyler, Parker (1971 [1949]) 'Documentary Technique in Film Fiction', in Jacobs, Lewis (ed.) *The Documentary Tradition*, New York: W. W. Norton, pp. 251–266. [*American Quarterly*, Summer 1949.]

Ullmann, Stephen (1964) *Style in the French Novel*, Oxford: Basil Blackwell.

Usher, M. D. (1998) *Homeric Stitchings: The Homeric Centos of the Empress Eudocia*, Lanham, MD: Rowman and Littlefield.

Venturi, Robert (1977 [1966]) *Contradiction and Complexity in Architecture*, London: The Architectural Press. [New York: Museum of Modern Art.]

Verweyen, Theodor and Witting, Gunther (1991) 'The Cento. A Form of Intertextuality from Montage to Parody', in Plett, Heinrich (ed.) *Intertextuality*, Berlin: De Gruyter, pp. 165–178.

Vieira, João Luiz (1998) 'Lessons from the Past: The Carnivalesque and the Avant Garde', in Vieira, João Luiz (ed.) *Cinema Novo and Beyond*, New York: Museum of Modern Art, pp. 101–112.

Vieira, João Luiz (ed.) (1998) *Cinema Novo and Beyond*, New York: Museum of Modern Art.

Vincendeau, Ginette (1992) 'Noir is also a French Word', in Cameron, Ian (ed.) *The Movie Book of Film Noir*, London: Studio Vista, pp. 49–58.

Vincendeau, Ginette (2003) *Jean-Pierre Melville* Vincendeau, Ginette (2006 [forthcoming]) 'French Film Noir in the Classical Era', in Spicer, Andrew (ed.) *European Film Noir*, Manchester: Manchester University Press.[2]

Walkley, Arthur Bingham (1970 [1921]) *Pastiche and Prejudice*, Freeport, NY: Books for Libraries Press. [London: William Heinemann.]

Warrack, John (1979) *Tchaikovsky Ballet Music*, London: British Broadcasting Corporation.

Warshow, Robert (1971 [1954]) 'Movie Chronicle: the Westerner', in *The Immediate Experience*, New York: Atheneum, pp. 135–154. [*Partisan Review* March–April 1954.]

Watkins, Glenn (1994) *Pyramids at the Louvre: Music, Culture and Collage from Stravinsky to the Postmodernists*, Cambridge, MA: Belknap Press of Harvard University Press.

Webster's Third New International Dictionary of the English Language Unabridged (1961), London: Bell.

Werness, Hope B. (1983) '*Han van Meegeren* fecit', in Dutton, Denis (ed.) *The Forger's Art: Forgery and the Philosophy of Art*, Berkeley: University of California Press, pp. 1–57.

Wescher, Herta (1968) *Collage* (trans. Robert E. Wolf), New York: Harry N. Abrams.

Wiley, Roland John (1985) *Tchaikovsky's Ballets: Swan Lake, Sleeping Beauty, Nutcracker*, Oxford: Clarendon Press.

Wiley, Roland John (ed.) (1990) *A Century of Russian Ballet: Documents and Accounts, 1810–1910*, Oxford: Clarendon Press.

Williams, Alan (1984) 'Is a Radical Genre Criticism Possible?', *Quarterly Review of Film Studies* 9: 2, 121–125.

Williams, Tony (1999) 'British Film Noir', in Silver, Alain and Ursini, James (eds) *Film Noir Reader 2*, New York: Limelightm, pp. 243–271.

Willis, Corin (2002) *The Signifier Returns to Haunt the Referent: Blackface and the Stereotyping of African-Americans in Hollywood Early Sound Film*, PhD thesis, University of Warwick, Coventry (unpublished).

Willis, Sharon (2003) 'The Politics of Disappointment: Todd Haynes Rewrites Douglas Sirk', *Camera Obscura* 54 (18:1), 131–174.

Wilson, Elizabeth (1990) 'These New Components of the Spectacle: Fashion and Postmodernism', in Boyne, Roy and Rattansi, Ali (eds) *Postmodernism and Society*, London: Macmillan, pp. 209–236.

Wilton-Ely, John (1996) 'Capriccio', in Turner, Jane (ed.) *The Dictionary of Art*, London: Macmillan (Grove), pp. 685–688.

Wojcik, Pamela Robertson and Knight, Arthur (eds) (2001) *Soundtrack Available: Essays on Film and Popular Music*, Durham: Duke University Press.

Wolff, Janet (1990) 'Postmodern Theory and Feminist Art Practice', Boyne, Roy and Rattansi, Ali (eds) *Postmodernism and Society*, London: Macmillan, pp. 187–208.

Wood, Robin (1968) *Howard Hawks*, London: Secker and Warburg/British Film Institute.

Wooton, Adrian and Taylor, Paul (eds) (n.d.) *David Goodis/Pulps Pictured: For Goodis' Sake*, London, British Film Institute (dossier).

Wright, Richard (1938) *Uncle Tom's Children*, New York: Harper & Brothers.

Wright, Richard (1940) *Native Son*, New York: Harper and Row.

Yearwood, Gladstone L. (2000) *Black Film as Signifying Practice: Cinema, Narration and the African-American Aesthetic Tradition*, Trenton, NJ: Africa World Press.

Zadan, Craig (1990) *Sondheim and Co*, London: Nick Hern Books.

Zamora, Lois Parkinson and Faris, Wendy B. (eds) *Magic Realism: Theory, History, Community*, Durham: Duke University Press.

Zarbus, Chantal (2001) 'Subversive Scribes: Rewriting in the Twentieth Century', *Anglistica* 5:1–2, 191–207.

Zarbus, Chantal (2002) *Tempests After Shakespeare*, New York: Palgrave.

Notes

1 This was reprinted in facsimile, bound together with Locke's *Negro Art: Past and Present*, in a volume entitled *The American Negro: His History and Literature* (New York: Arno Press, 1969) and it is this that I have worked from.

2 Page references in text are to a manuscript copy; I am grateful to Ginette Vincendeau for allowing me to consult this ahead of its publication.

Subject index

Name and title index

Related titles from Routledge

Now You See It: Studies on Lesbian and Gay Film
Second Edition
Richard Dyer

Now You See It, Richard Dyer's groundbreaking study of films by and about
lesbians and gay men, has been revised for a second edition, and features an
introduction by Juliane Pidduck outlining developments in lesbian and
gay cinema since 1990.
Now You See It examines familiar titles such as *Girls in Un (form, Un Chant
D'Amour,* and *Word Is* Out, in their lesbian/gay context as well as bringing
to light many other forgotten but remarkable films. Each film is
examined in detail in relation to both film type and tradition and the
sexual subculture in which it was made.
Now You See It is also a case study in the dynamics of lesbian/gay cultural
production. These films were formed from the filmic and subcultural
images, assumptions and styles available to lesbians and gay men which
both made the films possible and delimited the forms they could take
and what they could say. Such processes of formation and deformation
characterise all cultural production, but they carry a special charge for
lesbians and gay men seeking both to break free from and be heard in the
languages of a homophobic society.

ISBN 10: 0-415-25498-1 (hbk)
ISBN 10: 0-4l5-25499-x (pbk)

ISBN 13: 9-78-0-415-25498-4 (hbk)
ISBN 13: 9-78-0-415-25499-1 (pbk)

Available at all good bookshops
For ordering and further information please visit:
www.routledge.com

Related titles from Routledge

The Culture of Queers
Richard Dyer

For around a hundred years up to the Stonewall riots, the word for gay men was 'queers'. From screaming queens to sensitive vampires and sad young men, and from pulp novels to pornography to the films of Fassbinder, *The Culture of Queen* explores the history of queer arts and media.
Richard Dyer traces the contours of queer culture, examining the differences and continuities with the gay culture which succeeded it. Opening with a discussion of the very concept of 'queers', he asks what it means to speak of a sexual grouping having a culture and addresses issues such as gay attitudes to women and the notion of camp.
Dyer explores a range of queer-made culture, from key topics such as fashion and vampires to genres like film *noir* and the heritage film, and stars such as Charles Hawtrey (outrageous star of *Carry On* films) and Rock Hudson. Offering a grounded historical approach to the cultural implication of queerness, *The Culture of Queers* both insists on the cultural consequences of the oppression of homosexual men and offers a celebration of queer resistance.

ISBN 10: 0-415-22375-x (hbk)
ISBN 10: 0-415-22376-8 (pbk)

ISBN 13: 9-78-0-415-22375-1 (hbk)
ISBN 13: 9-78-0-415-22376-8 (pbk)

Available at all good bookshops
For ordering and further information please visit:
www.routledge.com

Related titles from Routledge

Only Entertainment
Second Edition
Richard Dyer

The idea of entertainment is a guiding principle for both makers and audiences of films, television programmes, and other media. Yet, while entertainment is often derided or praised, the concept itself is often taken for granted. *Only Entertainment* explores entertainment *as* entertainment, asking how and whether an emphasis on the primacy of pleasure sets it apart from other forms of art.

In this series of provocative and lucid essays Richard Dyer focuses on the genres most associated with entertainment, from musicals to action movies, disco to porn. He examines the nature of entertainment in movies such as *The Sound of Music* and *Speed,* and argues that entertainment is part of a 'common sense' which is always historically and culturally constructed.

This new edition of *Only Entertainment* features a revised introduction and five new chapters on topics from serial killer movies to Elizabeth Taylor. In the final chapter Dyer asks whether entertainment as we know it is on the wane.

ISBN 10: 0-415-25497-3 (hbk)
ISBN 10: 0-415-25496-5 (pbk)

ISBN 13: 9-78-0-415-25497-7 (hbk)
ISBN 13: 9-78-0-415-25496-0 (pbk)

Available at all good bookshops
For ordering and further information please visit:
www routledge.com

Related titles from Routledge

The Matter of Images: Essays on Representation
Second Edition
Richard Dyer

Now published in a revised second edition, *The Matter of Images* searches through the resonances of the term 'representations, analysing images in terms of why they matter, what they are made of and the material realities they refer to. Richard Dyer's analyses consider representations of 'out' groups and traditionally dominant groups alike, and encompass the eclectic texts of contemporary culture, from royalty to serial killers, political correctnesss, representations of Empire and films such as *Gilda, Papillon* and *The Night of the Living Dead.* Essays new to the second edition discuss Lillian Gish as the ultimate white movie star, the representation of whiteness in the south in *Birth of a Nation,* and society's fascination with serial killers.
The Matter of Images is distinctive in its commitment to writing politically about contemporary culture, while insisting on the importance of understanding the formal qualities and complexity of the images it investigates.

ISBN 10: 0-415-25494-9 (hbk)
ISBN 10: 0-415-25495-7 (pbk)

ISBN 13: 9-78-0-415-25494-6 (hbk)
ISBN 13: 9-78-0-415-25495-3 (pbk)

Available at all good bookshops
For ordering and further information please visit:
www.routledge.com